ART IN THE MAKING

IMPRESSIONISM

Esso

Sponsored by Esso UK plc

ART IN THE MAKING
IMPRESSIONISM

David Bomford, Jo Kirby, John Leighton and Ashok Roy

With contributions by
Raymond White and Louise Williams

The National Gallery, London
in association with
Yale University Press, New Haven and London

Dates of the Exhibition: 28 November 1990–
21 April 1991

Library of Congress Catalog Card Number
90–71601

British Library Cataloguing in Publication Data
Impressionism. – (Art in the making).
1. European paintings. Impressionism –
Catalogues, indexes
I. Bomford, David II. National Gallery. Great
Britain. III. Series
759.054074

ISBN 0–300–05035–6
ISBN 0–300–05036–4 pbk

Designed by Chris Millett
Edited by Diana Davies
Printed in Great Britain by
Balding + Mansell plc, London and Wisbech

The cover shows a detail from *The Beach at
Trouville* by Monet, set within a raking-light
photograph from the same painting.

Acknowledgements

During the preparation of this catalogue we have
received advice and help from numerous colleagues
in this country and abroad. In particular we would
like to thank Olivier Dupuy (Directeur Général),
Mark Nicholas and Bernard des Roseaux (Directeur
du Laboratoire) of Lefranc & Bourgeois, Le Mans,
for their most generous assistance with our re-
search into nineteenth-century painting materials.
In this context our thanks are due also to Martine
Jaoul, Musée National des Arts et Traditions
Populaires, Paris, and Peter Staples (Technical
Director), Winsor & Newton.

We are especially grateful to John House for
his support and for his invaluable comments on our
text. Our catalogue entry for Manet's *Music in the
Tuileries Gardens* benefited greatly from discussions
with Juliet Bareau, who also provided several
important references to the early exhibition history
of this picture. We would also like to thank
Kathleen Adler, John Gere, Richard Kendall, Paul
Josefowitz, Timothy Lennon, Jane Munro, Joachim
Pissarro, Anne Roquebert and Richard Thomson.

Within the National Gallery the assistance of
the following is gratefully acknowledged: Astrid
Athen, Peter Brett and the Working Party, Herb
Gillman, Patricia Goddard, Colin Harvey, Sara
Hattrick, James Heard, Mary Hersov, Jo Kent, Joan
Lane and the Audio-Visual Unit, Erika Langmuir,
Neil MacGregor, John Mills, Sarah Perry, David
Saunders, Margaret Stewart, Michael Wilson,
Louise Woodroff, and National Gallery Publica-
tions Limited, in particular Felicity Luard, Sue
Curnow and Emma Shackleton.

Our Editor, Diana Davies, has worked tire-
lessly and efficiently to prepare the text for
publication.

We are particularly indebted to Beverly
Nicholson for patiently typing the manuscript.

Contents

Sponsor's Preface

As with the two previous exhibitions in this series, *Art in the Making: Impressionism* does much more than bring together a collection of pictures of a period. It leads us behind the pictures, and even through them.

We see not just painted surfaces, but are given multi-disciplined information which brings the paintings themselves to life. With the help of the painstaking detail captured in the exhibition and in the catalogue, we can see that Impressionism was not only a surge of artistic freedom, but a movement whose time had come.

Any earlier and the frustrations with the constraints of academic practice would not have reached breaking point; any earlier and the chemistry of paint production would not have progressed to give the artists the new, stunning, vibrant colours we instantly associate with the movement; any earlier and the advances in technology such as those which substituted collapsible tin paint-tubes for pieces of pig's bladder, so helping the movement out into the open air, would not have been exploitable.

Our thanks are due to all the staff at the National Gallery for the dedication to detail and commitment to excellence which have given us this whole series. The title *Art in the Making* has served as a description not just of the paintings and their times, but of the modern work of conservation, and the exploration of scientific enquiry and technological techniques which have given us the ability to look back with much more knowledge and understanding of the process behind the creation of these masterpieces.

For our part, we as sponsors have been excited and enthralled by all that has been made available to a wider public. In this process we have been surprised by some of the similarities between producing a great painting and running a modern, technical business.

Masterpieces were created as the paint was applied, but from the early Italians to the Impressionists it is clear that behind the artistic movement was a whole array of practical considerations affecting the panels or canvases, access to suitable media, and the range of the palette. Each of the three exhibitions has shown artists striving at the boundaries of technical knowledge to perfect their art, and push back the frontiers of what was possible and pleasing.

We share with them, and the staff of the National Gallery, a desire for the best, and in this exhibition we see it.

Sir Archibald Forster
Chairman and Chief Executive
Esso UK plc

Foreword

In every public Gallery in the world, the Impressionist rooms are the busiest. That is no accident. We respond to spontaneous works of art with a delight that is spontaneous in return. Grown confident in the presence of sincerity, we reciprocate the directness of the artist, happy that no calculation or theory need stand between us and the pleasure of our looking. There is the heady illusion that we could almost have painted these pictures ourselves. Add to that the Impressionists' love of painting scenes of straightforward enjoyment and entertainment, and the mix becomes impossible to resist.

Yet at the same time we know that the spontaneous work of art is impossible. Skill of eye and hand can be won only after years of practice. Subjects must be chosen. First thoughts will almost always need to be developed further, or simply tidied up. The work of art is, and remains, an artifice and supremely artificial. And as the old cliché has it, the height of art is to conceal the art.

This exhibition is in part an investigation of that cliché: How do the Impressionists manage to keep up the appearance of effortless ease? Were they doing new things, or old things in a new way? Did they have materials denied to their predecessors? Was it in fact as easy for them as it seems? Watch the conjuror's hands very carefully, and you will see how he does the trick.

In this third *Art in the Making* exhibition, we can watch the hands very closely indeed. Using the scientific and photographic techniques deployed in the first two parts of this series, *Rembrandt* and *Italian Painting before 1400*, we can follow the stages of creation – whether the few hours of Monet's *Beach at Trouville* or the years needed for Renoir's *Umbrellas*.

This exhibition has been possible only because of dedicated work by members of the Gallery staff and remarkable generosity on the part of our sponsors Esso UK plc. It is customary and proper to thank both colleagues and sponsors at the beginning of an exhibition. In this case gratitude to both goes far beyond the usual. Our sponsors have supported three pioneering exhibitions, helping us to make available new research to a wider public, matching their open-handedness with an unusually strong commitment to the enterprise. The series of exhibitions has drawn on the skills and strengths of almost all Gallery departments. As the opening of the Sainsbury Wing draws nearer, the claims on time grow. And it is only the dedication of the authors of this catalogue and their colleagues in the Photographic Department, Design and Publications that has made this exhibition possible. To them and to Esso UK plc, on behalf of all of the National Gallery, I should like to express our warmest thanks.

Neil MacGregor
Director

Introduction

The Impressionist sits on a river-bank: depending on the weather, his angle of vision, the time of day, and whether it is windy or still, the water takes on every possible tone, and he paints, unhesitatingly, the water and all its tones. When the sky is overcast on a rainy day, he paints sea-green, heavy, opaque water; when the sky is clear, and the sun shining, he paints sparkling, silvery blue water; when it is windy, he paints the reflections made by the lapping waves; when the sun is setting and darts its rays over the water, the Impressionist, to capture the effect, lays down yellows and reds on his canvas.

This account of an Impressionist at work was written by Théodore Duret in 1878. Duret describes the apparent simplicity of the Impressionist approach, evoking a compelling image of an artist working out of doors, responding directly to the subject and striving to find equivalents in colour for fleeting effects of light and atmosphere. It is an image of Impressionism that has survived to the present, when works by Monet and his colleagues are often considered to be direct and spontaneous, as unproblematic in their physical make-up as in their subject matter.

It might seem unusual, therefore, to subject a group of Impressionist pictures to detailed technical examination and scientific analysis. The general characteristics of the Impressionists' methods and their attitudes to materials, brushwork and especially colour have been described on several occasions, but their pictures have been regarded as having few secrets to unlock, few complexities to unravel. In recent years, scholarly attention has tended to focus on the history of the Impressionist movement and on discussion of subject matter; the material basis of the pictures and how they were painted has largely been neglected. There is little technical information gained directly from the paintings themselves, and so our aim has been to fill this gap in Impressionist studies.

Fifteen paintings were chosen to reflect the development of Impressionism in its most formative years. Using X-radiography, infra-red photography and the analysis of pigments and paint medium, the aim has been to document the making of the pictures and to set their techniques within a wider context of French nineteenth-century painting practice. The artists discussed in the catalogue came to the fore during a period of dramatic change in patterns of artistic training, practice and patronage. This introduction provides background information about these issues, focusing in particular on the Impressionists' response to the new materials developed by nineteenth-century technology. The core of the catalogue is devoted to a detailed discussion of the fifteen chosen paintings and here we have attempted to retain a balance between the form of the pictures and their content, proceeding in the belief that our understanding and enjoyment of these works can be considerably enhanced by a detailed knowledge of how they were made.

Impressionist Techniques:
Tradition and Innovation

In 1876 the critic Edmond Duranty published a pamphlet entitled *The New Painting: Concerning the Group of Artists Exhibiting at the Durand-Ruel Galleries*. This essay, which appeared around the time when the Impressionists were showing their work together in their second group exhibition, was a serious and comprehensive attempt to explain a series of new tendencies in painting. After highlighting the breakdown of the academic system, with its inflexible teaching methods and its rigid adherence to tradition, Duranty praised the innovations of the younger generation who were exploring modern subjects and new approaches, contributing a 'new method of colour, of drawing, and a series of original points of view'.

Duranty was concerned to give a broad view of the new painting. He did not mention names and he avoided the recently coined label of Impressionism. Yet he was one of the first writers to formulate the now familiar opposition between the innovations of the Impressionists and the worn-out practices of academic and state-sponsored artists: 'Thus the battle really is between traditional art and the new art, between old painting and the new painting.'

It is, of course, possible to exaggerate the radical nature of Impressionism. Monet and his colleagues were not the first artists to exploit qualities of expressive brushwork and bright colour or to work directly from nature in the open air. Nevertheless, it is useful to follow Duranty's example and to set the working methods of the Impressionists against the background of accepted nineteenth-century painting procedures. Many of the technical issues addressed in our detailed analyses of individual pictures come into sharper focus when they are seen in the wider context of contemporary ideas about what constituted 'serious art'.

In this exhibition the apparent gulf between the spontaneity of Impressionist painting and the more laborious and elaborate approaches common to nineteenth-century academic art is illustrated by the display, as an introductory item, of an *académie*, a nude figure study which is presumed to have been painted by a French art student in the early 1800s (Plate 1). This work survives as something of an artistic curiosity, but it serves as a reminder that few artists in the last century could escape the dominance of the French Academy and the ideals that it promoted.

Throughout the upheaval of Revolution, Empire and Restoration the organisation of the Academy changed many times, but the principles that it enshrined remained remarkably constant. Its members appointed professors to the premier teaching institution, the Ecole des Beaux-Arts, sponsored the various student competitions and, as jurors, controlled the artists's principal market-place, the annual exhibition known as the Salon. A brief account of this influence over training and patronage provides an introduction to the career path that a young artist emerging in

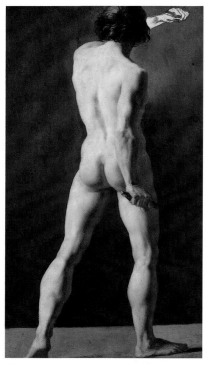

Plate 1 French School, nineteenth century, *Male Nude (An 'Académie')*. 67·3 × 36·8 cm. London, National Gallery

the 1850s or 1860s would be expected to follow.

The teaching at the Ecole des Beaux-Arts was intended for students who had already gained considerable experience. As the young Cézanne found to his cost, there was considerable competition for the limited number of places. Until 1863, when the programme was substantially reformed, the training was exclusively in drawing, and in order to learn the rudiments of his craft or indeed to obtain any practice in painting, the student was expected to enrol in one of the many private studios. Most of these were run by academicians and Beaux-Arts professors and the training tended to be directed towards the various annual competitions held at the Ecole.

There were examinations in perspective, expression, historical composition, landscape and anatomy, all leading towards the ultimate contest for the *Prix de Rome* in history painting. For the vast majority of students these competitions were a source of anxiety and frustration. For the few lucky winners, they guaranteed a successful academic career (Figs. 1, 2 and 4).

It might be assumed that the system of training in private studios linked the nineteenth-century artist with his medieval or Renaissance predecessor, who had acquired his skills by learning from an established master. In practice the studio was more like an art school than a workshop. For the academic master (who would normally attend the studio once or twice a week to correct the student's work) art was a respectable profession, not a humble craft, and the training he offered was as much for the intellect as for the hand and eye. Drawing was the most important activity. Writing in defence of the academic teaching system Ingres could claim that '. . . drawing is everything, the whole of art lies there. The material processes of painting are very easy and can be learnt in a week or so.'

The student's training followed a lengthy progression through clearly defined stages. The newest entrants in a studio made laborious copies of engravings before moving on to drawing plaster casts after the antique. Eventually, when the student was judged to be a proficient draughtsman, he would be allowed to pick up brushes

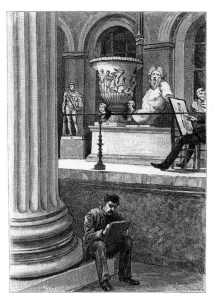

Fig. 2 *Drawing Casts of Antique Sculpture at the Ecole des Beaux-Arts*, engraving (Lemaistre, 1889)

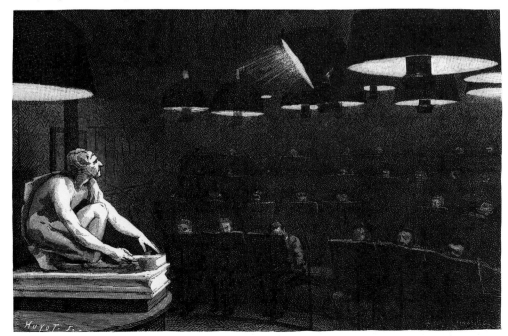

Fig. 1 *The Drawing Lesson*, engraving (Lemaistre, 1889)

and paint. Again he would begin by painting copies (usually of studies of a head provided by the master) before moving on to working from the life model.

From the initial drawing to the finishing touches, the painting of a head or a figure was an elaborate process. Most masters laid particular emphasis on the preparatory stages and the painting of an *ébauche* was central to academic practice. A drawing in charcoal or pencil would be worked over with a dilute, reddish-brown paint (known as the 'sauce'). This colour was also used to lay in the shadows. The areas in full light were painted next with thick paint mixed with plenty of white. Then the student began to develop the half-tones, usually working from light to dark. This stage could be quite freely painted with separate touches of colour and, at a distance, the individual brushstrokes would fuse to give the effect of smoothly modelled forms.

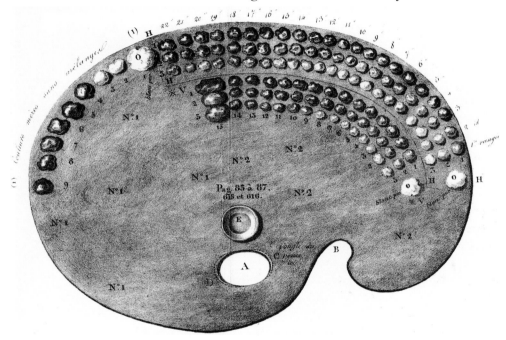

Fig. 3 Palette laid out with unmixed colours and a range of mixed tones for the preparation of an *ébauche* for flesh. (Bouvier, 1832)

The range of colour used in an *ébauche* was generally muted and dominated by earth colours. In his influential painting manual, Bouvier recommended two separate palettes for flesh painting, one for the *ébauche* and another for finishing (Fig. 3). For the *ébauche* he listed just nine colours, including black and white, but suggested that these should be laid out on the palette in at least fifteen groups of three mixtures, all of which had a specific function in the painting. His palette for finishing was more extensive (sixteen colours) and even more complex in its combinations and mixtures.

Once the *ébauche* was complete, it would normally be left to dry before being scraped down to provide a smooth base for the finishing layers. The method for completing the work was similar to the lay-in, except that the colour could be more transparent and luminous, and more attention would be paid to the smooth gradation of tones across the forms.

The male nude study in the National Gallery Collection is a typical academic exercise (Plate 1). The model has adopted a classical pose, which in this case is reminiscent of a famous antique sculpture known as the Borghese warrior. His raised arm has been left unfinished and it is still possible to see the initial pencil drawing (Plate 2). This has been reinforced with the red-brown 'sauce', which is also visible in other shadowed areas of the figure. It seems that the background was painted around

Plate 2 Detail of Plate 1

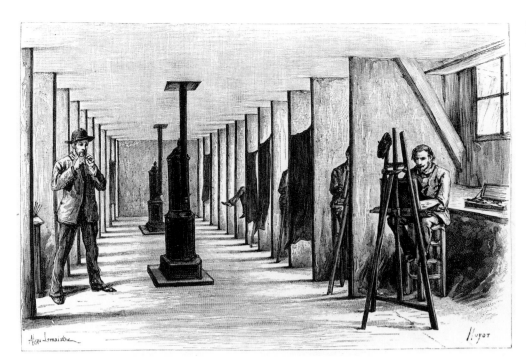

the figure at the same early stage. This *académie* illustrates another favoured device: the highlights are thickly worked but the shadows are thin and transparent, a method which helps to give an illusion of a sculptural form emerging from the background. Like so many academic studies, this example has been abandoned before completion. Although students were taught to pay careful attention to finish, there was often only a limited time available for a single pose and few studies went beyond the *ébauche* stage.

In addition to work from the model and the copying of Old Master paintings in the Louvre, students were schooled in the art of composition. The preliminary contest for the *Prix de Rome* involved painting an *esquisse-peinte*, a painted sketch of a subject from history or classical mythology. Students were encouraged to develop skills in producing these bold and simple sketches, mapping out a basic composition in broad masses of light and dark. Some of these studies appear to be astonishingly direct and spontaneous (Plate 4) but it should be stressed that they were just one part of the process of producing a finished work of art; the final picture would not betray any trace of this immediacy (Plate 3).

The academic system fostered an art that was controlled, deliberate and marked by an absolute precision of finish. These qualities could be admired in the polished surfaces of any number of large-scale history paintings in Salon exhibitions throughout the nineteenth century. The training outlined above was admirably suited to these grandiose productions, balancing the imitation of classical art and the Old Masters with the development of a student's own powers of invention and imagination. As the century progressed, however, it became increasingly obvious that the Academy, with its rigid doctrines and standard procedures, could not accommodate the growing emphasis on originality and individual expression. Locked into their own system, academicians refused to acknowledge the gradual ascendancy of the freer techniques associated with talents like Delacroix. By the mid-nineteenth century, 'academic' had come to typify convention and opposition to change.

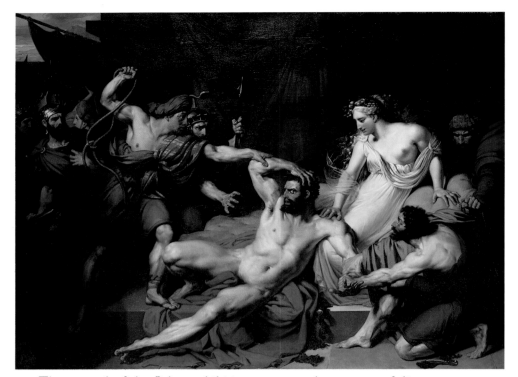

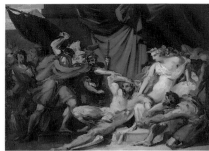

Plate 4 Joseph-Désiré Court, *Samson and Delilah* (*esquisse*), 1821. 24·5 × 32·5 cm. Paris, Ecole des Beaux-Arts

Plate 3 Joseph-Désiré Court, *Samson and Delilah*, 1821. 114·5 × 152 cm. Paris, Ecole des Beaux-Arts

The control of the Salon exhibitions was another source of discontent among artists. During the nineteenth century the Salon was transformed from a relatively small exhibition of officially approved artists into a huge public spectacle, displaying thousands of works in all media. In the early nineteenth century the exhibition was held in the Louvre but in 1857 it moved to the Palais de l'Industrie, a vast building on the Champs-Elysées originally constructed for the Exposition Universelle of 1855. The Salon, which was usually held annually after 1830, was the focus of all artistic activity, since it was the only significant venue for an artist to reach his public, to sell his work and to establish a reputation. There were opportunities to attract state patronage as well as private purchasers and many works bought by the government would find their way into the collections of provincial museums.

The series of exhibitions organised by the Impressionists between 1874 and 1886 was, in part, an attempt to bypass the dominance of the Salon. Yet the prestige of the Salon was difficult to ignore, as the critic Théodore Duret pointed out to Pissarro when he attempted to discourage him from showing in the first Impressionist show:

> You now have a group of art lovers and collectors who are devoted to you and support you. . . . But you must take one more step and become widely known. You won't get there by these exhibitions of private societies. . . . Among the 40,000 people who, I suppose, visit the Salon, you will be seen by 50 dealers, art lovers, critics who would never otherwise seek you out and discover you. . . . I urge you to exhibit; you must succeed in making a noise, in defying and attracting criticism, in coming face to face with the great public. You can't achieve all that except at the Palais de l'Industrie.

The importance of the Salon inevitably led to discontent, mainly caused by the make-up of the juries that selected the exhibits but also by the way that the works of art were displayed. The system for electing jurors was changed several times during the century, but the juries were usually dominated by members of the academic establishment, appointed with the approval of the government. In practice this meant

Fig. 5 Honoré Daumier, '*Thankless Country, you shall not have my work!*', 1840. Lithograph. London, British Museum, Department of Prints and Drawings

that artists whose work failed to conform with accepted notions of taste risked rejection, a humiliation that was regularly experienced by numerous independent artists, including, of course, the Impressionists (Fig. 5). If accepted by the jury, a picture would have to compete with thousands of exhibits which were crammed on to every available inch of space from floor to ceiling (Fig. 6). The arrangement was haphazard and unless an artist was well known or officially favoured he would be unlikely to secure a prominent place in the display. Even a small painting could be 'skied' – that is, hung in the top tier where it might be all but invisible.

The Salon may have played host to a bewildering range of styles but its character was largely conservative. Just as the academic system of training was thought to stifle talent, the Salon came to be viewed with hostility by many advanced artists. Controlled and manipulated by a privileged few, it often appeared to present a barrier against artistic freedom.

The artists represented in this catalogue began their careers against this background of conflict between conservative and innovating trends. With the exception of Cézanne and Morisot, they all underwent some formal training in the studio of an accepted master.

Manet spent six years in the studio of Thomas Couture, who was once described as the man who taught painting in twelve lessons. Couture was not attached to the Academy and does not seem to have trained his students for the *Prix de Rome*, but his studio was one of the most widely attended in the 1850s. His emphasis on the material procedures of painting set him apart from other teachers: 'I don't claim that I can turn out geniuses to order but I do train painters who know their job', he declared. His writings on art, known collectively as *Entretiens d'Atelier*, are an important source of information about studio practice in the mid-nineteenth century.

Although in several respects the training he offered was similar to the standard academic programme, with an emphasis on drawing, copying in the Louvre and study of the antique, Couture did encourage his pupils to adopt a broader, more expressive style based on the qualities of a sketch. The coarse, granular surfaces and pitted textures of Couture's works are far removed from the mirror finish demanded by the academicians. He placed particular importance on the underpainting, which was allowed to show through and influence the final effect. Most important, he taught his students to work quickly and to retain a degree of freshness and purity of colour in their finished works.

Early accounts of Manet's student days suggest that he was quick to disown the example of Couture. According to Antonin Proust, Manet poured scorn on history painting and ridiculed many of the artificial practices of the academic studio. His emancipation from Couture was probably more gradual than these accounts would allow, and the master's influence lingers in Manet's early work, even in his first major painting of modern urban life, *Music in the Tuileries Gardens* (Cat. no. 1). There are traces of Couture's approach in the frank exposure of the initial paint layers in some areas of the work and in the way that the brighter colours are set off by muted earth colours. It has even been suggested that the composition of *Music in the Tuileries* looks back to Couture's most famous work, *The Romans of the Decadence* (Fig. 7). However, Manet's picture is remarkable for its lack of respect for academic conventions. Any echoes of Couture's masterpiece seem playful rather than reverent: the master's elaborate compositional structure is transformed by Manet into a lively arrangement of loosely connected groups ranged across the canvas without any obvious hierarchy

Fig. 6 Honoré Daumier, '*The Salon Public – In Front of Meissonnier's Painting*', 1852. Lithograph. London, British Museum, Department of Prints and Drawings

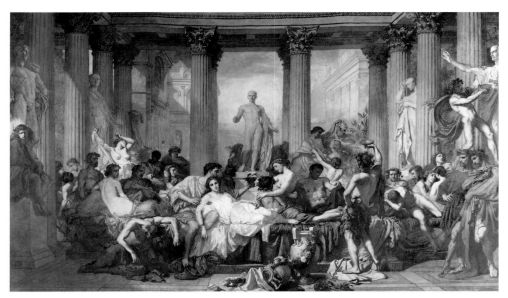

Fig. 7 Thomas Couture, *The Romans of the Decadence*, 1847. 466 × 775 cm. Paris, Musée d'Orsay

or underlying order. In its manipulation of different levels of finish and in the abrupt contrasts of tone and colour, *Music in the Tuileries* seems far removed from even Couture's painterly methods.

The early training of Monet and his colleagues is also marked by a spirit of rebellion against established studio practices. In a letter written in 1859 to Boudin, Monet describes the advice he had just received from the painter Constant Troyon: 'If you want to listen to my advice and practise serious art, begin by entering a studio where they only do the figure, *académies*; learn to draw . . . don't neglect painting; from time to time, go to the country to make studies. . . . Make some copies in the Louvre.'

Troyon was recommending nothing less than the discipline of an academic programme. He was later to suggest studying with Couture as a master, but Monet instead chose the equally prestigious studio of Charles Gleyre (Fig. 8). Like Couture, Gleyre was independent from the Academy and the Beaux-Arts. His own methods were conservative: he warned against the 'demon colour', despised visible brushwork ('the touch') and even recommended ivory black as the base for all tones. Nevertheless, he had a reputation among his students for his liberal attitudes to teaching, and probably encouraged those students who displayed a particular aptitude for landscape painting. When Gleyre was forced to close down his studio in 1864 because of ill health and lack of funds it was a disappointment for all his pupils. Although Monet in his later years strove to distance himself from Gleyre and his teaching, both Renoir and Bazille maintained that they had learnt the craft of painting in his studio.

In addition to the schooling offered by the private atelier system, Monet and his colleagues were able to take advantage of less formal opportunities for artistic training. This could involve working at one of the so-called 'free' studios like the Académie Suisse which provided no tuition but was open to anyone willing to pay a fixed amount each month for the services of a model. There were also numerous independent artists willing to share their ideas and experience. Looking back on his early career, Renoir describes his conversations with the Barbizon artist, Diaz, as the counterpart to his training at Gleyre's studio. Other artists like Corot and Courbet played the role of mentors to the younger generation, and the history of early

Impressionism depends in part on accumulating the few fragments of advice from such masters that have survived: Corot telling Pissarro to study tones; Boudin urging Monet to work in the open air; Diaz persuading Renoir to adopt clearer colours. Whatever the nature of the advice, the essential point is that the future Impressionists were able to balance an early academic training with the example of artists who had developed an original and personal style seemingly free from inherited practices and received ideas. Cézanne, for instance, planned to divide his time between Paris and Provence in order to 'avoid the influence of the academies' and to develop his individual approach.

Plate 6 Camille Pissarro, *The Towpath* (sketch). 24·4 × 32·4 cm. Cambridge, Fitzwilliam Museum

A feeling of independence from tradition, allied to the principle of working directly in front of nature, became increasingly important for Monet and his friends during the 1860s. As early as 1864 Monet declared that he had painted a sketch 'based entirely on nature . . . without having any painter in mind'. In terms of technique, this was a decade of experimentation. Yet elements of traditional practice were maintained alongside more innovative methods as the artists attempted to reconcile the demands of 'serious art' with a more immediate and expressive approach. Most of their efforts were directed towards large-scale exhibition pictures intended for the Salon. These appear to have been prepared in the conventional manner using studies painted out of doors as the base for compositions painted in the studio (Plates 5 and 6).

Many of the boldest works of the 1860s were studies. Monet's *Bathers at La Grenouillère* (Cat. no. 2), for example, was one of several studies which were painted in preparation for a larger picture that is now lost. The daring composition, the build-up of paint with rapid, textured brushmarks, and the high-keyed colour all combine to render an extraordinarily convincing effect of outdoor light and atmosphere. Monet himself may have described it as a 'bad sketch', but it was the informality and directness of studies like *Bathers at La Grenouillère* which would form the basis for the

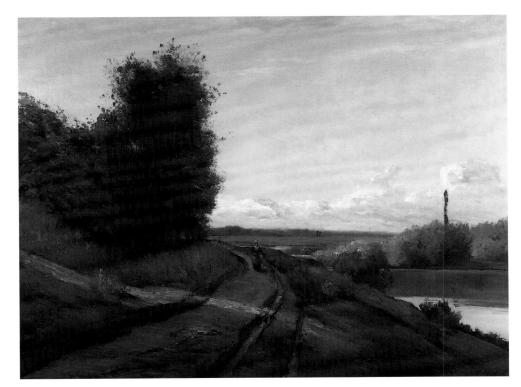

Plate 5 Camille Pissarro, *The Towpath*, 1864. 81·9 × 107·9 cm. Glasgow, Art Gallery and Museum. (Possibly exhibited at the Salon of 1864 as *Banks of the Marne*.)

techniques evolved by the Impressionists over the following decade. The traditional boundary between a sketch and a finished picture would become increasingly blurred as they sought to combine the qualities of both stages in their work.

Monet's development of a technique that could capture a sense of immediacy and directness is illustrated in a work painted the following year, *The Beach at Trouville* (Cat. no. 3). Slabs of textured paint suggest rather than describe form – the traditional chiaroscuro, the delicate modelling in graded tones, is replaced by abrupt juxtapositions of tone and colour. The presence of grains of sand across the surface underlines the casual, almost haphazard, nature of the technique, suggesting an element of chance rather than skill. Most striking of all, the composition appears to be without system or order. The human figures, sacred to academic art, are given no more importance than the chair, the parasols or any other objects in the picture. Thrust to the sides of the composition and clipped by the frame, the figures read as flat shapes against the strong sunlight. At the centre, where by tradition we might expect the focus of interest, Monet has left, quite literally, a blank space, a patch of bare primed canvas.

There is, of course, no evidence that Monet thought of this particular work as anything more than an informal sketch, nor that he envisaged exhibiting it. Although he was to show many equally daring works during the 1870s, he would normally take care to distinguish the status of different works, sometimes adding the words *esquisse* or *impression* to the title.

The Beach at Trouville may now be considered among the most typical products of Impressionism, but it is worth contrasting the casual appearance of this picture with the more refined qualities of works like *The Petit Bras of the Seine at Argenteuil* (Cat. no. 6). This was painted in 1872 during a period when Monet was producing some of his most vivid Impressionist paintings. For this quiet rural scene he has adopted a conventional composition with a carefully structured recession from the foreground through the middle distance to the horizon. A gentle mood is captured with restrained brushwork and subtle effects of colour. These subdued qualities may be more than just a response to the nature of the subject. Monet had to sell pictures to earn a living; this modest and uncontroversial work was probably a type of picture which he would have hoped to sell with ease.

A comparison of two works by Pissarro in the present catalogue also serves to illustrate how traditional approaches to picture making could persist alongside the more radical aspects of Impressionist painting. *Foxhill, Upper Norwood* (Cat. no. 4), painted with small, rapid touches of the brush, is a good example of Impressionist 'shorthand'. While in some areas there is considerable detail, several parts of the picture consist of the artist's first marks on the canvas, and the priming remains clearly visible. By contrast, in the larger *The Avenue, Sydenham* (Cat. no. 5) it is obvious that there is a more careful build-up of paint. Pissarro began by mapping out the composition in a subdued mid-tone – the traditional *ébauche*. This was then worked over with layers of brighter colour as the artist gradually refined the qualities of his first impression. The final picture, with its high-keyed tonality and lively brushwork, retains an appearance of spontaneity, but it is carefully finished, the result it seems of considerable labour. The existence of a study for this particular work further suggests an element of careful premeditation. *Fox Hill, Upper Norwood* has the quality of an informal sketch, but *The Avenue, Sydenham*, like Monet's *Petit Bras*, is finished to a degree that would have made it easier to sell.

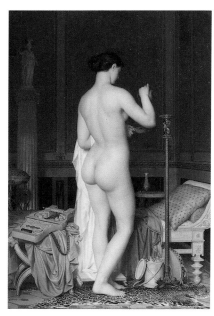

Fig. 8 Charles Gleyre, *Sappho (Le coucher de Sapho)*, 1867–8. 108 × 72·5 cm. Lausanne, Musée cantonal des Beaux-Arts

Looking back on the achievements of the Impressionists, the painter Maurice Denis wrote that their painting was characterised by an 'absence of all rule, the negation of academic teaching, the triumph of naturalism, the influence of the Japanese [and] liberation from all constraint'. There are a number of works in this catalogue which might support this view. Looking at Monet's *Beach at Trouville*, it would be difficult to imagine a picture which has less in common with the conventional procedures described earlier. Each element in the academic programme is subverted by Monet. Care and deliberation give way to spontaneity; order and unity to the appearance of a chance effect. However, there are other works examined here which suggest that the rift between traditional practice and Impressionist methods can be overstated. It is something of a surprise to learn, for example, that the daring effects of colour in Renoir's *At the Theatre* (Cat. no. 8) are achieved through a sophisticated application of glazes, a time-honoured method which is far removed from the direct, impasto techniques of some of his landscapes.

The attractive notion of a 'liberation from all constraint' could be misleading; the most freely worked Impressionist pictures must be seen alongside more finished and elaborate paintings which sometimes represent the accumulation of many layers of paint. Often it seems that the directness of the paintings is more apparent than real. Ultimately, the Impressionists did not, as Edmond Duranty claimed in 1876, 'cast aside the techniques of the past without another thought'. Yet, in their search to find fresh ways to render their novel subject matter, they evolved many new and exciting methods and showed a willingness to experiment with modern materials, often with breathtaking results.

Painting in the Open Air

Fig. 9 Paul Cézanne, *Camille Pissarro*, *c.* 1877. Pencil, 10 × 8 cm. Paris, Musée du Louvre, Cabinet des Dessins

The image of the Impressionist artist working out of doors producing complete paintings at a single stroke has become part of the legend of the movement. The Impressionists themselves were often eager to promote this compelling idea of the painter striding out to his motif, confronting the elements and painting directly from nature, recording only what he could see before him (Fig. 9). Yet, as with so many of the myths that have grown up around the Impressionists, this is a subject that requires careful attention. Monet may have declared that he had never had a studio, but very often the evidence of the actual paintings contradicts such statements. The Impressionists had to address not only the practicalities of producing works of art in the open air but also the need to consider and reflect upon their works away from the distractions of the subject.

The practice of sketching from nature was already well established in the early nineteenth century. In an influential treatise on landscape painting published in 1800, the academic painter and theorist Pierre-Henri de Valenciennes stressed the value of

Plate 7 Pierre-Henri de Valenciennes,
Buildings on the Palatine. 23 × 38 cm.
Collection of Mr and Mrs J. A. Gere

outdoor *études* for the training of artists and as part of the preparatory process. For Valenciennes, it was essential for the artist to execute these studies quickly and directly without attempting to develop the detail and careful finish expected from an exhibition picture. Speed was essential if the artist was to capture a convincing effect: '. . . all *études* from Nature should be done within two hours at the outside, and if your effect is a sunrise or a sunset, you should not take more than half an hour.'

Valenciennes' own studies are bold and broadly painted, yet his rapid notations were not produced as an end in themselves (Plate 7). Nature provided the artist with a dictionary of forms, but it was back in the studio that the painter applied his artistic grammar, transforming the raw material provided by his sketches into finished works of art. Valenciennes' exhibition pictures, arranged according to traditional compositional formulae, often betray little of the freshness and observation of his oil sketches (Plate 8).

Plate 8 Pierre-Henri de Valenciennes,
The Ancient City of Agrigentum, exhibited
at the Salon of 1787. 110 × 164 cm.
Paris, Musée du Louvre

In the first decades of the nineteenth century there was a dramatic increase in the number of artists attempting to pursue a career as landscapists. The establishment in 1817 of a *Prix de Rome* in historical landscape, a development encouraged by Valenciennes and his pupils, is one indication of the rising importance attached to landscape as a genre. *Plein-air* painting gradually became a popular activity for the summer months and regular colonies of artists were established, notably on the Normandy coast, in the area around Sèvres and, most important of all, the Forest of Fontainebleau. As Henriet explained in *Le Paysagiste aux champs*, Fontainebleau was 'the colony of colonies . . . the true school of contemporary landscape painting'. Of the many villages on the edge of the forest, Marlotte apparently attracted students from the Ecole des Beaux-Arts, but it was Barbizon that was to enjoy lasting fame.

Fig. 10 *Working in the Open Air*, illustration from Ernest Hareux, 1888–9

The development of portable equipment and materials further encouraged the *plein-air* painter. From suppliers' catalogues and artists' manuals it is obvious that a wide range of equipment was available specifically for outdoor use, including various designs for light-weight sketching easels and the essential *boîte de campagne*, a complete outdoor painting kit (Fig. 11). Some of these boxes could even be used as easels. The parasol was another indispensable piece of equipment (Fig. 10). Without it, warned Karl Robert, 'in full sunlight you will make studies that are so dark that you will be totally astonished on returning to the studio, not to be able to see a single detail.' Renoir echoed these complaints when he spoke of the difficulty of adjusting his tones in the glare of daylight. Advice even extended to recommendations for clothing suitable for painting in the countryside. The artist's clothes should be sombre in colour so as not to cast reflections on to the canvas and sufficiently hardwearing to withstand the various hazards of nature. As the artist Ernest Hareux noted, 'the least comfortable places are always the most picturesque.'

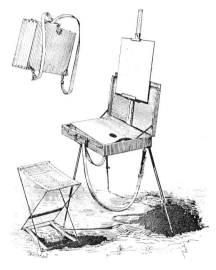

Fig. 11 *Boîte de Campagne*, illustration from the trade catalogue of Bourgeois *aîné*, 1888

Painting in the open air was an essential activity for the generation of landscapists active around the middle of the nineteenth century. Most retained the traditional distinction between outdoor studies and more elaborate studio compositions. Corot's sketches, and in particular his early studies produced in Italy, are rapid

Plate 9 Jean-Baptiste-Camille Corot, *The Roman Campagna with the Claudian Aqueduct*. 21·6 × 33 cm. London, National Gallery

Fig. 12 Charles-François Daubigny, *Villerville-sur-mer*, exhibited at the Salon of 1864, reworked 1872. 100 × 200 cm. The Hague, Mesdag Museum

and vivid notations of changing effects of light and atmosphere (Plate 9). Yet Corot rarely exhibited these sketches or paintings that had been painted directly from nature, and in his lifetime he was best known for his pastoral or ideal compositions painted in the studio. Théodore Rousseau constructed a special easel for drawing outside and often painted the *ébauche* for his larger compositions in front of the motif. Daubigny took this a stage further and is known to have painted at least one of his Salon paintings, a view of Villerville-sur-mer, entirely on the spot (Fig. 12). As recounted by his biographer Henriet this experiment had been fraught with difficulties:

> Daubigny attached his canvas to some posts solidly planted in the ground; and there it stayed, continually exposed to the horns of cattle and the pranks of naughty children until it was completely finished. The painter had specifically chosen a turbulent sky filled with large clouds chased by the angry wind. He was constantly on the alert for the right moment and ran to take up his work as soon as the weather corresponded to that of his painting.

Daubigny often tested the practical limits of *plein-air* painting, improvising equipment to withstand the elements. He built lean-to huts for shelter and, in 1857, launched his *botin*, the famous studio boat from which he painted numerous river scenes (Fig. 13). Inspired by Daubigny's example, Monet built his own studio boat in the early 1870s (Fig. 14).

Fig. 13 Charles-François Daubigny, *The Studio Boat (Le Botin)*. 11 × 16·2 cm. Pen and ink. Paris, Musée du Louvre, Cabinet des Dessins

Daubigny received as much criticism as praise for the immediacy and directness of his landscapes (Plate 10). In 1861, Gautier criticised the artist for producing 'nothing but sketches' and for being 'satisfied with a first impression'. But the same terms could be applied by Daubigny's supporters to endorse his approach. Thus Zacharie Astruc praised him as 'the painter of simple impressions' who retained 'a delicious naïveté – simple as a child before his subject, adding nothing, removing nothing'.

These comments reflect a new attitude to the work of *plein-air* landscapists in the second half of the nineteenth century. With the development of realist aesthetics, work produced out of doors was often associated with 'sincerity' and 'truth' and was seen in opposition to the false constructions of the studio. Freed from the constraints of an artificial environment the painter was able to experiment and to develop his personal response to nature, without the intervention of received ideas and without recourse to the art of the past. According to Théophile Thoré, writing in 1866, 'to

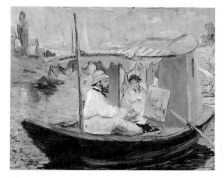

Fig. 14 Edouard Manet, *Claude Monet painting on his Studio Boat*, 1874. 80 × 98 cm. Munich, Neue Pinakothek

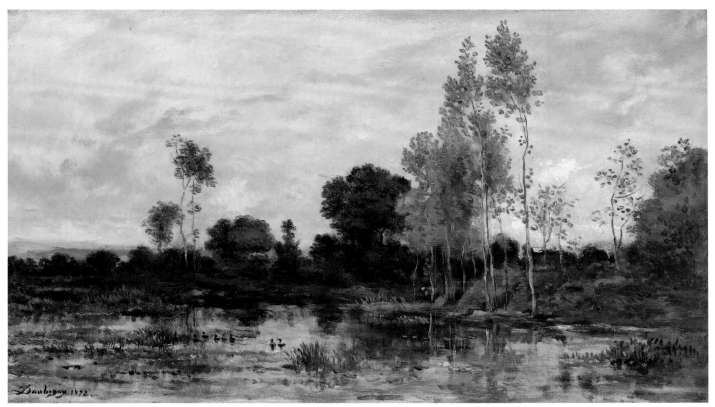

Plate 10 Charles-François Daubigny, *Alders*, 1872. 33 × 57·1 cm. London, National Gallery

paint in the open air, as one feels and as one sees, without thinking of anyone, either old masters or of the public, is without doubt the way to assure one's own originality.' In the same year Emile Zola could attack Corot's exhibition pictures for a lack of veracity: 'I prefer a thousand times a *pochade*, an *esquisse* painted by him in the open countryside, face to face with the powerful reality.'

These issues of truth and sincerity lie behind the Impressionists' devotion to painting outdoors. When Monet, Renoir and Sisley first worked in the Forest of Fontainebleau while on holiday from Gleyre's studio in 1863, they were treading paths that had been followed by several generations of aspiring landscapists. They returned there in 1865 after the closure of their master's studio, Monet to Chailly-en-Bière, Renoir and Sisley to Marlotte. Monet had already been exposed to the 'honesty' of painting directly from nature through his early contacts with Boudin and Jongkind, but he soon revealed a commitment to *plein-air* painting that would far outstrip his predecessors. At Chailly he began work on a huge *Déjeuner sur l'herbe*, a reprise of the theme of Manet's famous picture of 1863. This was an obvious challenge to an acknowledged leader of the avant-garde, but whereas Manet's picture had retained the conventions of studio lighting, Monet attempted to introduce a genuine sense of natural light into his work. He made numerous drawings and studies in oil from models posing in the forest and also worked on a large *esquisse* in the open air. The final work, an unwieldy 4 × 6 metres, was painted in the studio. But the canvas was left unfinished and was later cut down. It seems that Monet was unable to transpose the deftness of his sketching technique on to a monumental scale.

The ambitious *Déjeuner sur l'herbe* was swiftly followed by an even more daring project. In the summer of 1866 Monet began work on another large painting of life-

size figures in an outdoor setting, *Women in the Garden* (Plate 11). This time he abandoned the intermediary stages of sketches and drawings and worked directly on his vast canvas. In his pursuit of accuracy he even dug a trench into which the canvas could be lowered, thus enabling him to work on the top of the painting without altering his viewpoint. In the end, Monet had to resort to the studio to finish his picture; yet, whatever anxieties went into its production, *Women in the Garden* contains passages of remarkable freshness and observation. The white dresses read as simplified shapes, flattened by the glare of the sun. Their shadows are tinged with colour and, in the foreground, the reflected lights on the woman's face are defined with subtle juxtapositions of warm and cool colour. Monet later recalled that this picture marked the beginnings of his experiments with the principle of the 'division of

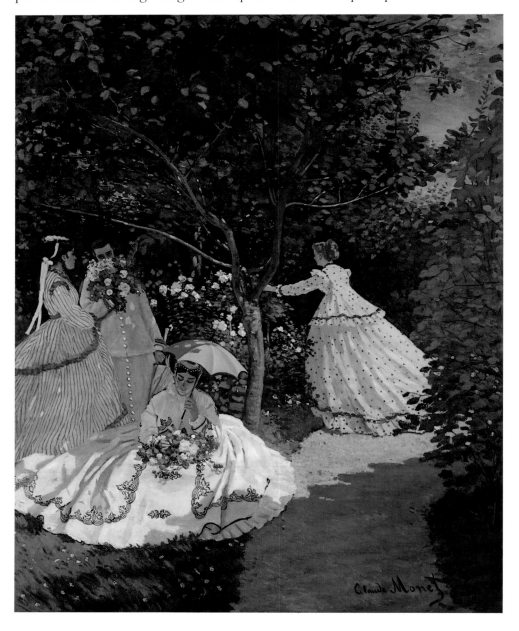

Plate 11 Claude Monet, *Women in the Garden*, 1866–7. 255 × 205 cm. Paris, Musée d'Orsay

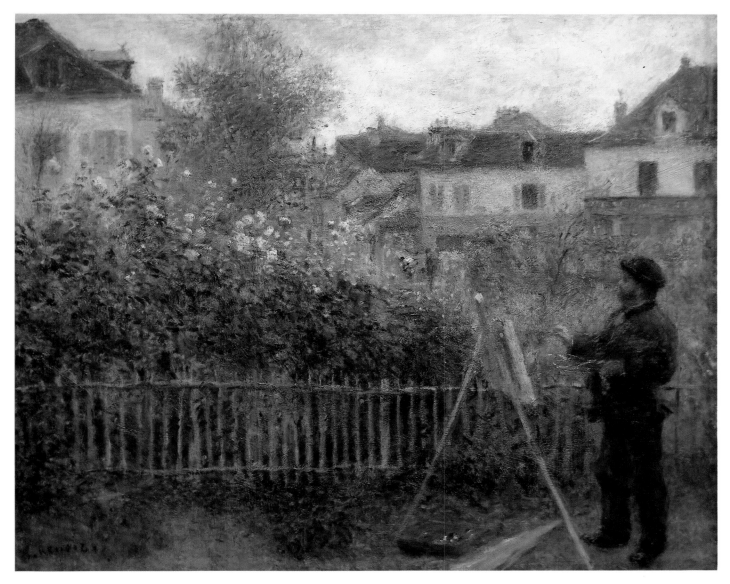

Plate 12 Pierre-Auguste Renoir, *Claude Monet working in his Garden at Argenteuil*, 1873. 46·7 × 59·7 cm. Hartford, Connecticut, Wadsworth Atheneum

colours' and noted how he was 'working at effects of light and colour which ran counter to accepted conventions'.

In the 1870s *plein-air* painting assumed a central role in the activities of the Impressionists (Plates 12 and 13). The close observation of nature helped to stimulate the development of techniques of brushwork and colour that could capture fugitive effects of outdoor light, weather and atmosphere. This is a period that is often associated with the gradual adoption of purer colour and it is certainly true that, in moving out of the studio, the Impressionists distanced themselves from the conventions of traditional chiaroscuro and moved towards a system of defining form and space through contrasts and nuances of colour. In 1874 Cézanne, following the example of Pissarro, was emphasising the need to 'replace tonal modelling by the study of colours'. Later he wrote to Pissarro from Provence: 'The sunlight here is so intense that it seems to me that objects are silhouetted not only in black and white, but also in blue, red, brown and violet. I may be wrong, but this seems to me to be the opposite of modelling.'

The brilliance of the Mediterranean light may have encouraged Cézanne's

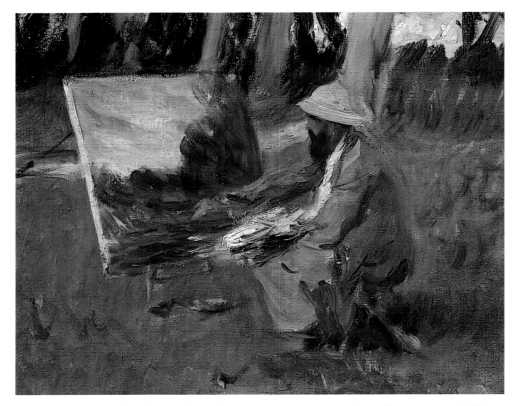

experiments with brighter colour, but it is important to stress the variety of effects that inspired the Impressionists. Although their work is often associated with strong sunlight, many of their most sophisticated exercises in colour stemmed from work in overcast conditions. In 1873 Pissarro declared that 'nature is coloured in winter and cold in summer'. Pissarro eventually came to favour a grey yet luminous sky which, in his view, intensified the colouring of a landscape.

In their dedication to *plein-air* aesthetics the Impressionists, like their predecessors, had to come to terms with the practicalities of working outside. Apart from the obvious difficulties of constantly changing weather, light and moving shadows, the motif itself could actually alter as the painter worked. A close look at the surface of Monet's *Bathers at La Grenouillère* (Cat. no. 2), for example, indicates that he may have had problems with the rowing boats, which must have changed positions constantly throughout the day. Berthe Morisot recorded her difficulties in working from a boat when staying on the Isle of Wight in 1875: 'Everything sways, there is an infernal lapping of water; one has the sun and the wind to cope with, the boats change position every minute. . . .' In the same letter she describes an equally distressing painting session on dry land: '. . . the moment I set up my easel more than fifty boys and girls were swarming about me, shouting and gesticulating. All this ended in a pitched battle, and the owner of the field came to tell me rudely that I should have asked for permission to work there. . . .' It seems that it was just as dangerous to work outdoors in the city. In a letter to Pissarro, the artist Ludovic Piette expressed his desire to paint the streets of Paris, 'sparkling in the sun', but if the painter should set up his easel in the street, 'the policeman will accuse you of starting a riot . . . the crowd will block your view, the carriages will run you over.'

It seems obvious that many of the paintings in this catalogue were painted in front of nature. Monet's *Beach at Trouville* (Cat. no. 3) is a prime example of a study

that must have been painted entirely in the open air and probably in a single sitting. It is equally apparent, however, that a number of the pictures included here must have been modified or completed back in the studio. In Pissarro's *The Avenue, Sydenham* (Cat. no. 5) the figures were added over paint that was already dry and it seems likely that such details would have been added away from the actual site. Several other pictures in this catalogue bear the tell-tale marks of the canvas pins that were used to separate wet paintings during transport to and from the motif, yet even a painting as fresh and direct as Sisley's *Watering Place at Marly-le-Roi* (Cat. no. 7) appears to have been modified slightly in the studio, after the main painting session.

Throughout the period of the Impressionist exhibitions the group were invariably associated with working out of doors. They were frequently described as the *école de plein-air*, and working directly from nature became part of their anti-academic stance. Monet remained adamant in his dedication to working out of doors and his courageous exploits in the face of nature and its extremes of weather are now legendary; there are accounts of him working in snow, ice, wind and rain and even, on one occasion, nearly drowning when he miscalculated the time of an incoming tide. His supporters stressed the integrity of his approach concluding, as did Mirbeau in 1889, that 'the open air is his only studio'. As Monet became preoccupied with increasingly transitory effects of atmosphere he became 'the anxious observer of the differences of minutes'. Often he worked on several canvases a day, returning time after time to the same spot in the hope of further work on his initial effect. Yet as Monet became more demanding in his attention to minute variations in light and atmosphere, he also seems to have resorted to work in the studio as part of the process of finishing his canvases. In the calm of the studio he was able to retouch his works, perhaps heightening a colour contrast or strengthening a design. In spite of his own declarations about working in *plein air* he seems to have needed to reflect on his pictures in the studio where he could, on occasion, impose a greater sense of decorative unity on his work.

Some of Monet's colleagues also came to find that work in the studio was indispensable. Renoir began to question the attractions of open-air painting in the 1880s and he returned to methods that he had employed earlier in his career, painting sketches and studies from nature which provided information for studio compositions. Working on Guernsey in 1883, he produced sketches that were 'documents for making pictures in Paris'. Later he often invoked the example of Corot to justify his practice of working in the tranquillity of the studio.

In the early 1880s and 1890s Pissarro also began to emphasise his constructive approach to art, creating an image of the painter compiling and organising the confused sensations he experiences in front of nature. Accordingly, work in the studio became an important part of his method. This return to a more traditional approach did not imply any loss of 'sincerity', but a devotion to 'truth' was now harnessed to more poetic ideals. In 1890 Georges Lecomte was at pains to stress the balance of Pissarro's approach – producing studies in front of nature but working on his important paintings in the studio, 'in all the truth of recollected emotion'. Two years later, Pissarro himself evoked the notion of a 'true poem': 'I do not paint my *tableaux* directly from nature: I only do that with my *études*; but the unity that the human spirit gives to vision can only be found in the studio. It is there that our impressions, previously scattered, are co-ordinated and enhance each others' value to create the true poem of the countryside.'

The Painter's Studio

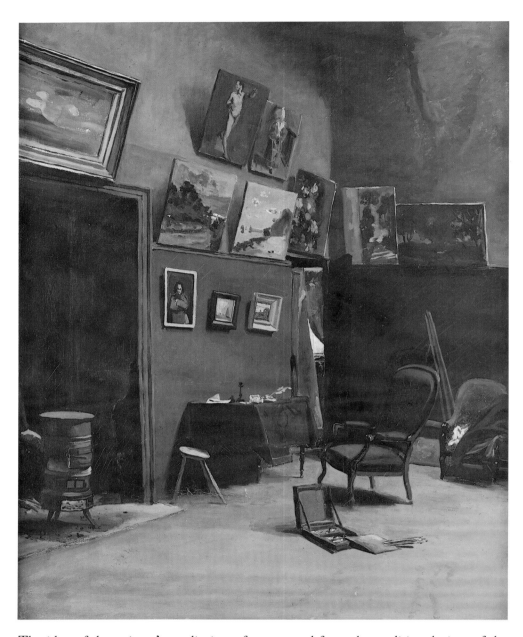

Plate 14 Frédéric Bazille, *Studio in the rue de Furstenberg*, 1865–6. 80 × 65 cm. Montpellier, Musée Fabre

The idea of the painter's studio is so far removed from the traditional view of the Impressionist painter working directly from nature that remarks such as Pissarro's, quoted above (see page 27), come as something of a surprise. Monet, in a famous remark to Emile Taboureux in 1880, said: 'My studio! But I have never had a studio, and I don't understand how someone could shut himself up in a room.' Even interviewers found themselves playing along with this myth, and it is amusing to read Maurice Guillemot, who interviewed Monet in 1898, correcting himself, perhaps with some irony: 'The sun is too piercing, so we must put off the tour of the garden until later and take refuge in the cool studio – or sitting-room rather, since our open-air painter works only out of doors.'

Nevertheless, as John House has observed, Monet was never without a studio of some sort, even in the 1870s. In the 1860s, he is known to have shared Bazille's studio on occasion: Bazille's painting of his own studio in the rue de Furstenberg (Plate 14) shows some of Monet's paintings on the wall. Bazille had long wanted this studio, which was in the same house as Delacroix's. In the painting, none of the usual attributes of the painter's studio is present – no painter, no model, no proper easel: just an open paint-box and palette on the floor and a stove in the corner. It is a room

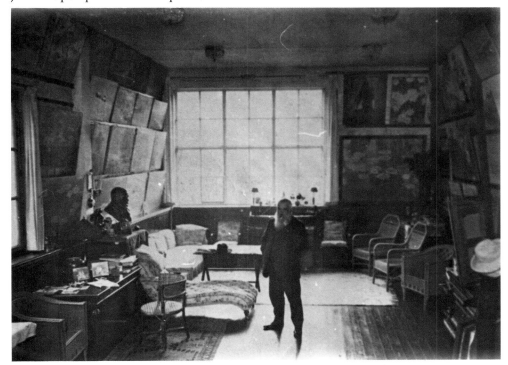

Fig. 15 Monet in his *salon atelier* at Giverny. Photograph, *c.* 1915

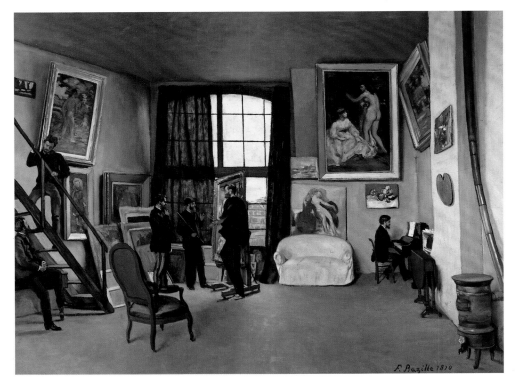

Plate 15 Frédéric Bazille, *Studio in the rue de la Condamine*, 1870. 98 × 128 cm. Paris, Musée d'Orsay

Fig. 16 Cézanne's studio at Aix en Provence. Photo Giraudon

temporarily occupied by a painter, but no more: the artist stayed there only from 1865 until February 1866.

For most of the young Impressionist painters, 'the studio' was at best a room rented for the purpose, at worst a temporary space in a lodging. Only later in their careers did they settle into the secure permanent studios that we now associate with them – Monet at Giverny, Renoir at Cagnes, Cézanne at Aix and Pissarro at Eragny (Figs. 15 and 16).

By 1870, Bazille had moved to the studio in the rue de la Condamine which he portrayed in one of the most evocative of all studio pictures (Plate 15). Here he is depicted surrounded by friends. Manet with his cane examines the painting on the easel; Monet may be the man standing to the left of him, and other figures have been variously identified as Zola, Zacharie Astruc, Renoir or Sisley. The figure of Bazille was apparently painted by Manet, somewhat out of scale even if Bazille was a very tall man. The armchair seems to have come from the rue de Furstenberg; a strong studio easel is now in evidence and the ever-present stove glows red in the corner.

By this time, the artist's studio had become a casual meeting place for the painter and his friends: the grandeur of the studio as depicted in paintings by Delacroix and Courbet has given way to something altogether gentler and more intimate. As Georgel, writing in the 1970s, says: 'the studio is no longer an imposing theatre, a vehicle for everlasting truths, as it still was with Courbet. It has become absorbed into

Fig. 17 Studio easel illustrated in the 1888 Bourgeois *aîné* catalogue

the rhythm of modern life . . . discontinuous, incomplete, precarious.' The traditional studio of the academic painter, north-facing with highly directed lighting, was perfect for chiaroscuro painting. With the new demands of Impressionist painters for light and colour, the old stereotypes of studio design could be transformed. The dark grey, green or reddish-brown walls of former times, so necessary for obtaining the full shadows of chiaroscuro, gave way to bright tones like the blue of the rue de la Condamine studio and light was allowed to flood in. The ultimate Impressionist studios were those built by Monet at Giverny which seemed, to many visitors, extensions of the garden, full of sunshine and flowers.

Fig. 19 Painting cabinet illustrated in the 1888 Bourgeois *aîné* catalogue

There are many reminiscences of the Impressionist painters at work in their studios. Jean Renoir's recollections of his father describe his almost obsessive neatness and cleanliness: 'Renoir's palette was as clean as a new coin . . . he almost invariably cleaned his brush after applying a colour . . . as soon as his brushes began to wear out or drip, he threw them away . . . his paint box and the table were always in perfect order. . . .' Berthe Morisot's biographer Fousseau tells us that 'in Paris, she was accustomed to paint in her drawing-room, laying aside her canvas, brushes and palette in a cupboard as soon as an unexpected visitor was announced.'

The equipment of the nineteenth-century studio was, in general, bought from commercial suppliers. Chapters on painting in the studio in textbooks by such writers as Karl Robert illustrate standard easels, paint-boxes and studio cabinets. Many such illustrations are taken straight from colourmen's catalogues, such as those of Lefranc and Bourgeois (Figs. 17 and 19). One of the most delightful illustrations of an imaginary painter at work formed the frontispiece of a Bourgeois catalogue (Fig. 18). Seated in the grandest of galleried studios, the painter is surrounded by all the latest equipment: elegant swan-necked studio easels, mechanical easels, table easels, a painting cabinet with turned columns, a mobile staircase for painting huge canvases, palettes, plaster casts and a screen for his model to change behind. At the right, we even see the outdoor painting gear ready for action: stool, back-pack with paint-box, folding easel and parasol. Unfortunately for Bourgeois, studios of this opulence were rare indeed.

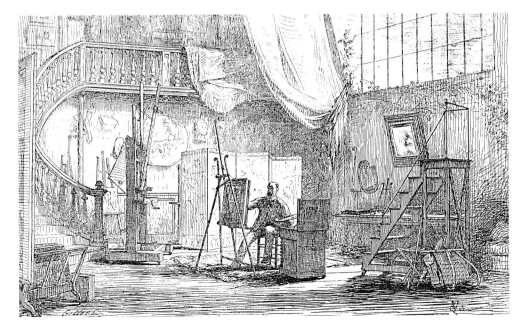

Fig. 18 Frontispiece of Bourgeois catalogue

Colourmen

The History and Development of Artists' Colourmen

The trade of the colour merchant in France had its origins in the medieval corporations of *épiciers* and *apothicaires*, the grocers and pharmacists. This ancestry is explained by the fact that many of the materials used in painting also had pharmaceutical uses, or were among the spices and other exotic materials imported from the Near East, Africa, India and beyond. By the late sixteenth century, the corporations, now united, had been elevated to the second rank of the prestigious Communauté de Marchands de Paris. There was initially a certain amount of overlap and competition between them: both the apothecaries and the grocers sold a variety of the items that could be defined as *drogues* (a category which included spices, minerals and resins), but only the apothecaries could make up the medicines prescribed by doctors. On the other hand, only the grocers were entitled to sell pigments and materials for dyeing in crude form; they also sold other items such as paper. However, they were not at that time permitted to grind the pigments or to produce paintings; this was the prerogative of the master painters, under the control of the painters' guild.

During the medieval period, and even into the seventeenth century, the painters' guild exercised total control over every aspect of the trade of painting, including the training of painters. However, the status of the artist was gradually changing: painting was becoming a profession, rather than a mere trade. As the power of the guild declined, the Académie des Beaux-Arts (founded in 1648) came to replace it, controlling the teaching of art and imposing what came to be official standards of taste and suitability of subject matter. The student still had to learn the craft of painting in the studio of a master painter, but now the emphasis was on academic success rather than on learning a trade.

At the same time, changes were also taking place in the selling of pigments, which had a gradual but inevitable effect on the preparatory work necessary in the painter's studio, and thus on the familiarity the painter traditionally had with his materials. It seems that pigments were available ready-ground by the latter part of the seventeenth century. According to the author of the much-reprinted *Traité de Mignature* (2nd edition, Paris 1674), ready-ground colours could be bought at the shop of a M. Foubert, and in later editions of the work published in the 1690s, the author recommends the 'well ground and very fine' colours sold by le Sieur Picard, *Marchand Epicier*.

In 1742 the corporation of grocers was divided into two distinct trades: the *épiciers grossiers*, who sold food, and the *épiciers droguistes*, who sold materials, other than drugs and food, for use in other trades. Not long after this date, those dealers who

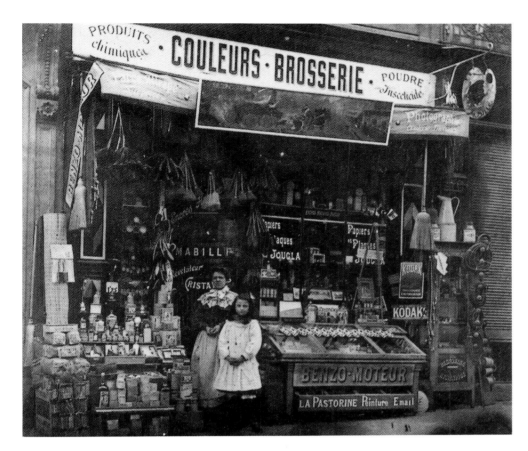

Fig. 21 Mabille's shop sign: *rapin*, rat, was a nineteenth-century nickname given to an apprentice or young student in the painter's studio

specialised in pigments and dyestuffs came to be known as *marchands de couleurs*: Antoine Pernety, in his *Dictionnaire portatif de peinture* (Paris 1757), refers to them under this name in the entry for canvases and by the 1770s the term was commonplace. Jean Félix Watin, author of an influential book on the materials and methods of painting first published in 1772, described himself as a *marchand de couleurs* on the title-page, and he is by no means unique in this, although the term *marchand épicier* was still in use.

In order to advertise their wares to the public, traders at this time commonly put up decorated signs outside their shops: perhaps a simple plaque on the outside wall, or an elaborate polychromed sculpture or a metal sign hanging above the street. Many colour merchants made use of the same advertising signs right through the nineteenth century, so when a shop changed hands, which was often the case, the business remained easily identifiable (Fig. 20). The shop trading in colours and other materials for painters, sign-painters and decorators under the sign *A la Momie* – an Egyptian mummy – had a number of owners and moved several times during its long life; it was founded in 1712 and closed only on the retirement of the last owner some years ago. During the eighteenth century the shop also sold incense and myrrh, as well as materials used in varnish making. The choice of sign in fact reflected the merchandise sold, since ground fragments of 'momie' were used as a transparent brown pigment. Artists' palettes were often used as signs to advertise colour merchants' wares (Fig. 21): in the 1840s, for example, Alphonse Saint-Martin traded under the sign *A la Palette de Rubens*. In 1858 the business of A. Dupille was identified by the sign *A la Palette d'Arlequin*, and his widow, with a partner named Letellier, was still in business under this sign twenty years later. Jean Laclef had a rather different

approach when, around 1775, he founded the colour-merchant's business which was later to become the firm of Lefranc: the sign he chose – *La Clef d'Argent* – was a pun on his name.

The early colour merchants tended to specialise in particular products, such as pigments or varnishes, which they often prepared themselves; however, they sometimes sold a range of other materials for painters as well. These were made by specialist craftsmen and bought in. Jean Watin, for example, was known for the varnishes he made, but the trade catalogue published in the 1776 edition of his book shows that he sold a wide range of products, including pigments (in crude form, in powder and ground in oil), oils, brushes and palettes, as well as resins and varnishes. The ancestry of his business is revealed by the fact that he still appears to have sold certain other 'spices', such as chocolate and vanilla. Apart from this, there are few differences between his catalogue and that of a nineteenth-century colour merchant. During the nineteenth century, however, the trade of selling materials for painting expanded to such an extent that colour merchants tended to sell materials either for the fine arts or for decorators, glass-painters, and related trades, but not for both (although, of course, a colour-maker might manufacture products for both). The catalogue produced by A. Lefranc in 1876, for example, includes not only colours, oils and palettes, but also papers, canvases and easels among its contents. The principal difference, however, is that the ranges of individual products are far greater. This is most noticeable with the pigments and is explained by the greatly increased number available by the mid-nineteenth century (discussed on pages 51–67).

The establishment of Colcomb-Bourgeois on the quai de l'Ecole was well known in the early nineteenth century for the newly available pigments which it stocked, such as the manufactured iron oxide pigments known as the Mars colours, and madder carmine, the preparation of which was first described by Charles Bourgeois in 1816. The shop was still trading in 1864, although by this time the business was no longer in the hands of the Colcomb family.

Colour-Makers and Colour Merchants

In the late eighteenth and early nineteenth centuries the trade of the colour merchant evolved in parallel with the development of the chemical industry and the exploitation of newly discovered chemical compounds such as chromium and the chromates (discussed on pages 60–3), leading to the rise of the specialist colour manufacturers. As a result, by the mid-nineteenth century, the trade consisted of, first, specialist manufacturers, who sold their products wholesale to the colour merchants or to other industries; secondly, similar manufacturers, who sold their products wholesale but who also had retail outlets of their own; thirdly, colour merchants, who sold a variety of products to the public but did not manufacture the raw materials themselves. They might, however, grind the pigments and put them into tubes ready for sale, in which case they could still be described as *fabricants de couleur*.

The share of the market devoted to the fine arts was quite small: the decorating and coach-building industries used a far greater proportion of pigments and varnishes, and the paper and dyeing industries were other important users. As a result, some pigments were manufactured on an enormous scale, such as lead white, zinc white, the chrome yellows, Prussian blue and ultramarine. Manufacturers tended to concentrate on a small range of pigments, sometimes only one or two. A glance at

the *Annuaire et Almanach du Commerce* for any year gives an idea of the range. Hardy-Milori, for example, manufactured carmine and cochineal lakes, Prussian blue, chrome yellow and a range of particularly fine chrome greens (containing Prussian blue and chrome yellow on a barium sulphate extender): the Milori greens, for which the company was famous. The company had first come to prominence around 1835 for its *bleu de Paris*, a variety of Prussian blue. La Société de la Vieille-Montagne, which played an important part in the history of the development of zinc white, manufactured this pigment and other zinc colours. Other companies specialised in lead white and related pigments: lead white was a traditional pigment that had been made on a large scale for a long time (Fig. 22). Until the mid-1860s, the name of Guimet, famous for his discovery of a process for making artificial ultramarine, appeared in the *Annuaire et Almanach* as an award-winning manufacturer of the pigment. Other pigments, such as Naples yellow and certain lake pigments, were used principally for artists' colours and were thus made on a much smaller scale. Partly because of this their position was, at times, precarious. Naples yellow appears at one point to have been made by only one manufacturer – in Marseille – and might have been unobtainable after his death had Lefranc not bought the process in 1868.

Natural madder lakes, containing purpurin and alizarin extracted from madder roots, were also under threat after the discovery of the process for preparing synthetic alizarin in 1868; very soon afterwards the synthetic dyestuff was being prepared on a large scale and there was a rapid decline in the market for the natural materials. Again the Lefranc company appear to have come to the rescue by purchasing the processes for preparing the natural materials from their manufacturer when he ceased production; Lefranc then organised the manufacture of natural madder lakes at their own factory at Issy. Purpurin was regarded as particularly important, as only this dyestuff gave the fresh, light, rose-pink lakes artists found so valuable. From the short dissertation A. Lefranc addressed to the members of the adjudicating panel at the Exposition Universelle in 1878, it is apparent that the company went to some trouble to make available pigments such as these, of little commercial importance overall. From the contact the business had with individual artists – the painter Jean-François Millet corresponded with the company on the

Fig. 22 Advertisement for Bezançon frères & Cie, lead white manufacturers. *Annuaire-Almanach du Commerce*, 1877

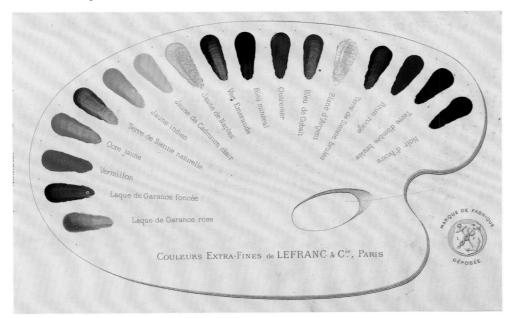

Plate 16 Samples of Lefranc & Company's oil paints, painted on to a printed diagram (Robert, 5th edition, 1891)

subject of Naples yellow, for example – Lefranc would have been aware of the importance of these colours for the artists' palette (Plate 16).

The small eighteenth-century shop could thus have grown into a thriving manufacturer by the mid-nineteenth century. Lefranc is an example of a colour-maker who for much of the period retailed his products directly to the public and also supplied other colour merchants; a catalogue dated 1867 gives prices for pigments, ground and unground, by the kilo, and presumably was aimed at other retailers. Colours ground in oil, in grades suitable for artists and for decorators, were also available by the kilo, but the range was not as wide. Catalogues of materials for artists dating from 1855 and around 1863 show that Lefranc sold empty tubes separately, as well as the pliers to close them after filling. Smaller outlets could have purchased these tubes, although it would have been just as easy to obtain them from the specialist manufacturers. Manufacturers like Lefranc or Bourgeois usually had a retail outlet within Paris and a factory that might be in the suburbs. When the great-nephews of Jean Laclef, Alphonse and Jules Lefranc, took over the business in 1836 they built a factory at Grenelle, where an 8 horse-power steam engine powered the grinding mills and all the processing of materials took place; the retail outlet at this time was still in the rue du Four-Saint-Germain, but moved several times in the following years. By 1876 the shop was in the rue de Turenne and the business had expanded so much that the factory had to move to a new site at Issy-les-Moulineaux. Similarly, Bourgeois had a shop in the rue du Caire and a factory in the passage du Génie. The businesses of those colour merchants who also ground colours (but did not manufacture them) often followed this pattern.

The manufacturers of pigments did not usually give them their final preparation; this was the responsibility of a more specialised manufacturer, who ground them and made them ready for use. This colour-maker – *fabricant de couleurs* – was often also a colour merchant, retailing his products directly to the public; some colour-makers sold their products to other retailers. Throughout the nineteenth century, complaints were made about the quality of artists' colours and colour-makers and colour merchants were accused of being more concerned with profits than with quality. The charges included deliberate falsification of individual pigments; inclusion of extenders and foreign materials to make up weight and give better handling properties and colour; use of poor quality and impermanent materials; and poor grinding of the paint. Some of these criticisms may have been justified. J.F.L. Merimée, writing in 1830, pointed out that, because painters no longer prepared their own colours, they were no longer able to distinguish good from bad; the details of preparation were left to the merchants, who were more interested in profit than in the conservation of paintings. Fifteen years later the chemist Jules Lefort made a very similar point: the aim of colour-makers was to supply a paint of as pleasing a colour as possible, as cheaply as possible, without inquiring too deeply into the long-term stability of the constituents. On the other hand, by this date, the defects of some of the newer pigments, like the chrome yellows, had become apparent and the problems associated with some of the older pigments, like the poorly drying bitumen, were already well known. Lefort described the properties a pigment should have – good covering power, insolubility in water and chemical stability, for example – and listed pigments in order of their chemical stability and fastness to light, and also their degree of toxicity, a subject of much concern generally. Subsequently, lists of this sort often appeared in artists' handbooks. Falsification of pigments, particularly the more

expensive, by the addition of inferior or less costly pigments did occur: for instance, cheaper impermanent brasilwood lakes were sometimes added to madder lakes, and later in the century fugitive aniline dyes were used to 'brighten' a number of colours. However, the use of extenders was not always a device to make up weight: sometimes they were necessary to improve the handling properties of the paint. The choice of extender could also have a considerable effect on the final colour and working properties of the paint.

The fact that so many nineteenth-century paintings are in reasonable condition today suggests that most colour merchants must have supplied perfectly sound products. Karl Robert (the pseudonym for the painter and publisher Georges Meusnier), in the first edition of his *Traité pratique de peinture à l'huile* (Paris 1878), which was aimed at the amateur painter, observed: 'Oil colours are found so well prepared today, at all the merchants, that no artist would dream of preparing them himself.' By the 1890s, however, there was considerable concern over the use of the recently introduced and impermanent aniline dyestuffs and various paint additives, roundly condemned by Vibert in 1891, and others. Even so, Robert, in the fifth edition of his book, also published in 1891, felt sufficiently confident to write that the amateur should not concern himself unduly; he should choose a good brand from a colour merchant he trusted. He did suggest, however, that artists should paint out samples of their paints, keep the tubes and then repeat the exercise six months later, to see if there was any change in colour.

For the painting to last well, it was important for the painter to understand the working properties of paint, the relative drying times of the pigments, and the use of siccatives where necessary. The training painters received in the studio should have given them an understanding of their materials, but by the mid-nineteenth century many artists – and Claude Monet is a good example – were very impatient with formal training. The writings of Lefort and others were influential and much quoted by those in the paint trade and by those writing for artists and amateur painters, but some artists felt that they did not have access to the information they needed. Renoir (who had been an assiduous student) showed a considerable concern with craftsmanship, particularly from the 1880s onwards, and regretted that painters no longer prepared their own colours. However, he also recognised the considerable time-saving advantages in not having to do so. From about 1878, he used colours ground for him by hand by the colour merchant Mulard in the rue Pigalle, a compromise he plainly found satisfactory. Delacroix, who also lamented the passing of traditional methods, had a long and close relationship with the colour merchant Haro, who opened a shop for the sale of paints and other artists' materials in the rue du Colombier in 1826. Delacroix exchanged many letters with Haro and, when he retired, with his son Etienne.

Preparation of the Paint for Sale

Some of the most vociferous complaints against colour-makers and colour merchants concerned the grinding of the colours. The brilliance of colour and overall quality of the finished paint depended as much on the careful washing and correct grinding of the pigments as on the care taken during their manufacture. The shape and size of the pigment grains affect not only the optical characteristics of the pigment, but also its behaviour during grinding with the oil medium. Grinding took place in two stages: the pigment was reduced from whatever form its manufacturer supplied it in – small

loaves, cone-shaped *trochisques* or lumps, perhaps – to a fine powder, which was then ground again with the oil to produce the final paint. Pigments varied in the amount of grinding they needed; some, like the green hydrated chromium oxide pigment *vert émeraude* (viridian), were difficult to grind and required some care to obtain the desired degree of fineness. Others, like *vert Véronèse* (copper acetoarsenite, emerald green) were easily friable and needed hardly any grinding with the oil medium. Unlike most of the traditional mineral pigments (see pages 66–71), many of the new pigments, like the chrome yellows and emerald green, were prepared by precipitation and, having a very small particle size in any case, would not have required the same amount of grinding as a natural earth, for example. Different pigments also had different oil-absorption properties (that is, they required different amounts of oil to convert the dry pigment to a smooth workable paste).

Many complaints were levelled against machine grinding, which, it was felt, did not take these differences into account; an experienced hand grinder would know how much grinding was needed and how much oil would be required in each case. It was also claimed that there was a lack of variation in the consistency of machine-ground paints. Hand grinding was done on a slab of porphyry or other suitable hard stone using a muller; it was hard work and slow, but many artists (including Renoir) felt that the end result was better. The pigment was ground with just enough of the chosen oil until it reached the correct consistency, not so sloppy that the colours ran, nor so stiff that they resisted the brush: some authors recommended the consistency of fresh butter. (The painter himself could add extra oil, perhaps one incorporating a drier such as *huile grasse*, or a diluent such as turpentine.) Earlier nineteenth-century writers often recommended the use of poppy oil, which yellowed less initially, for lighter colours, and linseed oil, which had more marked drying properties, for those colours that were known to dry badly. Later in the century poppy oil was recommended for all pigments except the poor driers (see pages 72–5). Siccatives were added by the artist as needed.

Fig. 23 Hermann's grinding machine. *Bulletin de la Société d'Encouragement de l'Industrie Nationale*, 1839

The presence of too much oil was known to be deleterious to the painting as it yellowed and darkened with age. Ducrot, writing in 1858, recommended putting paint that was too runny on to unsized (i.e. blotting) paper or on to a small piece of clean, new, white wood to absorb excess oil before use, a practice later followed by several of the Impressionist painters. The alternative was to keep the colours for a while to allow the oil to thicken, a practice Ducrot did not recommend as the excess oil would still be present to darken the colour in later years.

In fact the early attempts to produce mechanical grinders had not been very successful; Bouvier (the author of a very influential manual on painting) had made several attempts during the first decades of the century, only succeeding in the late 1820s. Initially, machines were considered suitable for decorators' colours only; they were not thought to give a product sufficiently finely ground for use as an artists' colour. One of the earliest relatively efficient machines was that of Lemoine (dating from the 1820s), which consisted essentially of one grinding stone rotating on another larger stone in a movement that was intended to mimic hand grinding, but permitted one man to do the work of several as it could be driven by steam. Another type of machine, used for grinding the pigment with the oil, had a number of horizontal cylindrical rollers, the spacing of which could be altered. In early models, the use of iron or steel rollers caused discoloration of certain pigments, such as lead white, and hard pigment particles (such as those of some of the ochres) damaged the

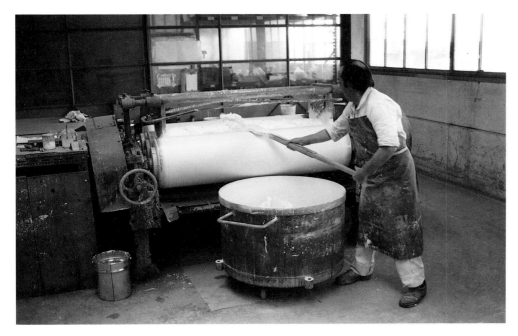

Fig. 24 Nineteenth-century grinding machine, still in use today for white paint. Lefranc & Bourgeois, Le Mans

rollers. Also it was found necessary to put the colour through the machine a number of times to obtain even a mediocre result. The use of granite or other hard stone rollers, and modifications to the method of setting the roller spacing by Hermann and others (from the late 1830s), led finally to greatly improved machines, which allowed grinding to be regular, methodical and rapid (Figs. 23 and 24).

From about the mid-nineteenth century onwards, the finished paint was sold in metal tubes, very similar to those available today. The invention of the collapsible paint tube in 1841, by John G. Rand, an American portrait painter then living in London, was one of the most important developments for nineteenth-century painting. The impetus behind the invention was the need for a container suitable for the long-term storage of ready-prepared oil paint, giving it a long shelf life while keeping it soft and ready for use: the normal method of storage at that time – in pieces of pig's bladder – was recognised to be inadequate. The piece of bladder was washed and blotted dry, a small pile of the colour was placed in the centre, on the inner surface of the bladder, and the edges were drawn together and tied tightly to exclude air. The final bladder was about the size of a walnut (Fig. 25). To extract the colour, the artist made a small incision in the wall, or pierced it with an iron tack – taking care not to burst the bladder lest it discharge its contents over him – and squeezed out the paint. The tack itself acted as a plug; plugs of bone or ivory were also used. Bladders were not suitable for long-term storage of the paint as they were not impermeable and the paint gradually hardened as the oil oxidised; they also required careful protection, ideally in a closed container from which air, light and moisture could be excluded. Once the bladder was punctured, the paint began to harden very quickly, no doubt resulting in the wastage of much expensive colour.

Before the development of metal tubes, various other methods of storage were tried, including syringes of brass or glass. The latter were available in France from around 1840 and, judging from Ducrot's description of filling them, were still available in the 1850s; they preserved the paint more efficiently than bladders and had the advantage that the colour of the paint could be seen, but they could not compete against the new tubes in convenience of use. The tubes were made of tin which, while

Fig. 25 Bladder filled with paint (Bouvier, 1832)

soft enough to be malleable, was sufficiently inert not to react with and discolour the paint. (Some writers describe tubes as being made of lead, but since lead was known to react with certain pigments their use must have been short-lived.)

Tubes were certainly available in France by around 1850, but the use of bladders continued for a number of years. Tube-colours were also more expensive: in a Lefranc catalogue of 1855, colours in tubes 'with patent hermetic closure' (later, certainly, a screw top) cost five centimes more than the same colours in bladders (the price difference had been ten centimes in 1850). They were available in different sizes, reflecting not only price differences between cheaper pigments and the expensive colours, but also the fact that some pigments, like lead white, were used in large quantity (Fig. 27). The tube could be filled by hand using a palette knife; the open end was closed with pliers and rolled over tightly two or three times to prevent paint escaping when the tube was squeezed. The specially designed syringe was far more efficient: the empty tube was fitted over the long nozzle of the syringe and a piston drove the colour into the tube as the wheel was turned (Fig. 26).

It must be said, however, that tube-colours did have their critics. Goupil-Fesquet, in an 1877 edition of his handbook on oil painting, recommended regrinding tube-colours in a little turpentine or similar spirit as the painter could not know how long they had been stored in the colour merchant's shop. Not surprisingly, individual tubes of paint might be faulty; Recouvreur in 1890 commented on the grey material which emerged at times from old tubes of paint. Vincent van Gogh, writing to his brother Theo in June 1890, mentioned the badly filled tubes of paint sent to him by Père Tanguy and by Tasset & l'Hôte, his regular suppliers.

The development of the paint tube had other effects. There was already a flourishing amateur market for the colour merchants' wares, as the number of handbooks for amateur painters published in France throughout the nineteenth century indicates; colour merchants, indeed, often sold such books. The introduction of paint in tubes contributed significantly to the ever-growing number of amateur painters as the century progressed. It also made the practice of painting away from the studio, in particular out of doors, very much easier. Painters had, of course,

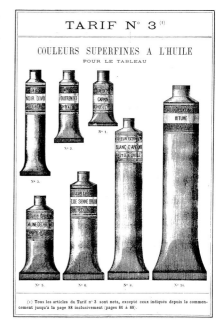

Fig. 27 Sizes of paint tubes supplied by Bourgeois *aîné*, 1888

Fig. 26 Nineteenth-century syringe for filling tubes. Lefranc & Bourgeois, Le Mans

worked out of doors before, using colours in bladders; they could take with them small containers of oils and diluents and a small glass plate and muller to grind colours if necessary. Some colours, like vermilion and certain lake pigments, were thought by some authorities to be better freshly prepared. However, this could not compare with the convenience of easily portable tubes of colour which could be carried in the pocket if necessary. Jean Renoir quotes his father as saying: 'Without paints in tubes, there would have been no Cézanne, no Monet, no Sisley or Pissarro, nothing of what the journalists were later to call Impressionism.'

The Impressionists' Colour Merchants

The task of painting out of doors in certain locations near Paris much frequented by artists, such as Argenteuil, Barbizon and Fontainebleau, was made a little easier by the presence of the occasional travelling colour merchant. Philippe Burty referred to colour merchants selling their wares in the then undeveloped district of Montmartre in 1860, for example, and Julien (Père) Tanguy, later to become the colour merchant used by Pissarro, Cézanne and van Gogh, among others, peddled his wares to the landscape painters of Paris before the Franco-Prussian War of 1870.

As a result of his activities during the Paris Commune of 1871, Tanguy was deported, but was able to return two years later and in 1874 opened his small shop in the rue Clauzel. His business was far removed from the large-scale, award-winning enterprise of Lefranc: he lived and ground his colours by hand in the room behind the shop, surrounded by stacks of paintings by Pissarro, Cézanne, van Gogh and others that he took for sale in part-payment for materials. Most remained unsold and were auctioned after his death in 1894 for the benefit of his widow. By 1880, Pissarro had bought over 3000 francs worth of painting materials from him, but Tanguy had sold only three paintings in return. However, Tanguy's wares were not always satisfactory: Pissarro, writing to Lucien in 1887, described a canvas as being of second quality (see also page 47), and van Gogh complained about his cobalt blue; he also described Tanguy's colours as insipid.

There was, however, one considerable advantage to the painter in dealing with a small concern: if he had a good relationship with his supplier, he could have some control over the quality of the materials. Delacroix, writing to Madame Haro in 1827, asked for some colours 'all of them more liquid than the colours prepared for everyone else'. Later in the century Pissarro obtained colours 'on a base of zinc' (presumably zinc white) – which he may well have ordered to be prepared specially – from the colour merchant Contet, who by 1886 had taken over the shop previously owned by Latouche. Pissarro had used colours of this type much earlier when living in London in 1870–1 (see pages 66, 140). From 1888 van Gogh requested his colour merchants to grind his colours coarsely, in the belief that they would thereby absorb less oil.

Tanguy had learned the trade of grinding colours at the Maison Edouard, which, before the end of the 1860s, was in the rue Neuve-Breda. Edouard was reputed to be one of the best colourmen in Paris, particularly known for oil colours and pastels. Other establishments selling artists' materials stocked Edouard's colours; Moirinat, in the faubourg Saint-Honoré, where Berthe Morisot was later to buy the canvas on which *Summer's Day* was painted, advertised that they stocked *couleurs fines d'Edouard* in the *Annuaire et Almanach du Commerce* for 1864. By 1868 the firm had been taken over by Mulard, who had previously bought another business, that of the Maison

Chenal at 116 rue de Rivoli. This establishment, too, had been known for its fine quality colours and Mulard, advertising in 1864, mentioned watercolours and powder pigments suitable for grinding in oil. By the early 1870s, the address of the business was given as 8 rue Pigalle. The names of the original houses were still well known, however. 'G. Edouard's French Oil Colours' were listed in the catalogue of Lechertier, Barbe & Company of Regent Street, London (a French business with an English branch) in 1885. They were also particularly recommended by Ludwig Fischer, the author of a handbook on oil painting published in Vienna in 1898; he described them as excellent and especially suitable for miniature painting because they were so finely ground. According to Jean Renoir, the pigments were ground by hand at Mulard's establishment. Later, at the beginning of the present century, Renoir's colours came from Moisse, who had ground them at Mulard's but later had his own shop. Monet also purchased colours from Mulard and Moisse during this period.

Another colour merchant known to have been used by the Impressionists is Hardy, from whom Monet asked his friend Bazille to purchase colours in 1869. Little is known of Hardy, but there was a colour merchant of this name in the rue Childebert in 1868. The painter Diaz purchased colours from the Maison Deforge and, in the early 1860s, generously enabled the impoverished young Renoir to obtain colours there also. At that time the business (run by Deforge and Carpentier, and later by Carpentier alone) was at 8 boulevard Montmartre, with a workshop at 37 boulevard Clichy. By 1868 the workshop had moved to the rue Legendre and a few years later the shop moved to 6 rue Halévy, the address from which Monet purchased the canvas used for *The Gare Saint-Lazare* (Cat. no 10). By the early 1880s the Maison Deforge had been taken over by Bertrand and Company, but was still a flourishing concern.

Many of the colour merchants known to have been patronised by the Impressionists were in the area of Paris north of the Louvre and bordering on Montmartre. In the early 1880s Monet purchased canvases and colours from Vielle and Troisgros in the rue de Laval (the modern rue Victor-Massé). In the 1850s the firm of Troisgros in the rue de la Verrière had specialised in easels, stretchers, frames

Fig. 28 Advertisement for the Maison Ange Ottoz. *Annuaire-Almanach du Commerce*, 1858

MAISON ANGE OTTOZ.

FABRIQUE DE COULEURS FINES ET DE TOILES A TABLEAUX.

Magasin, rue de la Michodière, 2. — Fabrique, rue du Helder, 11.
SEULE MAISON VENDANT AUX PRIX DE FABRIQUE.

Couleurs à la cire, huiles, vernis, bronzes, boites, palettes, crayons, papier imprimé, siccatif Courtray et tout ce qui concerne la peinture.

Toiles tout imprimées jusqu'à 5 mètres 50 de largeur.

Toiles ordinaires de 3 fr. 50 c. le mètre au lieu de 4 fr. 50 c.

Toiles fines, fortes et coutils à 7 fr. le mètre au lieu de 9 francs.

Expédie en France et à l'Étranger.

and similar items. A son of the family remained at this address as a cabinet-maker, while the other branch of the business moved to the rue Saint-Germain-l'Auxerrois, just east of the Louvre. Some years later the colour merchant H. Vielle set up in business in the rue Breda, moving to 6 rue de Laval by the mid-1870s. By 1881, H. Vielle and E. Troisgros, colour merchant and stretcher-maker, had gone into partnership at 35 rue de Laval where, in May of that year, Monet asked the dealer Paul Durand-Ruel to send them 500 francs owed to them, on his behalf.

The name 'Ottoz' occurs on the backs of several Impressionist canvases. The shop was founded in 1827 by Ange Ottoz, at 2 rue de la Michodière, and his colours were recommended by no less an authority than Bouvier in his manual on oil painting in 1832 (and perhaps earlier). Thirty years later the business had expanded considerably: Ange Ottoz, *fabricant de couleurs fines et toiles à tableaux*, also had a workshop in the rue de Helder and dealt in pictures (Fig. 28). By the early 1860s his son Jérôme had opened his own establishment at 22 rue Labruyère and other sons (Alexis and possibly Henry) were trading at 46 rue Notre Dame de Lorette. Alexis, like his father, was also a picture dealer and restorer. The long-lived Ange remained in business in the rue de la Michodière, until his son Henry took over in 1871 or 1872. Manet's *Music in the Tuileries Gardens* (Cat. no. 1), dated 1862, was painted on a canvas purchased from Ange Ottoz, while *The Petit Bras of the Seine at Argenteuil* (Cat no. 6) by Monet, of around 1872, was painted on a canvas bearing the stamp of the same rue de la Michodière establishment, but in this case the name of Henry Ottoz can just be deciphered. Jérôme Ottoz, whose portrait had been painted by Degas (Fig. 29), was no longer trading by this date. Both the Maison Ange Ottoz and Alexis Ottoz's business seem to have ceased trading by 1876. Renoir's *At the Theatre* (Cat. no. 8) is painted on a canvas purchased from Alexis Ottoz at 46 rue Notre Dame de Lorette; thus, although the painting, judging by the style of the girl's costume, appears to be dated around 1876–7 (see page 152), Renoir must have bought the canvas some time earlier. By 1876, a certain G. Ottoz had opened a shop in the rue Larochefoucauld, and in the early 1880s a member of the family was trading in the rue Fontaine: the original shop in the rue de la Michodière had gone, but the dynasty continued.

It is clear that the Impressionist painters remained loyal to a relatively small number of colour merchants over quite long periods of time. The modern state of affairs, where relatively few large concerns produce ranges of artists' materials available in many outlets, was still undeveloped. Also, if a painter was happy with his materials he was unlikely to change his supplier. A close relationship between artist and colourman was thus not only possible, but also valuable to artists, particularly if the colour merchant was also a picture dealer. However, the main advantage to the painter lay in his familiarity with a particular colour merchant's supplies: the progress of technical developments in the paint trade was perhaps rather more rapid than most artists, lacking adequate technical knowledge, were able to comprehend. Although some of the businesses patronised by the Impressionists were quite modest, others, like those of the Ottoz family and Mulard, were highly regarded, which emphasises their concern for the quality of their materials.

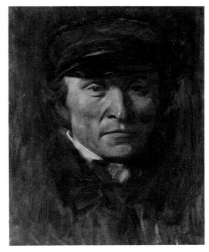

Fig. 29 Edgar Degas *Portrait of Jérôme Ottoz, c.* 1875–7. 46 × 37 cm. Present location unknown.

Canvases and Primings for Impressionist Paintings

In the mid-nineteenth century, painters still sometimes stretched and primed their own canvases. This was probably routinely taught as part of the young artist's training, and standard instruction manuals such as that written by Bouvier had detailed chapters on the cutting to size and stretching of primed or unprimed canvases. In 1842 Jean-Pierre Thénot wrote on the subject of stretching and priming canvases in his *Essai de peinture à l'huile*: 'All these details of fabrication are exclusively the concern of the colour merchants, who, in the interest of their commerce, are stimulated to prepare their canvases well; the least negligence in this regard would make them lose their reputation.' Whatever the truth of this statement, it does suggest that, even by this date, self-primed canvases tended to be the exception rather than the rule. It is interesting that two of the paintings in this catalogue, Renoir's *Boating on the Seine* (Cat. no. 11) and Monet's *Lavacourt under Snow* (Cat. no. 13), appear to be on self-primed canvases, and there are other reported instances in Impressionist paintings. Renoir apparently liked to prepare some of his canvases in the studio throughout his career: much later, Jean Renoir recalled how he would prepare canvases for his father with flake white in linseed oil and turpentine. The vast majority of painting canvases, however – including Renoir's – were bought ready-primed from a supplier or from an artists' colourman. Examination of the catalogues of the colour merchants Lefranc and Bourgeois, dating from the second half of the nineteenth century, gives a very clear picture of the range of canvases and preparations that were available.

Canvases were usually bought ready-stretched on to strainers (without keys) or stretchers (with keys) corresponding to a range of fixed sizes. These standard sizes, which were numbered, were absolutely constant, no matter who the supplier was, and seem to date back at least to the mid-eighteenth century and probably to the seventeenth. In Antoine Pernety's *Dictionnaire portatif de peinture, sculpture et gravure* (Paris 1757), the same numbered sizes appear – given in *pieds et pouces* (feet and inches) rather than centimetres, but corresponding exactly to the basic nineteenth-century sizes. The number denoting the size originally indicated the price of the canvas in *sous* in the pre-Revolutionary period; thus, a number 10 canvas would have cost ten sous.

By the mid-nineteenth century, each size was available in three basic rectangular shapes: *figure*, *paysage* and *marine*. For each numbered size, the three formats would have one dimension the same, but the other would differ, *figure* being the widest and *marine* the narrowest. There were two *paysage* and *marine* formats for each numbered size, one larger than the other, giving a total of five possible formats. Before the late 1880s, only the *figure* format was available in the full range of sizes (nos. 1–120); the

Fig. 30 Range of ready-stretched canvases from Lefranc & Company, *c.* 1863

TOILES POUR LA PEINTURE A L'HUILE, TENDUES SUR CHASSIS.

DÉNOMINATIONS.	DIMENSIONS En mètres.	DIMENSIONS En pouces.	CHASSIS ORDIN. Toile ordinaire.		CHASSIS A CLEFS Toile ordinaire.		CHASSIS A CLEFS Toile fine.		CHASSIS ORDIN. OVALES, Toile ordinaire.		CHASSIS A CLEFS OVALES, Toile fine.	
			fr.	c.	fr.	c.	fr.	c.	fr.	c.	fr.	c.
De 1.	0,216 sur 0,162	8 sur 6	»	50	1	25	1	70	1	65	4	20
De 2.	0,243 — 0,189	9 — 7	»	50	1	30	1	80	1	65	4	30
De 3.	0,270 — 0,216	10 — 8	»	60	1	40	2	10	1	75	4	60
De 4.	0,324 — 0,243	12 — 9	»	60	1	50	2	25	1	75	4	80
De 5.	0,369 — 0,288	13½ — 10½	»	80	1	80	2	50	2	»	5	40
De 6.	0,405 — 0,324	15 — 12	»	90	2	»	2	80	2	30	5	80
De 8.	0,459 — 0,378	17 — 14	1	20	2	60	3	25	2	80	6	50
De 10.	0,540 — 0,459	20 — 17	1	50	3	»	4	25	3	25	8	»
De 12.	0,594 — 0,486	22 — 18	1	70	3	50	4	75	3	60	9	»
De 15.	0,668 — 0,540	24 — 20	1	90	3	75	5	25	4	»	10	»
De 20.	0,729 — 0,594	27 — 22	2	40	4	50	6	75	5	20	12	»
De 25.	0,810 — 0,648	30 — 24	2	80	5	»	7	75	6	40	13	50
De 30.	0,918 — 0,729	34 — 27	3	30	6	75	8	60	6	80	15	»
De 40.	0,999 — 0,810	37 — 30	4	25	7	75	11	20	8	30	18	»
De 50.	1,161 — 0,891	43 — 33	5	25	9	»	13	50	10	»	22	»
De 60.	1,296 — 0,972	48 — 36	6	25	10	75	16	50	12	»	26	»
De 80.	1,458 — 1,134	54 — 42	8	20	14	50	21	50	14	50	»	»
De 100.	1,620 — 1,296	60 — 48	10	»	18	»	27	»	17	50	»	»
De 120.	1,944 — 1,296	72 — 48	12	»	20	»	32	»	21	»	»	»

TOILES POUR MARINES ET PAYSAGES, CHASSIS ORDINAIRES.

Mêmes prix que pour les Toiles pour la peinture à l'huile tendues sur châssis, p. **47.**

DÉNOMINATIONS.	DIMENSIONS EN MILLIMÈTRES.	DIMENSIONS EN POUCES.
De 5.	360 sur 189, 216, 243, 270.	13 ¼ sur 7, 8, 9, 10.
De 6.	405 — 216, 243, 270, 297.	15 — 8, 9, 10, 11.
De 8.	459 — 270, 297, 224, 351.	17 — 10, 11, 12, 13.
De 10.	540 — 351, 378, 405, 432.	20 — 13, 14, 15, 16.
De 12.	594 — 378, 405, 432, 459.	22 — 14, 15, 16, 17.
De 15.	648 — 405, 432, 459, 486.	24 — 15, 16, 17, 18.
De 20.	729 — 486, 513, 540, 567.	27 — 18, 19, 20, 21.
De 25.	810 — 540, 567, 594, 621.	30 — 20, 21, 22, 23.
De 30.	918 — 621, 648, 675, 702.	34 — 23, 24, 25, 26.

paysage and *marine* formats were only available in the middle range of sizes (nos. 5–30) (Fig. 30). By the late 1880s the smallest canvas available 'off the shelf' was a no. 1 *marine* at 22 × 12 cm; the largest was a no. 120 *figure* at 195 × 130 cm. Oval formats were also available. The table, illustrated from Bourgeois's catalogue of 1888, shows the range (Fig. 31).

Within the range of sizes and formats, different weights of canvas – *ordinaire* (a

NUMÉROS	DIMENSIONS			TOILE ORDINAIRE			TOILE 1/2 FINE	TOILE FINE	
	FIGURE	PAYSAGE	MARINE	CHASSIS ordinaires carrés	CHASSIS à clés, carrés modèle déposé (1)	CHASSIS ordinaires ovales	CHASSIS à clés, carrés modèle déposé (1)	CHASSIS à clés, carrés modèle déposé (1)	CHASSIS à ciés, ovales anciens
	m. m.	m. m.	m. m.	fr. c.	fr. c.	fr. c.	fr. c.	fr. c.	fr. c.
1	0 22 × 0 16	0 22 × 0 14	0 22 × 0 12	» 60	» 65	1 50	» 70	» 85	3 50
2	0 24 × 0 19	0 24 × 0 16	0 24 × 0 14	» 65	» 75	1 60	» 80	1 »	3 75
3	0 27 × 0 22	0 27 × 0 19	0 27 × 0 16	» 70	» 85	1 75	» 95	1 20	4 »
4	0 33 × 0 24	0 33 × 0 22	0 33 × 0 19	» 80	1 05	2 »	1 20	1 50	4 75
5	0 35 × 0 27	0 35 × 0 24	0 35 × 0 22	» 90	1 25	2 25	1 40	1 75	5 50
6	0 41 × 0 33	0 41 × 0 27	0 41 × 0 24	1 »	1 50	2 50	1 70	2 20	6 »
8	0 46 × 0 38	0 46 × 0 33	0 46 × 0 27	1 30	1 75	3 »	2 10	2 70	6 50
10	0 55 × 0 46	0 55 × 0 38	0 55 × 0 33	1 50	2 25	3 75	2 70	3 55	8 50
12	0 60 × 0 50	0 60 × 0 46	0 60 × 0 38	1 80	2 55	4 25	3 10	4 15	9 50
15	0 65 × 0 54	0 65 × 0 50	0 65 × 0 46	2 »	3 »	4 50	3 60	4 85	11 »
20	0 73 × 0 60	0 73 × 0 54	0 73 × 0 50	2 50	3 50	5 75	4 20	5 70	12 50
25	0 81 × 0 65	0 81 × 0 60	0 81 × 0 54	2 80	4 15	6 75	5 05	6 80	14 »
30	0 92 × 0 73	0 92 × 0 65	0 92 × 0 60	3 30	5 15	7 50	6 30	8 55	15 »
40	1 » × 0 81	1 » × 0 73	1 » × 0 65	4 25	6 10	9 »	7 55	10 15	20 »
50	1 16 × 0 89	1 16 × 0 81	1 16 × 0 73	5 25	7 65	11 »	9 35	12 75	22 »
60	1 30 × 0 97	1 30 × 0 89	1 30 × 0 81	6 25	8 95	13 »	11 05	15 15	28 »
80	1 46 × 1 14	1 46 × 0 97	1 46 × 0 89	8 20	11 60	16 »	14 30	19 70	32 »
100	1 62 × 1 30	1 62 × 1 14	1 62 × 0 97	10 »	14 65	20 »	18 05	24 80	36 »
120	1 95 × 1 30	1 95 × 1 30	1 95 × 1 14	12 »	18 15	22 »	22 20	30 30	40 »

(1) Voir figure, page ci-contre.

NOTA. — Les Châssis *hors mesure* sont livrés dans les 24 heures de la réception de la Commande.

loosely woven, medium-weight canvas) and *fine* (more tightly woven) – could be purchased. From the late 1880s a *demi-fine* canvas was also available. The standard weave was a simple tabby, the warp and weft threads passing over and under each other alternately, but other weaves were also used, such as double-threaded tabby (see Cat. no. 6) or twill (*coutil*). Linen was the usual fabric, but cotton and hemp were also obtainable. A number of sources, from the 1840s onwards, recommended the use of hemp canvases, particularly for large paintings: the fabric was stronger and could be stretched tightly without tearing; it was also cheaper. It does not seem to have been very widely used, however, and perhaps was not generally available in the second half of the century. Thin, coarsely woven, cheap fabrics were used for sketching canvases.

Unprimed and primed canvases could be bought simply by the metre. Prepared canvases were also available in 10 × 2 m lengths, with the possibility of a greater variety of weaves and weights of canvas than those available ready-stretched: *ordinaire*, *demi-fine*, *coutil*, *fine forte*, *fine*, *très-fine* and *extra-fine* are listed in the 1888 Bourgeois catalogue. *Demi-fine* was also available prepared for watercolour and gouache. This range became available only late in the century; Lefranc's catalogues dating from the 1860s and 1870s only list *ordinaire*, *demi-fine* and *fine*, ready-primed for oil painting (together with the canvas *pour fixé*, presumably, from its relative cheapness, intended primarily for studies). By 1883 a *coutil* canvas was also available, at the same price as the *fine*. It is likely that ready-stretched canvases of non-standard sizes were available to order; this was certainly the case by the late 1880s. Some painters preferred to buy prepared canvases by the roll, together with bare stretchers. This also allowed them to use non-standard size stretchers. Late in life, according to

Fig. 31 Range of ready-stretched canvases from Bourgeois *aîné*, 1888

his son Jean, Renoir 'seldom made use of canvas fastened to stretchers of fixed size . . . he would buy large rolls of canvas and cut out a piece with his tailors' scissors. For portraits, however, he did use canvas mounted on stretchers of a set size . . . he had in mind antique picture frames, which he admired so much, as they usually correspond in size to the standard stretchers.'

The standard numbered sizes of canvas were very familiar to painters, who constantly referred to them when describing their paintings. Monet wrote from Saint-Adresse to Bazille in October 1864, 'I'm going to get down to a still life on a size 50 canvas of rayfish and dogfish with old fishermen's baskets . . .', and Pissarro referred to a canvas of 30 *basse* (that is, probably, the smaller of the two landscape formats) in a letter to his friend Eugène Murer in 1878. Later, writing to his son Lucien from Rouen in October 1883, he described a painting of the view from a café balcony that he had started: 'Unfortunately it is only a number 10 canvas; I am going to re-do it.'

Whether canvases were bought in standard sizes or by the roll, they were available with commercial primings that varied in both colour and thickness. Essentially, there were two thicknesses, corresponding to a single or a double application of ground. Single-primed canvases were designated *à grain*, because the canvas weave remained fairly prominent: Impressionist painters often chose them for their grainy texture, over which the use of dryish oil paint could produce the sparkling, broken effects that they found so appropriate for landscape painting. Double-primed canvases were known as *lisse* (smooth) because the texture of the weave was filled to a greater degree.

The textures of canvas and ground remained important to the Impressionist painters throughout their careers. Pissarro in a letter to Lucien in 1887 complained about a canvas supplied by the colour merchant Tanguy: 'It is dreadful and of second quality; I beg you to ask Contet to send me a number 30 square canvas, the area of my stretcher, with enough turnover to be able to nail it on well. Fine canvas with white plaster (*plâtre*): the layer *very thin, very thin*. I am waiting to start my painting.' It is interesting that Pissarro only asked for the canvas, to fit a pre-existing stretcher or strainer; the priming requested could have been an absorbent ground in a glue, rather than an oil, medium. In this instance, the white pigment seems to have been plaster (hydrated calcium sulphate), although chalk and other similar materials were also used.

The colour of the priming was especially important to the Impressionist painters, since they often used the ground itself to stand for parts of the finished composition. Coloured primings listed in the colourmen's catalogues are usually described as shades of 'grey' or 'yellow', but we may assume that these were extremely pale tints indeed, not far removed from white – perhaps, for example, a light cream for 'yellow'. We may also assume – although many catalogues fail to mention it – that all the canvas types and sizes were routinely available prepared with plain white grounds.

A whole variety of coloured primings is observed on Impressionist paintings, some of which could undoubtedly be bought ready-made, or specially ordered from colourmen. Alternatively, the painter himself might apply a second, tinted, layer over a standard ready-made priming. The upper, pale mauve layer in Monet's *Petit Bras of the Seine at Argenteuil* (Cat. no. 6), for example, may have been applied by Monet himself or by the colourman at his request. Significantly, only the lower, greyish-white layer is present on the turnover edges: this indicates that the upper, tinted, layer

was applied when the canvas was already on its stretcher.

The materials of the ground layers comprise a very limited range of pigments and extenders, bound in a drying oil. Analysis has shown that, of the fifteen paintings discussed in the catalogue, eleven have linseed oil grounds (see pages 74–5). The exceptions include the two pictures Pissarro painted during his stay in London in 1870–1 and two canvases, one by Renoir, the other by Monet, which are known to have been self-primed. Pissarro's *Fox Hill, Upper Norwood* (Cat. no. 4) was painted on a canvas of standard size bought from the London colour merchant Charles Roberson; the priming, consisting of two layers of lead white and chalk, contains walnut oil. The supplier of the canvas for *The Avenue, Sydenham* (Cat. no. 5) is not known; in this case the ground, also commercially prepared, was found to contain poppy oil. Of the self-primed canvases, Renoir's *Boating on the Seine* (Cat. no. 11) has a very thin whitish ground consisting of lead white ground in poppy oil. The greyish-buff ground of Monet's *Lavacourt under Snow* (Cat. no. 13) has two layers, each containing a mixture of pigments. Analysis of the binding medium gave slightly ambiguous results, but the ground may contain walnut oil (see page 75).

In the grounds of all Impressionists pictures lead white is the principal white component. It is often mixed with either chalk or barium sulphate as an extender. The explanation for this is probably that a cheaper grade of lead white, perhaps equivalent to that used by decorators, may have been used for the priming. Commercial grades of the pigment (often named *céruse* or *blanc de plomb*) almost invariably incorporated a proportion of another white pigment, frequently chalk or other white earths, or barium sulphate. Barium sulphate was very commonly used; Lefort, writing in 1855, described a number of standard grades of *céruse* mixed with barium sulphate, from *blanc de plomb surfin* (85 per cent *céruse*, 15 per cent barium sulphate) to a grade containing as little as 25 per cent *céruse* and 75 per cent barium sulphate. Small amounts of other pigments were often mixed with the white. These coloured components were usually inexpensive earth colours and black, used only in minute quantities to soften the coldness and hardness of a pure white ground. Traces of yellow ochre were detected in the grounds of several of the paintings, for example

Fig. 33 Sized canvases drying, Lefranc-Bourgeois factory, Le Mans, 1990

Fig. 32 Application of size to a stretched canvas in the Lefranc-Bourgeois factory, Le Mans, 1990

Monet's *Bathers at La Grenouillère* (Cat. no. 2) and Cézanne's *Hillside in Provence* (Cat. no. 15), warming the colour of the ground to a pale cream. The warm pale grey colour of the ground of Monet's *Beach at Trouville* (Cat. no. 3) is due to tiny quantities of black and translucent yellow pigments: black alone would have given a cooler grey. The upper ground of Monet's *Petit Bras* is given its pale mauve colour by the presence of tiny amounts of a red ochre pigment, as well as black.

The commercial process of applying the ground layers by hand was a standard one; it had been used for very many years and is still used to this day. Lengths of canvas were stretched on to huge wooden frames: the normal size probably corresponded to the 10 × 2 m roll that, as we have seen, could be bought ready-prepared. Once stretched, the canvas on its frame was placed horizontally across large trestles. The first coating was of an animal glue size in water, applied warm, the purpose of which was to seal the canvas fibres and prevent direct contact between the fabric itself and the oil layer that was to follow; the degradative effects of drying oils on canvas had been known for centuries and a preliminary size layer was standard practice. Excess size would be scraped off the back of the canvas. When dry, the canvas was rubbed with pumice stone to efface prominent knots and irregularities in the grain. The ground layer of lead white (with any pigments or extenders) was then applied across the entire surface. The application of both the size and the oil-bound priming was normally carried out by two men working with long, flexible, slightly tapered knives, one on either side of the frame. They would pour the liquid glue or priming mixture on to the canvas and then walk steadily up and down, spreading and smoothing the layer (Fig. 32). Although appearing to be a simple action, it required considerable skill and long practice to achieve the smooth, even ground that would satisfy the critical eyes of professional painters. The process was repeated if required for a smoother – *lisse* – surface for the finished canvas. To allow the layers to dry, the canvas frames were then stacked in rows (Fig. 33).

Many standard size canvases still have their suppliers' stamps on the back of the fabric (Fig. 34). This would usually indicate the retailer of the stretched canvas, who was not necessarily its manufacturer. Examples of surviving canvas stamps (or those recorded during lining) may be seen in Cat. nos. 1, 4, 6, 7, 8, 10 and 12. They are all

Paris suppliers, except for Robersons of London, who supplied the canvas for Pissarro's *Fox Hill*. The canvas for Pissarro's *The Avenue, Sydenham* may also have come from Robersons, although no stamp is now visible. However, in this context, it is interesting that the binding medium has been identified as poppy oil, rather than the walnut oil of *Fox Hill*.

Occasionally, a stamp is also found on the back of the stretcher itself. This may refer to the supplier of the canvas, who primed and stretched it (and who may also be the retailer); however, it could also in some cases identify the manufacturer of the stretcher itself. An example of such a stamp, that of E. Hostellet (Fig. 35), occurs on the stretcher of Monet's *Gare Saint-Lazare* (Cat. no. 10). Hostellet, who had a business at 4 rue Laval, manufactured easels and mannequins, among other articles for painters. While it is not certain that the firm also made stretchers, it would not be at all surprising.

Fig. 35 Claude Monet, *The Gare Saint-Lazare* (Cat. no. 10), back of painting, showing stamps on canvas and centre bar of stretcher

Impressionism and the Modern Palette

The first three decades of the nineteenth century saw an unparalleled development and elaboration of the artists' palette, particularly in France, but also in Germany and England. Newly invented pigments appeared at greater frequency and with greater impact on technique than at any other time in the history of easel painting. The process continued over the next forty years as more new painting materials came to be introduced which, by the 1870s, the decade of Impressionism, made up a fundamentally new range of artists' pigments, many of which are still in use by painters today. Against a background of rapid technical innovation, and its commercial exploitation, the painters of Impressionism saw no reason to struggle with the traditional painting materials promulgated by the Academy, embracing instead the powerful colours of the spectrum that a new science promised to deliver.

A number of factors had provided the impetus for the nineteenth-century expansion of the artists' palette. Perhaps of greatest importance was the appearance in France of a new systematic chemistry in the later part of the eighteenth century: Lavoisier's *révolution chimique*. At the same time there were great improvements in methods of analysis of chemical compounds, stimulated largely by mineralogical research. In this, French scientists were at the forefront: the chemists Vauquelin, Courtois and Thénard accounted for some of the most significant discoveries of materials which were to be adopted as artists' pigments. Their researches rested in turn on the chemical philosophy expounded by Lavoisier's intellectual followers: Berthollet, Fourcroy and Guyton de Morveau. Their development of a modern view of chemical reaction provided the theoretical framework for the discovery of many new chemical compounds.

The most far-reaching extension of the range of available artists' pigments came from research within inorganic chemistry: essentially the chemistry of metals and their compounds. The bulk of the new pigments that were introduced to painting in the nineteenth century, and came to form the Impressionist palette, were synthetic inorganic materials, based, for example, on chromium, cadmium, cobalt, zinc, copper and arsenic (Plate 17). Their sources were the expanding metallurgical industries of France and Germany.

Chromium was discovered by L. N. Vauquelin in 1797. Vauquelin isolated chromium from a rare orange-coloured mineral found in Siberia (crocoite), and named it *chrôme* in tribute to the great variety of strongly coloured compounds that could be made from the new metal. Vauquelin's studies of the chemistry of chromium were the subject of a comprehensive scientific *mémoire* published in 1809, in which he described the preparation and properties of a number of dense yellow, orange and green compounds. Vauquelin's primary interest was the chemistry, not the pigment

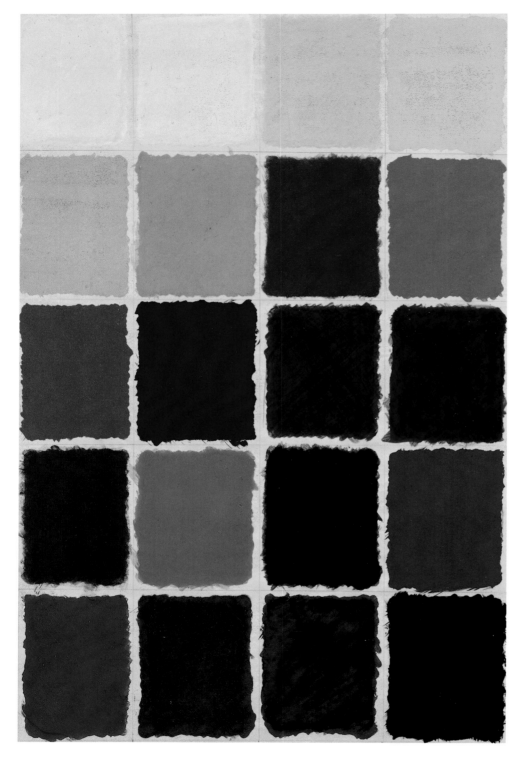

Plate 17 The principal pigments used in Impressionist painting. *Top row*, left to right: zinc white, lead white, 'lemon yellow' (barium chromate), chrome yellow (lead chromate). *Second row*: cadmium yellow, Naples yellow (lead antimonate), yellow ochre, chrome orange (basic lead chromate). *Third row*: vermilion, red ochre, natural madder lake, crimson (cochineal) lake. *Fourth row*: Scheele's green (copper arsenite), emerald green (copper acetoarsenite), viridian (hydrated chromic oxide), 'chrome green' (Prussian blue mixture with chrome yellow). *Bottom row*: cerulean blue (cobalt stannate), cobalt blue (cobalt aluminate), artificial (French) ultramarine, ivory black (bone black)

applications of these materials, although he comments on their potential as colouring agents in his conclusion. The significance of the research was that it prefigured changes which were to come about in the artists' palette later in the century. The centrality of modern scientific enquiry had been clearly established in the colour trade.

Certain other discoveries, for example the invention of a synthetic form of

ultramarine in the 1820s, had come from investigations with a more directly commercial motive than Vauquelin's research. There was a new and expanding market for artists' materials, and the continuing growth of amateur painting ensured the economic stimulus behind the search for and production of improved artists' pigments. These were perceived to be products of relatively high value, the commercial advantages of which could be protected by registering patents covering the details of their preparation and manufacture. Some of the newly discovered coloured materials had proved unexpectedly inexpensive to synthesise on a large scale – the raw materials turning out to be cheap and plentiful – and were manufactured not only as *couleurs fines* intended for use by artists, but also found more widespread applications in, for example, decorators' paints, for block-printing, in enamelling and, most important for French industry, as ceramic glaze colorants. Apart from the chemical discoveries that made the manufacture of new pigments possible, rapid improvements in chemical processing and production technologies in the late eighteenth and early nineteenth centuries began to remove the uncertainties in supply, quality and cost that had always restricted the choice of pigments available to painters.

The rather sudden expansion in the artists' palette in the early decades of the nineteenth century can be seen to have been a genuine extension of choice. Traditional pigments were not rendered obsolete overnight. J. F. L. Mérimée's *De la Peinture à l'huile*, first published in 1830, provides a commentary on artists' pigments and their uses, and records the new or recent introductions alongside many materials with a long history in painting. For example, he gives equal weight to genuine ultramarine from lapis lazuli and to its newly invented synthetic counterpart; the new pigments, Scheele's green and emerald green, are described (see below), but not recommended in place of the traditional pigments *terre verte*, a natural earth, and verdigris, one of the most ancient of manufactured pigments. He lists long-established types of bright red vermilion pigment, but also a newly discovered iodide of mercury recommended as an opaque scarlet colour. It was premature for some of the newer pigments to have proved their value or revealed their drawbacks in practice, although with the distribution in England in 1835 of George Field's *Chromatography*, a more rigorous science of testing pigments for their permanence was beginning to be influential. In 1855, Jules Lefort's *Chimie des couleurs par la peinture à l'eau et à l'huile* dealt systematically, for the first time in France, with the chemistry and permanence of artists' pigments.

By 1891, J. G. Vibert had published a series of his public lectures, given at the Ecole des Beaux-Arts under the title *The Science of Painting*, which offered a radically changed prescription for the artists' palette. This author says of his own work: 'Will it cause painters to adopt a more rational method? May we hope, thanks to it, to see the masterpieces of the future preserve their brilliance and freshness?' A lengthy appendix specifies a 'list of colours, which may be used with perfect certainty'. Vibert gives them as: *lead white*, zinc white, *earth colours*, cadmium yellows, strontium chromate yellow ('lemon yellow'), *vermilion*, *madder lakes*, cobalt blue, artificial ultramarine, chromium oxide green, cobalt green (Rinmann's green), cobalt violet and manganese violet (the traditional pigments are italicised; see also below for fuller details).

It is noticeable that of these thirteen recommendations for stable colours, nine were the products of nineteenth-century technology, and were underwritten as

permanent by scientific investigation. The book rejects as unsuitable a large number of traditional artists' pigments, as well as some of the newer materials over which doubts had already been cast. Competition was clearly stiff between the colour houses and other suppliers, and it is interesting to note that Vibert offers in his book an unconditional endorsement, in the form of a 'commercial guarantee', of the colours made exclusively by the Paris firm of Lefranc & Co.

The new choice of pigments for easel-painting rested heavily on novel metal compounds, but nineteenth-century developments in organic chemistry were also to have an impact on artists' materials. One large class of traditional pigments was made by combining a strongly coloured dyestuff with a translucent inorganic base material in a process called lake making. The dyestuffs, which are exclusively organic compounds, that is, molecular compounds of carbon, had always been derived from plant or insect sources. The madder plant, which contains a red dyestuff called alizarin, has had a long history in lake pigment making; scale-insect sources such as lac and cochineal, which also yield red dyes, were used as well. Similarly, translucent yellows could be made with dyes extracted from a number of plant types. The analysis of organic compounds, and particularly their synthesis, is a great deal more difficult than the analysis of most inorganic compounds, so it is not surprising that natural dyestuffs were not artificially duplicated until as late as the second half of the nineteenth century. There were many commercially available artificial inorganic materials deriving from old technologies, but the first synthesis of a simple organic compound – urea – from inorganic starting materials had been achieved only in 1828, by Wöhler.

In fact, the first artificial organic dyestuff to be prepared had no natural equivalent. It was a deep purple dye known as mauveine, discovered by chance in 1856 by a Scottish chemist, William Perkin, while working with aniline, a by-product of coal tar. It was the first of a series of so-called coal-tar colours. Mauve, as it was named first in France, was rapidly adopted as a watercolour pigment, the attraction being its powerful tone. The preparation of mauveine was the precursor of an artificial dyestuffs industry that was to become economically important throughout Europe.

In this field, the true prize discovery was the first-ever synthesis of an artificial form of a natural dyestuff by two German chemists in 1868: C. Graebe and C. Lieberman. They described the first preparation of alizarin, the red colouring matter of the madder plant, and immediately patented their discovery. This was an advance of great commercial value; the textile-dyeing industry was suddenly freed from dependence on the labour-intensive cultivation of natural madder. The extensive madder-growing industry in France and elsewhere was eventually destroyed by the appearance of synthetic alizarin; large quantities of the new dyestuff were used for textile dyeing, and a certain amount to make artificial madder lake pigments. There remained a specialist demand for natural madder lakes (*laque de garance*), and the catalogues of the colour houses often carried both types as artists' pigments, in many varieties and shades of colour. Rather later, red lake pigments prepared from the new aniline dyes Perkins had developed began to appear on the market. These were often strikingly vivid in colour, and bore attractive names such as geranium lake and nasturtium lake, but they were impermanent pigments, and particularly vulnerable to fading.

It was not only the pigment content of *couleurs fines* that underwent great change

in the middle years of the nineteenth century. The first collapsible metal paint tubes, fabricated of lead or tin sheet, became available from 1840, and these not only improved the storage life of manufactured oil paints, but also made artists' colours truly portable for the first time, thus allowing painters to work out of doors. Pigments began to be regularly machine-ground from the late 1830s, but the resulting slicker texture and more 'buttery' feel did not necessarily meet with the approval of all painters. The manufacturers hoped to reduce the amount of the most expensive constituent of a tube-colour: the pigment, and pigments with high tinting strengths were therefore attractive. Manufacturers could incorporate extender or filler materials, such as pulverised silica, alumina, china clay and barium sulphate (*blanc fixe*) in a smooth paste of well-ground pigment and medium, reducing production costs. Extenders often improved the handling qualities of the paint, so the advantages were twofold. These formulations were designed to be suitable for mass-production methods. Other kinds of additives, particularly wax, were also sometimes combined with oil paint to modify the stiffness of the paste and its working properties (see also page 75), but this seems to have been more experimental, and such modifications may have been at the expense of durability.

The evidence of the contemporary literature on painting practice is that French painters of the later nineteenth century were just as concerned about the permanence of their materials as painters of previous generations. But the Impressionist painters and their contemporaries lacked or had abandoned the formal technical training of the old-fashioned *atelier*, and were thus forced to rely on the manufacturer, the colour supplier or the chemist to endorse the qualities of their products. Anecdotal judgements among painters were common. There was plenty of choice in artists' materials with many sources of supply, and the colour houses vied with one another to attract the attention of their customers by publishing extensive catalogues and laying scientific claims.

The usually well-preserved condition of Impressionist paintings is due in fact to contemporary improvements in the technology and constitution of artists' tube paints. Not only were the pigments more stable than before, but a better understanding of the siccative (drying) action of oil paints had largely solved the problems of poorly drying pigments such as zinc white, ultramarine and viridian, and these could now be used in thickly laid impasto without difficulty. The unchanged appearance of the paintings in the catalogue show that many of the scientific claims made for the newer pigments were fully justified.

The Impressionists adopted modern painting materials enthusiastically. Although Monet and Renoir in particular are known to have carped about their suppliers' products, the new tube-colours on offer were the best solution to their needs in practice as painters. *Couleurs fines* were widely available in consistent quality; they were in general cheaper than before and they were untroublesome to carry and work with. But, most important, they made use of new pigments of striking vividness and stability. Impressionist painting concerned itself with the modern, and to reject wholesale the difficult and gloomy materials of academic painting would surely have suited the Impressionist palette well.

New Blues in the Nineteenth Century

Blue pigments had always represented something of a problem to painters. The traditional and most desirable blue pigment was natural ultramarine, extracted from a

Fig. 36 L. J. Thénard (1777–1857). Inventor of cobalt blue

semiprecious stone, lapis lazuli, but it was scarce and always extremely costly. There were other possible choices for easel-painting: mineral azurite, smalt (a blue glass pigment containing cobalt) and a vegetable dyestuff, indigo. All these were unsatisfactory in one way or another, while the invention around 1704 of **Prussian blue**, a synthetic pigment of variable reliability and reputation, had also not fully resolved the painters' needs. An improvement in the palette here was much sought after, and in the early years of the nineteenth century had both the encouragement of the French government and the backing of French industry.

In the first half of the eighteenth century it had been shown by a Swedish chemist, Brandt, that the blue colour of smalt was attributable to a previously unknown metallic element, cobalt. Research into the chemistry of cobalt followed, and it was the success of cobalt-containing glazes for Sèvres porcelain that had suggested to Thénard (Fig. 36) the possibility of an artists' pigment based on the metal. He found that a pure blue could be obtained by heating together either cobalt phosphate or cobalt arsenate with alumina. Later preparations simplified Thénard's method, and the pigment was made by calcining cobalt oxide with alumina to form the binary oxide, cobalt aluminate ($CoO.Al_2O_3$), known as **cobalt blue**, Thénards blue and, sometimes, as Dresden blue. This pigment represented a considerable advance for painters: in common with all refractory compounds, cobalt blue is extraordinarily stable. It is also a pure blue colour (Plate 18) and lacks the greenish undertone of azurite, Prussian blue and indigo, while possessing the additional advantage that the cobalt content of the pigment chemically assists and accelerates the drying of oil paint.

The discovery of cobalt blue took place in 1802, but it was not published until 1803. On account of its obvious demand in the market, the pigment was manufactured soon after its discovery and equally rapidly adopted by painters. With synthetic ultramarine (see below), cobalt blue is a staple part of the Impressionist palette, the only disadvantage being its relatively high cost. It remained an expensive but vital material throughout the nineteenth century.

The quality and colour of the pigment can be seen at its best in the extensive deep blue paint of the river in Renoir's *Boating on the Seine* (Cat. no. 11) and in the powerful blue tints of the snowfield in Monet's *Lavacourt under Snow* (Cat. no. 13; Plate 19). Cobalt blue also forms the lighter tones of the water in Monet's *Bathers at La Grenouillère* (Cat. no. 2). Skies painted in cobalt blue, where the pigment is mixed with white, and sometimes also with other blue pigments, are common in Impressionist painting, and can be found, for example, in Monet's *Beach at Trouville* (Cat. no. 3) and in Manet's *Music in the Tuileries Gardens* (Cat. no. 1). Large quantities of cobalt blue in conjunction with artificial ultramarine are responsible for the overall strongly blue tonality of Renoir's *Umbrellas* (Cat. no. 14), and the pigment occurs also in his *At the Theatre* (Cat. no. 8), in Sisley's *Watering Place at Marly-le-Roi* (Cat. no. 7) and in Morisot's *Summer's Day* (Cat. no. 12). Monet's usually elaborate mixtures of pigment often contain cobalt blue, as in *The Gare Saint-Lazare* (Cat. no. 10).

Another blue pigment derived from cobalt was also introduced in the nineteenth century, although rather later. It was an artificial compound of cobalt and tin oxides, cobalt stannate ($CoO.nSnO_2$), and was supplied first in 1860 as a watercolour pigment called *caeruleum* by the English colour-maker Rowney. The modern name is **cerulean blue** and it has a greenish tinge rather than the pure slightly violet blue of cobalt aluminate. Cerulean was clearly available in France as an oil paint in the 1870s

Plate 18 Particles of cobalt blue by transmitted light. Magnification, 170×

Plate 19 Detail from Monet's *Lavacourt under Snow* (Cat. no. 13) showing the use of cobalt blue in the foreground. Touches of pure cadmium yellow occur above in the distance

Fig. 37 SEM micrograph showing particles of synthetic (French) ultramarine. Gold-coated. Magnification, 4,580×

(*bleu céleste*) as it has been identified in Berthe Morisot's *Summer's Day* as well as in several paintings by Edouard Manet (Plate 20). Certain of Monet's colour mixtures examined in this study, particularly those from *The Gare Saint-Lazare*, contain cobalt stannate. Since cerulean was generally produced by chemical precipitation rather than at high temperatures in a furnace, its attraction may have been the ease of manufacture compared to that of cobalt blue itself.

Even more essential to painters was a synthetic form of ultramarine, now commonly called **French ultramarine**. Its invention was the result of a long period of research into the nature of the mineral pigment, the composition of which had eluded analysts for generations. The aim was to manufacture an artificial substitute. The commercial potential was clear. A reliable analysis of lapis lazuli, the source of the natural pigment, was first published in France in *Annales de Chimie* by Clément and Désormes in 1806. There followed descriptions of blue compounds thought to be similar to lazurite (the blue colour of natural ultramarine) formed as the by-products of industrialised chemical technologies. Vauquelin had also recorded blue crystalline masses found in a demolished glass furnace at Saint Gobain. These discoveries were important indications of the starting materials and conditions required to manufacture a synthetic form of ultramarine.

The search was given new impetus by the offer of several prizes for a method of preparation. The most generous came from the Société d'Encouragement pour l'Industrie Nationale in 1824, which offered 6000 francs to anyone who could devise a method to make synthetic ultramarine of the quality of lapis lazuli ultramarine at a cost of no more than 300 francs per kilogram. (Interestingly, natural ultramarine pigment was still available in the late 1860s from Lefranc & Co. at a trade price of 2333 francs per kilogram, roughly seven hundred times the price of the synthetic pigment.) An engineer turned colour manufacturer working in Toulouse named J. B. Guimet received the prize in 1828, but his right to the award was immediately contested by C. Gmelin, Professor of Chemistry at the University of Tübingen, who claimed to have discovered a similar synthesis independently in 1827. However, Guimet was able to prove that his process had been perfected in 1826, and artificial ultramarine is still seen as a French invention, as its modern name testifies. Large-scale production of the pigment, not only for artists' purposes, followed soon after both in France and Germany.

The preparation of artificial ultramarine involves heating together in a closed furnace a pulverised mixture of china clay (kaolin), sodium carbonate, charcoal, silica and sulphur. A blue frit results, which is then ground and any contaminating soluble salts extracted with water. The material is then re-ground to make the blue pigment, which has a variable complex composition ($Na_{8-10}Al_6Si_6O_{24}S_{2-4}$), similar to that of lazurite (natural ultramarine). Both Guimet's and Gmelin's methods were variants on this same essential procedure. The synthetic pigment can be made in a variety of shades of blue, and it can substitute very well for the pure blue of the natural pigment. Its colour is more intense and, despite some early doubts, the durability of well-made French ultramarine is probably as good as genuine ultramarine in oil. The particle form of synthetic ultramarine is quite distinct from the mineral pigment, appearing in paint samples under the microscope as fine rounded grains of a very intense deep blue (Plates 21 and 22); however, scanning electron micrographs show that particles of French ultramarine have a much more irregular character (Fig. 37).

The attractions of synthetic ultramarine for artists were considerable, and by the

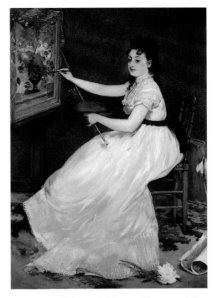

Plate 20 Edouard Manet, *Portrait of Eva Gonzalès*, 1870. 191·1 × 133·4 cm. London, National Gallery. Cerulean blue was used for the foreground

Plate 21 Particles of natural (lapis lazuli) ultramarine by transmitted light. Magnification, 250×

Plate 22 Particles of synthetic (French) ultramarine by transmitted light. Magnification, 430×

1870s it was a standard blue for oil painting in France, and a great deal cheaper than the cobalt pigments. Its discovery had replaced the most expensive of all artists' pigments with one of the least costly. The relatively poor drying quality in oil of both natural and French ultramarine was overcome in the new synthetic pigment by the addition to the paint of certain metal salt siccatives (driers).

The paintings in this catalogue show a widespread reliance on artificial ultramarine. The later stage of Renoir's *Umbrellas* is particularly rich in French ultramarine, and the striking colour intensity of the pigment can be seen in the pure deep blue impasto touches to the left in Pissarro's landscape *The Côte des Boeufs* (Cat. no. 9; Plate 23). Many of the other pictures make use of the pigment in one way or another, the painter often exploiting its very high tinting strength as a substitute for black in dark pigment mixtures. Monet employs these 'optical' dark tones very extensively throughout his *Gare Saint-Lazare* (Cat. no. 10) and Cézanne makes use of the technique to construct the shadows between the rocks in *Hillside in Provence* (Cat. no. 15). Skies painted in French ultramarine can be seen in Pissarro's *The Avenue, Sydenham* (Cat. no. 5; Plate 24) and in Cézanne's Provençal landscape.

Arsenical Greens

The improvement of green pigments was also of concern to painters. At the beginning of the nineteenth century the range of green pigments was rather unsatisfactory, either dull in colour or difficult to work with. Some were reactive and impermanent. In general, the practical solution had been to make greens as colour mixtures, usually based on some combination of a traditional blue and yellow pigment, then often adjusted in tone with white, black and earth colours. Elaborate combinations were commonplace. Only one new green pigment had been found – by the Swedish chemist C. W. Scheele in 1775 while he was researching the chemical properties of arsenic. **Scheele's green**, an arsenite of copper ($CuHAsO_3$), is a rather dirty green colour (Plate 25).

As Scheele himself pointed out, copper arsenite is exceedingly toxic, a considerable fault in an artists' pigment, but despite this it had a brief vogue, more for decorators' paints than for easel pictures. Of the pictures included in the catalogue, Scheele's green has been identified only in Manet's *Music in the Tuileries Gardens*, where it occurs with other pigments in a background glaze. By the late 1870s Scheele's green was hard to come by.

Scheele's green might have continued as part of the new range of artists' pigments had it not been for the invention in 1814 of a rival copper and arsenic-containing green. Schweinfurt green, named after the town in Germany where it was first produced, was a pigment that was to epitomise the revolution in painters' materials in the nineteenth century. It was clearly admired by the Impressionists for its strong, even lurid, hue. No other single green pigment approaches its intensity of tone, which is of a bright avocado colour, more powerful than the best types of malachite. The chemical composition is copper acetoarsenite ($Cu(CH_3COO)_2.3Cu(AsO_2)_2$), and its preparation, described in a paper of 1822 by Justus von Liebig, involved dissolving verdigris (basic copper acetate) in vinegar (acetic acid), and adding to the warmed solution a quantity of white arsenic (arsenic trioxide). A dull green compound precipitated first, which had to be recrystallised from vinegar to yield the brilliant-coloured pigment copper acetoarsenite, known in English as **emerald green**. It must have been available in France quite early, since the

Plate 23 Deep blue impasto in pure artificial ultramarine from the left edge of Pissarro's *The Côte des Boeufs* (Cat. no. 9). Thin cross-section by transmitted light. Magnification, 170×

Plate 24 Detail of the sky from Pissarro's *The Avenue, Sydenham* (Cat. no. 5)

Plate 25 Particles of Scheele's green (copper arsenite) by transmitted light. Magnification, 170×

preparation is recorded in full by Mérimée in 1830, who says it was sold under the names *vert de Vienne*, *vert de Brunswick* as well as *vert de Schweinfurt*.

By the time of the Impressionist painters, the green had come to be known as *vert Véronèse*, the term *vert émeraude* being reserved for a transparent form of chromium oxide green pigment, usually called viridian in English (see below under chromium pigments). True emerald green, in the form of the copper acetoarsenite pigment, was a surprising success, in spite of the disparagement of some commentators, including Vibert, and its poisonous nature. The attraction must have been its uniquely vibrant colour, sometimes seen in Impressionist outdoor painting of the highest key, and a hue virtually impossible to obtain with any straightforward pigment mixture. This was because strength and vividness of colour were seen to be inextricably bound to the use of unmixed pigment. Emerald green was a suitable foil for the other regularly used powerful hues of cobalt blue, ultramarine, chrome yellow, chrome orange, cobalt violet and vermilion.

Emerald green can be readily identified on paintings, and is also easily recognised under the microscope in paint samples. Its formation as a precipitate from aqueous solution yields bright green crystals of a characteristic globular form, which are also strongly birefracting (Plates 26 and 27). The survival, usually intact, of these regular spherulites in nineteenth-century paint samples indicates that the pigment was probably not ground in any way, but simply mixed with an oil medium before being loaded into tubes. The particle size is generally quite coarse in comparison with most nineteenth-century machine-ground pigments (Plate 28). A clearer view of the surprising structural detail of the 'spherical' particles of true emerald green is revealed in the scanning electron microscope (Fig. 39).

Copper acetoarsenite was not only supplied as an artists' pigment, but, since it was cheap to make, was also manufactured on a large scale (Fig. 38) for decorators' paints and particularly for printed wallpaper colours, combined with a binder of glue size. The toxicity of emerald green was sometimes quite dangerous in these

Plate 26 Particles of emerald green (copper acetoarsenite) by transmitted light. Magnification, 150×

Plate 27 Particles of emerald green under the microscope in polarised light. Magnification, 150×

Plate 28 Cross-section from pinkish-brown roof, right, in Pissarro's *The Côte des Boeufs* (Cat. no. 9), showing a large spherical particle of emerald green in the underlayer. By comparison the other pigments present are finely ground. Magnification, 330×

Fig. 39 SEM micrograph showing particles of emerald green (copper acetoarsenite). Gold-coated. Magnification, 2,030×

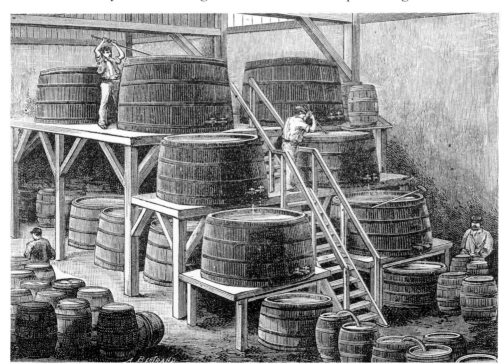

Fig. 38 Nineteenth-century methods for the manufacture of emerald green (copper acetoarsenite) on a large scale

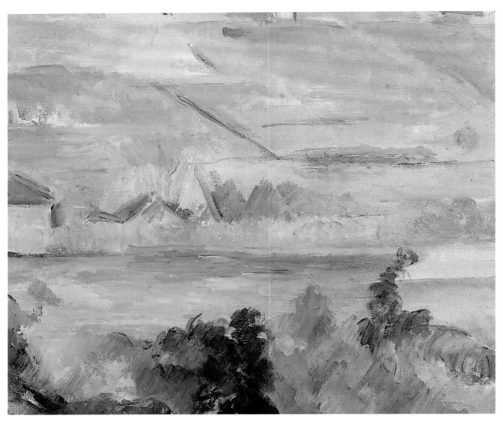

widespread applications: if allowed to become damp, the pigment will release a highly poisonous gas called arsine. The toxic effects of this phenomenon were well-known in the nineteenth century. However, when the pigment is protected in a dried oil or varnish film, this reaction is largely prevented and seems not to have worried easel painters working with *vert Véronèse*, that is, emerald green.

The characteristically bright colour of emerald green can be seen at its purest in the foreground impasto of Pissarro's *The Côte des Boeufs* (Cat. no. 9), and most particularly in Cézanne's *Hillside in Provence* (Cat. no. 15) where streaks and patches of the undiluted pigment form the brilliant green fields of the middle distance (Plate 29). Monet employs emerald green too, but he often subdues its colour by admixture with other pigments, as in *Bathers at La Grenouillère* (Cat. no. 2) and *The Gare Saint-Lazare* (Cat. no. 10). Monet's *Lavacourt under Snow* (Cat. no. 13) shows his application of emerald green in pure form. Emerald green occurs widely in the group of paintings discussed here, being used also in pictures by Manet (Cat. no. 1), Renoir (Cat. nos. 8 and 14) and Morisot (Cat. no. 12). There is microscopical evidence that in the paint used by Manet for *Music in the Tuileries Gardens* the emerald green had been ground during manufacture, the particles occurring as irregular shattered fragments, rather than as the more usual coarse globular grains.

A second green commonly found in Impressionist painting is a chromium oxide pigment called viridian, which is discussed further below.

Pigments Based on Chromium

Vauquelin's work on chromium chemistry published in 1809 is of some significance in colour history (Fig. 40). It followed the discovery in the Var region of France of mineral deposits of chromium in the form of iron chromate (chromite), which

Fig. 40. L. N. Vauquelin (1763–1829). Discoverer of metallic chromium, chrome yellow and other artists' pigments

60

provided a new source of the metal both for chemical investigation and for the production of colouring materials. As a consequence, Vauquelin's chemical research concentrated on the preparation of chromic oxide (Cr_2O_3) from purified chrome ore, and the synthesis from it of coloured chromate compounds. The applications for chromium were seen by Vauquelin to be principally as a colouring material for porcelain and enamel painting. He wrote that chromic oxide developed, after exposure to high temperature, 'un vert extrêmement beau, qu'on n'avoit jamais pu obtenir avec les autres métaux'. Green chromic oxide had already been used successfully by this time on Limoges pottery, but its application as an artists' pigment, now called opaque chromium oxide, seems not to have come until the 1840s, and it was probably not widely available until the 1860s.

Chromic oxide is a fairly dull mid-green colour, and although it is extremely stable, as its high temperature applications in ceramic glazes and enamelling suggest, its appeal to painters must have been limited. It has been identified, however, in Monet's *The Petit Bras* (Cat. no. 6), as an addition to colour mixtures in the browns of the foreground.

A second green oxide pigment, hydrated chromium (III) oxide ($Cr_2O_3.2H_2O$), called **viridian** in modern English, proved a great deal more versatile. The history of invention of genuine viridian is not entirely clear, but it appears to have been made first in the 1830s by a French colour-maker in Paris called Pannetier, who supplied the pigment at a high price but kept his method of preparation a secret. A synthesis of the pigment was patented in France by Guignet in 1859. Initially called Pannetier's green, then later Guignet's green, viridian came to be generally known in France as *vert émeraude*, a pigment quite distinct from the green known in English as emerald green (which is called in France, *vert Véronèse*; otherwise, copper acetoarsenite, see above).

Plate 30 Particles of viridian by transmitted light. Magnification, 170×

Hydrated chromium oxide green (viridian), like its anhydrous equivalent, is a very stable pigment in all painting techniques, but of a much more powerful deep cold green than the opaque chromic oxide. It is also a fairly transparent pigment, making it useful for glazing as well as mixing in tint (Plate 30). It is used as frequently as emerald green in the paintings in this catalogue; all of the pictures by Monet contain viridian: for the mixed greens of the boats in *Bathers at La Grenouillère*, for foliage in *The Petis Bras* and *Lavacourt under Snow*, for Madame Boudin's hat in *The Beach at Trouville*, and in conjunction with a wide range of other pigments in *The Gare Saint-Lazare*. Viridian is used by Pissarro for mixed light greens in the foreground of *The Avenue, Sydenham* (Cat. no. 5), while Sisley employs it undiluted in the deepest blue-green foreground parts of *The Watering Place at Marly-le-Roi* (Cat. no. 7). The bank of reeds in Renoir's *Boating on the Seine* (Cat. no. 11) is painted in pure viridian worked into an underlayer of chrome yellow; there it is the only green pigment used in the picture (Plate 31).

A number of samples examined for this study showed the combined use of emerald green (copper acetoarsenite) and viridian (transparent chromium oxide), but it is not clear whether these are instances of deliberate mixing by the artist. Examples are to be found in Pissarro (Cat. no. 5) and Cézanne (Cat. no. 15). It is likely that for manufactured tube paints small quantities of viridian were added to emerald green, or that mixtures purporting to be solely the more expensive transparent chromium oxide pigment were sold under the name *vert émeraude*. Many shades of green were advertised as tube-colours, and the confusion in terminology for these greens – and

Plate 31 Detail from Renoir's *Boating on the Seine* (Cat. no. 11) showing the use of viridian in the foreground bank of rushes

for other colours – in France and England no doubt permitted some laxity in the labelling.

The principal importance of chromium as a source for artists' pigments lay in the range of yellow and orange colours that could be produced as chromate salts. Of these, lead chromate provided a great variety of pigments that were treated as distinct colours. The archetypal form is called **chrome yellow**. Vauquelin described the precipitation of lead chromate from potassium chromate solution, and commented on the variation in colour that could be obtained according to the acidity or alkalinity of the solution and its temperature. He reported lead chromate precipitates forming as 'orange-yellow' from neutral solution, 'deep lemon yellow' in acidic conditions, and 'a yellowish red or sometimes a beautiful deep red' when excess alkali was present. The red and orange products are basic lead chromate ($PbCrO_4.Pb(OH)_2$), which came into use as distinct artists' pigments from the 1830s or 1840s under the names **chrome orange** and **chrome red** (Plate 32 and Fig. 41) (see also below). These were the first pure opaque orange pigments of strong colour intensity to become available to painters.

Chrome yellow (as lead chromate) came to be manufactured on a large scale because of its relative cheapness, its versatility as a pigment and the range of yellow shades that could be made. Production began in the second decade of the nineteenth century in France, England and the United States. Apart from the number of shades of chrome yellow that naturally result from varying the conditions of precipitation, it was found that the pigment could be further modified in colour and working properties by co-precipitation with lead sulphate to form solid solutions of any calculated composition, yielding an even greater variety of dense primrose-coloured products. Since lead chromate has a high tinting strength, it could also be extended in manufactured paint by the incorporation of white inerts such as barium sulphate, calcium sulphate and china clay, which also improved the working properties of the paste. The nineteenth-century colour houses offered a considerable range of types of chrome yellows, as well as several other forms of chromate yellow. An even greater number of names for these yellows also seem to have been in circulation.

Pure lead chromate will precipitate in two crystalline varieties, one of which, a monoclinic form, is sometimes just resolvable under the optical microscope as fine needles in nineteenth-century paint samples (Plate 33). The structure of the pigment particles is seen more clearly in the SEM (Fig. 42). The great variety of chrome yellows that may have been used make their precise identification in paint samples difficult. Characterisation of these pigments is now achieved by a combination of optical microscopy, scanning electron microscopy (SEM), elemental analysis (LMA or EDX) and crystallographic identification by X-ray diffraction (XRD). These techniques have been applied recently to the analysis of chrome yellow samples from van Gogh's *A Cornfield, with Cypresses* of 1889 (London, National Gallery), where the paint of the 'cornfield' ranges from a deep brownish yellow to a light straw colour, and reveals something of the large choice of chrome pigments available by that time.

The performance of chrome yellow was much discussed in nineteenth-century treatises and manuals of painting, but the conclusion was usually that it was not among the most stable of colours. Monet spoke late in his life of 'dreadful chromes', referring to their tendency either to fade or to discolour in polluted sulphurous atmospheres. The situation was confused by a profusion of names for chromate pigments, including those described as '**lemon yellows**'. These sometimes contained

Plate 32 Detail from Manet's *Music in the Tuileries Gardens* (Cat. no. 1) showing the use of chrome orange in the woman's bonnet

Fig. 41 SEM micrograph showing particles of chrome orange. Gold-coated. Magnification, 3,150×

Plate 33 Detail of a cross-section from Pissarro's *The Côte des Boeufs* (Cat. no. 9) showing the needle-like form of chrome yellow (lead chromate) pigment. Magnification, 410×. See also Fig. 42

lead chromate, but were also made from more stable alkaline earth chromates, particularly those of barium and strontium, but also of calcium. The preparation of barium chromate had been described by Vauquelin in 1809, and it was being made as an artists' pigment by the middle of the century. The chromates of both barium and strontium were usually sold under the name 'lemon yellow'; the barium pigment was sometimes misleadingly also called *outremer jaune* (ultramarine yellow). Although much weaker in both tinting strength and covering power than actual chrome yellow (lead chromate), the attraction of the alkaline earth chromates as pigments was their greater permanence and resistance to blackening. Barium chromate (see Plate 34 and Fig. 43) was judged to be particularly stable. For similar reasons a complex chromate of zinc and potassium (**zinc yellow**) was developed as an artists' oil colour, becoming widely available from the 1850s. Zinc yellow has been identified in the early stage of Renoir's *Umbrellas* (Cat. no. 14).

Fig. 42 SEM micrograph showing particles of chrome yellow (lead chromate). Gold-coated. Magnification, 6,730×

Chromate pigments were very widely used in French nineteenth-century painting. A particularly clear case is Renoir's *Boating on the Seine* (Cat. no. 11) in which the skiff is painted in a mixture of chrome yellow (lead chromate) and strontium chromate, giving the range from brownish yellow to a much brighter yellow, while the gunwale is outlined in chrome orange (basic lead chromate). The broken reflections of the skiff in the water are clearly also painted in the same pigments. *At the Theatre* (Cat. no. 8) contains both lead and barium chromate pigments in the yellow paint of the theatre setting, so too does the background foliage paint in Monet's *Bathers at La Grenouillère* (Cat. no. 2). Chrome yellows are used in Sisley's *Watering Place* (Cat. no. 7) and for mixed greens both in Pissarro's *The Avenue, Sydenham* and *The Côte des Boeufs* (Cat. nos. 5 and 9) as well as in Monet's *The Petit Bras* (Cat. no. 6). Chrome orange forms the brightly coloured bonnet of one of the women standing in the crowd to the right in Manet's *Music in the Tuileries Gardens* (Cat. no. 1; see Plate 32).

Plate 34 Particles of barium chromate ('lemon yellow') by transmitted light. Magnification, 170×

Chromates were also incorporated into manufactured pigment mixtures, particularly in combination with Prussian blue, to make strident greens, sold under the names of **chrome green** or cinnabar green. The manufacturing process produced pigment combinations of such fine particle size and intimate mixture that the individual grains of yellow and blue cannot be resolved under the optical microscope, and chrome green gives the appearance of a single pigment. Monet made use of this manufactured mixture of Prussian blue and lead chromate yellow for some of the brighter yellow-green foliage in *Bathers at La Grenouillère* (see Plate 37).

Fig. 43 SEM micrograph showing particles of barium chromate ('lemon yellow'). Gold-coated. Magnification, 892×

There is evidence that by the 1880s painters were more cautious in their use of chrome yellow pigments, and adopted instead pigments of greater durability, particularly Naples yellow (see below) and the cadmium colours. Renoir habitually used Naples yellow in the 1880s, and in Monet's later paintings a variety of cadmium-containing pigments have been identified.

Cadmium Colours

During the 1870s the Impressionists seem to have relied mainly on chromate pigments for their yellows, although alternative bright yellow and orange types of cadmium sulphide pigment had been available from the mid-1840s. The new metal cadmium had been discovered by F. Stromeyer in 1817 while working on the by-products of a zinc smelter at Salzgitter in Germany. (Cadmium often occurs with zinc ore in nature.) Stromeyer prepared the dense yellow- and orange-coloured sulphides

of cadmium, and also recommended their use as artists' pigments. However, the scarcity of metallic cadmium limited the scale of production until this century; today **cadmium colours** are manufactured as artists' pigments in quantity. The technical literature on painting from early in the nineteenth century records many endorsements of cadmium pigments; Vibert's book, for example, recommends cadmium yellow particularly as a durable yellow, and mentions also yellow earths, either natural or synthetic, and strontium chromate ('lemon yellow') as stable.

The high cost of cadmium yellow and cadmium orange pigments must have precluded their widespread use in the 1870s; in France the colour-makers had invested in chrome yellow production, cadmium colours being more readily available in Germany and in England. Few applications of cadmium-containing pigments were found during the examination of paintings in the catalogue, although cadmium yellow is reported to have been used by Monet for the painting he made in 1873 of his house at Argenteuil (Art Institute of Chicago). Later paintings by Monet, including those analysed at the National Gallery, show the consistent use of cadmium colours in preference to chromate yellows. *Lavacourt under Snow* (Cat. no. 13) of 1879 is the earliest example of a National Gallery picture by Monet so far examined containing cadmium (see Plate 19). Interestingly, cadmium yellow has been identified both in Morisot's *Summer's Day* (Cat. no. 12) of 1879 and in Manet's *The Waitress* (London, National Gallery) of 1878, at a time when their choice of painting materials would have influenced one another (see pages 180–1). *The Waitress* also contained Naples yellow (lead antimonate, see below) and chrome yellow pigments.

Pure Mauve Pigments

Until the appearance in 1859 of the first opaque pure mauve-coloured pigment, **cobalt violet**, painters had always relied on pigment mixtures to make purple and violet. Cobalt violet (Plate 35), as it was first manufactured in France, was either the phosphate or the arsenate of cobalt ($Co_3(PO_4)_2$ or $Co_3(AsO_4)_2$); or sometimes a mixture of both compounds. In 1868, a second new violet pigment was invented in Germany, in the form of manganese violet (Nurnberg violet), which is chemically manganese ammonium phosphate. Neither the cobalt nor the manganese pigments is particularly high in tinting strength or covering power, but they provided the strongest mauve colours without recourse to pigment mixtures. As in the case of emerald green, it is difficult to duplicate the forcefulness of these pigments by combinations of colour; the use of a single powerful pigment is much more straightforward.

Plate 35 Particles of cobalt violet (cobalt phosphate) by transmitted light. Magnification, 170×

Monet's liking for the intense purple shadows cast by strong sunlight could not easily have been achieved without the new opaque pure violet pigments, although these materials were not widely used in the 1870s. Unusually, cobalt violet seems to have been on Monet's palette as early as 1869, for *Bathers at La Grenouillère*. All the other pictures examined from the 1870s make use of pigment mixtures to achieve the stronger mauves and purples, particularly mixtures of red lake pigment and white with cobalt blue, as in Renoir's *At the Theatre* (Cat. no. 8) and in the early stages of *The Umbrellas* (Cat. no. 14), or with French ultramarine, in its later reworking.

Zinc White versus Lead White

An early manufactured pigment, lead white, with the composition of a basic carbonate of lead ($2PbCO_3.Pb(OH)_2$), had always quite satisfactorily met the need of

painters for a dense white whether they painted in tempera or in oil. There was no compelling reason, as far as easel-painting practice was concerned, to find a replacement for this lead pigment as the standard white in oil. However, towards the end of the eighteenth century the public health authorities in France had become concerned about the toxicity of lead white, the risk being not so much to painters of easel pictures, but to the workers in the manufacturing industry. Lead white was made in great quantity (Fig. 44), the bulk of the pigment forming the basis of decorators' paints. The production process, and particularly scraping the pigment from the metallic lead from which it was made, and grinding it, was a considerable health hazard.

The French chemist Guyton de Morveau, working in Dijon, had been commissioned to survey available white pigments and inerts that could possibly replace poisonous lead white for house painting. He reported in 1782 his conclusion that **zinc white** (zinc oxide, ZnO) offered the best alternative. This white compound was already being manufactured and supplied as a pigment by Courtois, the laboratory demonstrator at the Dijon Academy, who had shown that zinc white, unlike lead white, was immune from blackening in the presence of sulphurous gases. Courtois set up retail outlets for his new white pigment, first locally and later in Paris. The non-darkening quality of zinc white was a great advantage for painting in aqueous media such as watercolour, in which, generally, lead white will eventually discolour. The disadvantages of zinc oxide as a universal white pigment were its relatively poor covering power, its higher cost (roughly four times that of lead white at the beginning of the nineteenth century) and, most seriously, its significantly poorer drying performance in oil medium. Courtois had tried to rectify this defect by introducing zinc sulphate into the paint as a drier, with only partial success. The technology gradually improved, and the invention of the new white was to stimulate a debate as to the relative merits of lead white and zinc white for painting that was to continue on and off in France throughout the nineteenth century. Surprisingly, it involved the judgements of the leading chemists of the time, including Fourcroy, Berthollet and Vauquelin.

Most vocal in this debate was E. C. Leclaire who, between 1835 and 1844, mounted a vigorous public campaign in favour of zinc white, and later proved his point by demonstrating the sound performance of the pigment in the painting of more than 2000 houses and public buildings. In conjunction with a chemist named Barruel, Leclaire had also shown that the poor-drying characteristic of zinc white could be overcome for oil paints by treating the linseed oil medium with driers such as litharge (lead monoxide) or pyrolusite (manganese dioxide). By 1849 Leclaire was manufacturing these improved zinc white oil paints near Paris, receiving a gold medal from the Société d'Encouragement for his efforts. The first decree interdicting lead white was issued in August 1849 by the Minister of Public Works. By 1909, the use of lead white in any paintwork for buildings was proscribed in France; similar legislation soon followed in a number of European countries.

After Leclaire's improvements in production methods the cost of zinc white as a pigment fell. By 1876, Lefranc's catalogue was listing *blanc de zinc* as a tube-colour at the same price as the cheapest form of lead white. None the less, lead white seems to have continued as the principal white pigment for easel-painting; presumably its poisonous nature represented little real risk to painters using ready-made tubes of paint. The qualities of lead white were well known, and artists were not to be

Fig. 44 French nineteenth-century scraping mill to collect flake white (lead white pigment) from metallic lead

persuaded that a traditional pigment should be cast out in favour of a newer, less suitable, introduction. The objection was not only to the variable drying performance of zinc white, but also to its lesser opacity and its colder, flatter tone. There were, of course, exceptions. Van Gogh is known to have used large quantities of zinc white, frequently writing to his brother Theo for extra supplies.

Analysis of samples from the paintings recorded here show that zinc white was indeed not the usual choice of Impressionist painters, although some of the paints have been shown to contain zinc in more than trace quantities. Of samples examined by analysis, only Pissarro's *The Côte des Boeufs* (Cat. no. 9) contained zinc oxide in the whites, but in conjunction with a greater proportion of basic lead carbonate (lead white). This is most likely to be a paint manufacturer's mixture; there would be no reason for Pissarro himself to combine the two pigments, and artists' tube-paints consisting of several white pigments and inerts were marketed in the second half of the nineteenth century.

The detection of zinc in a variety of coloured samples from Impressionist pictures suggests that zinc white had a more important role as a lightening agent to adjust tone and opacity in *couleurs fines* than it had as a pure white. Since a number of the coloured pigments with which zinc white was combined in tube-paint formulations were good driers in their own right, the main defect of zinc oxide in these applications was nullified. In comparison with lead white, the lesser density and more neutral tone were advantages for manufactured mixtures. Pissarro's *The Avenue, Sydenham* (Cat. no. 5), for example, has a high proportion of zinc in the light greens, which contain emerald green as the principal colouring agent (Plate 36). It is interesting to note that Pissarro went to some trouble to order zinc-white-based tube-colours from Contet, his colour supplier in the 1880s (see page 41). Similarly, zinc has been detected at high levels in samples of orange-red (chrome orange), dull red (vermilion) and green (Scheele's green and emerald green) from Manet's *Music in the Tuileries Gardens* (Cat. no. 1), while the white paint in the picture has been shown by analysis to be pure lead white.

Lead white, under various and sometimes misleading names, was available to artists in a number of grades of quality. Between 1855 and 1883, Lefranc's catalogues of artists' materials list three qualities of lead white under the names *blanc d'argent*, *blanc de céruse* and *blanc de plomb*, in order of decreasing price. All contained basic lead carbonate, the so-called 'silver white' being sold as the highest quality and purest pigment for oil painting. Unground dry flake white (*blanc de plomb en écailles*) was also available wholesale.

Until the early years of the nineteenth century, lead white had been made industrially in several European countries by a process perfected in Holland in the seventeenth century. Dutch- or stack-process flake white (*schulpwit*) was famous for its purity and was widely exported. Essentially, the method involved exposing a 'stack' of lead strips or buckles to the chemical action of acetic acid (vinegar) vapour in the presence of carbon dioxide; the reaction taking place in a closed chamber. A white corrosion crust of basic lead carbonate develops on the metal's surface. A cheaper form known as *lootwit* was also made in Holland, either of lesser purity or a mixture of lead white deliberately extended with powdered chalk. This material was equivalent to the white supplied as *céruse* in France, and recommended for house-painting and for the grounds of pictures on canvas, although *céruse* could also mean plain lead white, perhaps not of the best quality. Analysis of the white ground layers

Plate 36 Mixed light green based on a tint of zinc white with emerald green, viridian and other pigments. Detail from Pissarro's *The Avenue, Sydenham* (Cat. no. 5)

of the commercially prepared canvases used by the Impressionists has shown that chalk (calcium carbonate) was a common extender for the lead white in this application (see also page 48). Barium sulphate appears also to have been mixed with lead white as the priming material for canvases, for example in Monet's *Bathers at La Grenouillère* (Cat. no. 2) and Cézanne's *Hillside in Provence* (Cat. no. 15).

As with many other cases of pigment manufacture, French industry was keen to displace foreign imports of lead white. One imported source was Austrian lead white, properly called *blanc de Krems* after its place of origin. This form, also described as Vienna white, and commonly, although mistakenly, termed Cremnitz white (Cremnitz is in Hungary), had a high reputation among painters for its purity and stability.

Krems white was made using an improved design of the Dutch stack process which was later adopted in France at a large factory set up in Clichy. By 1839 the manufactury in Krems had closed, presumably because it was unable to compete with more modern production methods. Again it had been the Société d'Encourage-ment pour l'Industrie Nationale that had promoted the production of an improved pigment in France, awarding a prize in 1809 for a method capable of matching the quality of the lead white from Krems. Another French innovation followed, with the invention of a fast wet-process for forming basic lead carbonate, which involved bubbling carbon dioxide into a suspension of lead oxide in distilled vinegar. The production costs of this method were considerably lower, and it was less hazardous than the stack process.

There is no doubt that, for easel-painting, lead white pigment in the traditional form of artificial basic lead carbonate was the consistent choice of the Impressionists. This is confirmed by the analysis of samples of pure white paint from Impressionist pictures using X-ray powder diffraction analysis, which provides unambiguous identification of the pigment and will also detect any co-mixed materials, provided that they are crystalline, as are most of the common extenders. As with Manet's *Music in the Tuileries*, lead white, neither extended nor combined with other white materials, has been confirmed in pictures by Monet, Renoir, Sisley, Pissarro and Morisot. Examination in the scanning electron microscope of the detailed particle form of the lead white used has shown that, in general, the pigment appears to be of the stack-process type, rather than that produced by wet precipitation.

Traditional Pigments in Impressionism

Lead white was a clear survivor as a staple material for easel-painting throughout the nineteenth century, and certain other long-established pigments continued to be regularly used. There was no technical reason to replace perfectly satisfactory artists' pigments with newer introductions, except where the costs of raw materials or manufacture were regarded as excessively high. Counterposed to this was the pressure of technical innovation and of commercial competition.

Vermilion

Among the traditional coloured pigments, perhaps most noticeable in Impressionist painting is the bright opaque red of **vermilion** (mercuric sulphide, HgS). Vermilion is a pigment of extremely powerful tone and of great density, and was widely available from French colour suppliers as an artists' oil paint throughout the nineteenth century. The only red to compete with vermilion did not appear until after the

publication of a German patent in 1892 for cadmium red (cadmium sulpho-selenide). This new pigment, chemically related to the cadmium yellows and oranges (see above), was probably not in full commercial production until about 1910, and even after this time did not rapidly displace vermilion as a favoured artists' and decorators' colour. Vermilion frequently figures in Impressionist palettes, and its intense red colour and usually sound performance in oil paint made it an essential pigment. There were, however, certain technical problems in producing tube-colours of vermilion in oil that would not separate, and attempts were sometimes made by the manufacturers to improve the wetting of the pigment particles by the medium with additives such as wax and non-drying oils, to support the structure of the prepared paint or to act as plasticisers.

Vermilion was available as *couleurs fines* in several varieties. In its earliest forms, vermilion pigment was made by grinding mineral cinnabar (natural mercuric sulphide); or, as an artificial equivalent, by combining mercury and sulphur directly, then subliming the product (dry-process or Chinese vermilion). A wet process to make red mercuric sulphide was invented in Germany in the late seventeenth century, and became the main method of preparation for the pigment during the nineteenth century, since it was a cheaper and easier process than the dry, sublimation method. Wet-process vermilion is usually known as English or German vermilion. Its other advantage was that it could be made in a variety of shades, from a bright scarlet to a strong dark orange, whereas the dry-process product was less versatile in colour. Wet-process vermilion was also sometimes further chemically processed to modify its tone.

The chemical composition of natural cinnabar and of the dry- and wet-process vermilions is identical, and their distinction in paint samples at present has therefore to rely on detailed examination of the pigment particle morphology in the scanning electron microscope. No full survey has been carried out for nineteenth-century paintings, but study of samples from Monet's *Bathers at La Grenouillère* (Cat. no. 2) of 1869 and van Gogh's *A Cornfield, with Cypresses* (London, National Gallery) of 1889 indicates that these painters had bought paints containing wet-process vermilion (see Fig. 45).

French colour suppliers' catalogues published during the Impressionist period, for example those of Lefranc and Bourgeois, offer *cinabre* as well as vermilions described as *anglais*, *de Chine* and *français*. It is not clear of what type the last variety is, but the price of each kind was roughly equivalent. *Vermillon anglais* was probably the wet-process product.

Vermilion is used in a number of the paintings illustrated in the catalogue. Sometimes it occurs in tint, as in the flesh paint of Renoir's *At the Theatre* (Cat. no. 8) and the rose tones of Monet's *Lavacourt under Snow* (Cat. no. 13), or to produce muted lilacs in mixtures, for example in Cézanne's *Hillside in Provence* (Cat. no. 15). Vermilion is used at full strength in the scarlet flowers and the figures to the left in *Bathers at La Grenouillère* (Plate 37) and for the brighter red highlights in Pissarro's *The Côte des Boeufs* (Cat. no. 9).

Fig. 45 SEM micrograph of wet-process synthetic vermilion from Monet's *Bather's at La Grenouillère* (Cat. no. 2). Gold-coated. Magnification, 12,000×

Naples Yellow

Studies of paintings from the 1870s suggest that the principal opaque yellows used were most frequently based on chromate pigments, usually chrome yellow (lead chromate, see above). Another lead-based yellow pigment, in which the second

essential component is combined antimony, had been used in France in the eighteenth century for oil painting, although its origin was probably in a seventeenth-century technology for ceramic glazes. This was a pigment called **Naples yellow** (lead antimonate), but the name has also been applied as a description of colour rather than restricted to a pigment based on lead and antimony. The genuine antimonal yellow pigment was highly variable in composition and in colour quality: usually it was gritty in texture and difficult to grind. Many painting treatises warned of its impermanence and incompatability with other pigments. Examples of true Naples yellow in French painting of the eighteenth and early nineteenth centuries show the pigment generally lacking in strength of colour and often with a distinctive pinkish or brownish-orange tinge. From time to time better types were produced. The introduction of chrome yellows, and to some extent cadmium yellows, tended to displace Naples yellow as the choice for the opaque strongly coloured hues required for easel-painting.

At the Exposition Universelle of 1878, the colour manufacturers and suppliers Lefranc announced their adoption of a new process to make improved lead antimonate yellows, based on methods used at a factory in Marseille for colouring ceramics. Lefranc had been selling a tube-colour listed as *jaune d'antimoine* for some time, and, confusingly, another they described as *jaune de Naples*. Their new product probably signals a change in the acceptability of lead antimonate yellow as an artists' pigment, presumably because its purity and strength of colour had been improved. In later catalogues both *jaune d'antimoine* and *jaune de Naples* are still listed as separate colours, the antimony pigment being twice as expensive. The colour called Naples yellow is almost certainly a mixture of pigments, based on a yellow such as lead chromate, mixed with lead or zinc whites, and the hue adjusted with small amounts of ochre, vermilion and so on. Similar mixtures labelled Naples yellow have been identified in nineteenth-century colour boxes at the National Gallery.

From the survey here, lead antimonate does not seem to have been much used in the 1870s, although it does occur, with other yellows, in Manet's *The Waitress*

(London, National Gallery) of 1878. Renoir is known to have abandoned chrome yellows in favour of Naples yellow in the 1880s, while Monet replaced chromes with cadmium. Interestingly, Renoir's extended treatment of *The Umbrellas*, over roughly five years in the early 1880s, shows this shift in palette very clearly: the early parts of the composition contain zinc yellow (zinc potassium chromate), while in the later reworking Renoir uses genuine Naples yellow. Rather earlier, in 1862, Manet makes use of a mixed yellow containing zinc white, chrome yellow and earth pigment for the primrose-coloured bonnet of one of the women in the crowd in *Music in the Tuileries* (Plate 38). This is probably a manufacturer's formulation of a tube-colour that is likely, at the time, to have been called *jaune de Naples*.

Lake Pigments

The traditional function for lakes in oil painting had been as glazing pigments to modify and add depth of colour to a paint layer beneath, which would usually have been allowed to dry before the glaze was applied. This technique was not appropriate in the purer form of the Impressionist painting method, since the deliberation involved ran counter to the intent. However, lake pigments, particularly reds, are commonly found in Impressionist pictures and were clearly a standard part of the palette. Notes made by Monet, Renoir and Pissarro of their pigment selections or orders confirm this.

The striking intensity and colour saturation of **red lake pigments** made them attractive to the Impressionists. They used them to mix light clear rose or mauve colours as tints with white and blue; at full strength to produce heightened colour contrasts when set next to powerful blues, greens and oranges; and for mixtures of relatively translucent colour where a strong red was required, but where opaque vermilion would have made the combination too dense.

Red lake pigments were available in a great many varieties and shades of colour. In the process of making lakes, which involved co-precipitating a coloured dyestuff on to an inorganic base material (the lake substrate), there were a number of factors that could influence the precise colour of the product. There was a choice of red dyestuffs; there was a range of suitable substrates; and the chemistry and conditions of precipitation could be controlled. Each of these factors could affect the hue obtained in the finished lake, and a considerable range, from pure fiery reds to deep purple-reds, was manufactured. A lake pigment could also be gently charred to produce browner-toned reds, as in *laque de garance brûlée* (burnt madder).

In the 1870s when Lefranc carried four types of vermilion as artists' colours, they were also offering nearly thirty types of red lake in oil. It is difficult to be sure of the identity of all of these translucent reds, since some of the names under which they were sold did not indicate their content, for example *laques de Smyrne* and *laques de Robert*. The first are certainly madder lakes, the second, probably so. The commonly found terms *laque de garance* (madder lake) and *laque carminée* (carmine [crimson] or cochineal lake) were clearer descriptions of their composition. The evidence from the paint technology literature of the period indicates that madder, its extracts and cochineal were the principal sources of red dyestuffs for artists' pigments, but from the late 1870s certain synthetic red dyestuffs were also employed in lake pigment manufacture.

Red lakes of varying colours have been identified in a number of the paintings illustrated in the catalogue. They are often seen as translucent deep red flakes in paint

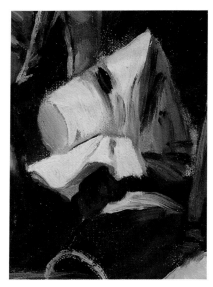

Plate 38 Detail showing the use of a mixed 'Naples yellow' shade from Manet's *Music in the Tuileries Gardens* (Cat. no. 1)

samples and cross-sections. Analysis of the red dyestuffs these lakes contain remains difficult, but with certain exceptions, the substrates have been shown by analysis usually to be hydrated alumina and sometimes calcareous. A mixed substrate containing both aluminium and tin oxides has also been identified (in Monet's *Gare Saint-Lazare*), but this seems to be a special case.

Renoir employed a deep red lake with cobalt blue to make violet-toned shadows in *At the Theatre* (Cat. no. 8), and an intense purplish carmine colour to contrast with the cobalt blue of the river in *Boating on the Seine* (Cat. no. 11). The combination of red lake pigment with cobalt blue occurs in the early stages of the painting of *The Umbrellas* (Cat. no. 14) and with French ultramarine in the later stages. Quantities of brownish-red flakes of lake pigment are found in the warm mixed browns of Pissarro's *The Côte des Boeufs* (Cat. no. 9). Monet's *Gare Saint-Lazare* (Cat. no. 10) is rich in a synthetic red lake added to the translucent darks, while in *Lavacourt under Snow* (Cat. no. 13) a deep carmine colour is used both pure and combined with other pigments in the group of trees beyond the snowfield (Plate 39).

Plate 39 Cross-section showing Monet's use of red lake pigment in *Lavacourt under Snow* (Cat. no. 13). Magnification, 280×

Earth Pigments and Black

Since colour of a high key is a fundamental part of Impressionist painting, it might be thought that the duller earth colours – represented by the broad categories of pigment called ochres, siennas and umbers – could have no part in their design. From the pictures surveyed here, it can be said that **earth pigments** were used with discretion by Impressionist painters. Their attitude is perhaps summed up by Renoir, who remarked in a note of his palette from his Impressionist phase: 'yellow ochre, Naples yellow and raw sienna are intermediate tones only, and can be omitted since their equivalents can be made with other colours.' Monet mixed even the dullest of reds, browns and yellows from elaborate combinations of colourful high-key pigment. Examples can be found in all his paintings illustrated in the catalogue, with the exception of the early *Beach at Trouville* (Cat. no. 3) in which earth pigments are used, but even here they are modified with more strongly coloured additions (Plate 40).

Recorded Impressionist palettes often do include at least one earth colour. Most commonly specified among the natural earths are: *ocre jaune* (yellow ochre), *ocre de ru* (a brown ochre), *terre de Sienne naturelle* (raw sienna), *terre de Sienne brûlée* (burnt sienna), *brun-rouge* (a burnt natural ochre). Others, including manufactured iron oxide pigments (Mars colours), such as *orange de Mars* are also mentioned. Sampling and analysis have shown that over half the pictures in the catalogue contain at least one earth pigment, but usually in some subsidiary role. The analytical evidence also points to the predominance of natural earth pigments over their synthetic counterparts. Some of the uses the Impressionists made of earth colours are mentioned in the catalogue entries.

Plate 40 Top surface of an unmounted fragment of paint from the cushion on the foreground chair in Monet's *The Beach at Trouville* (Cat. no. 3), showing the addition of cobalt blue and other pigments to an earth colour. Magnification, 150×

The possible role for a black pigment was even more controversial (see page 90). There are very dark, seemingly black, parts in several of the pictures in the catalogue, so sampling has been used to determine whether these contain genuine black pigment, or rather are very dark colour mixtures.

It has been shown that a common technique in Impressionist painting was to construct 'optical' darks, particularly greys, from pigment mixtures, where the role of a black pigment is taken by French ultramarine. This occurs, for example, in Monet's *The Beach at Trouville* and in a more elaborate way in *The Gare Saint-Lazare*. It is also used in both of Pissarro's London scenes, *The Avenue, Sydenham* and *Fox Hill, Upper*

Norwood, and in Cézanne's *Hillside in Provence*. Monet's *Gare Saint-Lazare* has a strongly dark tonality in the locomotives and station interior, but the paint is virtually devoid of black pigment. Madame Boudin's uncompromisingly black dress and parasol in *The Beach at Trouville* contain a good deal of **ivory black** pigment, but, consistent with the development of Impressionist thinking, it is modified by the addition of colour. In the same way, the two tiny figures on the river bank in Monet's *The Petit Bras of the Seine* are painted in ivory black mixed with chrome yellow and a little vermilion, but appear in the picture to have been painted with pure black paint (Plate 41). Obviously Manet could hardly avoid using a good deal of black pigment for the dark clothes of the crowd in *Music in the Tuileries*, but even there some cobalt blue seems to have been incorporated to adjust the tone of the black paint. On the other hand, Renoir was content to use pure ivory black, unmodified by any coloured pigment, in the underlayers for *At the Theatre*, so too was Morisot in her *Summer's Day*.

The identification of black pigments in paint samples is often difficult: most are derived from some source of carbon, often a pyrolysed vegetable product, for example *noire de bougie* (refined lampblack), *noire de pêche* (charred peachstone black) and *noire de vigne* (charred vine-twig black). These are generally not microscopically distinguishable. However, the artists' black pigment called *noir d'ivoire* (ivory black; also *noir d'os*, bone black) is fundamentally different in constitution, and amenable to identification by analysis. As its names suggest, it was prepared by charring waste ivory or bone, both of which contain principally calcium phosphate. The pigment is composed of carbon and residual calcium phosphate, which can be detected from the presence of calcium and phosphorus in suitable samples of black. *Noire d'ivoire*, as it was most generally known, has been confirmed by analysis as overwhelmingly the most commonly used black pigment in Impressionist painting. But in Renoir's *Boating on the Seine* and Monet's *Lavacourt under Snow*, probably the purest forms of Impressionism in its technical meaning, no black of any kind is used, instead the pictures vibrate with powerful spectral colours.

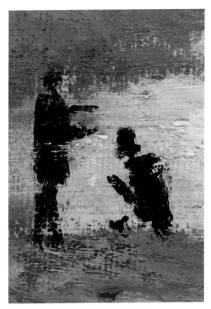

Plate 41. Detail from Monet's *The Petit Bras of the Seine at Argenteuil* (Cat. no. 6)

Impressionist Paint Media

The survey presented in the table on pages 74–5 lists the drying oils found in samples taken from the Impressionist paintings discussed in this catalogue. The varied findings fully reflect the variety of oil painting media offered by artists' colourmen at the time. The term 'drying oil' refers to an oil expressed from vegetable sources which has the potential to become semi-solid by the joining together (polymerisation) of the individual molecular units of which it is composed. Traditionally such oils were

linseed oil, favoured by Northern European painters for many centuries; walnut oil – 'nut oil', much used in Italy in earlier centuries, but gradually replaced by the better drying linseed oil; poppy oil, so far only identified in some eighteenth-century British and nineteenth-century French paintings. This last is the poorest drier but has the benefit of yellowing least of all three oil types. Walnut oil has properties and some compositional features (used for analytical identification) in between linseed and poppy oils.

A number of the works presented here contain poppy oil; moreover, some contain poppy oil with some colours and linseed with others. Clearly, mixtures of such paints would lead to the presence of a mixture of the two oils in any sample taken for analysis. In identifying the source of the medium, the presence of a mixture of linseed with poppy oil in the same sample could lead the analyst to conclude, wrongly, that walnut oil had been used, rather than a mixture. This is because the relative amounts of principal components present in walnut oil, used as an indicator during analysis, are intermediate in value between those for linseed and poppy oils. In general, where poppy oil has been employed in certain areas and linseed oil in others, areas which give an analysis corresponding with walnut oil have been cautiously interpreted as 'poppy + linseed oil mixture'. It is a reasonable first assumption that those pictures with samples consistently indicating the presence of walnut oil, or walnut oil with only one of the other oils, are less likely to contain mixtures of linseed and poppy, and in these cases the results obtained have been attributed to the presence of walnut oil rather than mixtures.

Technically it was more difficult to express the oil from poppy and linseed than from walnut. With the advent of mechanical and solvent methods of extraction in the nineteenth century, the differences in the cost and effort of production for the three oils ceased to be of any consequence. However, consideration of the relative pricing of the three commodities as shown in catalogues produced by artists' colourmen can be quite instructive. Lefranc's catalogue for 1883, for example, shows that poppy, linseed and drying oils (that is, linseed oil heated with a lead drier) were at the low end of the price range – namely, 2.40 francs per kilogram. Processing these oils by decolourising nearly doubled the price to 4 francs per kilogram. This is also the price for nut oil, which probably reflects its rarity value rather than high production costs. This price differential is also demonstrated in the Lefranc catalogue for 1876. Prices per kilogram were 3.20 francs for *huile grasse* (thickened linseed oil with enhanced drying properties) and 3 francs for *huile d'oeillette* (poppy oil), whereas *huile de noix* (walnut oil) was substantially more expensive at 5 francs per kilogram.

Summarising the table, we may say that, for all samples of paint examined, instances of poppy, walnut – including the poppy + linseed mixture – and linseed oils are represented in almost equal proportions. On the other hand, samples taken from grounds mostly contain linseed oil, the better and quicker dryer. Despite the number of *Brevets d'Invention* (patents) appearing at this period, in which additives to improve the properties of the basic oil formulation featured, only nine samples appear to contain additives. The presence of resin, possibly in the form of a metal salt, has been reported by Delbourgo and Rioux in a sample of paint taken from one of Monet's Rouen Cathedral series of paintings, dating from 1892–4. The table shows that resin has been detected in samples from Morisot's *Summer's Day* (Cat. no. 12), Renoir's *At the Theatre* (Cat. no. 8) and Monet's *Lavacourt under Snow* (Cat. no. 13), all dating from the late 1870s. It has not been possible to identify the resin in all cases, nor to say in

Table
A survey of Impressionists' paint media

Artist	Picture	Date	Sample	Medium
Edouard Manet	*Music in the Tuileries Gardens* [1]	1862	1. Ground 2. Pale blue of sky, top edge 3. Black of shoe, left-hand man 4. Green of trees, right-hand edge 5. White of dress, kneeling girl, centre 6. Brown of earth, bottom edge	Linseed oil Poppy + linseed oil mixture Poppy + linseed oil mixture Linseed oil Poppy oil Poppy (predominantly) + linseed oil mixture)
Claude Monet	*Bathers at La Grenouillère* [2]	1869	1. Ground, left-hand edge 2. Green foliage, right-hand side 3. Green foliage, upper left-hand side 4. White impasto, highlight of wave	Linseed oil Poppy oil Poppy oil Poppy oil
Claude Monet	*The Beach at Trouville* [3]	1870	1. Ground 2. White impasto by knee of woman in blue 3. Black dress, right-hand figure 4. Grey-blue sky	Linseed oil Poppy oil Linseed oil Poppy + linseed oil mixture
Camille Pissarro	*Fox Hill, Upper Norwood* [4]	1870	1. Ground 2. White paint of sky 3. Blue paint of sky 4. Dark green, bottom edge	Walnut oil Poppy oil Walnut oil Walnut oil
Camille Pissarro	*The Avenue, Sydenham* [5]	1871	1. White cloud 2. Pale blue of sky 3. Dark green of grass 4. Greyish-brown paint, left-hand edge	Poppy oil Poppy oil Walnut oil Walnut oil
Claude Monet	*The Petit Bras of the Seine at Argenteuil* [6]	1872	1. Lower ground 2. Upper, lilac ground 3. Dark green paint of river bank, right-hand edge 4. White impasto highlight of lake	Linseed oil Prepolymerised linseed oil Poppy oil (?) Prepolymerised poppy oil
Alfred Sisley	*The Watering Place at Marly-le-Roi* [7]	1875	1. Brownish ground 2. White snow, bottom edge 3. Black paint, right-hand edge 4. Light bluish grey of stream	Linseed oil Poppy oil Linseed oil Poppy (predominantly) + linseed oil mixture
Pierre-Auguste Renoir	*At the Theatre* [8]	1876–77	1. Ground 2. White of collar, right-hand figure 3. Dark blue of dress, right-hand figure	Prepolymerised linseed oil + pine resin Linseed oil + a little pine resin Prepolymerised linseed oil + pine resin present
Camille Pissarro	*The Côte des Boeufs at L'Hermitage* [9]	1877	1. Ground 2. White impasto of house, centre 3. Dark blue impasto, top of tree trunk 4. Red paint, bottom edge	Linseed oil Walnut, possibly poppy oil + non-drying oil or fats Walnut oil Walnut oil + a little beeswax
Claude Monet	*The Gare Saint-Lazare* [10]	1877	1. Ground 2. Black from roof of station 3. Greyish white of steam	Linseed oil Linseed oil (predominantly) + poppy oil mixture Poppy oil
Pierre-Auguste Renoir	*Boating on the Seine* [11]	c.1879	1. Ground 2. White highlight on wave crest 3. Dark blue from foreground	Poppy oil Prepolymerised poppy oil Linseed oil + a little castor oil

Artist	Picture	Date	Sample	Medium
Berthe Morisot	*Summer's Day* [12]	1879	1. Ground	Linseed oil
			2. White highlight impasto from dress of centre figure	Poppy oil + some resin mixture
			3. Grey paint of dress of centre figure	Poppy + linseed oil + some resin mixture
			4. Dark blue dress, left-hand figure	Poppy oil
Claude Monet	*Lavacourt under Snow* [13]	*c.*1879	1. Ground, bottom edge	Walnut oil (?)
			2. White of snow, bottom edge	Poppy oil
			3. Dark blue of shadow on snow	Walnut oil + a little pine resin
			4. Dark green	Walnut oil
Pierre-Auguste Renoir	*The Umbrellas* [14]	1881–6	1. Ground from right-hand turnover	Probably linseed oil
			2. White impasto, right-hand girl's hat	Poppy oil
			3. Red of hair, right-hand edge	Poppy oil
			4. White of upper arm, man with umbrella, left-hand turnover	Linseed oil with a little castor oil
			5. White cloud, top edge	Linseed oil with a little castor oil
			6. Dark blue, right-hand woman's dress	Gouache (gum) medium
Paul Cézanne	*Hillside in Provence* [15]	*c.*1886	1. Ground	Linseed oil
			2. White impasto highlight from rocks	Walnut oil
			3. Greyish blue of distant hills	Walnut oil
			4. Yellow, lower right-hand edge	Walnut oil

what form it is present; various oil-resin mixtures were available for artists to use as painting media, discussed below, quite apart from the possible use of resin in driers.

Certain samples obtained from three pictures – Pissarro's *The Côte des Boeufs* (Cat. no. 9), and Renoir's *Boating on the Seine* (Cat. no. 11) and *Umbrellas* (Cat. no. 14), all dating from the late 1870s or early 1880s – were found to have a non-drying fat or oil, such as castor oil, mixed with the drying oil. This may have been added to retard the drying of the oil and prevent the paint hardening in the tube.

In some cases there was evidence that some form of heat-bodying of the oil, with or without driers, had been carried out. The result is a stand or 'fat' oil and such samples have been labelled as prepolymerised. Such an oil has considerably enhanced drying properties. The *huile grasse* mentioned in the colour merchants' catalogues discussed above is of this type; in this case the oil (probably linseed) would probably have been heated with a lead salt, such as litharge, or possibly a manganese – or other suitable metal – salt. When, in addition to the oil being prepolymerised, resin is present, then we may suspect the use of an oil-resin varnish medium, such as the *huile copal* referred to in the colourmen's catalogues; the samples taken from Renoir's *At the Theatre* were found to contain both, and a medium of this type may have been used.

In general there has been little scope to examine paints based on the heavy pigment vermilion which, after grinding with oil, has a tendency to settle and leave an oil-rich surface layer. However, one such vermilion sample, taken from Pissarro's *The Côte des Boeufs*, was found to contain a little beeswax in addition to the oil. It may well be that beeswax was added to thicken the medium and reduce the tendency for the vermilion to settle on standing.

Among the samples taken from Renoir's *The Umbrellas* was one taken from a dark blue area, thought to have been worked on by the painter some years after the painting was started. This paint was found to be susceptible to water and the medium was identified as a gum, suggesting the use of a gouache or similar paint.

Nineteenth-Century Colour Theory

The developments in the understanding of various aspects of colour science can be explained only briefly in what is intended to be an introduction to a discussion of the Impressionists' use of colour. The aim is to indicate the scope of the researches being carried out in the fields of colour vision and colour classification and to show how far, if at all, the results obtained were reflected in handbooks and treatises of painting and in the practices of artists themselves. It is necessary to understand that different aspects of the physics, physiology and aesthetics of colour were of interest in different countries, according to the research that was carried out in each. There was, of course, transmission of information on a scientific level, but the writings for, and by, artists reveal differences in emphasis. In France eighteenth- and early nineteenth-century discussions of colour in painting had always been very much more theoretical than those of the English writers; nevertheless, to some extent they can be seen to reflect developments in colour science.

In the first half of the nineteenth century, all research into the nature of colour and of colour vision was hampered by the failure to understand the fundamental difference between the mixture of light of different wavelengths, and thus of different colours, and the mixture of coloured pigments. Isaac Newton had shown in 1666 that white light could be separated into its component colours by means of a prism; by 1704, when he published *Opticks*, his collected work on colour, he named the seven colours of the spectrum as: red, orange, yellow, green, blue, indigo, violet (Plate 42). It is clear from his other experimental work that he suspected that white light could be made from fewer colours than these. At much the same time, a number of writers, including André Félibien in France and the physicist Robert Boyle in England, had put forward the idea that there were three primary colours – red, yellow and blue – from which all other colours could be mixed. They were, of course, referring to

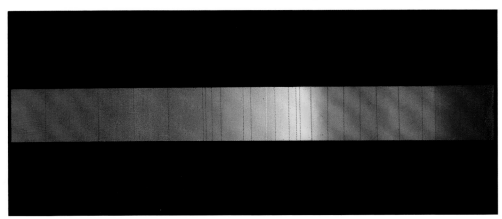

Plate 42 Colours of the spectrum (Chevreul, 1864)

pigments: Boyle wrote, in 1664, that these colours were those used by painters, together with black and white.

When towards the end of the eighteenth century research began to be carried out on how light was received on the retina of the eye, it was assumed that the three primary colours were the same for light as they were for pigments. Thomas Young, for example, published in 1802 his theory that the retina was sensitive to red, yellow and blue light, proposing the existence of three types of nerve in the retina, one sensitive to each colour. Shortly afterwards, as a result of further research published by William Hyde Wollaston and some further study of his own on the relative proportions occupied by each colour in the spectrum, Young modified his choice of colours to red, green and violet. He realised that, if his theory was correct, he should be able to recombine the three colours to obtain white, as Newton had attempted before him, not only by the simple use of another prism to recombine his rainbow of light into white light, but with ordinary painters' pigments. Young attempted the recombination by painting sectors of red, green and violet on a disc and spinning the disc fast enough to prevent it flickering, a method used by other workers – including the German physicist and physiologist Hermann von Helmholtz, and the Scottish physicist James Clerk Maxwell – in colour-matching experiments fifty years later. The resultant colour was not white but, at best, grey.

In subsequent work on colour vision and colour classification, a subject of considerable interest during the first half of the nineteenth century, the most extraordinary rationalisations were put forward to explain this phenomenon. To some extent the misunderstanding appears to have been based on the physiological fact that any colour will appear white to the eye if it is bright enough. If a coloured material, including something grey, is illuminated by strong sunlight, which Newton and many other eighteenth- and nineteenth-century researchers used for their experiments, it will reflect light sufficiently brightly to appear white. Some authors, notably the German-born printer Jakob LeBlon, stated correctly that the primary pigments mixed would give black; LeBlon went on to distinguish this from the mixture of the 'impalpable' colours which would give white. Although his work, *Coloritto*, was published in London and in Paris (in 1756), he was working outside the mainstream academic tradition, and it is doubtful whether it would have had much influence at the time.

The failure of experimental work using pigments to give the results expected was explained only in 1852: Hermann von Helmholtz, in a series of careful experiments, was able to demonstrate the difference between the mixing of coloured light, *additive mixing*, and the mixing of pigments, *subtractive mixing*. However, he came to the conclusion that Young could not be correct in his hypothesis that there were three types of nerve or receptor in the retina, as occasionally it was necessary to mix more than the three primary colours to obtain a desired match. Some ten years later, he realised that the anomalous results could be explained by assuming that the receptors overlapped in their spectral sensitivities and thereafter he supported Young's three-receptor theory. James Clerk Maxwell was also carrying out a series of elegant colour measuring and matching experiments from about 1854 onwards, which enabled the proportions of each of the three additive primary colours (red, green and blue) necessary to match all the colours of the spectrum to be calculated algebraically and plotted on a diagram. Rather than using painted discs for his spinning disc experiments, he used circles of red, green and blue paper so that the size of the

coloured sectors could be altered, and thus he was able to succeed where Young had failed. The work Helmholtz and Maxwell carried out was of great importance for Ogden Rood, who made it the basis for his own *Modern Chromatics* (1879), the French edition of which was to be influential on the work of Seurat, Signac and Pissarro in the 1880s.

Additive and subtractive mixing of colour are discussed at length elsewhere (see pages 84–5), but it is perhaps useful to define them here briefly. If the visible spectrum is divided into three portions, such that the dividing lines occur in the yellow and in the blue-green regions, the colours of the three resulting portions are red, green and blue; the red is an orange-red, and the blue a blue-violet (Plate 42). If these are mixed in the correct proportions, white and all other colours of light may be obtained: these are the *additive* primary colours, to which, as we have seen, Young proposed that the retina of a human eye was sensitive. Red and green light mixed give yellow. A pigment is coloured because it reflects light of certain wavelengths, strongly absorbing light of other wavelengths. Three pigments can be chosen which absorb each of the three portions of the spectrum described above, while reflecting the other two. The colours of these are: a greenish blue (technically known as cyan), which absorbs the red; a bluish red (magenta), absorbing green; and yellow, absorbing the purplish blue, collectively called the *subtractive* primary colours (see Plate 47). These are ideal primaries, used by printers today, but in practice they were not known or used by nineteenth-century painters: red, yellow and blue were taken to be the subtractive primaries. It is clear that if pigments of these three colours are mixed together in the correct proportions, they will, in theory, absorb light of all wavelengths, reflecting none, and the result should be black; in practice one obtains some sort of grey because pigments are not of sufficient spectral purity of colour.

The principal contribution by French research workers to early nineteenth-century colour theory was in the field of colour classification. During the course of this research, a set of fundamental principles was put forward which was to have a profound influence on the future development of painting in France and elsewhere. The author was the chemist Michel Eugène Chevreul, and the principles were the laws of the contrast of colours. By this time, the work of Newton was well known. The entry for *Couleur* in the great *Encyclopédie, ou Dictionnaire raisonné* of Diderot and D'Alembert, first published in the 1750s, describes Newton's works and goes on to explain primary and secondary colours, a secondary colour being that made by the mixing of two primary colours. More interestingly, as far as the later work of Chevreul is concerned, the article also describes the discoveries of the Comte de Buffon, first published by the French Academy of Sciences in 1743. De Buffon's work was on 'accidental colours'. He described coloured after-images: on looking at a square of red paper on a white background and then moving the eye to look at plain white, a faint green square could be seen. Also, while looking at the red, a corona of green could be seen around it. He also described coloured shadows: shadows of objects against a white wall during a red sunset appeared greenish. His observations may be recognised as precursors to those of Goethe, for example, whose *Theory of Colour* was published in 1810.

Earlier attempts to classify colours so that a desired colour could be specified exactly, often by a system of letters or numbers, had included the colour triangle of Tobias Mayer (1758), Johan Lambert's colour pyramid (1772) and the entomologist Moses Harris's little-known colour wheels (*c.* 1766). Newton, too, had produced a

colour circle, but had not developed its possibilities very far. In another field, the chemist and artist Charles Bourgeois published a paper in 1812 on the three primary colours in nature – red, yellow and blue (by which he meant both pigments and light).

The optical effects of placing one colour next to another in painting or in decorative schemes had already been touched upon by C.-A. Prieur in a paper published in *Annales de Chimie* as early as 1805, which Chevreul had read. Gaspard Grégoire's *Théorie des couleurs*, which was published around 1820, seems not to have been known to Chevreul. Grégoire described the mixing of the three primaries to give black (he recommended the use of carmine, gamboge and ultramarine) and the construction of twelve series of colours, mixing the pure colour with white and black to give tints and tones of the colour, a total of 336 in all, together with seven greys and the white of the paper. Using these tables it was possible to specify any colour by a set of numbers. He defined complementary colours as those which give a grey when mixed, such as red and green: each contains what the other lacks to complete the reunion of the three primary colours. If these opposed colours were employed together, without mixing, as in decoration for example, they contrasted very agreeably and went well together, violet with yellow, red with green, and blue with orange.

As Director of Dyeing at the Gobelins tapestry workshop, Chevreul had been asked to look into the apparently low intensity of certain colours. He found that the apparent brightness of a particular colour depended more on the colours surrounding it than on the intensity of the dyeing. As a result of this discovery, he formulated the law of simultaneous contrast of colours, which describes the effect perceived if two colours are placed next to one another, touching: the differences between them – in hue, saturation of colour and brightness – are then at their greatest.

Chevreul explained that each colour was modified by the effect of the complementary colour of the other, and that the effect was most marked when the pair of colours were themselves complementary: a red next to a green, for example, appears redder because it is enhanced by the complementary colour of green, that is, red; equally, the green appears greener. He defined also successive contrast of colours, whereby the eye, having looked at a patch of colour for a time, perceives the complementary colour on moving away. It can be seen that this is no more than a formulation of de Buffon's 'accidental colours'. Chevreul was well aware of the physiological explanation for the phenomenon and cited the work of Scherffer, published in 1754, who proposed (correctly) that the effect was caused by retinal fatigue. In the case of mixed contrast, if the eye, having looked at a patch of colour – orange, for example – looks away, not at plain white, this time, but at yellow, the yellow will appear green because the blue after-image of the orange is superimposed upon it. The effects of these phenomena in painting, particularly in the work of the Impressionists, is discussed below (see pages 85–9).

Chevreul extended his work to mixtures with white and black, and discussed its application to a number of fields, including dyeing and painting. (His application of the laws of contrasts to the framing of pictures is discussed below on page 103.) In order that his researches could be put to practical use, Chevreul constructed a very precise colour wheel to demonstrate colour relationships. It is arranged so that complementary colours are opposite one another. The diagram shows seventy-four *nuances* (hues) of colour and twenty degrees of tonal gradation, from white at the centre to the darkest colour at the circumference. There were thus 1440 colours

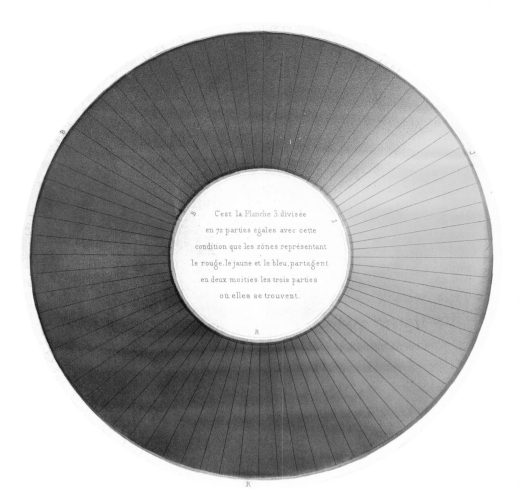

Inside circle: C'est la Planche 3 divisée en 72 parties égales avec cette condition que les zônes représentant le rouge, le jaune et le bleu, partagent en deux moities les trois parties où elles se trouvent.

Plate 43 Chevreul's colour circle, divided into 72 sectors (Chevreul, 1864)

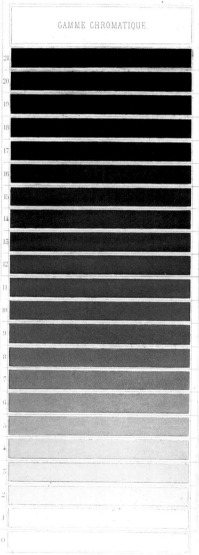

GAMME CHROMATIQUE

representing the primaries, their combinations with each other and their tints with white. Gradations into black were shown on a quadrant turning on an axis perpendicular to the circle; in the book this quadrant was hinged. The intention was to construct a hemisphere in order to classify and describe possible changes in colour. But both model and diagram had a number of deficiencies.

Rather more valuable, as far as paint manufacturers, dyers and many others were concerned, were the coloured circles and scales of *couleurs rabbatues* (or *rompues*, colours mixed with black or grey), which appeared in book form in Chevreul's *Des Couleurs et de leurs applications aux arts industriels* in 1864 (see Plates 43 and 44). The colour printing was carried out by a Monsieur Digeon by a process of chromogravure, using chrome yellow, carmine and artificial ultramarine, and must have been extraordinarily difficult; it is hardly surprising that Digeon was awarded a medal for his efforts in 1858 by the Société d'Encouragement pour l'Industrie Nationale. The 1862 edition of Riffault-Deshêtre's *Nouveau manuel complet de fabricant de couleurs* states that the series was available at low cost and could be found in all the colour-makers' workshops. As a result, convenient quality control of colour and colour specification by comparison with a standard could be obtained. Presumably artists could have seen or obtained the circles if they so desired, although it is not known if any artist did so: no example appears to have made its way into painters' handbooks at this time, even though colour diagrams of one sort or another were not uncommon.

Plate 44 Chromatic scale: the pure colour mixed with fixed amounts of white and black (Chevreul, 1864)

Early nineteenth-century French treatises on painting restricted their discussion of colour to what was, by this time, the universal knowledge of Newton's discovery of the spectral colours and the primary and secondary colours. Their other concerns were with warm and cold and advancing and retreating colours, which were mentioned by Grégoire in his book. Detailed discussion of the practical use of colour and the comparison of colour harmonies with musical scales, which appear in English treatises of the period, were rarely mentioned in French publications. The work of Bourgeois on the primary colours was explained to the artist by Paillot de Montabert in his treatise of 1829. J.-F.-L. Mérimée gave a thorough treatment of colour as it was then understood in his work of 1830, and included a colour wheel showing the primary and secondary colours; the centre of the wheel is correctly coloured grey, because if all three primaries – or a primary and its complementary colour – are mixed, a grey is the result (Plate 45). Mérimée did not support the view that complementaries should be considered as enemies and could not be placed beside one another without discord. This view was expressed by Delaistre in his rather conventional *Cours méthodique du dessin et de la peinture* of 1842; with the aid of a triangle of primary colours and a complex little diagram of a star and triangles inscribed in a circle, he explained that complementaries, like yellow and violet, contrasted harshly, while those next to one another, like red and orange, went well together (Fig. 46).

Plate 45 Merimée's colour wheel (Merimée, 1830)

The work of Chevreul on the contrast of colours did not have an immediate impact on the writers of artists' handbooks, although Chevreul intended it to be useful to people working with colours. It seems, however, that the work was of some interest to certain artists, notably Delacroix, although it is hard to ascertain how far the remarkable colour combinations this artist used were the result of a knowledge of Chevreul's work and how far they were the results of his own observations. Certainly later in his life, while convalescing in Dieppe in 1854, he made a series of notes on colour which show his interest very clearly, commenting on the violet shadows and green reflections on the sea, for example. In his Journal in January 1857, he remarked that all earth colours should be banned, and this was several years before the Impressionists themselves decided to ban them. The Impressionists could have known the short book by Théophile Silvestre published in 1864, which includes some discussion of Delacroix's methods. It is known that they admired his work. For them, as for many young painters, the murals in the church of Saint-Sulpice, only finished in 1861, were key works. The startling webs of colour woven across the surfaces of flesh and fabric must have been a source of inspiration to them all (see Fig. 47 and Plate 46).

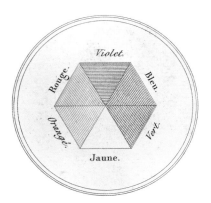

Fig. 46 One of Delaistre's colour diagrams (Delaistre, 1842)

Clearly, some change in artists' perception and treatment of colour contrasts and harmonies – at its most pronounced in the work of Delacroix – appears to have been taking place in the years around the 1850s. Perhaps an element of this is reflected in a small book on the handling of colour in painting by Marie Elisabeth Cavé, first published in the 1850s and reprinted a number of times thereafter. The book is in the form of letters addressed to a lady with two daughters, who are learning to paint. On a number of occasions Madame Cavé indicates that she believes that colour should be lively: 'Colour above all thrives on oppositions. And, to speak of red hair . . . do you know what we use to model it? Indigo. . . . The harmony of tones is in the contrasts.' She goes on to speak of the happy effect of blue flowers with orange stamens. Her understanding of colour contrasts is perhaps intuitive rather than grounded in theory

Fig. 47 Eugène Delacroix, *Jacob wrestling with the Angel*, 1849–61. Paris, Saint-Sulpice, Chapelle des Anges

Plate 46 Eugène Delacroix, *Jacob wrestling with the Angel*, detail of Fig. 47

(and she may have been influenced by Delacroix), but it seems indicative of a general change – 'something in the air' – that was taking place.

By the 1860s and 1870s it is clear from handbooks and from the writings of artists themselves that Chevreul's laws of the contrast of colours, particularly that of simultaneous contrast, were becoming well known. A clear exposition of this law was given by Charles Blanc in his *Grammaire des arts du dessin*, first published in 1867. Blanc provided an analysis of Delacroix's colour which, however inaccurate it may have been in fact, was later to be deeply influential on the writings of the Neo-Impressionist painter, Paul Signac. (He included the rather charming account of Delacroix observing that the yellow colour of the carriage he had ordered gave rise to violet shadows.) Thomas Couture, the teacher of Edouard Manet, may also have read Chevreul's book. If he had, Manet could well have absorbed a few of his theories. Couture stressed the use of complementary colours in juxtaposition, for example, and even prepared the *ébauche* or preliminary lay-in of a painting in the complementary

colour to the tones that were to go above it. He condemned the mixing of more than three colours to give the desired effect, saying that the colour died as a result.

Perhaps the clearest indication that the work of the colour theoreticians had penetrated the world of the artist is given in the 1877 edition of Goupil-Fesquet's handbook on oil painting. In the short section on the contrast of colours, an outline of a colour circle is provided with the suggestion that the reader uses Chevreul's chromatic circles to complete the diagram.

Impressionist Use of Colour

The Myth and Reality of Impressionist Colour

The basis of all Impressionist painting was the empirical observation of colour and light. In an often-quoted remark to Lilla Cabot Perry, Monet said: 'When you go out to paint, try to forget what objects you have before you, a tree, a house, a field or whatever. Merely think here is a little square of blue, here an oblong of pink, here a streak of yellow, and paint it just as it looks to you, the exact colour and shape, until it gives your own naive impression of the scene before you.'

Essentially, this appears to encapsulate the one fundamental principle of Impressionist technique: observe and record. However, in considering the Impressionists' use of colour, it is important to strike a balance between the homespun simplicity of Monet's remarks and the elaborate mythology that many writers and critics have constructed in the century since.

In a valuable analysis of Impressionist technique published in 1944, J. Carson Webster disposed of the most widely held misconception of all: that the Impressionist painters exploited a process of 'optical mixing' by using separate touches of pure prismatic colours that fused in the eye of the beholder. According to the principles of this particular myth, green is made up of individual patches of blue and yellow, purple of blue and red, and so on; the use of unmixed colours is supposed to produce a brighter effect by quasi-additive mixing than by conventional subtractive mixing of pigments (see below). But, as Webster pointed out, this theory is simply not borne out in practice. Even the most cursory observation of Impressionist paintings shows greens and purples to be either single pigments or conventional pigment mixtures. Moreover, even if optical mixing were intended from the juxtaposition of pure colours, the result would, in fact, be less intense than a traditional blending of pigments into a unified mixture: Webster demonstrated that a quasi-additive mixture of blue and yellow makes a rather faint, greyish green, whereas a simple subtractive paint mixture gives the familiar bright green observed on paintings. Also, the coloured brushstrokes on Impressionist paintings are simply

too large for retinal fusion to take place at normal viewing distances. The use of the *tache* (coloured patch or stroke) in Impressionist works was never intended to produce optical mixing but rather to suggest form and light by means of clearly differentiated colours.

The corollary to the myth of optical mixing is that – as light is in nature – all the paints in Impressionist paintings are made up of the six or seven pure hues of the spectrum. This sort of statement stems from the more romantic analyses of some of the early critics, who assumed a direct equivalence between observed phenomena and their reconstruction in paint. Edmond Duranty in 1876, the year of the second Impressionist exhibition, wrote of the Impressionist painters: 'Proceeding from intuition to intuition, they have little by little succeeded in breaking down sunlight into its rays, its elements, and to reconstitute its unity by means of the general harmony of spectrum colours which they spread on their canvases.'

Recognising that white light fragmented into the colours of the rainbow was one thing: recreating white light with mixtures of available pigments was quite another. The Impressionist painters were perfectly aware that they could only represent, directly but imperfectly, with paint the effects of light that they observed; they, themselves, never suggested otherwise.

The brilliant analysis of Impressionism by the French poet Jules Laforgue (writing in 1883 of a small exhibition in Berlin that included pictures by Monet, Pissarro, Renoir and Degas) recognised the phenomena that the Impressionist painters were responding to, but made no unrealistic claims about how they translated their observations into paint. He wrote:

> In a landscape flooded with light . . . where the academic painter sees nothing but a broad expanse of whiteness, the Impressionist sees light as bathing everything not with a dead whiteness, but rather with a thousand vibrant struggling colours of rich prismatic decomposition. Where the one sees only the external outline of objects, the other sees the real living lines built not in geometric forms but in a thousand irregular strokes, which, at a distance, establish life. . . .
>
> The Impressionist sees and renders nature as it is – that is, wholly in the vibration of colour. No drawing, light, modelling, perspective, or chiaroscuro, none of those childish classifications: all these are in reality converted into the vibration of colour and must be obtained on the canvas solely by the vibration of colour. . . . [In the work of] Monet and Pissarro, everything is obtained by a thousand little dancing strokes in every direction like straws of colour – all in vital competition for the whole impression.

No mention here of spectral colours reconstituting themselves on the canvas: indeed, the implication is that the very discreteness of the coloured 'straws' is necessary for colour vibration to occur. Laforgue's perceptiveness lay in his ability to distinguish between observed natural phenomena and the material limitations of any attempt to capture them on canvas.

Primary and Complementary Colours

There was much confusion in the nineteenth century – which remains to this day – about what we now know as *additive* and *subtractive* mixing of colours. Additive mixing refers essentially to coloured lights, and the additive primaries, from which all other colours can be made, are green, orange-red and blue-violet; when these three

lights are combined, they produce white. Subtractive mixing applies to combinations of pigments, inks and so on, and the subtractive primaries are cyan, magenta and yellow; when these three colours are mixed together as pigments, they produce a dark grey or black. Confusion lies in the fact that adjacent touches of coloured paint can combine in a weakly additive way if they are small enough: thus, both subtractive and additive mixing can occur simultaneously.

The two sets of primaries are highly interdependent, because the secondary colours produced by combining the three possible pairs of additive primaries are the subtractive primaries, and vice versa (Plate 47). The terminology of colour used here for the subtractive primaries – cyan, magenta and yellow – is that used in modern printing technology. These are the precise hues that, combined together and with black and white, will produce any desired colour on the printed page. In the language of practising painters, the names of primary colours become considerably less precise and are usually referred to simply as blue, red and yellow. In practice also, because artists' pigments do not correspond to the theoretical 'pure' primaries, a whole range of pigments is needed to produce all the required colours in a painting.

As we have seen, by the nineteenth century, the concept of primary and secondary colours was already standard text-book material, but had little relevance to the way in which painters actually handled their colours. Of much greater practical significance were *complementary colours*, which were discussed at length by Goethe, Chevreul and others. Two colours are described as complementary when, together, they complete the spectrum. In theory, two lights of complementary colour will produce white, and two pigments of complementary colour will produce black when mixed; in practice, obtaining pairs of lights or pigments that precisely cover the spectrum between them is so unlikely that perfect white or black is never achieved.

The fundamental complementary pairs are: green with magenta, orange-red with cyan, and blue-violet with yellow (Plate 48). It will be seen that each pair consists of an additive primary coupled with a subtractive primary. Referring back to Plate 47 explains why this should be so. As an example, orange-red and green mix additively to produce yellow; blue-violet completes the spectrum and therefore yellow and blue-violet are complementary. Similarly, magenta and yellow mix subtractively to produce orange-red; cyan completes the spectrum and therefore orange-red and cyan are complementary. These, it should be stressed, are only the fundamental complementaries. A whole range of intermediate colours are also complementary to each other, and part of the function of the colour circle (page 80) is to indicate all complementary pairs by placing them opposite to each other. In the non-technical vocabulary of the painter, the basic complementary pairs are usually referred to as red/green, blue/orange and yellow/violet.

Complementary colours have great significance for the painter who is trying to record effects of nature. In attempting to set down their truthful observations of the scenes before them, painters have to take account of physiological reactions in their own eyes and interpret them in terms of the painted image. The eye can rapidly become fatigued by any strong colour, so that it becomes temporarily 'blind' to that colour and can only 'see' the remainder of the spectrum. In other words, it sees for a short while the complementary of the original colour. Goethe, in his *Theory of Colours*, summarised the phenomenon thus: 'Every decided colour does a certain violence to the eye, and forces it to opposition.'

The significance of negative or complementary after-images appears to have

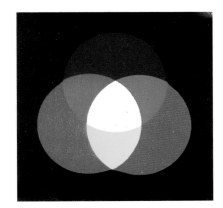

Plate 47 Additive (top) and subtractive colour mixing. The additive primaries, green, orange-red and blue-violet, combine to produce yellow, magenta and cyan, which are the subtractive primaries. Similarly, the subtractive primaries combine to produce the additive primaries

Plate 48 Fundamental complementary pairs: green and magenta, orange-red and cyan, blue-violet and yellow

been understood by some painters in the mid-nineteenth century. The effect of shadows tinged with the complementary of an adjacent bright highlight was frequently used by Delacroix. In his journal for 7 September 1856, he described a boy climbing up a fountain by Saint-Sulpice: 'I saw him in full sunlight: dull orange in the lights, very lively violet tones for the parts emerging from shadow, and golden reflections in the shadows turned towards the ground.'

Coloured shadows feature consistently and prominently in Impressionist paintings, especially those depicting sunlit scenes of snow and landscape. The colour in the shadow can be made up of several tones, including reflections from nearby objects and the reflected blue of the sky where appropriate; but it was the inclusion of the complementaries of adjacent highlights that gave these paintings their psychological veracity and made them the subject of so much favourable and unfavourable comment.

The use of complementaries by the Impressionists is usually quite straightforward. Yellow sunlight on snow produces violet shadows, and as the sun turns to orange in the late afternoon the shadows become bluer and greener. Goethe had already described such effects:

> During the day, owing to the yellowish hue of snow, shadows tending to violet had already been observable; these might now be pronounced decidedly blue, as the illuminated parts exhibited a yellow deepening to orange. But as the sun was about to set, and its rays began to diffuse a most beautiful red colour over the whole scene around me, the shadow colour changed to a green, in lightness to be compared to a sea-green, in beauty to the green of the emerald. *(Theory of Colours)*

In summer landscapes, too, the Impressionists often used complementaries – purplish red for the shadows of trees and dull violets for the shadows of rocks or across dusty roads (Plate 49). Antonin Proust recalled how Manet walked with him, talking of colour: 'over here a cedar rose up isolated in the midst of a demolished garden. "You see its skin," he said, "and the purplish blue tones of the shadows?".' Manet was later to say, 'I have finally discovered the true colour of the atmosphere. It's violet. Fresh air is violet. . . . Three years from now everyone will work in violet.'

Plate 49 Paul Cézanne, *Hillside in Provence* (Cat. no. 15), detail

86

The use of blue and violet tones by the Impressionists provoked much comment by their contemporaries. Duranty (1879) described their general palette as 'almost always proceeding from a violet or bluish spectrum'; Duret (1878) said that 'the Impressionist paints people in violet woods. . . .' Wolff (1876) thought that Renoir's purple-tinted nudes were 'corpses in a state of decay'. Huysmans, in *L'Art moderne*, came to the conclusion that the Impressionists were all suffering from a collective sickness, the same as that suffered by 'hysterics and a number of people suffering from diseases of the nervous system'. Their retinas were diseased, he went on, but there was hope: 'The most afflicted, the weakest of these painters have been overcome; others have recovered little by little and now have only rare recurrences.' The good-natured Pissarro reported to Lucien in a letter of 9 May 1883 that Huysmans 'for a while considered us sick, touched with the disease that attacks painters, "Daltonism" [colour blindness]; little by little he has come to take the position that we are cured and he calls us the only painters of the moment, convinced that we represent the regeneration of French art which had reached its last gasp. . . .'

Colour Contrasts

By the same physiological process that induces complementaries into observed shadows, adjacent complementaries appear very strongly contrasted, each seeming to enhance the other. This was one of the main observations of Chevreul, who in 1839 formulated his laws of simultaneous, successive and mixed contrast; with these laws he defined principles of colour juxtaposition that had been instinctively understood by artists for centuries, but not before articulated in any scientific or systematic way.

The essential principle of colour contrast was expressed by Chevreul in 'a very simple law': 'In the case where the eye sees at the same time two contiguous colours, they will appear as dissimilar as possible, both in their optical composition and in the height of their tone.' Simultaneous contrast occurs with any colours (not just complementaries) placed side by side: at their junction, the contrast between them will appear more intense than within the body of each colour. A strong colour tends to irradiate its surroundings with its own complementary: therefore if two complementaries are placed together they can enhance each other. However, Chevreul also warned that the size of the adjacent coloured patches was critical: if they were too small (as, for example, with threads in a tapestry), then the complementaries might combine additively to give only a neutral grey tone.

These principles were understood by the Impressionist painters, even if they were not familiar with Chevreul's research. We have seen how the imitation of complementary after-images in shadows added a new immediacy to their painting. They also used complementary interactions to suggest the vibration of light and atmosphere. Frequently, blue and orange are used alongside each other in order to heighten tone and suggest brilliance and vibrant contrast: examples include Renoir's *Boating on the Seine* (Cat. no. 11; Plate 50) and Monet's *Lavacourt under Snow* (Cat. no. 13; Plate 51) in which blue and orange tones of striking intensity are made even more vivid by juxtaposition.

Similarly, green and red are often used together, as in one of the most radiant of all Impressionist paintings, Monet's *Regatta at Argenteuil* of 1872 (Paris, Musée d'Orsay; Plate 52). Here, Monet exploits a whole range of complementary contrasts: red with green, orange with blue, and creamy yellow with pale violet. He also uses

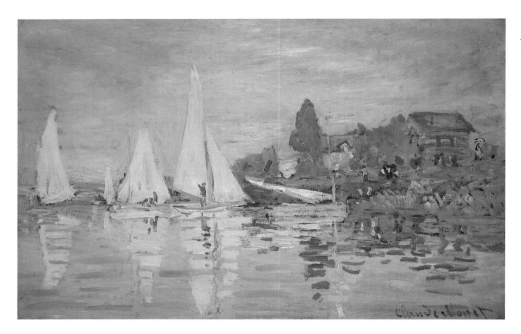

the more subtle simultaneous contrasts of similar colours – red with orange and different shades of green with each other. The size of the *tache* plays a major role in the appearance of the painting: clearly differentiated colour patches are used to give a hard-edged force to the handling; nothing is intended to be blurred or diffused here. Monet's use of complementary contrasts was well known to his contemporaries: in an interview in 1888, he said, '. . . colour owes its brightness to force of contrast rather than to its inherent qualities; . . . primary colours look brightest when they are brought into contrast with their complementaries.'

Simultaneous contrast can be used in more subtle ways than simply allowing complementary colours to spark against each other. In many of the paintings in this catalogue, colour contrasts play a telling but often unobtrusive role in the overall appearance. Frequently, the ground or priming remains exposed in places and its colour can appear quite significantly different depending on the adjacent paint layers. The warm pale grey priming of Monet's *Beach at Trouville* (Cat. no. 3), for example, seems to vary in tone from area to area within the composition – but this is simply an effect of simultaneous contrast against the different colours through which it appears. Similarly, the pale mauve ground in Monet's *The Petit Bras of the Seine at Argenteuil* (Cat. no. 6) seems to react in different ways under the changing shades of the variegated sky.

The device of a white or cream-coloured ground showing through a loosely painted blue sky is also commonly used in Impressionist paintings: pale shades of complementary yellow or faint orange seem to be induced on the exposed priming by the blue, and these will suggest the shimmering warmth of sunshine in the air. An example of this is the sky beyond the trees in Pissarro's *Côte des Boeufs* (Cat. no. 9; see Plate 155).

Simultaneous contrast is not simply an effect of colour; it can also apply to brightness: a middle tone will look lighter against a dark background than against a light one. The smoke and steam in Monet's *Gare Saint-Lazare* (Cat. no. 10) appear quite changed when surrounded by the black station roof or by the pale sky beyond. But other effects are at work here, too: the use of translucent paint layers over a dark

underlayer will give rise to a cooler, bluer tone than when used over a light underlayer. Colour effects can thus be induced in several ways, and Impressionist paintings, for all their apparent directness and simplicity, exploit them to the full.

Impressionist Practice

The palette illustrated by Bouvier (see Fig. 3) represents an academic approach to colour that is meticulously calculated and almost obsessive in its organisation. A similar approach based on a system of precisely graded tints permitted a seemingly infallible routine which was taught to many painters in nineteenth-century France: it allowed little spontaneity or invention of technique and was seen to be the latest refinement in academic painting prctice.

This theoretical palette contrasts strikingly with two others illustrated here. One of the last palettes of Delacroix (published by Piot), used in the painting of the Chapel of Saints-Anges at Saint-Sulpice (1855–61), is shown in Plate 53. The patches ranged around the outside of the palette are pure colours and the remainder are almost all simple mixtures of single colours with white: only three of the combinations do not contain white. In his paintings for Saint-Sulpice, Delacroix was concerned about the need for luminosity of tone (*clarté*); by using colours mixed with white, a version of the technique known as *peinture claire*, he was able to raise the brightness of the painting overall. Delacroix's palette is quite informal compared with the systematic academic arrangement of Bouvier. The colours and tints are not arranged in a discernible formula or pattern, but nevertheless the mixtures of colours do appear to be somewhat preconceived.

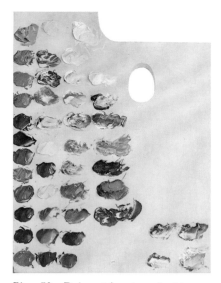

Plate 53 Delacroix's palette for his paintings in Saint-Sulpice (1855–61)

The Saint-Sulpice palette is still relatively extensive and complex. The palettes of the Impressionist circle, by contrast, were more limited and apparently used more empirically. The startling self portrait of Bazille of about 1865–6, although hardly an Impressionist painting, shows us an uncompromisingly Impressionist palette in use (Plate 54). Eight colours, including black and white, are casually arranged around a chaotic *mélange* of pigment mixtures, mostly involving white. There can be no doubt that these are the very colours Bazille used for this self portrait.

These examples of Delacroix and Bazille at work introduce us to the practical manipulation of colour in Impressionist paintings. As both Shiff and House have pointed out, there were three prevailing notions of colour that the nineteenth-century painter could adopt, and each finds echoes on the three palettes we have examined. First, there was chiaroscuro, which stressed form in light and shade, rather than colour; second, *peinture claire* in which everything is suffused with a pale, luminous tonality (the paintings of Corot and Boudin spring to mind); and third, painting in pure colour in which forms are defined by colour relationships rather than by line or light and shade. Shiff demonstrated that in essence Impressionism was a combination of the second and third, the *peinture claire* and colouristic conventions.

Plate 54 Frédéric Bazille, *Self Portrait*, 1865. 108·9 × 71·8 cm. Chicago, Art Institute

This had significant implications for the ways in which Impressionists worked. The choice of priming colour, for example, determined the final tonality of the whole painting. The most widely used colour was white or cream, but many other pale tints of grey, buff, mauve and even brown were used also, especially by Monet. Later in life he assured the Duc de Trévise that he 'always insisted on painting on a white canvas, to establish my scale of values'. By then it was certainly true, but throughout the 1870s he had used many tinted grounds and, early in his career, he had even used occasional dark grounds in imitation of Courbet.

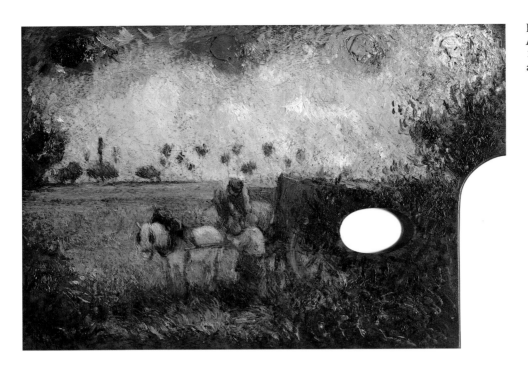

Plate 55 Camille Pissarro, *The Artist's Palette with a Landscape, c.* 1877–9. 24·1 × 36 cm. Williamstown, Mass., Sterling and Francine Clark Art Institute

Working from the basic colour of their pale grounds, the Impressionist painters could rapidly lay in high-tone pure colour effects, or construct the more elaborate white-based mixtures of *peinture claire.* The purity and brilliance of colours were the key to the atmospheric rendering of Impressionist scenes, and this eventually resulted in an avowed rejection of black pigments by Impressionist painters. 'There is no black in Nature' became a famous dictum, but black lingered in small amounts on their palettes for some time, as the catalogue entries below demonstrate. It is still found in Monet's *Gare Saint-Lazare* (Cat. no. 10) of 1877 and only further analysis of his paintings in the late 1870s and early 1880s will show when it disappeared altogether. Black is entirely absent from his *Lavacourt,* painted probably in 1878/9.

Earth pigments, too, were considered unsuitable for the brilliant colours of some Impressionist pictures, although both black and earth pigments continued to be employed quite happily by painters such as Renoir and Berthe Morisot throughout the 1870s. Pissarro was said by Cézanne to have 'banned' earth colours from his palette as early as 1865; but this is demonstrably untrue, since earth pigments are also found in many of his paintings from the 1870s. Small amounts of an orange-coloured earth are found in *The Côte des Boeufs* of 1877, but it is interesting to note that, by this date, Pissarro was duplicating simple earth colour with complex mixtures of higher-toned pigments.

A final palette may be mentioned here. Pissarro left a fascinating record of his method in the form of a landscape painted on his palette (Plate 55). Around the edge are the six colours he used to construct the painting itself. He demonstrates here – as in *The Côte des Boeufs* of about the same time – how he could construct a composition of remarkably consistent and restrained tonality from pigments of the highest chromatic brilliance.

The Paint Layers and Surface of Impressionist Paintings

Impressionist paintings are rarely as spontaneous and direct as they appear. The fleeting effects of light and weather they captured conveyed an illusion of immediacy that was not necessarily reflected in the technique of painting. Some Impressionist paintings were, it is true, painted at a single sitting, in one concentrated session of working in front of the motif. Monet's *Beach at Trouville* (Cat. no. 3) is a notable example of a painting completed *au premier coup*. But this is, surprisingly, the only picture in the present catalogue of which this can be said. Even Sisley's *Watering Place at Marly-le-Roi* (Cat. no. 7), apparently the most rapid of *plein-air* renderings, was modified in small details later by the painter himself (see Plate 139).

Many of these pictures were painted in more than one stage, sometimes over days or weeks. This does not, however, imply slowness of working, since a typical Impressionist painter might have a large number of paintings in hand at once. There are many accounts of the extraordinary number of canvases Monet had under way at any one time. Lilla Cabot Perry described how the painter would work on his series paintings, keeping them all at hand, ready to capture the particular light effect that he sought:

> Monet had already had experience of this sort in painting on sixteen or more canvases one after the other for a few minutes at a time, from his small boat on the Epte. Later, for his water-garden pictures . . . he had grooved boxes filled with canvases placed at various points in the garden where there was barely room for him to sit as he recorded the fleeting changes of the light. . . . He often said that no painter could paint more than one half hour on any outdoor effect and keep the picture true to nature. . . .

One effect, in his *Poplars* series, 'lasted only seven minutes, or until the sunlight left a certain leaf, when he took out the next canvas and worked on that.'

Although Monet's series paintings of the 1890s are a special case, these descriptions of the painter at work do convey a general principle: that the Impressionist painters often worked over a longer period of time and in a more complex manner to achieve their apparently spontaneous effects than might be imagined. Sometimes they even returned to a painting weeks or months later to correct an effect that displeased them. Monet is recorded (again by Mrs Cabot Perry) as not wishing to part with a painting of Etretat until he had done something more to the sky, 'as the clouds did not quite suit him, and characteristically, to do this he must needs go down to Etretat and wait for a day with as near as possible the same sky and atmosphere, so it was some little time before I could take possession of the picture.'

The physical evidence for all this may be seen on many of the paintings examined

here. Frequent observations of dried brushstrokes in layers below the surface confirm the build-up of paintings in distinct stages. In Pissarro's *Fox Hill, Upper Norwood* (Cat. no. 4), for example, the outlines of trees and landscapes were initially sketched in with lines that do not quite coincide with the final image. In Berthe Morisot's *Summer's Day* (Cat. no. 12), the positions of the far river bank and the woman's parasol have been altered significantly. In Pissarro's *The Avenue, Sydenham* (Cat. no. 5), a complete figure has been painted out and new figures added at a late stage by Pissarro himself.

In these, and other numerous examples, the lower layers were undoubtedly dry before they were painted over, since their crisp strokes have not been blurred by the later brushwork. What this implies in terms of time lapse is debatable. Drying times of oil paints can vary enormously, depending on the type of paint (whether driers were added, and so on) and ambient conditions around the painting. For modern oil paints, a thick lead-white brushstroke will just hold its shape after two days (Plate 56); in general, painting over a brushstroke without disturbing it at all suggests an interval of at least several days.

Plate 56 Blue brushstrokes painted across a broad stroke of modern flake white at intervals of (from top) 0 hours, 2 hours, 18 hours, 24 hours, 48 hours and 72 hours. After 48 hours, the white stroke is just holding its shape; after 72 hours it is firm

The terminology used of Impressionist brushwork is descriptive, if somewhat repetitive. The above examples illustrate *wet-over-dry*, but the more obviously 'Impressionist' types of handling are *wet-over-wet* and *wet-into-wet*, both of which occur everywhere in these paintings. Although, as we have seen, distinct stages are often identified, much of the painting was carried out with great speed and fluidity across the canvas, superimposing, blurring together and juxtaposing vivid touches of wet oil paint. Wet-over-wet implies drawing a stroke of one colour across the wet paint of another, as in Morisot's *Summer's Day* (Plate 57). Wet-into-wet describes the actual blending of colours on the picture surface; examples of this may be seen on Monet's *Bathers at La Grenouillère* (Cat. no. 2) and Renoir's *At the Theatre* (Cat. no. 8) (Plates 58 and 60).

Plate 57 Berthe Morisot, *Summer's Day* (Cat. no. 12), macro detail, interior of boat

A most distinctive feature of Impressionist brushwork is the use of the *tache*, the coloured patch or stroke. In academic painting, forms could be smoothly modelled or linear; part of the Impressionist initiative was to define forms in clearly differentiated patches of colour, which gave the effect of light surrounding and reflecting off objects rather than the specific shapes of the objects themselves. Notable examples in Monet's work are the *Bathers at La Grenouillère*, *The Beach at Trouville*, in which the highlights on Camille's dress appear to be almost abstract slabs of pale, thick paint (Plate 59), and the *Regatta at Argenteuil* (see Plate 52), in which the whole scene is captured in broad, opaque strokes of brilliant colour.

Plate 58 Claude Monet, *Bathers at La Grenouillère* (Cat. no. 2), macro detail, background, centre right

The use of the *tache* was by no means an Impressionist invention. Zola, in his study of Manet (1866), described the painter's novelty in recording his subjects as he saw them, '*par larges taches*', and it is to Manet's handling that the Impressionist painters were particularly indebted. Cézanne is said to have referred to Manet's *Olympia* as '*une belle tache*'. However, painting by *tache* had been singled out for its anti-academic tendency before Manet: in 1861, Gautier criticised Daubigny's landscape paintings, which were, he said dismissively, 'little more than assembled *taches* of colour'. Later, when the technique was firmly established, the effect of juxtaposed *taches* was incisively analysed by Bracquemond, who had participated in the first Impressionist exhibition in 1874, in his *Du dessin et de la couleur* (1885). Describing the work of painters given the general title of *tachistes*, he said: 'the more the *tache* takes importance on itself, the more the modelling disappears.' Here was as

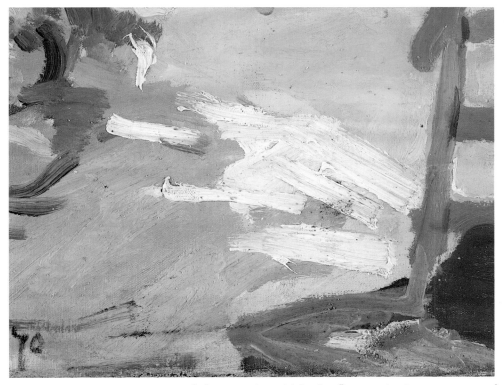

Plate 60 Pierre-Auguste Renoir,
At the Theatre (Cat. no. 8), macro detail,
bouquet of flowers

Plate 59 Claude Monet, *The Beach at Trouville* (Cat. no. 3), detail of highlights on Camille's dress. Sand grains and flattened impasto are also visible

succinct a statement as any of the way in which the Impressionists constructed images of their motifs.

The *tache* in the precise form described here could only have been a nineteenth-century introduction. True, painterly effects of a comparable directness were apparently achieved by many Old Masters, such as Rembrandt and Velázquez; but only in the nineteenth century was the most significant innovation in brush-making since medieval times – the metal ferrule – properly introduced. This allowed the production of flat (as opposed to round) brushes for the first time, and permitted a different kind of brushstroke. The characteristic, broad, flat, evenly loaded stroke that is the basis of Impressionist handling is particularly difficult to achieve with a brush of round section, since the pressure with such a brush would vary from the centre to the edge of the stroke. But, using dryish, fairly stiff paints and flat, square-ended brushes of precisely chosen widths, effects such as the highlights in *The Beach at Trouville* (Plate 59) were easily achieved.

In practice, the Impressionist painter would use both flat and round-section brushes, usually bought from their regular suppliers (Fig. 48). The brushes shown in Bazille's self portrait (see Plate 54) are flat and square-ended, but some of the brushes in Monet's *Corner of a Studio* (Plate 61) appear to be round. Painters liked their brushes to be long-handled and flexible, and late in life Monet is known to have had especially long flexible brushes made to order for producing the extraordinary texture effects on some of his series paintings.

The texture of his paint surfaces was a constant preoccupation for Monet. He was convinced that some of Rembrandt's paintings were more thickly and heavily painted than anything he (Monet) had ever produced, but that 'time with its levelling touch had smoothed them down'. He showed Mrs Cabot Perry two of his Rouen Cathedral paintings; one had been hung on the wall of his studio for two or three years, the other had been kept in one of his grooved storage boxes. 'The difference between the

Fig. 48 Flat-ferrule brushes in the 1888 Bourgeois *aîné* catalogue

two was very marked', she reported, 'the one exposed to the air and constant changes of temperature had so smoothed down in that short space of time that it made the other one . . . look like one of those embossed maps of Switzerland that are such a delight to children.'

The use of texture by the Impressionist painters was a key element in their technique, complementing and emphasising their use of colour. The *tache* is not simply a colour sensation – it has weight, thickness and texture, which all affect the viewer's perception of its colour. The play of light across the surfaces of Impressionist paintings – sometimes rich and smoothly fluid, sometimes dry, granular and almost chalky – can be used as a deliberate evocation of the natural light effects depicted. Sisley, in one of his letters, stressed that the 'animation of the canvas is one of the hardest problems in painting . . . I am in favour of a variation of surface within the same picture. . . . effects of light, which have an almost material expression in nature, must be rendered in material fashion on the canvas.' In view of such stated objectives, it is all the more important to understand how these surfaces originally looked and how subsequent lining and varnishing may have affected them (see page 100).

The manipulation of paint by brushes of assorted sizes and shapes – and, occasionally by palette knife – could produce a great variety of texture effects. The early palette knife paintings of Pissarro and Cézanne (not represented in the present catalogue) have a bold, smooth force quite unlike the feathered, dragged marks of a brush painting. The use of the knife to apply paint is easily identified; it is seldom found in any Impressionist works after the early 1870s, but seems to occur in a small area of Monet's *Lavacourt under Snow* (Cat. no. 13), painted near the end of the decade.

It is in their use of brushwork that the Impressionists most transformed accepted practice. Whirling, flickering dashes of paint were pefectly suited for capturing the intangible qualities of light, air, cloud and vapour (Fig. 49). Sometimes, brushwork could be used in an almost mannered form, which emphasises the elaboration and pattern of the surface. Two of the most distinctive uses of brushwork in this catalogue are found in Pissarro's *The Côte des Boeufs* and Berthe Morisot's *Summer's Day*. The Pissarro has a surface that is worked and reworked into an almost woven structure, with deep, spiked impasto over many stages of painting (Plate 62). The Morisot, by contrast, is much more fluidly handled and the whole painting is finished with shimmering, liquid, zig-zag brushstrokes (Fig. 50).

That each *tache*, or knife-mark, or web of brushstrokes was intended to be quite distinct in Impressionist paintings was not always well understood. The myth of optical mixing has been discussed on page 83 and early critics assumed that the viewer must retreat to an appropriate distance for the individual brushmarks to fuse and blend. Huysmans wrote of Pissarro's *Pathway at Le Chou* in 1881: 'up close, it is a piece of masonry, a bizarre, rough patchwork, a ragout of all sorts of tones covering the canvas; at a distance, it is air circulating, . . . water vanishing into thin air, sunlight spreading. . . .' Chesneau, in 1874, wrote of Monet's *Boulevard des Capucines*: 'From a distance, . . . in this shimmering of great shadows and great effects of light, one salutes a masterpiece. You approach, and everything fades away; there remains a chaos of scrapings from an unintelligible palette.' On the other hand, Charles Bigot, who in 1876 described Impressionist paintings as 'a shimmering chaos of brutal brushstrokes', was the first critic to understand the deliberate calculation of the Impressionist brushstroke. Bigot was certainly critical of the new painting, but

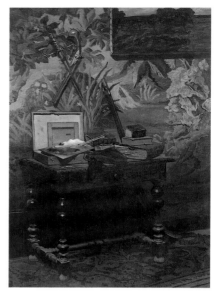

Plate 61 Claude Monet, *Corner of a Studio*. 182 × 127 cm. Paris, Musée d'Orsay

94

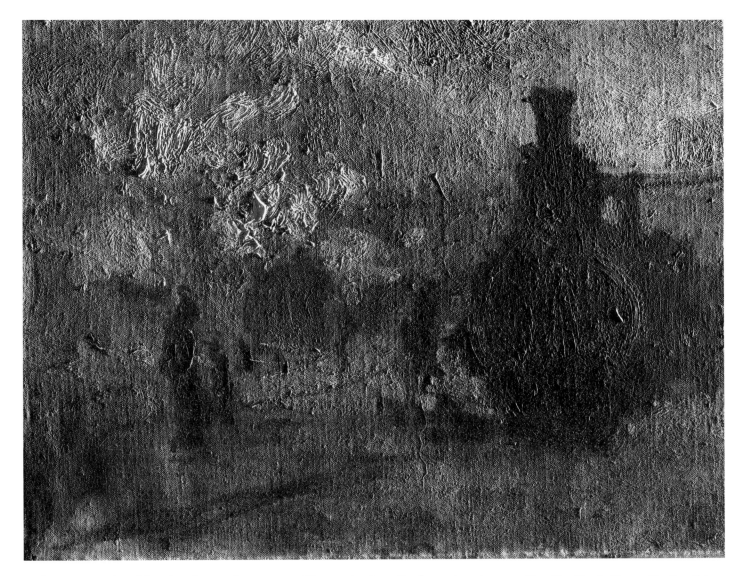

Fig. 49 Claude Monet, *The Gare Saint-Lazare* (Cat. no. 10), detail photographed in raking light

perhaps appreciated its aims better than some of its apologists; far from the viewer stepping back to allow the colours to merge and coalesce, '. . . that is exactly what the new school does not allow. They want us to be able to count the strokes of the brush or, better yet, those of the palette knife.' Frédéric Chevalier, in 1877, further developed this argument and was the first to equate the broken brushwork with the Impressionist illusion of immediacy in rendering the momentary effects of light; he drew attention to 'the brutal workmanship . . . for which they have a fondness, the appearance of spontaneity that they seek above all, the intentional incoherence.'

Much as many critics have tried, it is impossible to categorise the types of marks made by these painters' brushes. It is difficult even to trace any stylistic development in the work of a single painter, since the approach varied enormously from work to work. Rewald, in his *History of Impressionism* (1946), observed that Monet and Renoir 'adopted a comma-like brushstroke which permitted them to record every nuance they observed.' But Impressionist brushwork cannot be reduced to a single repeated formula of this kind, as even the few paintings in this catalogue demonstrate. The best discussion of the brushwork of an Impressionist painter is John House's analysis of Monet in *Nature into Art* (1986). There, House makes a specific point about Monet's

development between the mid-1860s and the early 1870s which is equally applicable to other painters and other periods: '. . . he extended his range of types of brush mark, but every fresh refinement was added to his basic repertory of pictorial devices for rendering what he saw. One method did not supersede another; each might be called upon whenever appropriate.'

Of course, personal styles and straightforward development can be traced in the works of individual painters: the emergence in the mid-1870s, and later development, of Cézanne's 'constructive stroke' – defining form and light in parallel hatchings of colour – is a well-known example. But often, as House implies, such development is not a simple linear process. Different styles of painting may be adopted for works painted simultaneously, but whose functions differ.

Although the traditional terminology of *tableau*, *étude*, *pochade*, *esquisse*, *croquis* and *ébauche* was somewhat blurred by the Impressionist approach, Monet and the others often described their work in such terms. Moreover, any analysis of brushwork has to take account of the intended function of a particular work. In the 1870s, for example, it might be difficult to believe that a painting as calm and ordered as *The Petit Bras* (Cat. no. 6) could be from the same hand as the extraordinary *esquisse* of *The Tuileries* (Plate 63). Both are painted on mauve-coloured primings (that of *The Tuileries* is quite dark), but there any similarity ends: one is quite clearly a finished work, the other a rapid sketch in whirling loops of paint, not originally intended for sale.

There seems to have been little distinction between *pochade* and *esquisse* for Monet. *Bathers at La Grenouillère* was described as a '*mauvaise pochade*' by Monet himself, but equally frequently he used the term *esquisse* for similar sketches. As his popularity grew, however, the distinction between these preliminary sketches and finished paintings became less important to him, and he was often criticised for

selling work with (as the singer Faure complained of one picture) 'not enough painting on it'. Monet later rejected such criticism as 'stupid' and said, '. . . who is the judge of when to stop, if not the painter?'

The build-up of the paint layers was, as we have seen, frequently carried out in distinct stages. Here, too, academic terminology is sometimes appropriate, in that the first stage of working might often correspond to the traditional *ébauche*. Below the fluid colour layers of many Impressionist paintings is a rapid lay-in of monochrome or dull tones, establishing the shape of the composition (see, for example, Monet's *Gare Saint-Lazare*, Cat. no. 10). Monet maintained that the first look at the motif was the truest and most unprejudiced and is reported to have said that

> the first painting should cover as much of the canvas as possible, no matter how roughly, so as to determine at the outset the tonality of the whole. As an illustration of this, he brought out a canvas on which he had painted only once; it was covered with strokes about an inch apart and a quarter of an inch thick, out to the very edge of the canvas. Then he took out another on which he had painted twice; the strokes were nearer together and the subject began to emerge more clearly.

Pissarro, too, recommended covering the canvas quickly at first, and then working it up in subsequent layers. In his *Advice to a Young Painter, Louis le Bail* (late 1890s) he said, 'cover the canvas at the first go, then work at it until you can see nothing more to add.' The nature of the *ébauche* in Impressionist paintings could vary from a few rapid outlines to a fairly detailed lay-in of the whole scene. Usually, some sort of positioning of the main elements of a composition was established first, no

Fig. 50 Berthe Morisot, *Summer's Day* (Cat. no. 12), photographed in raking light

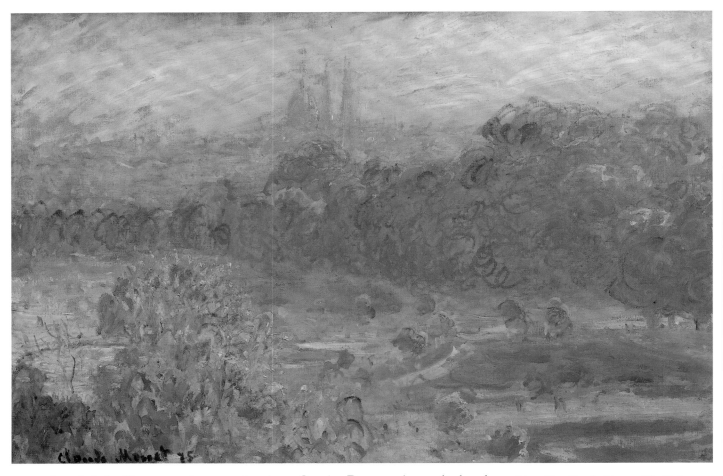

Plate 63 Claude Monet, *The Tuileries
(esquisse)*, 1875. 50 × 75 cm. Paris,
Musée d'Orsay

matter how briefly. However, the portrait painter Carolus Duran, who studied under
Manet, claimed otherwise: 'no preparation in colour or monochrome was allowed,
but the main planes of the face must be laid directly on the unprepared canvas with a
broad brush. . . . they were painted quite broadly in tones of flesh tint, and stood side
by side like pieces of mosaic, without fusion of their adjacent edges.' In all the
paintings examined here, it must be said – including Manet's *Music in the Tuileries* – at
least some sketching lines in paint are observed under the main colour layers. Even
Monet's *Beach at Trouville* (Cat. no. 3), the most direct of Impressionist paintings, has
some thin dull underpaint establishing the shapes of the two principal figures.

The final texture effects found in Impressionist paintings are the unusual,
singular ones, unique to particular paintings. Accidental occurrences like the sand
grains on *The Beach at Trouville* add a pleasing anecdotal element to our view of the
making of the painting. Elsewhere, too, features on the picture surface can conjure up
an image of the painter at work. Manet's well-known habit of scraping down his wet
paint with a knife is vividly illustrated in the green background of *Music in the Tuileries*.
Monet also would occasionally scrape his wet paint, probably with the end of the
brush, in an attempt to lighten passages that had become too dense: an example of
this is found in the trees at the right of *The Petit Bras of the Seine at Argenteuil* (Cat.
no. 6).

The Appearance, Condition and Framing of Impressionist Paintings

In the century or more since they were painted, many Impressionist paintings have changed significantly in appearance. Aspects of their technique make them particularly vulnerable to a variety of processes and treatments that might be regarded as standard for more traditionally painted Old Master pictures. It was not understood at the time they were painted – and it has been frequently misunderstood since – that these were paintings whose novelty lay not just in the image they presented, but also in their physical nature. Painters were making demands of their materials that had not been made before – and these, in turn, demanded methods of care and treatment that were equally unfamiliar.

All the pictures described in this catalogue are on canvas and most of them have relatively thin commercially applied grounds of white, cream or some other light colour. Moreover, the ground frequently plays a key role in the composition and tonality of the final image. Any colour change, no matter how slight, can alter the balance of a picture irretrievably; and the colours can be affected crucially by any process that introduces new materials into the ground itself or into the canvas behind. In this context, the process of *lining* is especially significant.

Lining

The practice of lining canvas paintings is a traditional one, dating back to the seventeenth century. Essentially, a second canvas is stuck to the back of the original in order to strengthen it; at the same time, the adhesive used is allowed to penetrate through the canvas layers into the ground and paint and consolidate them also. There is, therefore, considerable potential for colour change in all these layers if unsuitable adhesives are chosen. In addition, the physical procedure of lining with heat and pressure can flatten the type of prominent impasto found in Impressionist paintings: the unnaturally flat surface of Pissarro's *The Avenue, Sydenham* (Cat. no. 5) has undoubtedly been caused by lining.

Impressionist painters were well aware of lining as a practice – were, indeed, occasionally in favour of it for their own pictures. Degas is quoted in Vollard's biography, however, as approving only the 'Italian' method because it did not involve the use of a heavy iron. The only picture liner he trusted was Chapuis of rue Crétet, but Vollard says even they disagreed when Chapuis argued that a certain canvas was 'too fine' for the Italian method. Degas later rescued fragments of Manet's large *Execution of Emperor Maximilian* and had them lined on to a second canvas, on which they have remained to this day. Manet had some of his own pictures lined as he painted them: *The Waitress* in the National Gallery and *Au Café* in the Reinhardt collection, Winterthur – initially one large painting but separated by Manet himself – were both lined in the middle of the painting process. Pissarro's *Côte des Boeufs* (Cat.

no. 9) has a very early, possibly original, lining.

The basic adhesive in use for picture lining in the nineteenth century was almost invariably animal glue. This, as it happens, was a very good choice because most painting canvases were already sized with a similar glue and the lining process did not appreciably darken them further. Five of the pictures in this catalogue have been glue-lined (Cat. nos. 2, 5, 9, 11 and 15). Of these, only *Boating on the Seine* (Cat. no. 11) may have darkened appreciably, since bare canvas is visible through the ground in many places and an especially heavy lining glue has saturated the fibres. The paint of the others may have been flattened somewhat, but their colour appears essentially undimmed.

Serious darkening problems arose with the widespread use of wax and wax-resin as adhesives this century. Pale canvases will go almost black if molten wax soaks into them and, behind thinly applied primings, this can lead to a significant drop in tone in pictures where the ground is prominent. In addition, the wax can penetrate into a leanly bound priming and darken it directly.

The effect of all this on a painting may be difficult to gauge. For example, in Sisley's *The Watering Place at Marly-le-Roi* (Cat. no. 7), wax-lined in 1958, there has undoubtedly been some loss of luminosity in the beige-coloured ground and, since the ground is visible almost everywhere, the picture can be said to have darkened slightly overall. However, the thicker strokes of white paint on top are not only unaffected by the darkening, they appear actually brighter, enhanced by simultaneous contrast. Darkening as a result of lining, then, is selective, affecting areas within a picture differently, altering the colour *balance* of a composition.

In many cases, wax-lining may be carried out without any detectable darkening. This implies the presence of an opaque well-bound priming that neither darkens under the influence of wax nor allows the blackened canvas behind to show through. Four paintings in this catalogue (Cat. nos. 1, 3, 4 and 14) that have been wax-lined in the last thirty years have substantial grounds that seem to have resisted darkening. Nevertheless, wax-lining of Impressionist paintings is now considered unacceptable. If lining is unavoidable – in the case of a badly torn canvas, for example – then alternative adhesives are available that do not penetrate or darken the canvas fibres.

Wherever possible, lining is avoided altogether, even though the painting is undeniably more fragile in this state. Unlined paintings, of which there are five in this catalogue (Cat. nos. 6, 8, 10, 12 and 13), are much prized. This is partly because they may have valuable information on the back, in the form of suppliers' stamps and so on. Principally, however, a painting that is unlined is intrinsically closer to its original state, changed only by the passage of time. The process of lining is a major intervention that may sometimes be unavoidable – that may, indeed, leave the paint surface superficially unchanged; but the overall structure is different and the almost intangible qualities of an untouched painting, in direct descent, as it were, from the artist's hand, have been lost.

The Effects of Dirt and Varnish

The optical qualities of the paint and ground are more dramatically, but usually less irreversibly, affected by layers of dirt and varnish on their top surfaces. The practice of varnishing paintings is, of course, very old; its purpose is to protect the paint and to give to the colours a gloss, saturation and unified clarity which they may have lost on drying.

However, these very qualities were often precisely contrary to the effects that many Impressionist painters sought to achieve. They frequently used paint deliberately leached of some of its oil, so that the resulting appearance might be dry and matt: such a surface would scatter the light falling on it, and appear desaturated and slightly chalky. The optical effect of a varnish – even a totally clear one – applied over paint like this, would be to deepen and saturate the colours and give a uniform shine to all areas of a painting, regardless of whether different surface glosses were intended.

Impressionist painters often expressed the wish that their paintings should not be varnished. On the back of one of his paintings, *Landscape at Chaponval* of 1880 (Paris, Musée d'Orsay), Pissarro wrote, 'please do not varnish this picture, C. Pissarro.' Monet, too, was reluctant to varnish his paintings, but many were varnished by dealers in order to sell them. Durand-Ruel apparently told him that 'collectors find your canvases too plastery; to sell them, I am obliged to varnish them with bitumen.' Such a heavy and probably tinted varnish would have been disastrous for the brilliant, dry surfaces of Impressionist paintings. Even when they permitted varnishing by dealers, these painters stressed the need for a totally colourless film. Pissarro wrote to Murer in 1878: 'I am going to recommend to the dealer not to varnish [it] except with a colourless varnish.'

Since they were painted, most Impressionist paintings have been varnished, first by dealers, perhaps trying to give them a more traditional 'finished' look, and then by collectors and museums, who have varnished and revarnished them routinely for protection. The inevitable consequence of all this varnishing is the natural discoloration of the resins used and the complete distortion of key values of texture and colour. Cleaning even a slightly discoloured varnish from an Impressionist painting is usually a revelation (Plate 64); when the discoloration is more significant,

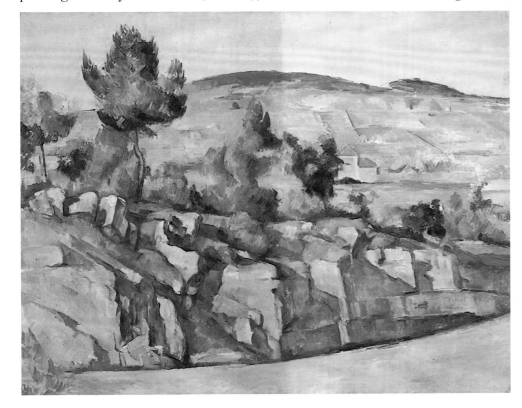

Plate 64　Paul Cézanne, *Hillside in Provence* (Cat. no. 15), during varnish removal

results can be startling (Plate 65). Occasionally, significant dirt layers are found beneath varnishes, indication that some time elapsed before varnishing was carried out. Where a painting has never been varnished (there are no such cases in this catalogue) the build-up of grey dirt directly on the paint surface can be both distorting for the image and difficult to remove: very refined cleaning methods have to be employed.

The whole visual vocabulary of Impressionist paintings is dependent on vivid colour contrasts and subtle colour interactions; any discoloration – from above or below – can destroy the painter's intention. Treatment now is confined to minimal intervention. Linings, if they are carried out at all, are performed only with adhesives that do not penetrate the canvas; varnishes for newly cleaned paintings are applied very thinly with relatively low refractive-index resins that will protect, but not optically saturate, the paint layers. For the fragile surfaces of unlined and – very occasionally – unvarnished pictures, protection in the form of a glazed frame may be necessary.

Framing

It is not always realised that our perception of the appearance of a painting is considerably affected by its frame. The traditional eighteenth- and nineteenth-century frame was made of carved wood, which was then gilded. The use of moulded plaster for frames became common during the nineteenth century, but the frame retained its traditional appearance. In general it was viewed purely as an isolating element, separating the painting from the surrounding wall, but it also had the additional benefit of providing an element of ornamentation to the painting. However, while such a frame might be entirely appropriate for a conventional or traditional picture displayed in the Salon or in an official collection, many artists felt that this was not necessarily the case for a contemporary painting. Pissarro

complained bitterly about the installation of the collection of paintings, including Impressionist pictures, bequeathed to the French government by the painter Gustave Caillebotte, in an annexe to the Luxembourg Museum in 1896. The authorities chose gold frames for them, suitable for their new setting, but not, Pissarro plainly thought, for the paintings themselves: in a letter to his son Lucien he described the room as poorly lit, the frames as villainous and the paintings as being too tightly hung.

The Impressionists developed the use of white and coloured frames, which were more in harmony with their paintings. The use of flatter mouldings, too, permitted some continuity between the painting and its frame, and, if desired, between the picture and the surrounding wall (the colour of wall coverings in exhibition venues is discussed on page 107). White frames were often used from the 1870s; their luminosity matched the overall lightness of tone of the paintings, particularly the landscapes, and picked up the pattern of light. White permitted every touch of colour in the painting to play its full part: no one colour was emphasised at the expense of another.

At first the use of white frames was considered revolutionary; Paul Durand-Ruel strongly disapproved of Pissarro using them at the third Impressionist exhibition in 1877, as Pissarro's letters reveal. This is understandable: for a dealer who wished to sell paintings, even contemporary paintings, to an uncomprehending public, to abandon the conventional gold frame would appear to be the act of a madman. Pissarro was rather amused when, a few years later, Durand-Ruel exhibited a number of his paintings in London in the desired white frames. For Pissarro's one-man show in May 1883, Durand-Ruel allowed the painter to display his pictures as he liked. Pissarro wrote to his son: 'I have put plenty of space between each painting. I am quite satisfied with my arrangement. Durand has left me completely free; I have two rooms with white frames, looking very good.'

The use of coloured frames or mounts had been suggested by Chevreul in his *De la Loi du contraste simultané des couleurs* of 1839, although no artist had taken up the idea in France before the Impressionists. Chevreul had taken eight identical lithographs of a lake scene and had framed each in a plain wood frame, with a coloured card border between the print and the frame. These were then compared with a ninth copy of the print bordered in white. Chevreul found that the use of coloured borders enhanced the harmonies and contrasts of the colours in the print. Certain Impressionist painters tried the effect of frames of all colours. At the fourth Impressionist exhibition, the American artist Mary Cassatt exhibited portraits in red and in green frames, and for the fifth exhibition, Pissarro showed paintings in frames in the complementary colour to the dominant tone of the painting. His letters reveal a continuing interest in coloured frames; he wrote to his niece Esther advising her on the choice of colour for a frame – a salmon pink seems to have been proposed – and suggesting the mixture of pigments she should use to obtain it. Unfortunately, very few nineteenth-century paintings are now displayed in the experimental coloured frames the artists chose originally. A rare surviving example is Caillebotte's *Richard Gallo and his Dog Dick at Petit-Gennevilliers* (Plate 66). The greenish colour of the frame, as well as enhancing the greens of the trees and grass, gives a warmth to the brilliant reflections in the water and an agreeable harmony to the painting as a whole.

During the 1880s, the strict Salon regulations on the exhibiting of pictures relaxed sufficiently to permit the use of dark wood or black frames: indeed Hareux, writing in 1888–9, thought these were very appropriate for paintings of 'violent

Plate 66 Gustave Caillebotte, *Richard Gallo and his Dog Dick at Petit-Gennevilliers*, 1884, in its original frame. 89 × 116 cm. Private Collection

coloration where yellow dominates', if a gold fillet bordered the painting itself. The Impressionists themselves did not reject the gold frame completely. Although Pissarro never liked them, Renoir retained an affection for them, admiring well-crafted, crisply carved wood and the warmth of colour of the gold, which he found particularly effective for portraits. He is known to have used standard size canvases for his portraits, because they would fit the gold frames generally available. Monet, too, did not object to the use of gold frames, as the element of luxury they provided often increased the chance of a sale.

Dealers, Galleries and the Exhibition of Pictures

The first Impressionist exhibition of 1874 exemplifies the changes that were taking place in the sale and exhibition of pictures in the middle decades of the nineteenth century. The traditional dominance of the Salon was beginning to be challenged as painters became increasingly dissatisfied both with the selection procedures and with the overcrowded hanging of paintings. At the same time, the market for paintings was growing and, in parallel with this, specialist picture dealers began to appear. The backgrounds of such dealers varied, as did the scale and range of their activities, but a great many rose from the ranks of the colour merchants.

One of the colour merchants most frequently mentioned by Pissarro and Monet in their correspondence was Latouche. Louis Latouche and his wife ran a small shop selling paints and other artists' materials at 34 rue Lafayette, on the corner of the rue Lafitte. *The Watering Place at Marly-le-Roi*, by Sisley (Cat. no. 7), was painted on a Latouche canvas. Latouche was himself a painter, exhibiting in the first Impressionist exhibition held in premises belonging to the photographer Nadar in the boulevard des Capucines in 1874. One reason for his prominence in their correspondence is that he was also a dealer, accepting works from his painter customers and showing them in his window in the hopes of attracting a purchaser. Boudin wrote, in a letter to a friend in 1869, that a study of Sainte-Adresse by Monet had attracted large crowds in front of the window when displayed there in 1867.

The progress from colour merchant to picture dealer was not uncommon: Haro, Delacroix's colour merchant, dealt in pictures by the 1850s and, as we have seen, Ange and Alexis Ottoz followed the same path (see page 43). The development came about as the colour merchant took paintings in exchange or as part-payment for materials, as Père Tanguy did for Pissarro, van Gogh and others. Pictures were also hired out for short periods. The father of Paul Durand-Ruel started his career as a dealer by agreeing to take watercolours, lithographs and paintings as payment from his artist customers in the late 1820s and early 1830s. The business had started as a paper shop, to which Durand-Ruel *père* had added artists' materials at the suggestion of friends. By 1833 he left the management of the stationery business to an employee (to whom, in fact, he sold the business in 1839) and opened a new branch devoted solely to artists' materials and paintings in the rue des Petits Champs. The firm was still dealing in artists' materials as late as 1869, by which time the shop was situated at 1 rue de la Paix. Only then did Paul Durand-Ruel, who had taken over the business from his father in 1865, decide to concentrate his energies on being a dealer. He gave up the rue de la Paix premises (to his lasting regret, for they were in an excellent situation) and bought the premises between the rue Le Peletier and the rue Lafitte, with entrances on both, which became the gallery where the second and third Impressionist exhibitions were held.

Many dealers started by selling engravings. In the eighteenth and early nineteenth centuries, colour merchants had often sold engravings for young artists and amateur painters to copy; Adolphe Goupil started a business producing and publishing high-quality engravings of Old Master and contemporary paintings in 1827. At first he bought only contemporary paintings for reproduction, choosing academic Salon paintings with popular, often historical, themes, like the works of Paul Delaroche and his followers. Gradually he began to sell the paintings as well and thus developed a highly profitable business: by 1864 the firm had a number of branches all over Europe and a correspondent in New York. The uncle of Vincent and Theo van Gogh, also named Vincent, was associated with the firm and both his nephews, as a result of his benevolent influence, worked in one branch of Goupil's or another· at some point in their lives. In 1875 the firm was taken over by Etienne Boussod (married to Goupil's grand-daughter) and a partner, Valadon, but it remained extremely successful.

The sort of pictures that a dealer would normally handle were standard-sized works (see pages 44–6). The enormous paintings sometimes exhibited at the Salon, and intended for public buildings, would be quite impossible to sell to the ordinary customer. In general, also, it would be difficult to sell works that were

unconventional in appearance. Criticisms of the Impressionists reveal that the sketchy 'unfinished' quality of some of their work was disliked and misunderstood by many critics, who either mocked or dismissed such paintings as *ébauches* or *pochades*. In the early 1870s Monet worked up paintings like *The Petit Bras* (Cat. no. 6) to a conventional degree of finish, but later in the decade he did not conform to this convention and often found his work unsaleable. Durand-Ruel (who was, perhaps, unusual in being less concerned than some dealers about the question of finish) encouraged him to pay more attention to this aspect of his work and by 1880, when Emile Zola criticised him for having 'given in . . . to his facility of production' at the expense of quality, Monet had already been obliged to revise his ideas.

Dealers tended to specialise in a particular type or school of painting, or in the works of certain selected painters, whose work they particularly admired or expected to be able to sell. In the 1840s Durand-Ruel *père* was associated with the paintings of the Barbizon School; later, in 1855, the firm entered into an unwritten agreement with the academic painter William Bouguereau, whereby they would purchase much of his work over the next ten years. Paul Durand-Ruel was the first dealer to acquire a monopoly of an artist's works when he bought up Théodore Rousseau's entire stock of sketches – seventy paintings – in one transaction. Goupil dealt in fashionable popular contemporary art; his daughter had married the successful Salon painter Jean-Léon Gérôme, and the gallery specialised in painters like Gérôme, Meissonier and other well-known academic painters; they also dealt in Barbizon School paintings when their works became popular.

A dealer like Goupil was in an entirely different league from the small dealers like Latouche or Père Martin. Martin (who had been a singer and chorister before selling paintings) had been one of the first to sell Corot's works and was a supporter of Jongkind. He worked hard to persuade the public to take up the works of Pissarro, who first came into contact with him around 1868, although after the first Impressionist exhibition in 1874 he refused to take the artist's work, disliking Pissarro's latest 'heavy, common style with that muddy palette of his'. A successful business could afford to pay artists well because sales were almost guaranteed. Martin, who lived at 52 rue Lafitte from the late 1860s until 1876, when he moved to rue Saint-Georges, paid only 20–40 francs or so to Pissarro for example, and might sell the paintings for around 60–80 francs.

Durand-Ruel seems to have supported the Impressionists sometimes against his better judgement as a businessman, but he made the point in his Memoirs that the fashionable always sold far more easily than the work of truly great painters: the more original and personal the style of the painters, the less the public understood it. To a large extent his loyalty was repaid: he was always on cordial terms with Renoir, for instance, standing as godfather to one of the painter's children, but with Monet his relationship was less easy. Durand-Ruel wanted his artists to deal exclusively with him, particularly after he had arranged a successful exhibition of their work in New York in 1886. Monet was not above playing one dealer off against another and, in the early 1880s, had also made successful business arrangements with the dealer Georges Petit, who bought three of his paintings in 1879 or 1880 and exhibited his work on several occasions thereafter.

The location of the dealer's premises was an important consideration. Durand-Ruel was loath to give up his gallery in the rue de la Paix because it was particularly well sited. Before acquiring the premises in the rue Lafitte/rue Le Peletier, he had

hoped to rent the rooms in the boulevard des Italiens in which Louis Martinet, the publisher of the *Courrier Artistique*, had organised exhibitions from 1861 to 1865 – Manet had exhibited there in 1861 – with the rich people of Paris passing his door. Sadly, the deal fell through and although the premises he obtained had two entrances the roads themselves were less frequented by the sort of clientele he wanted to attract.

Few dealers had any exhibition space; the best they could do was to put an attractive picture in their shop window, as Latouche did with his Monets, in the hope of encouraging customers to inspect the rest of their stock. In 1858, Théophile Gautier described the rue Lafitte as 'a sort of permanent Salon' since five or six shops displayed works in their windows which were changed regularly and illuminated at night. By 1877 there were about seven picture dealers in the street, one of whom was Durand-Ruel. If an artist or groups of artists wished to put on an exhibition, it was usually necessary to rent – and decorate – rooms for the purpose, as the Impressionists did for their first group exhibition. They were fortunate in that Durand-Ruel was able to put on some of their subsequent exhibitions. In 1883, for example, he organised a series of one-man shows at his new galleries at 9 boulevard de la Madeleine, featuring, successively, Boudin, Monet, Renoir, Pissarro and Sisley. From the evidence provided by his letters, we know that Pissarro was very enthusiastic about the project. Durand-Ruel, in later life, came to realise that such ventures might establish the reputation of the painters, but that they were not good for sales: prospective purchasers became confused by the abundance of choice and hesitated to buy anything.

Today, the public are accustomed to seeing Impressionist and other similar, medium-sized, nineteenth-century paintings displayed well-spaced, in a single row, against a pale-coloured wall. This was not the case in the second half of the nineteenth century. Philippe Burty described the walls of the rooms in which the first Impressionist exhibition was held as having been covered in a brownish-red woollen fabric; the walls of galleries were commonly this colour. The paintings would thus have stood out as light bright areas against a dark ground, from which they were separated by their gold frames (the use of white and differently coloured frames came a little later; see page 103). It must be remembered that, to some degree, the works displayed at the Salon and other official exhibitions appeared to the general public to indicate high quality, thus it is not surprising that dealers and those hoping to sell paintings imitated some of the Salon practices. (The Salon had strict rules governing the exhibition of pictures, which extended to such details as the width of frame bordering the picture and the details written on the label.) From around 1880, artists began to experiment with different coloured wall coverings, abandoning the official red-brown. Pissarro, when he heard of James McNeill Whistler's exhibition of etchings at the Fine Art Society, Bond Street, in rooms decorated in white and yellow, commented that the Impressionists had been the first to try such experimental colours at the fifth Impressionist exhibition in the rue des Pyramides in 1880: Pissarro's room had been lilac and yellow.

The Salon rooms differed from private exhibition space in being spacious, rather high and in having very particular and implacable lighting conditions. In the first half of the nineteenth century, the Salon was held in the Salon Carré of the Louvre, later spreading into adjoining rooms. Because there was so little space, paintings were hung in four or five rows, one above the other, frames frequently touching. Any small painting hung high up, just below the ceiling, would be impossible to see. From 1857,

the Salon exhibition was held in the Palais de l'Industrie in the Champs-Elysées, which was more spacious, but the paintings were still hung in rows, one above the other, and the small informal picture could easily be lost among the highly finished, bitumen-brown, standard Salon fare (Fig. 51). François Bonvin, writing to Louis Martinet on the occasion of the exhibition of his works that the dealer put on in 1861, commented that intimate pictures needed an informal setting. Goupil-Fesquet, in a handbook for painters published in 1877, recommended that small paintings should be hung at eye level so that they could be seen close up; middle-sized paintings should be hung above, inclined so that the spectator's line of vision was perpendicular to their surfaces.

The Impressionists, naturally, liked their pictures to be well hung, in at most two rows, if small. Pissarro, writing to Lucien in March 1883, commented favourably on the exhibition of Monet's works at Durand-Ruel's galleries, saying that there were not too many canvases and that they were well arranged (Fig. 52; see also page 103). Burty, writing on the 1880 Salon at which Monet exhibited *The Seine at Lavacourt*, described it as having been hung in the uppermost row, whereas at the rue des Pyramides, where the fifth Impressionist exhibition was held, it would have been easily visible at eye level. The viewing distance was perhaps rather more critical for freely handled paintings than for conventional works. Jules Castagnary, describing Monet's *Boulevard des Capucines* at the first Impressionist exhibition, said he would have to cross the road to find a good vantage point. On reviewing Monet's one-man show at Durand-Ruel's in March 1883, Burty quoted a friend of Monet as saying that he painted from a distance, and therefore the finished work should be viewed from a distance, in normal daylight, to judge its effect accurately, otherwise the surface appeared confused. Pissarro, later still, around 1888 (by which time he was experimenting with the colour and technique of his work – in parallel with the Neo-Impressionist works of Seurat and Signac) recommended a distance of about three times the diagonal of the picture.

The lighting of pictures was recognised to be particularly important. Burty described the daylight entering Nadar's rooms from the sides, as it would do through the windows of an ordinary apartment. By contrast, Merson, writing some years

earlier, in 1861, described the daylight entering the Palais de l'Industrie 'through the ice-cap of crystal topping the building' as illuminating paintings ruthlessly, draining pale colours and reducing delicate harmonies to nothing. On the other hand, some parts of the interior were shaded from the light and thus plunged in gloom. Hareux, in 1888–9, warned the amateur painter hoping to exhibit at the Salon that any softness or indecisive drawing which might pass without notice in the even studio light, would be pitilessly exposed in the Salon light. He advised the painter to take his painting into the strong daylight of the street to gauge the effect. Goupil-Fesquet's handbook recommended that paintings should be inclined, particularly if varnished, to avoid reflections from the windows; unvarnished paintings were almost impossible to light well. Monet, concerned that sunlight would fall directly on his canvases, wrote to Durand-Ruel in March 1883 requesting that blinds should be installed to protect his pictures (see also Cat. no. 9, page 165).

The effect of the frame on the appearance of Impressionist paintings is discussed elsewhere (see pages 102–4). However, it is perhaps worth mentioning here that the development of the use of a framing border with a flat profile not only emphasised the continuity of the painting with its frame, but also reduced the amount of shadow cast by the frame on the painted surface, making the painting that much easier to light.

The care taken over the hanging and lighting of paintings by the Impressionists gradually bore fruit, as may be seen by the comments of critics, who compared their exhibitions very favourably with the standards of exhibition and hanging at the Salon. By the 1880s, however, the climate had changed. The influence of the Salon was in decline, and public interest shifted towards the private specialist exhibitions, such as the one-man or group shows put on by commercial dealers like Georges Petit and Paul Durand-Ruel. It was in shows such as these that the future lay.

Fig. 52 Durand-Ruel exhibition at the Grafton Galleries, 1905, including Monet's *Lavacourt under Snow* (Cat. no. 13), showing the more spacious arrangement preferred by the Impressionists

THE CATALOGUE

Edouard Manet

1. Music in the Tuileries Gardens

Signed: éd Manet 1862
76 × 118 cm (30 × 46½ in.)

Early in 1863 Manet held his first major show in the gallery of the dealer Martinet on the boulevard des Italiens. The exhibition attracted considerable attention. Among the visitors were Claude Monet (who is reported to have been deeply impressed), and his friend Frédéric Bazille, who wrote to his parents: 'You wouldn't believe how much I am learning by looking at these pictures! One of these sessions is worth a month of work.' The fourteen paintings on display at Martinet's included *Music in the Tuileries Gardens* (Plate 69) which, of all Manet's work of the early 1860s, has a claim to be regarded as the most influential on the younger generation of Impressionists. In its subject matter it is the predecessor of numerous paintings of contemporary urban life in an outdoor setting, and in technique the bold handling of paint and unconventional use of colour provided a striking model of painterly freedom.

The Tuileries Gardens were a popular meeting place for the Parisian leisured classes. Concerts were performed regularly in one of the wide avenues that led from the rue de Rivoli to the river, and Manet's painting depicts the elegant crowd attracted by one of these events. The picture, however, is more than a general image of a fashionable milieu. Among the spectators it is possible to identify a number of Manet's friends and acquaintances. The artist himself appears at the extreme left; next to him, with the cane, is the painter Albert de Balleroy (who shared Manet's studio until 1859) (Plate 67); seated to their right is the poet and sculptor Zacharie Astruc; the two seated women in the foreground have been identified as a Madame Loubens and, with the veil, Madame Lejosne, the wife of Commandant Hippolyte Lejosne (in whose home Manet had met Baudelaire and Bazille); behind them, the three men in conversation may be identified as Baudelaire, the critic Théophile Gautier and Baron Taylor, Inspector of Museums (Plate 68). Immediately to their left is the painter Fantin-Latour. In the right-hand section of the painting the standing man leaning

forward slightly is probably Manet's brother, Eugène, and further back, seated against a tree, is Offenbach, the composer of popular operettas.

A wide range of sources has been proposed for the imagery of *Music in the Tuileries*, from Velázquez and Spanish art to contemporary engravings and illustrations of Parisian life. It has also been demonstrated convincingly that the painting reflects Manet's response to the ideas of his friend Baudelaire and especially his efforts to promote an art based on the experience of modern life. The artist must certainly have been familiar with the issues raised in Baudelaire's essay *Le Peintre de la vie moderne*, published in 1863 but written during the winter of 1859–60.

Baudelaire's enthusiasm for an art of the boulevards was fuelled by his admiration for the work of the artist-illustrator Constantin Guys (Fig. 53). Manet evidently shared this enthusiasm and, like Baudelaire, he owned a number of Guys's brilliantly observed drawings of everyday life. Some of the studies relating to *Music in the Tuileries* seem particularly close in spirit to works by Guys with their summary effects which border on caricature.

Although *Music in the Tuileries* bears the marks of Manet's careful study of Old Masters and contemporary art, the painting may have evolved from his interest in working outdoors, *en plein air*. This enthusiasm is documented before the Tuileries

Plate 67　Edouard Manet, *Music in the Tuileries Gardens*, detail showing Manet (left) and Balleroy

Plate 68　Edouard Manet, *Music in the Tuileries Gardens*, detail showing (from left to right) Baudelaire, Gautier and Taylor

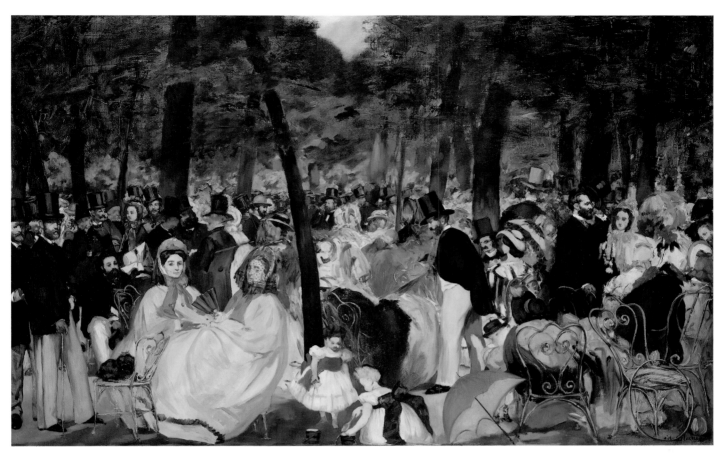

Plate 69 Edouard Manet,
*Music in the Tuileries
Gardens*

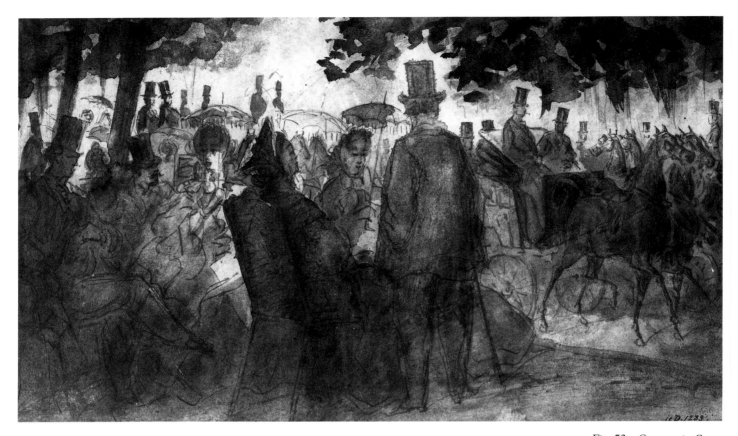

project, most notably by a sketch of Ambroise Adam in his garden datable to 1861. Many of the qualities of this freely handled and informal study are carried over into *Music in the Tuileries*.

According to his friend and biographer Antonin Proust, Manet went to the Tuileries almost every afternoon in the company of his friend Baudelaire, 'making studies in the open air, under the trees, after the children at play, and the groups of nurses (*nourrices*) resting in chairs'. There is an ink and wash sketch showing trees and a seated figure on a bench (Fig. 54), and a small oil study of nursemaids and children playing in a setting similar to that of *Music in the Tuileries* (Fig. 55). These may be examples of the open-air studies mentioned by Proust, although the oil study is quite highly worked.

Several other sketches and studies relating to *Music in the Tuileries* have survived. The most important of these is an ink and wash drawing on a double page from a sketchbook, which shows the two figures in conversation at the centre of the painting – the seated woman in the dark shawl pointing her folded parasol at the man standing with his hand behind his back (Fig. 56). This, it would seem, was the heart of Manet's composition, around which the rest of the picture evolved. Although it has been suggested that the curious

curved tree trunk behind the woman was a late idea, invented to link the upper and lower halves of the composition, the drawing clearly shows how Manet planned the positions of the trees from the beginning. Most of the minor figures in the drawing were not developed in the painting, but one – the tall man in the grey hat with his back to us – does reappear to the right of the broad tree trunk.

Comparison of the drawing with its corresponding area on the painting is particularly revealing: here Manet's apparently casual – even contradictory – attitude towards the notion of 'finish' is encapsulated. The figure of Eugène Manet is as highly finished as any figure in the painting. The seated woman, on the other hand, is little more than the preliminary painted lay-in; the sketchy drawing lines and the underlying white ground are both highly visible (Plate 70). The female heads immediately behind her (which do not appear in the drawing) are similarly 'unfinished'. This may well have been one of the first areas to be painted, and yet – while Manet worked up all the other figures to some degree of completion – he left this, the precise centre of the painting, unfinished and unfocused. In a work as carefully contrived as *Music in the Tuileries*, this must have been a conscious decision, a calculated reversal or rejection of established practice, emphasising that there is no central focus to the composition.

Other drawings used for details of the painting exist, but none gives further clues as to its evolution. The woman in a bonnet, in profile, to the left of Madame Loubens, is drawn on the same sheet as a study for the straw-hatted woman immediately above Madame Lejosne (Fig. 58). The head of Offenbach is drawn on the same sheet as his complete standing figure, which was not used (Fig. 57). The girl in the yellow straw hat immediately to the right of Offenbach was also drawn. Other drawings on these sheets appear to be close to – but not exact studies for – further figures in the painting.

Manet may have worked in the open air in preparation for this work, but there is no doubt that the final picture is a studio construction, as complex in its technique as in its design. It is very difficult to determine the exact order of working, but some general and some specific observations about Manet's methods can be made here.

The canvas, although not standard in size, was bought by Manet from the supplier Ange Ottoz of 2 rue de la Michodière, Paris, whose stamp was discovered on the back during relining in 1964 (Fig. 59). The ground, commercially applied, is a plain white one of lead white and chalk, and may be seen through and between the painted forms in many

Fig. 55 Edouard Manet, *Children in the Tuileries*. 38·1 × 46·4 cm. Providence, Museum of Art, Rhode Island School of Design

areas of the picture.

On this white ground, Manet sketched out his figures with a few thin lines and washes of dark colour which, as we have seen, are still partly visible in the central group. The great frieze of figures evolved over a considerable period of time as Manet worked out how the various groups might be constructed. It seems that there were at least two stages in the evolution of the painting. The initial lay-in, which incorporated information from some of the studies already mentioned, was followed by the imposition of the specific likenesses of the artist's friends and acquaintances. The extent of the first lay-in is not clear, but it seems likely that when Manet began work he had no precise idea how many portraits he would include, and obviously fitted in some of the heads at a late stage. There are two clear examples of this: the head of Offenbach

Plate 70 Edouard Manet, *Music in the Tuileries Gardens*, detail of seated woman

Fig. 56 Edouard Manet, *The Tuileries Gardens*. Pencil and ink wash on two sheets of a sketchbook, 18·5 × 22·2 cm. Private Collection

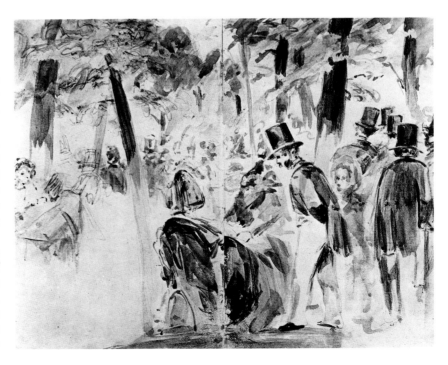

against the broad tree towards the right – who, indeed, *is* little more than a head since Manet did not paint his shoulders (Plate 71); and, towards the left, the striking full-face portrait of Fantin-Latour (Plate 72) for which Manet had to put in a block of pink paint over the dark background, still visible around the hat brim and in the X-ray (Fig. 60).

The canopy of foliage which forms the entire upper half of the painting has every appearance of being unfinished or even damaged – but it is certainly almost unchanged since Manet completed his painting. He clearly intended the effect seen here, perhaps to throw the line of figures below into sharper relief, and achieved it by painting dark green tones and then scraping back almost to the ground with a palette knife (Plate 73). This was an early passage of painting since it passes under the heads of the figures. Once the figures began to be developed, other opaque greens were brushed on to give form to the foliage, to outline the heads and hats and to link foreground and background by suggesting green filtered sunlight under the distant trees. This forms the light horizontal band seen across the centre of the X-ray.

In painting the figures themselves, Manet's departure from traditional practice was every bit as radical as the unfocused composition or the scraped background. Gone are the conventions of chiaroscuro painting, the modelled forms, the cool half-tones between highlight and shadow. Instead, Manet gives us a succession of images simplified as flat unmodulated blocks of light and dark, captured with the uncompromising directness of a flash photograph. An analogy with photography may be appropriate here, since Manet is known to have been influenced by the newly emerging technology. It may not be too fanciful either to suppose that the way the figures in *Music in the Tuileries* appear to move in and out of focus might also derive from a familiarity with photographic images.

The development of the painting in compositional blocks was clearly a lengthy process. A great variety of superimposed brushwork can be seen across the picture, both wet over dry and wet-into-wet, both detailed and expansive. The final touches even included a tiny illusionistic detail in *trompe l'oeil*: having already signed the painting 'éd Manet' in the lower right corner, he painted the chair against which the hoop leans, and then seems to have painted the hoop itself passing, with witty ambiguity, in front of the signature (Plate 74). The date, 1862, painted in a different colour, was probably added slightly later by Manet himself, possibly for the exhibition at Martinet's in 1863.

The range of pigments employed by Manet differs in some ways from the developed Impress-

Fig. 58 Edouard Manet, *Two Women in Profile.* Conté crayon, 18·5 × 11 cm. Private Collection

Fig. 57 Edouard Manet, *Study of Four Figures.* Pencil, 18·2 × 10·9 cm. Paris, Musée du Louvre, Cabinet des Dessins

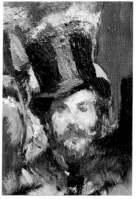

Plate 72 Edouard Manet, *Music in the Tuileries Gardens*, detail showing Fantin-Latour

Plate 71 Edouard Manet, *Music in the Tuileries Gardens*, detail showing Offenbach

116

ionist palette of the following decade. There is strikingly heightened colour in small areas, particularly for the bonnets and hats of the women in the crowd, picked out within a generally sombre setting. The choice of materials in the painting expresses these contrasts, with the widespread use of earth pigments, white and black in the foreground composition of browns, creams, blacks and greys. These provide a foil for the more powerful colours, such as cobalt blue, chrome orange and emerald green, all newly available pigments.

The spread of dark green foliage occupying the upper half of the picture is laid in with an unusual combination of glazing pigments. The glaze is mixed from two related nineteenth-century copper-arsenic greens, Scheele's green (copper arsenite) and emerald green (copper acetoarsenite), in a matrix of yellow lake pigment. Further depth is imparted to the translucent paint by the addition of some ivory black, and the yellowish tone of the lake is reinforced with a certain amount of yellow ochre (Plate 75). Paint of this constitution is sufficiently translucent to act as a genuine glaze. Since it is applied in this part of the picture as a single layer directly on to the primed canvas and subsequently scraped back, the luminosity of the light-coloured ground shines through the dark, saturated green of the foliage. The colour and translucency of these greens are reminiscent of the darker landscape and foliage glazes, also applied over a light ground, in other pictures by Manet of the early 1860s, notably in the *Déjeuner sur l'herbe* (signed and dated 1863; Paris, Musée d'Orsay). Manet's use of glaze paint layers in this way relates more closely to traditional practice than to later Impressionist techniques, although in *Music in the Tuileries*, the pigments chosen to produce the effect were modern.

The dense green used to link together the upper and lower sections of the composition contains the same pigments used for the dark green foliage glaze, but rendered opaque by the addition of white pigment and, in the yellower areas, enriched with yellow ochre. This layer was applied directly over the dark glazing green seen exposed in the upper parts of the trees, both in the middle distance and as more isolated patches higher up, to add detail within the canopy of foliage (Plate 76).

The foreground is in general more thickly and opaquely worked, as the X-ray (see Fig. 60) indicates. The black clothes of the male figures in the crowd, however, appear rather dark in the radiograph, since they are depicted principally in ivory black, which is relatively transparent to X-rays. Interestingly, these very dark paints are not pure black, but incorporate a variety of coloured pigment particles, particularly cobalt blue, with

small amounts of orange-brown ochre and even a little white, to enliven otherwise flat dark tones (Plate 77). The lighter greys of the clothes and in the foreground are similar, with the white component increased, but they also show the addition of coloured pigments such as cobalt blue, viridian and ochre to produce an extra dimension of subtle colour. Surprisingly, even the cream and light brown colours of the foreground and the dresses of Madame Loubens and Madame Lejosne, although mainly based on earth colours mixed with white and a little black, incorporate colourful pigment, particularly cobalt blue.

In *Music in the Tuileries*, the most vivid touches of colour, particularly the blues, reds and yellows used to depict the assortment of headgear worn by

Fig. 59 Edouard Manet, *Music in the Tuileries Gardens*, detail of back of canvas during relining, showing canvas stamp

Plate 73 Edouard Manet, *Music in the Tuileries Gardens*, detail of trees

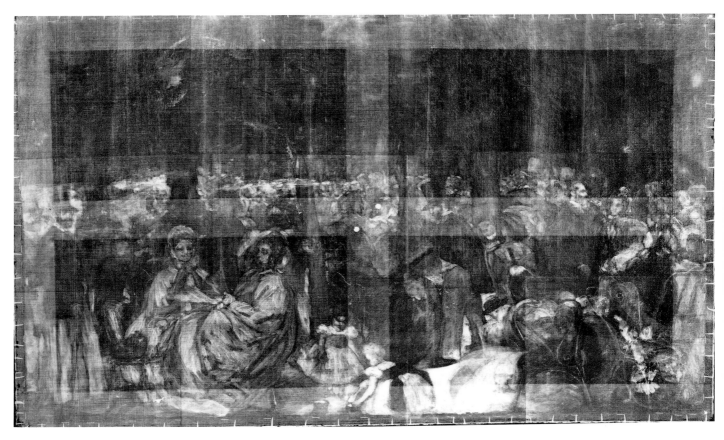

the women, are painted in much purer pigment. The light mid-blues are simple mixtures of cobalt blue with white, while chrome orange (Plate 78) in one case, and vermilion in the other, are used unmixed for the bonnets of the two women at the far right of the crowd. Apart from yellow ochre, which occurs in certain of the mixed paints mentioned above, two types of 'Naples yellow' have been identified in the picture. The dull, slightly mustard-yellow highlights on the cane chairs are in streaks of genuine Naples yellow, that is, of the composition of a lead-antimonate pigment (*jaune d'antimoine*). On the other hand, the lighter primrose yellow of the bonnet of the woman at the left is in a pre-formulated tint made from zinc white ground with lead chromate and yellow earth. The colour is a manufacturers' mixture, likely to have been sold in the 1860s as a tube-colour under the name '*jaune de Naples*'.

The detection of zinc, as zinc white, in a number of the coloured paint samples is also unusual, since analysis has shown that the white

Fig. 60 Edouard Manet, *Music in the Tuileries Gardens*, X-ray

Plate 74 Edouard Manet, *Music in the Tuileries Gardens*, detail showing signature

pigment in the picture is pure lead white (basic lead carbonate). Zinc oxide is present in the otherwise pure vermilion, chrome orange and emerald green paints, as well as in the yellows, and it is known that zinc-white-based tints were sold as tube-colours at this time. The aim was to produce manufactured shades of colour of a cleaner, lighter appearance than those incorporating lead white. Similar specialist materials were chosen rather later by Pissarro for his two London scenes (Cat. nos. 4 and 5), in which zinc is also present in certain of the colours, particularly the mixed greens.

A detailed analysis of *Music in the Tuileries* reveals the extent of Manet's innovative approach. Elements of traditional practice remain, for example in the use of complex glazes, but overall, the painting is remarkable for its breadth of handling and daring manipulation of colour effects. There seems little doubt that Manet was mounting a conscious challenge to established pictorial conventions. The lack of a central focus or of any measured spatial recession seems deliberately artless. Similarly, the combination of several techniques of brushwork within a single painting further undermines its coherence and unity. Although it is clearly the result of an elaborate process of construction and experiment, *Music in the Tuileries* retains a sense of immediacy and even of improvisation that Manet often sought to achieve and that seems admirably suited to its novel outdoor subject.

Manet's works caused an uproar when they were shown at Martinet's gallery in 1863, and *Music in the Tuileries* in particular provoked considerable outrage. The 'spotting' of colour across the surface disturbed the conservative critic Paul Mantz, who saw 'colour caricatured, not colour itself'. Manet's use of visible touches of paint (*taches*) was equally distressing for an audience conditioned to the mirror-smooth finish of academic art. Hippolyte Babou recognised 'the *tache*-Baudelaire, the *tache*-Gautier, and even the *tache*-Manet . . .' An anecdote recounted by Zola in 1867 also conveys the antagonism provoked by the *tache*: 'an exasperated *amateur* was threatening to take violent action if *Music in the Tuileries* was allowed to remain in the exhibition gallery. I understand the anger of the *amateur*: imagine under the trees of the Tuileries a whole crowd, a hundred people perhaps, who are bustling around in the sun; each person is a simple *tache*, scarcely fixed, on which the details become lines or black dots. If I had been there, I would have asked the *amateur* to stand at a respectful distance: then he would have seen that these *taches* were alive, that the crowd was talking, and that this canvas was one of the characteristic works of the artist, the one where he has most obeyed his eyes

and temperament.' The hostility which greeted Manet heralded the criticism which would later be directed at the Impressionists. Certainly his liberating example was not lost on the younger generation. The summary brushwork, bold colour and informal composition of *Music in the Tuileries* all anticipate the techniques and devices that would be fully explored by Monet and his colleagues in the 1870s.

Plate 75 Dark green glaze for foliage, comprising a mixture of Scheele's green, emerald green and yellow lake with some added ivory black and yellow ochre. The glaze is painted directly over the white ground. Thin cross-section by transmitted light, 545×

Plate 76 Opaque yellow-green of foliage, with white pigment and further yellow ochre added to the glazing mixture shown in Plate 75. The opaque highlight is painted over the green glazing layer. Cross-section, 370×

Plate 77 Very dark paint of Eugène Manet's coat (far left), showing the addition of cobalt blue, white and orange-brown earth pigment to a matrix of ivory black. Top surface of an unmounted fragment, 100×

Plate 78 Chrome orange used for the bonnet of the standing woman, far right. Top surface of an unmounted fragment, 200×

119

Claude Monet

2. Bathers at La Grenouillère

Signed lower right: Claude Monet 1869
73 × 92 cm (28¾ × 36¼ in.)

During the summer of 1869 Monet worked with Renoir at La Grenouillère, a well-known café and bathing place on the banks of an island in the Seine near Bougival. In the 1860s this was a popular venue with local residents and day trippers from Paris. Although it may not yet have acquired the seedy associations described, for example, by Maupassant in the 1880s, certainly the atmosphere was relaxed and informal, attracting a broad spectrum of society.

La Grenouillère was frequently described and illustrated in popular journals in the late 1860s and these accounts enable us to reconstruct the site in some detail. A café and an office for renting boats were constructed on a platform on two barges, moored permanently to the river bank. Nearby an area was roped off for bathing. A small rounded island (known as the 'camembert' or 'flower pot') provided a popular vantage point and this was connected to the café and to the bank by narrow wooden walkways. To paint the view in the National Gallery picture (Plate 80) Monet must have set up his easel on the floating platform looking towards the bathing area. The islet is just out of the picture, but is included in Renoir's painting of the same view (Plate 79).

The Grenouillère paintings are remarkable for their informality and spontaneity, and yet both Monet and Renoir seem to have had a more ambitious project in mind. In a letter to Bazille of 25 September 1869, Monet described his plans for the forthcoming Salon exhibition: 'I do have a dream, a painting [*tableau*] of the bathing place at La Grenouillère for which I have made a few bad sketches [*mauvaises pochades*], but it is no more than a dream. Renoir, who has spent two months here, also wants to paint the same picture.'

The National Gallery painting, together with a work of similar dimensions in the Metropolitan Museum of Art, New York (Plate 81), and a smaller study of boats (Fig. 61) must be counted as these 'bad sketches'. A more elaborate composition of this motif was produced, but it is presumed to have been destroyed and is now known only through old photographs (Fig. 62).

It seems that Monet was still adhering to traditional practice, producing studies after nature which could be developed into a painting suitable for submission to the Salon. Yet there is some evidence that he was closing the gap between a sketch and a finished work. Both the National Gallery and Metropolitan pictures are large for *pochades* and appear to have been only slightly smaller than the lost painting. If Monet was happy to work on this scale out of doors, there is no reason why the final painting could not have been worked on, at least in part, in front of the motif. Interestingly, this painting does not relate directly to either of the studies but combines elements from both. The London and New York paintings might be decribed as dress rehearsals for the effects of light and colour which were to be incorporated into the larger image. Unfortunately the surviving photographs (see Fig. 62) do not allow us to judge the degree of finish in the lost picture.

While we can only speculate on the relationship between this group of pictures, a detailed

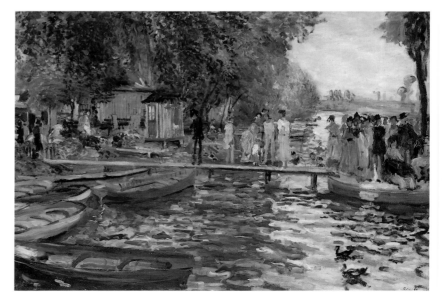

Plate 79 Pierre-Auguste Renoir, *La Grenouillère*, 1869. 65 × 93 cm. Winterthur, Oskar Reinhart Collection

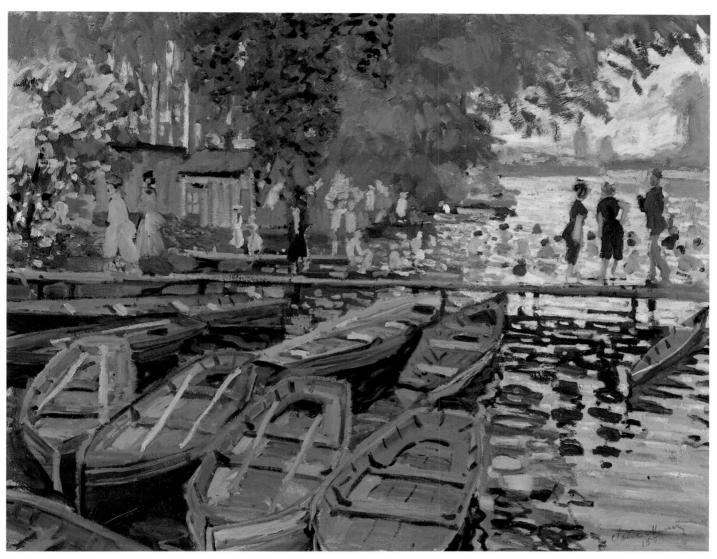

Plate 80 Claude Monet,
Bathers at La Grenouillère

analysis of the London painting offers an insight into Monet's technical experimentation at a key point in his career.

The canvas, of no. 30 figure size (pages 45–6), is of standard format, and was therefore presumably commercially primed. The cream-coloured ground, containing lead white with a little yellow earth and some barium sulphate as extender, is hardly used in the final image. The only area in which it influences the paint layers significantly is in the sky and foliage at the upper right corner. These areas are very sketchily painted and the cream priming is left uncovered at many points.

The technique of *Bathers at La Grenouillère* seems astonishingly direct, even now. Monet had to work with great rapidity to capture the fleeting effects of rippling water, dappled sunlight, shifting boats and the constant movement of bathers and promenaders. His method of working with broad, flat square-ended brushes and fluid, opaque paint allowed him to apply his colour at enormous speed – in thickly dabbed clusters for the pale green sunlit trees at the upper left, in broken, horizontal slabs for the water at the right, and in long continuous outlines for the boats and the catwalk. Paint textures are used to suggest light and substance as well as form: in many parts of the picture, the material nature of the paint itself overwhelms the details of the scene depicted.

It is interesting to compare the nascent Impressionist technique of *Bathers at La Grenouillère* with an important painting of the previous year, *On the Seine at Bennecourt* (Art Institute of Chicago; Plate 82). In the earlier picture, the elements that make the Grenouillère paintings so new and distinctive are already present, but in a less fragmented form. The rapid, fluid working in several stages, the bold handling with flat square-ended brushes, the brilliant hues, the drab green foliage with black shadows – all anticipate the Grenouillère style. But the difference is immediately obvious in the water. In the Chicago painting the handling is broad and continuous, but by the following year the colour has become broken and chopped. This is not just the difference between calm and rippled water, but also deliberate fragmentation of the image.

On the Seine at Bennecourt was painted in distinct stages with clear alterations to the image as work proceeded. For example, X-rays have revealed that there was originally a child on the woman's lap, which was subsequently painted out and replaced by the little white dog.

Similarly, Monet did not arrive at the apparently instantaneous image of *Bathers at La Grenouillère* without significant revisions. Dried brush-

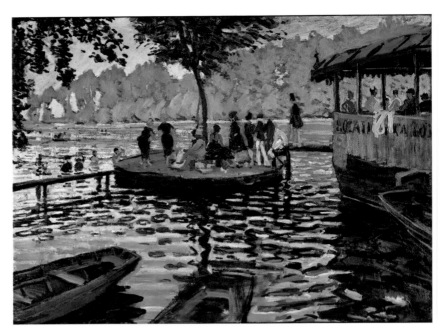

Plate 81 Claude Monet, *La Grenouillère*, 1869. 74.6 × 99·7 cm. New York, Metropolitan Museum of Art

Fig. 61 Claude Monet, *Rowing-boats*, 1869. 33 × 46 cm. Bremen, Kunsthalle

strokes under the present surface and the evidence of the X-ray (Fig. 63) show that he not only altered the arrangement of his composition, but probably also made a first rapid lay-in of boats with the canvas the other way up. Curving forms that may be faintly discerned in the upper half of the X-ray

Fig. 62 Claude Monet, *La Grenouillère*. Destroyed?

122

make sense as boats only if the picture is inverted; brushstrokes beneath the foliage and the central figures appear to belong to this first sketch.

This seems to have been a false start and Monet soon turned his picture over to begin again; but even in this painting the outlines of the boats were shifted several times as he worked. Perhaps he was responding to real alterations in the scene before him, as the boats were moved around. The red painted gunwales of boats in various different positions can be seen quite clearly below the present surface (Plate 83).

The X-ray also reveals that there was originally more pale sky and more extensive light foliage in the upper right centre; Monet blocked out much of it with the dense green background, thereby confining the brilliant sunlit areas to the edges of the painting. Even more intriguing is the possible reworking of an area at the far right edge. It seems that Monet may have included a glimpse of the 'camembert' itself, as in Renoir's corresponding picture. The X-ray indicates that what appears to be

Plate 82 Claude Monet, *On the Seine at Bennecourt*, 1868. 81·5 × 100·7 cm. Chicago, Art Institute

the curve of the island and its reflection were later painted out. The small skiff was then added over this area.

The execution of *Bathers at La Grenouillère* is impulsive and experimental and may be seen as an exploration of the painting methods which Monet was to develop in the 1870s. Many of Monet's later

Fig. 63 Claude Monet, *Bathers at La Grenouillère*, X-ray

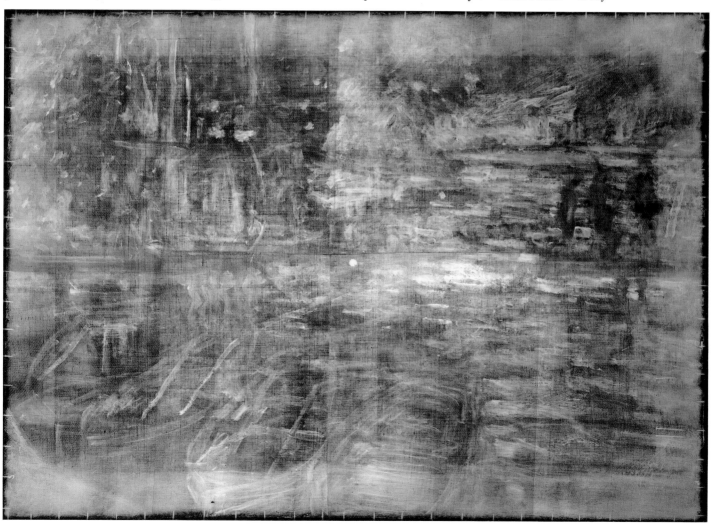

ideas concerning paint manipulation and the use of colour are already present, but not applied in a systematic way. The immediacy of painting wet-into-wet, and drawing one colour into another, is clearly seen throughout the composition, perhaps most obviously in the painting of the water (Plate 84) and the boats, while even the purer-coloured strokes and touches of unmixed paint at the surface were dabbed and drawn over the underpainting before it was dry (Plate 85).

The picture exposes two consistent traits in Monet's construction of colour, which he tended later to separate as distinct techniques in any one painting. Colour mixtures for the drabber paints in *Bathers at La Grenouillère* are often surprisingly elaborate combinations of highly coloured pigment, as they are also, for example, in *The Petit Bras of the Seine at Argenteuil* (Cat. no. 6) of 1872 and in *The Gare Saint-Lazare* (Cat. no. 10) of 1877. In other later pictures, Monet concentrated on the use of purer high-key colour, relying on its juxtaposition to create flickering effects, as in the Lavacourt snow scene (Cat. no. 13) of around 1879.

Both techniques occur in this early *pochade*. In the duller-coloured paints, for example the bluish greens, khakis and olive tones of the boats in the foreground, Monet mixes combinations involving emerald green, viridian and cobalt blue (Plate 86), all individually strongly coloured pigments, while the greyer tones are similarly constructed, with black and white pigment added. Others of the coloured greys in the picture are even more complicated combinations (Plate 87). In the 1870s, Monet's use of black became less apparent, but it is interesting that here, in the very dark water between the boats, which is based substantially on ivory black, he has also mixed in cobalt blue and red ochre to indicate a nuance of colour even in the deepest shadow.

Purer strokes and touches of pigment are applied and worked over the whole surface of the picture. Pure bright red vermilion forms the flowers at the left edge (Plate 85); a streak of unmixed chrome yellow makes a highlight on one of the distant boats; and patches of 'chrome green' on its own are dabbed to make the livid yellow-green foliage in the upper left. The constitution of the chrome-green colour is a combination of chrome yellow with Prussian blue, but it was sold in this pre-mixed form as one of the cheaper artists' pigments; in practice, it can be regarded as a single pigment.

Prussian blue as a separate colour, once again unmixed, is used for the intense blackish blues of the dark reflections on the water's surface, and also for the figures on the catwalk that cause them. The

Plate 83 Claude Monet, *Bathers at La Grenouillère*, detail showing altered positions of boats

Plate 84 Swirls of cobalt blue and white from the mid-tone of the water. Top surface of an unmounted fragment, 100×

Plate 85 Pure vermilion of flower, left, dabbed over underpaint while wet, drawing up colour from the lower layers. Cross-section, 200×

Plate 86 Dull blue-green gunwale of foreground boat, painted in emerald green, viridian and cobalt blue. Cross-section, 415×

pigment largely disappeared from Impressionist painting in the 1870s, rejected as one of the more old-fashioned and poorly performing artists' colours; it was replaced particularly by cobalt blue, by synthetic ultramarine and to some extent by cerulean blue. The mid-blue tones of the water here are in cobalt blue with white, the mauver streaks containing also some red lake pigment.

The full range of Monet's palette for *Bathers at La Grenouillère* is large. Fifteen separate pigments have been detected in the painting, and it is not certain that the entire range has been identified in this study. Monet seems to have selected his paints rather arbitrarily from the considerable choice on offer in the 1860s, perhaps because he was unsure of his exact requirements when going to paint out of doors. Cost must also have been a factor; many of the paints used here were among the less expensive artists' colours.

The works that Monet and Renoir produced at La Grenouillère are often celebrated as important documents in the history of Impressionism, and in technique and subject matter are frequently cited as introducing some of the major concerns of Monet and his colleagues in the 1870s. In making such claims it is possible not only to overlook aspects of Monet's work in the later 1860s, but also to elevate the status of pictures which were apparently produced as sketches for more finished exhibition paintings. Nevertheless, there is no doubt that the two artists were embarking on a significant initiative in paint handling and use of colour. In spite of Monet's disparaging comments about his *pochades*, the qualities of directness and immediacy that they presented would become the basis of his subsequent work.

There is a curious footnote to the technical history of this picture. At some point after its completion an area of heavily tinted varnish was added to the foliage at the upper right. The patch of sky with its barely concealed *pentimenti* was also overpainted. Presumably these alterations were carried out by a subsequent owner or dealer in order to 'improve' the crude appearance of this area of Monet's sketch. The overpainting and varnish were removed when *Bathers at La Grenouillère* was acquired by the National Gallery in 1979 (Figs. 64 and 65).

Plate 87 Mixed grey paint for roof of small hut, middle distance, containing a variety of coloured pigment particles. Top surface of an unmounted fragment, 200×

Fig. 64 Claude Monet, *Bathers at La Grenouillère*, detail of top right corner before removal of overpaint; and Fig. 65 after removal of overpaint

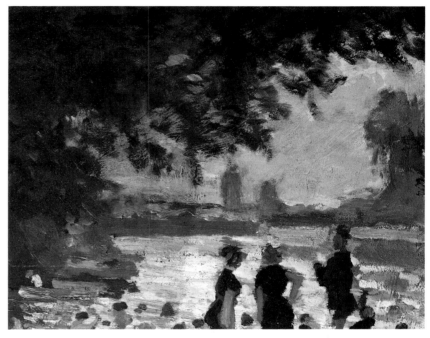

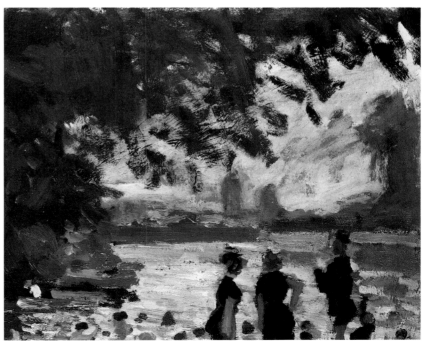

Claude Monet

3. The Beach at Trouville

Signed lower left: Cl. M. 70
37·5 × 45·7 cm (14¾ × 18 in.)

Monet married his first wife, Camille, on 28 June 1870. Soon afterwards he took his bride and their three-year-old son to Trouville on the Normandy coast. They stayed until the autumn, when Monet left for England to avoid the Franco-Prussian war. Trouville, a small but fashionable resort, had already attracted the attention of contemporary artists. Courbet had worked there in 1865 and 1866, and Boudin had painted numerous views of the beach during the 1860s. This was also familiar territory for Monet, who had worked nearby on previous painting campaigns along this coast. Boudin and his wife joined the Monet family in mid-August. In a letter to Monet written nearly thirty years later, in 1897, Boudin recalled: 'I can still see you with that poor Camille at the Hôtel de Tivoli. I have even preserved from that time a drawing that represents you on the beach. . . . Little Jean plays on the sand and his papa is seated on the ground, a sketchbook in his hand. . . .'

During this stay Monet produced one view of the harbour and three paintings of the seafront with its row of elegant hotels (see Plate 103). The National Gallery picture (Plate 89) is one of five smaller works which depict figures on the beach (Plate 90). All of these are rapid and summary in execution and although there is no evidence that they were preparatory studies, it is possible that Monet may have been gathering information for a larger picture of figures in an outdoor setting, an idea that had preoccupied him in the later 1860s. Monet added his initials and the date to the National Gallery picture, which suggests that he saw it as complete in itself. The informal nature of this signature might well indicate that the picture was intended as a private gift, but unfortunately the early provenance is unknown.

Monet has adopted a close-up view of the figures, ignoring the precedent of Boudin's paintings in which colourful groups of figures are strung along the line of the beach and observed from a distant vantage point (Plate 88). Camille seems to

Plate 88 Eugène Boudin, *Beach Scene, Trouville*. 18·2 × 46·2 cm. London, National Gallery

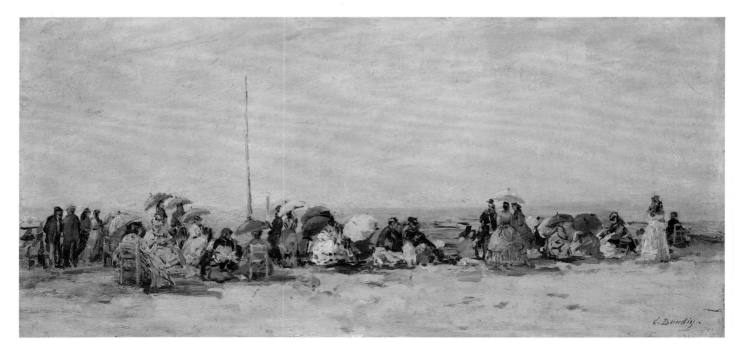

Plate 89 Claude Monet,
The Beach at Trouville

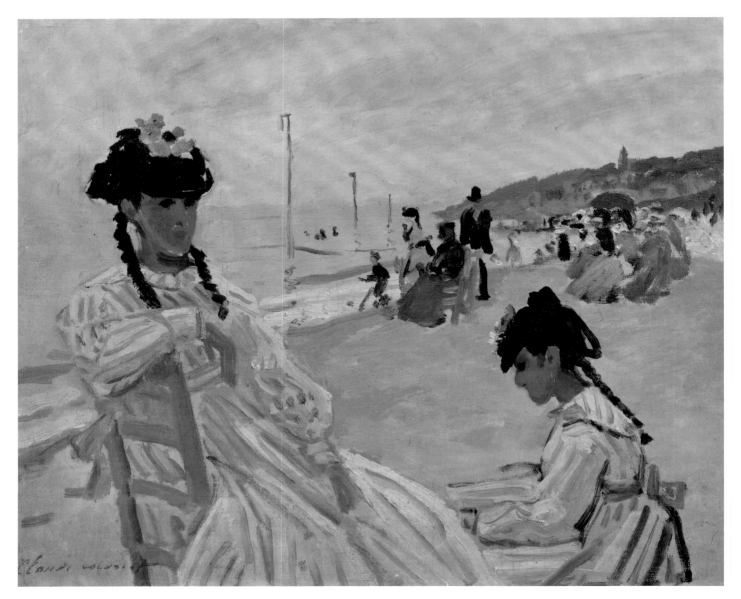

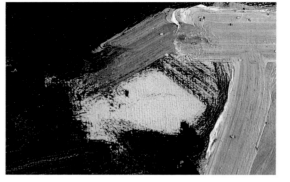

Plate 90　Claude Monet,
The Beach at Trouville, 1870.
38 × 46 cm. Paris, Musée
Marmottan

Plate 91　*Far left* Claude
Monet, *The Beach at
Trouville*, detail of Camille's
bonnet
Plate 92　*Left* Detail of
hand, showing unpainted
ground colour

have posed for most of the beach scenes and in this picture she is the woman at the left with the flowered hat and light blue and grey dress. Across her face, Monet has painted a veil or shadow. A veil might seem odd, but appears in at least one other related beach painting; a shadow seems incompati-ble with the angle of the sun. Her companion in the darker costume has been variously identified as a member of Monet's family, as Camille's sister and, perhaps most convincingly, as Madame Boudin. Hanging on the chair-back may be a child's beach shoe, evidence perhaps of the unseen Jean.

Monet painted *The Beach at Trouville* on a commercially prepared canvas corresponding to the standard no. 8 portrait size (see pages 45–6). The painting is lined and no supplier's stamp is visible or recorded.

The ground is composed principally of lead white with small quantities of yellow and black pigment (see Plate 98). Its colour is a slightly warm pale grey and this is visible all over the painting: indeed, Monet's use of the ground colour as a key component of the finished design is demonstrated as vividly here as in any of his other works. It is seen, quite unmodified, in many parts of the sky, around the chair, as a highlight in Camille's floral bonnet (Plate 91) and as the unpainted hand of the woman on the right (Plate 92). At the very centre of the composition there is a patch of uncovered ground colour – a startling device, as radical in its way as the cropped figures at either side.

Consciously or not, Monet exploits the various effects of simultaneous contrast: the apparent tone of each patch of ground colour is modified by the colours that surround it. Thus, next to the black of the dress on the right the ground looks neutral, cool and light. Alongside the pale sand colour of the beach, the grey ground takes on a darker, bluer

Plate 93 Claude Monet, *The Beach at Trouville*, macro detail of sand particles on Camille's dress

Plate 94 Claude Monet, *The Beach at Trouville*, macro detail of sand cluster near bottom of painting

Plate 96 Claude Monet, *The Beach at Trouville*, macro detail of sand, showing hollows where grains have been lost

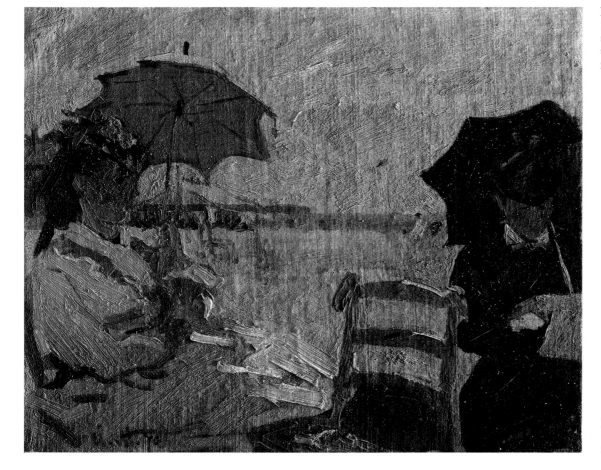

Plate 95 Claude Monet, *The Beach at Trouville*, in raking light

look. Up in the sky, among the slightly greenish brushstrokes, it assumes a hint of mauve. The contrast is both of colour and of brightness. In a work of such rapid execution the effects are as likely to be improvised as carefully pre-determined. Monet may well have intended at first to paint the hand of the woman on the right, but the effect of leaving it bare might have intrigued him. Similarly, the exact amounts of unpainted ground, now fixed for ever, were at the time the result of a sponta-neous empiricism that we can only partly recapture today. Nevertheless, the light grey underlying tone was a premeditated choice, perfectly suiting the fresh luminous effects of light and atmosphere that Monet sought to capture.

The Beach at Trouville is the quintessential *plein-air* painting – so much so that the surface of the painting is peppered with grains of real sand, blown there by the very wind that Monet is depicting in the flapping of the flag and the tug of the parasol. Until recent cleaning, the full extent of the sand was not appreciated, because much of it had been discreetly retouched during a previous restoration. Under the microscope, the sand can be seen to contain a great variety of multicoloured shell fragments (Plate 93). Most of them lie right on top of the paint surface, but some are actually mixed in with the paint, indicating that Monet probably got sand on his palette and on the painting as he worked. Near the bottom of the picture – through the chair-back, in Camille's dress and on the chair-seat – are three thick sand clusters that look like fingerprints (Plate 94). There are many pitted hollows in the paint surface where sand grains have been lost (Plate 96).

The grains of sand, together with the bold brushwork, are revealed strikingly in a raking-light photograph (Plate 95). Monet used a variety of brushes, ranging from a fine point for the flagpole to a broad, flat square-ended bristle for the almost abstract highlights on Camille's dress. The highest white impasto here has been flattened while still soft by the impression of another canvas, presum-ably as a result of Monet stacking his pictures immediately after painting (Plate 97). Everywhere the paint is worked wet-in-wet, with later brush-strokes dragging and blending with earlier ones to produce subtle colour mixtures on the picture surface. For example, an orange-beige stroke at the right of the beach passes down beside the shoulder of the woman in black, just touches it at the bottom and then curves away to the left dragging a streak of black with it (Plate 101): it then touches the brown-grey of the chair-back and becomes progressively darker. Similar effects of wet-in-wet handling may be observed throughout the picture.

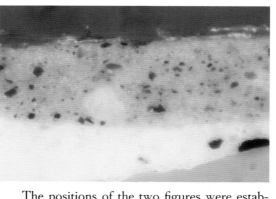

Plate 97 Claude Monet, *The Beach at Trouville*, macro detail of flattened paint, showing canvas impression

Plate 101 Claude Monet, *The Beach at Trouville*, macro detail of wet-in-wet brushwork

Plate 98 *Left* Cross-section from Madame Boudin's black dress, showing the addition of coloured pigments to the ivory black paint. Magnification, 550×

Plate 99 Cross-section from green ribbon on Camille's bonnet painted in viridian and white, with a black layer containing coloured pigment beneath. Magnification, 550×

Plate 100 Cool grey shadow of Camille's dress, comprising white tinted with French ultramarine, ivory black and red-brown ochre. Cross-section, 550×

The positions of the two figures were estab-lished with a thin dark lay-in. This may be seen under Camille's dress as a dull, scrubbed blue. The woman at the right was first sketched in with thin black paint, still visible in her hat; successive layers of broad bluish black and deep black detailing gave

shape to the figure.

It is rare in Impressionist paintings to find a pure black. What appears to be deep black here is made up of ivory black with earth pigments, cobalt blue and even a little vermilion (Plate 98). In general, whenever Monet appears to be using pure black pigment, a range of other colours is mixed in. A similar black mixture is also used for the dark trimming of Camille's bonnet, for example beneath the viridian decoration (Plate 99). The grey shadows of Camille's dress are given their principal tonality by the use of French ultramarine with a little vermilion and black (Plate 100). This is the only use of ultramarine in the painting. All the other blues are cobalt: for example, both the light grey-blues of the dress and the grey-blue parts of the sky are white and cobalt blue with small quantities of black and vermilion (Plate 102). The ribbon of the right-hand woman and the decoration on Camille's bonnet are pure cobalt blue with a little white. The blue parasol lining is also cobalt blue, but modified with small amounts of black and red earth.

The dull red of the cushion on the chair is a mixture of a red-brown earth pigment, white, black and cobalt blue. Earth pigments are used for the flesh colours and Camille's chair-back. The colour of the beach comprises white, yellow earth, vermilion and a little black.

The Beach at Trouville stands poised between Monet's ambitious figure paintings of the 1860s and his smaller informal compositions of the 1870s. He was still preoccupied with the problem of painting figures in bright outdoor light, but transitory effects of light and atmosphere were beginning to take precedence over traditional subject matter. Like *Bathers at La Grenouillère* of the previous year, the painting has the quality of a bold experiment: the broad, rapid handling, the luminous colour and informal arrangement conspire to render an extraordinary effect of spontaneity and immediacy.

Another painting from the Trouville group illustrates further Monet's freedom of handling and use of the uncovered grey ground. In *L'Hôtel des Roches Noires, Trouville* (Paris, Musée d'Orsay; Plate 103) a similar pale grey ground is visible. The brilliantly conceived flag is simply an unpainted area in the surrounding sky, with cream and red horizontals dashed over it to give a vivid impression of the wind tugging at the striped fabric. The figures at the left are painted over the already partly dry railings and lamps; but there is a great deal of wet-in-wet painting too, and similar use of broad brushwork and high impasto. In addition, Monet seems to have used a palette knife to apply some of the clouds – a technique reminiscent of Courbet but absent from *The Beach at Trouville*.

Plate 102 Bluish grey of Camille's dress, consisting of white, cobalt blue with a little vermilion and black. Small amounts of yellow and black pigments tint the ground layer. Cross-section, 200×

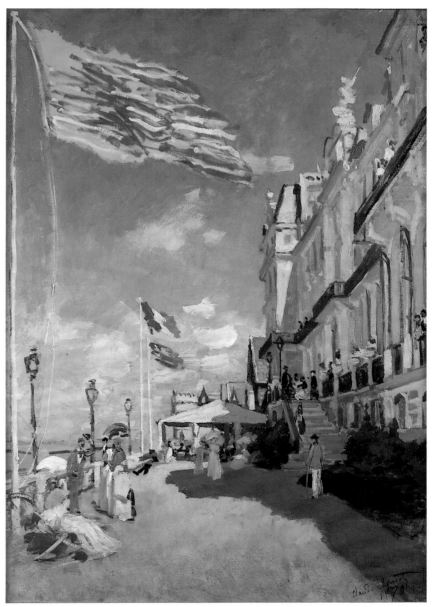

Plate 103 Claude Monet, *L'Hôtel des Roches Noires, Trouville*, 1870. 81·1 × 58·3 cm. Paris, Musée d'Orsay

Camille Pissarro

4. Fox Hill, Upper Norwood

Signed lower right: C. Pissarro. 70
35·3 × 45·7 cm (13⅞ × 18 in.)

Pissarro came to London during the Franco-Prussian War in the winter of 1870–1. When the Prussians invaded Paris in September, Pissarro, his mistress and two children left their home in the suburb of Louveciennes and took refuge with his friend Ludovic Piette at Montfoucault in Mayenne, before leaving for London, probably in early December

Pissarro's mother was already living in the south London suburb of Lower Norwood and the artist and his family took lodgings close by. This was a brief but important interlude for Pissarro. He met Paul Durand-Ruel, who later became his most important dealer, and renewed his contact with Monet, who had also escaped to the safety of England. Although he soon became disillusioned with his lack of success in finding buyers for his work, Pissarro later looked back on this stay with some fondness: 'Monet and I were very enthusiastic over the London landscapes. Monet worked in the parks whilst I living in Lower Norwood, at that time a charming suburb, studied the effect of fog, snow and springtime. We worked from nature . . .'

Twelve paintings and a small number of drawings and watercolours dating from this period in London have survived. All of them depict motifs within walking distance of Pissarro's accommodation (Plate 105). Although the traditional title of the National Gallery picture (Plate 106) identifies it as a view in Lower Norwood, the site depicted is probably Fox Hill in Upper Norwood. Many of the houses in this street have been rebuilt since the nineteenth century, but the general character of the street, with its distinctive bend, seems to correspond with Pissarro's picture (Plate 104). In any case, Pissarro probably had little interest in the detailed topography of a south London suburb – in March 1871 he exhibited one of his London paintings with the simple title *Snow Effect*.

The painting is now lined, but the original supplier's stamp was formerly visible on the back of the canvas (Fig. 66). Although indistinct,

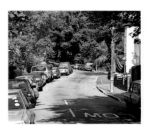

Plate 104 Photograph of Fox Hill, 1990

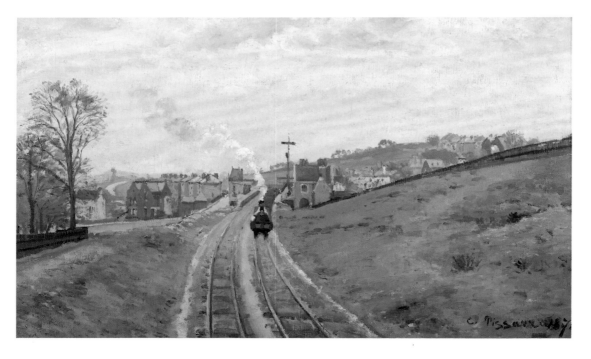

Plate 105 Camille Pissarro, *Lordship Lane Station, Dulwich*, 1871. 44 × 72·5 cm. London, Courtauld Institute Galleries

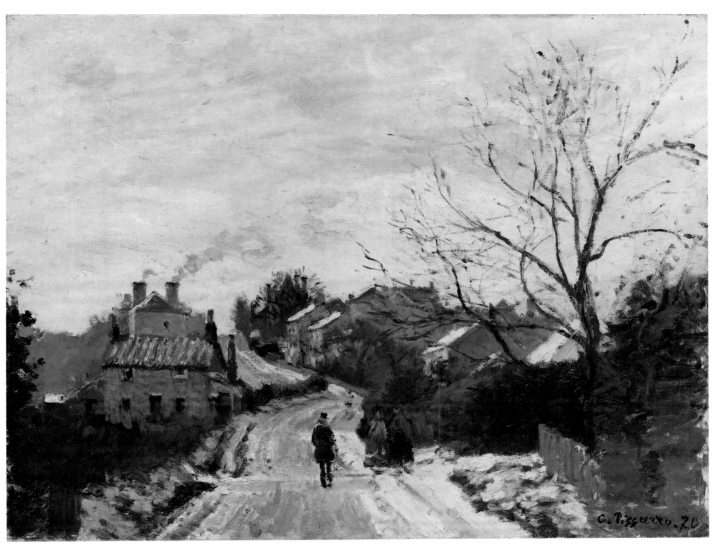

Plate 106 Camille
Pissarro, *Fox Hill, Upper
Norwood*

it is unmistakably from Charles Roberson & Co. of 99 Long Acre, London. The canvas is one of Roberson's standard sizes and the ground contains lead white and chalk in oil, the standard ingredients of Roberson's commercially applied primings. It is almost white in colour and is visible at the left and right edges and around the green fence, lower right.

Fox Hill appears to be a rapid, spontaneous *plein-air* rendering, painted largely wet-in-wet. However, closer examination shows that Pissarro must have worked on it in several stages. He seems to have sketched out the bare outlines of the composition in generally muted tones. At the next stage he worked rapidly with fluid paint, blending his colours on the canvas itself as he covered his *ébauche*. The large tree was streaked into the wet sky with stiff dark paint that skipped over the canvas weave (Plate 107) following only approximately the structure laid down in the initial sketch. Large areas of foliage were energetically brushed in at the right in dull reddish-brown earth colours with occasional orange touches, leaving the white ground bare at the edge. A reserve was left for the green fence to be included immediately afterwards. Everywhere, at this stage, thick strokes of lead white, merging with underlying and adjacent colours, were added for the snow (Fig. 67).

The two women appear to belong to this phase of working, but the man with the walking stick who greets them was painted a little later over the dried paint of the road (Plate 108) and does not show in the X-ray. There seems to have been a more distant figure in black beyond him, subsequently obliterated by horizontal bands of blue shadow. The painting may have been signed considerably later, since the colour of the signature does not correspond with any other paint used in the picture and it may have been mixed with varnish.

The evidence for this unexpectedly complex sequence consists mainly in the identification of dried brushstrokes below the upper layers, which follow the surface structure closely but not exactly. Some of these can be seen in the sky where the visible tree branches lie alongside branches from the preliminary lay-in which form dried tracks under the paint of the sky (Plate 109). Elsewhere, careful observation shows similar dried brushmarks defining the main features of the initial sketch.

Pissarro's palette in *Fox Hill* is fairly wide-ranging. The warm grey background on the left, for example, consists of a mixture of French ultramarine, vermilion, red earth, white and traces of black and yellow – a surprisingly elaborate combination, similar to the 'optical grey' observed in *The Avenue, Sydenham* (Cat. no. 5). The greens of the fence and elsewhere contain viridian and other pigments

Fig. 66 Camille Pissarro, *Fox Hill, Upper Norwood*, detail of back of canvas before lining, showing supplier's stamp

Plate 107 Camille Pissarro, *Fox Hill, Upper Norwood*, macro detail of tree branch and sky

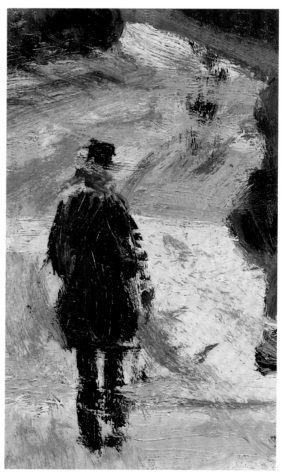

Plate 108 Camille Pissarro, *Fox Hill, Upper Norwood*, detail of man and painted-out figure beyond

(Plate 110). The dull reds, browns and orange are earth pigments.

The overall colour balance shows much more contrast between light and dark than in *The Avenue, Sydenham*. For all its layered structure, *Fox Hill* is still equivalent to a direct rendering of the scene before us. Colours are used strongly to make decided tonal contrasts between highlight and deep shadow. Half-shadows on the snow are simply painted in pale blue – used here partly as an approximate complementary to the warm colour of the worn snow, but also reflecting the blue of the sky. In *The Avenue, Sydenham* by contrast, everything appears confined within a narrow range of colour value and is diluted with white in a refined *peinture-claire* technique (see page 139).

Plate 109 Camille Pissarro, *Fox Hill, Upper Norwood*, macro detail of tree branch and traces of its original position

Plate 110 Translucent mixed dark green of foreground, left, containing viridian, an orange-red ochre, chrome yellow, ivory black and other pigments. Top surface of an unmounted fragment, 200×

Fig. 67 Camille Pissarro, *Fox Hill, Upper Norwood*. X-ray

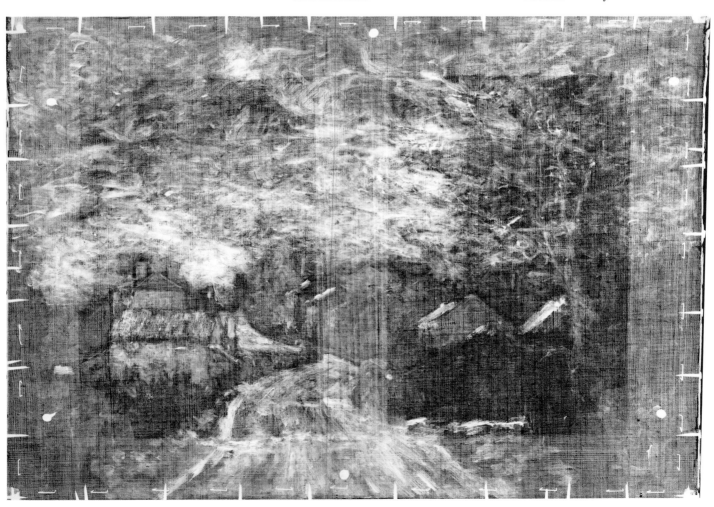

Camille Pissarro

5. The Avenue, Sydenham

Signed lower left: C. Pissarro. 1871
48 × 73 cm (19 × 28¾ in.)

The Avenue, Sydenham (Plate 113) is one of the twelve paintings dating from Pissarro's stay in London in 1870–1 (see also Cat. no. 4). The painting has the atmosphere of a spring scene, with trees coming into leaf, and was probably painted in April or May 1871, shortly before his return to France in June. Identification of the site presents little difficulty and the view is still recognisable today in what is now called Lawrie Park Avenue in Sydenham (Plate 111). The church of Saint Bartholomew, Westwood Hill, is in the background.

The composition of *The Avenue, Sydenham* is comparable to street scenes which Pissarro had painted alongside Monet at Louveciennes the previous year. The format is traditional, dominated by the receding avenue with the trees framing the central view, and establishing this perspective was clearly the first step in Pissarro's working procedure. This is demonstrated in a watercolour or gouache sketch of this scene (Paris, Louvre, Cabinet des Dessins; Plate 112) which appears to be a preparatory study. In the sketch the figures are drawn rudimentarily and many details, such as the white fence posts, are not shown. Pissarro has first pencilled in the converging lines and then the trees and buildings. This sequence seems to have been followed in the finished painting. Although the paint layers are mostly too thick for much underdrawing to be visible or detectable by infra-red photography, there is a line marking the side of the church tower that may be drawing, and another defining the right-hand chimney of the three red chimneys at the left. It is quite likely that Pissarro would have quickly and lightly sketched the basic 'scaffolding' for the composition, but it is now almost totally covered by paint.

The drawing may have been strengthened in places with buff-coloured paint. This was followed by a characteristic first phase of painting that is often found in Pissarro's work: the laying-in of the main areas with blocks of colour that do not quite touch. This technique is clearly revealed in the X-ray of the picture, in which all the principal areas —

the road, the fences, the buildings – appear to be silhouetted in black (Fig. 68).

After this first stage of painting, the ground colour would still have been visible between these separate areas. In the next phase the composition was gradually unified with wet-in-wet brushwork on top of the understructure; by the time this was complete, the ground was hardly visible.

The two main stages of painting are evident both on the picture surface and in cross-sections. In many areas the brushstrokes of the first lay-in can be seen below the upper layers. The grass verge at

Plate 112 Camille Pissarro, *The Avenue, Sydenham*. Pencil and watercolour or gouache, 15 × 25 cm. Paris, Musée du Louvre, Cabinet des Dessins

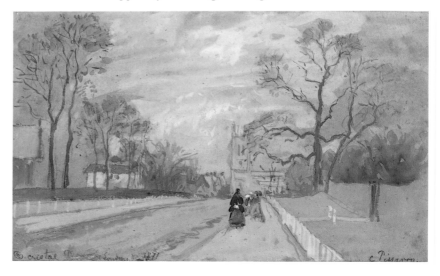

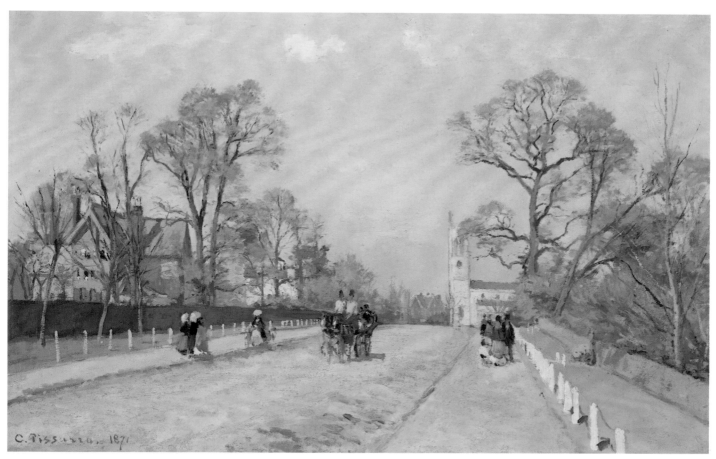

Plate 113 Camille Pissarro, *The Avenue, Sydenham*

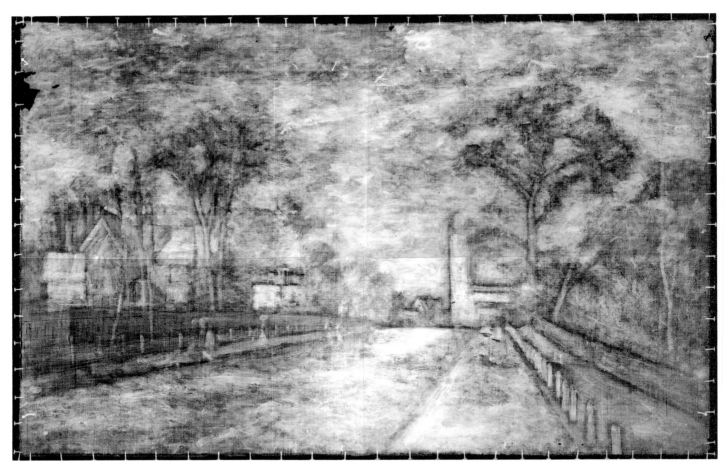

the right is painted in two layers of green (Plate 114), the lower one passing under the white posts, but the upper one going around them; this upper layer is denser and richer in lead white – hence the dark silhouette around each post in the X-ray. Two layers of green also make up the opposite verge. The grey fence on this left side is also painted in two stages: the initial lay-in was a light brown and then a complex 'optical grey' mixture was added on top (Plate 115).

The largest trees were painted directly on the ground (Plate 116) and the sky filled in around them, but other trees and branches were painted over the sky. Bushes and foliage were worked up from a basic greyish buff-coloured underpaint.

The figures were painted last, over paint that was dry. The dried brushwork of the left-hand pavement underlies the groups of figures there (Plate 117), and the horse-drawn carriage is quite clearly painted on the already completed roadway. The figures hardly register in the X-ray.

The most intriguing group is the one on the right-hand pavement below the church. Originally Pissarro painted just one woman walking towards us. This corresponds to the Paris sketch and was clearly intended by Pissarro until the very last

Fig. 68 Camille Pissarro, *The Avenue, Sydenham*, X-ray

Plate 114 Cross-section from the grass verge to the right, in two layers. The upper layer, containing viridian and emerald green, is richer in lead white than the lower. The underlying green layer is a complex mixture of pigment. Magnification, 200×

Plate 115 Dark grey of fence, left, containing white, French ultramarine, vermilion, orange-red ochre and only minor quantities of black. The underlayer is a mixed light brown. Cross-section, 200×

phase of the painting. Presumably he then noticed the rather emphatic and unwelcome vertical created

by the single figure and the church tower above, and decided to alter it. He painted out the figure and added the group alongside; the overpaint he used has darkened a little and cracked in drying. Through it we can just make out the woman's shape and the pink oval of her face: she is partly visible in an infra-red photograph – and even more so in an infra-red reflectogram (Figs. 69 and 70). A cross-section shows that she was wearing a turquoise dress worked in emerald green and that she was initially sketched in black over the already dry paint of the pavement (Plate 118).

Pissarro also subtly adjusted the topography to suit his purpose. The image of the church itself is modified for the painting: comparison with its actual somewhat solid appearance shows that Pissarro seems to have narrowed and elongated the tower and reduced the number of dark windows in order to give it a lighter, less substantial quality (Fig. 71).

For *The Avenue, Sydenham*, Pissarro used a commercially primed canvas, prepared with two ground layers of lead white and chalk, the upper layer richer in lead white. Although the ground is creamy white in colour, it is barely visible through the densely worked paint layers. Nevertheless, the clear, light tonality of this painting is striking, and owes much to the use of a great deal of white pigment; undiluted coloured pigment of a high key is relatively lacking. Much of the picture is worked in elaborate mixtures of pigment, lightened with white, leading to less intense contrasts than would result from the use of unmixed colours alone. This technique of using a pale or blond tonality to portray bright outdoor light was often used by landscape painters in the mid-nineteenth century, most notably by Corot. Instead of sharp contrasts of light and dark, everything appears unified in a colour field of constant value. This is one of the manifestations of the method known as *peinture claire*. The sky here is exceptional, with French ultramarine as the only coloured pigment used to tint the white matrix. In contrast, for the foreground greens Pissarro made use of elaborate mixtures in which he combined viridian, emerald green, chrome yellow and white, then further adjusted these with small quantities of French ultramarine, vermilion, earth pigment and ivory black (see, for example, Plate 114). The creams and warm browns of the roadway, footpaths and groups of trees are similarly complex in constitution, based on tints with white of varying proportions of vermilion and orange-red earth mixed with small amounts of ultramarine, ivory black, chrome yellow and even occasional additions of green pigment (see, for example, Plate 116). The strongly coloured strokes

Plate 116 Mixed brown underlayer for the trees, right, comprising white, vermilion, orange-red ochre, French ultramarine and traces of green. The creamy-white ground lies directly beneath. Cross-section, 550×

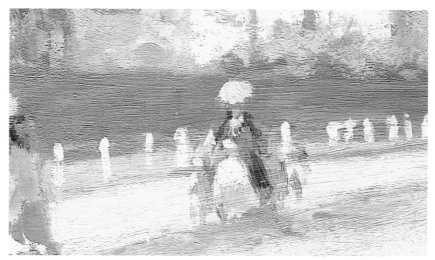

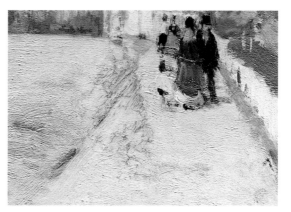

Plate 117 Camille Pissarro, *The Avenue, Sydenham*, detail

Fig. 69 Camille Pissarro, *The Avenue, Sydenham*, detail of infra-red photograph, revealing parts of the painted-out figure

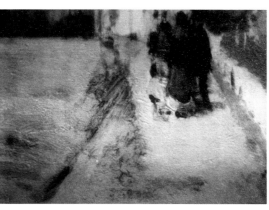

Fig. 70 Camille Pissarro, *The Avenue, Sydenham*, infra-red reflectogram, showing more of the hidden figure

which make up the red-brown shutters of the house to the left are more simply painted, substantially with only vermilion and orange-coloured earth pigment combined with white, although even here a trace of ultramarine has been added.

The detection of zinc as well as lead in a number of paint samples, including a pure white, suggests that the white used is a mixture of lead and zinc pigments. Similar results were recorded for *The Côte des Boeufs* (Cat. no. 9), painted six years later, signifying the unusual but perhaps consistent choice by Pissarro of a manufacturers' mixture of white supplied as an artists' tube-colour.

The use of French ultramarine as a dark component for paint mixtures is not unusual in Impressionist painting. The very high tinting strength of the pigment and its intense dark blue colour make it a suitable substitute for black in this role. The warm dark grey of the fence to the left, for example, involves a surprising conjunction of ultramarine and white with vermilion and an orange-red earth; only the smallest quantity of genuine black pigment is actually present (see Plate 115). The intention must have been to suggest nuances of colour even in the darkest tones. The pigment mixture for this warm deep grey is similar to that used for the browns of the trees, except that there the proportion of ultramarine was reduced, and the vermilion and earth colours predominate. By this method a coherence of colour in the more muted parts could be constructed, since the same

pigments are employed, differing only in their relative proportions in the paint layer. Tinted 'optical greys' of this kind are not unique to Pissarro's *Sydenham*, the same technique having been exploited by Monet for *The Beach at Trouville* (Cat. no. 3), and, much later, habitually by Cézanne, as in the blue-black shadows of *Hillside in Provence* (Cat. no. 15). Pissarro's painting of *Fox Hill, Upper Norwood* (Cat. no. 4) makes use of these warm and cool greys in the middle distance, also based on mixtures containing ultramarine in place of a black pigment. However, in the Sydenham view, the dark clothes of the group of figures walking on the left-hand footpath are painted with much purer ivory black, adjusted only slightly with a little red earth pigment and white.

The structure and colouring of *The Avenue, Sydenham* are consistent with other similar-sized paintings of 1871, including *Lordship Lane Station,*

Plate 118 Cross-section from painted-out figure, concealed beneath light greyish brown of pavement, right. The green intermediate layer, containing emerald green, is the woman's dress, and an initial dark sketching layer is visible beneath. Magnification, 200×

Fig. 71 Photograph of The Avenue, Sydenham, *c.* 1890

Dulwich (London, Courtauld Institute Galleries; Plate 105), and *The Crystal Palace* (Art Institute of Chicago; Plate 119). The same restricted colour values occur in all three pictures, such as the widespread use of greyish buff both for underpaint and for the finishing layers. It seems that Pissarro was consciously aiming at an atmospheric uniformity with limited colour contrasts.

The Avenue, Sydenham is a typical example of Pissarro's measured approach to Impressionism. The picture was obviously the result of careful planning and, although it retains the swift, broken touch of the *plein-air* painter, the forms are quite crisply defined and highly worked. The colour is vivid but hardly daring, the strong perspective providing a structure for the bright tonality. Indeed, the composition seems so familiar, it is tempting to compare the tree-lined view and the distant church to the famous seventeenth-century painting by Hobbema, *The Avenue at Middelharnis*. Pissarro may well have seen this work when it went on show at the National Gallery early in May 1871.

It is also interesting to compare *The Avenue, Sydenham* with its more modest counterpart, *Fox Hill, Upper Norwood*. Pissarro explored a range of different subjects in London and the smaller picture, with its picturesque groups of houses, has a distinctly rural character. It is more vigorously painted than the Sydenham view and still displays the qualities of a rapid outdoor sketch. By contrast, *The Avenue, Sydenham* is an imposing view of a fashionable, residential area, peopled with elegant bourgeoisie. Pissarro was keen to establish a market for his work in England and this respectable scene, worked to an acceptable degree of finish, was presumably the type of picture that he would have hoped to have placed with a dealer. His new contact, Durand-Ruel, bought four of his paintings in London and this was probably among them. Although the exact date of this purchase is not known, it appears in the stockbooks of Durand-Ruel's firm in August 1871.

Plate 119 Camille Pissarro, *The Crystal Palace*, 1871. 47·2 × 73·5 cm. Chicago, Art Institute

Claude Monet

6. The Petit Bras of the Seine at Argenteuil

Signed lower right: Claude Monet
54 × 73 cm (21¼ × 28¾ in.)

After a year spent in voluntary exile in England and Holland to avoid the Franco-Prussian war and the Paris Commune, Monet returned to France late in 1871. He settled in Argenteuil, a small suburban town on the Seine about nine kilometres from Paris. In the second half of the nineteenth century Argenteuil was famous as a centre for amateur boating and sailing and Monet's numerous paintings of the river banks, the regattas and the boat basin are among the most celebrated products of Impressionism. Less well known is a group of works depicting the Petit Bras, a backwater less than a mile downstream from the town. As the name implies, the Petit Bras was a narrow stretch of water separated from the main river by the Ile Marante. It was a tranquil corner which had a reputation as a quiet haven.

In 1872 Monet painted several pictures of the view looking upstream towards Argenteuil with the Ile Marante on the left (Plate 120). Sisley and Renoir, who worked with Monet on occasion at Argenteuil, painted the same motif. However, for the National Gallery picture (Plate 121), Monet has turned around to paint the view downstream, a vista with a rather different character. Here the river curves gently towards an empty horizon. The single large house across the river on the Ile Marante and the two small figures (presumably fishermen) are the only evidence of human intrusion into the landscape.

Plate 120 Claude Monet, *Sailing Boats at Argenteuil*, 1872. 50 × 65 cm. Paris, Musée d'Orsay

Plate 121 Claude Monet,
The Petit Bras of the Seine at
Argenteuil

Monet has switched from presenting Argenteuil as a suburban playground to depicting a more traditional rural scene. The gentle mood is heightened by the traditional compositional format, reminiscent of river scenes by Daubigny and Corot. As the spectator's eye is led along the diagonals of the river and the screen of poplars, the space is clearly defined as a progression from foreground, middle distance to background.

Monet bought his canvas ready prepared from Ange Ottoz of 2 rue de la Michodière, whose somewhat indistinct oval stamp is seen on the back: it is of standard no. 20 landscape size (see pages 45–6) and has remained unlined and on its original stretcher (Fig. 72). The canvas is an unusual one, tabby woven but of distinctly open weave because each thread is doubled. It is so open that the reverse of the ground layer can be seen clearly from the back between the threads. In places the ground has been forced through the weave to form small light-coloured lumps on the back of the canvas (Plate 122). The coarseness of the canvas is visible on the front of the painting where dryish paint has been

dragged across the corrugated texture.

The basic ground colour is greyish white, containing lead white, chalk and a little black: this is present alone on all the turnover edges. On the picture surface, there is a second thin ground of a pale mauve colour, containing lead white with traces of black and red earth, which is present

Fig. 72 Claude Monet, *The Petit Bras of the Seine at Argenteuil*, back of canvas

Plate 122 Claude Monet, *The Petit Bras of the Seine at Argenteuil*, back of canvas, detail

everywhere under the paint layers and is most obviously visible in the sky. This second priming, which may have been applied by Monet himself, or by Ottoz at his request, was one of Monet's many tinted grounds from the 1870s. He used a whole variety of pale ground colours throughout this period of his career, ranging from the creamy whites of the Grenouillère pictures in 1869, through the pale greys of the Trouville pictures in 1870, to the beige, mauve and even brown grounds of the mid- and late 1870s. There is no particular pattern to his choice: throughout he was also using white grounds.

The use of pale mauve in *The Petit Bras* sets up intriguing complementary contrasts in the sky, which is scumbled with greenish-yellow paint of a similar value. On their own the two colours are fairly desaturated and pale, but where they meet and surround each other, surprisingly forceful simultaneous contrasts occur, enhancing the separate tones and creating subtle vibrations of colour across the otherwise pallid sky.

The mauve priming may also be glimpsed between the colours of the water in the centre of the painting, but is completely covered by the thicker foreground. The general order of working is not easy to establish: the sloping foreground river bank seems to have been painted first and then heightened in colour and texture as work proceeded. The lightest horizontals in the river were the very last strokes of all, as they even overlap the two figures which were themselves added at a fairly late stage (Plate 123).

The sky at the left is painted densely around the tall poplars, which rely on the mauve ground for their underlying colour; warmer, browner stippling on top of the sky then completes the trees. At the right, the warm brown paint is used more densely for the trees, overlapping a reserve which had been left in the sky. The paint is applied so opaquely that Monet has had to lighten it by adding streaks of sky paint on top to suggest light filtering between the tree trunks. The area immediately above and to the left of the house is slightly rubbed and confused: here, Monet has successively added a block of sky paint over the brown trees and then quickly added trunks and branches over that, which have blurred and rather lost their form.

At the upper right is an example of a further technique Monet occasionally employed to lighten areas that had become too dead and dense. Here, he has scratched the paint – perhaps with the handle of his brush – to allow the light-coloured priming to show through (Plate 124). Another well-known example of this practice is his *Autumn Effect at Argenteuil* (London, Courtauld Institute Galleries),

Plate 123 Claude Monet, *The Petit Bras of the Seine at Argenteuil*, detail

Plate 124 Claude Monet, *The Petit Bras of the Seine at Argenteuil*, detail of scratched paint in the trees, upper right

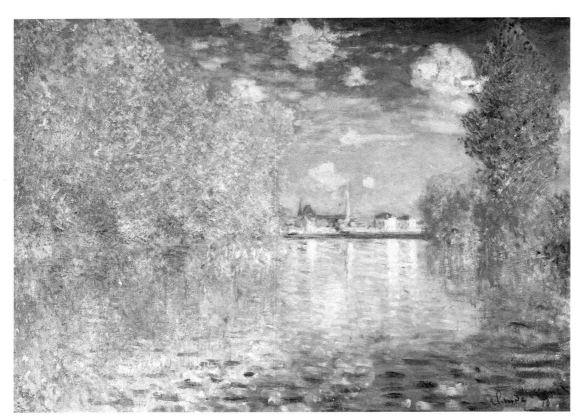

Fig. 73 Claude Monet, *Autumn Effect at Argenteuil,* 1873. 55 × 74·5 cm. London, Courtauld Institute Galleries

of 1873, in which very pronounced scratch marks are seen also in thickly painted trees at the upper right (Plate 125 and Fig. 73).

The tonal structure of *The Petit Bras of the Seine at Argenteuil* is complex. The composition may be divided into three distinct zones, each painted in a different technique: the cloud-filled sky painted with shifting pale tints; the middle distance defined in more strongly tinted greys; and the foreground with its stronger colour and sharper contrasts.

In the foreground the yellows, greens and browns, and their wide range of intermediate hues, are obtained by mixing, in varying ratios, some eight or nine separate pigments, many of which are strongly coloured on their own, but much duller in effect when they are combined. Two separate ranges of colour mixture are used. In all the tones where yellow appears to dominate, chrome yellow with some yellow ochre makes up the matrix (Plate 126), which is adjusted with varying but usually small amounts of white, black, vermilion, viridian and synthetic ultramarine. For the tonal range of the browns, white is mixed with an array of coloured pigment, typically: vermilion, opaque chromium oxide green, yellow and red earths, synthetic ultramarine, chrome yellow and black (Plate 127). The mauver browns contain more of the red components, vermilion and red ochre, and also a greater proportion of ultramarine and black,

Plate 125 Claude Monet, *Autumn Effect at Argenteuil,* 1873. Detail of Fig. 73

while in the mid-tone opaque brown colours, the proportion of chrome yellow is higher.

The middle distance is painted quite differently. It is a great deal more thinly and sketchily worked, Monet allowing the light-coloured ground to contribute to the soft tonalities. The paint is made essentially as a range of tinted greys, based on mixtures of synthetic ultramarine with white, then combined with other pigments to provide the coloured undertone (Plate 128). Apart from the basic greyish-blue mixture, the shifting muted colours are obtained by the addition of varying amounts of vermilion, red ochre, chrome yellow and ivory black. In the rosiest tones, the vermilion becomes a significant contributor, while as the greys become a shade greener, the yellow component is strengthened.

The sky makes use of yet another harmonised tonal system: of subtle very light tints based on a cream-coloured mixture of white with a small amount of yellow; the greener parts contain just a little French ultramarine. Both tones are enhanced by contrast with the mauve-tinted ground.

The picture does not involve pigment applied in pure form. Even for the small dark figures that punctuate the composition, apparently painted solely with black, Monet has mixed into the ivory black a small amount of chrome yellow and vermilion (Plate 129).

Monet's use of the most elaborate combination of paints seems intended to achieve a coherence in colour construction. This is a characteristic feature of his paintings of the 1870s. He attempts to unify his colours by the permutation of a large but constant selection of mixed pigments. The technique is most comprehensively used in *The Gare Saint-Lazare* (Cat. no. 10), painted some seven years later; clearly it was a favourite method.

At first glance *The Petit Bras of the Seine at Argenteuil* appears to represent an earlier stage in Monet's stylistic development. The traditional composition, muted colour scheme and restrained handling seem to have little in common with the daring effects employed in, for example, *Bathers at La Grenouillère* (Cat. no. 2). Certainly there is nothing radical about the use of an overall blond tonality dominated by atmospheric greys to create a luminous effect of overcast skies; this approach was well established among French landscape painters and was associated in particular with the work of Corot. But although the final effect of his picture is subdued, Monet has achieved his greys and browns through complex mixtures of strong clear colours. Subtle contrasts of colour are used alongside more conventional tinted greys as Monet combines his interest in brighter

colour with a more traditional tonality.

The earliest provenance of this picture is not known, but it seems safe to assume that Monet would have painted it with an eye to a dealer sale. When analysed in detail his methods may have been unusual, although the result was sufficiently conventional to conform to the established market for modest and informal rural landscapes.

Plate 126 Strongest greenish-yellow highlight from foreground river bank, principally of chrome yellow combined with yellow ochre. A more complex mixed yellow-brown paint lies beneath, over the light-coloured ground. Cross-section, 550×

Plate 127 Dark brown of foreground, comprising white mixed with vermilion, opaque chromic oxide green, yellow and red earths, French ultramarine, chrome yellow and black. Top surface of an unmounted fragment, 200×

Plate 128 Bluish grey near horizon, consisting of white tinted with French ultramarine, red ochre and other pigments. Top surface of an unmounted fragment, 200×

Plate 129 Ivory black tinted with chrome yellow and vermilion for the dark figures on the river bank. Top surface of an unmounted fragment, 100×

147

Alfred Sisley

7. The Watering Place at Marly-le-Roi

Signed lower left: Sisley. 75
49·5 × 65·5 cm (19½ × 25¾ in.)

Sisley moved to Marly-le-Roi early in 1875. He lived there until 1877 exploring motifs in and around the village and the neighbouring areas of Louveciennes and Port-Marly. Situated some fifteen kilometres from Paris, Marly-le-Roi was the site of the Château de Marly constructed for Louis XIV in the late seventeenth century. Conceived as a refuge from the formality of court life at Versailles, the château had been famous for its spectacular *jardins d'eau*, a formal garden in the grand manner laid out with fountains, cascades, and a series of terraced pools which reflected the architecture of the elegant royal retreat. Water was pumped up from the Seine via an aqueduct at Louveciennes to fill the reservoirs in the park at Marly before going on to feed the fountains at Versailles.

The château was demolished during the Revolution but the countryside around Marly still retained the imprint of its grandiose past. The pumping station (rebuilt in the 1850s) and the remains of the aqueduct appear in several pictures by Sisley. In Marly itself he painted one of the last vestiges of the water garden, an *abreuvoir* (watering place) which acted as an overflow on the edge of the park.

The *abreuvoir* is shown in the foreground of the National Gallery painting (Plate 132). Its surface is frozen and covered with snow except for a small corner at the right under the flow of water from an outlet. Beyond the *abreuvoir* is the boundary wall of the park and the Côte de Coeur Volant leading south up the hill towards Louveciennes. This view has changed remarkably little since Sisley's day and the exact location where he set up his easel can be readily identified (Plate 130). The artist lived nearby at 2 route de l'Abreuvoir and in 1875–6 he depicted the watering place in at least a dozen paintings (Plate 131). In the nineteenth century this majestic pool apparently provided a convenient place for the women of Marly and Louveciennes to wash their clothes. Yet there is no hint of irony in Sisley's paintings of these historic remains; the *abreuvoir* is just another topographical element in

Plate 130 Photograph of the Watering Place at Marly-le-Roi, 1990

the picturesque grouping of the village.

The date on the National Gallery painting is somewhat difficult to decipher, but it is almost certainly 75. Sisley painted several views of the *abreuvoir* under snow in 1875, including a composition which shows a similar view looking along the road at the opposite end of the *abreuvoir* (Plate 133). In both pictures he adopts a favoured compositional format. Like Pissarro (Cat. no. 5), Sisley often used a centrally placed road as a ready-made device to establish space and recession.

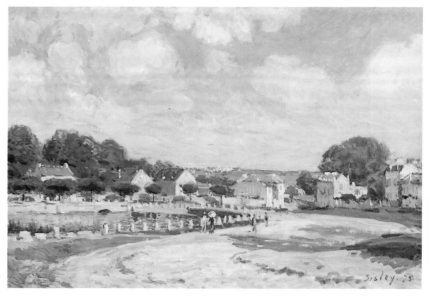

Plate 131 Alfred Sisley, *The Watering Place at Marly-le-Roi*, 1875. 39·5 × 56·2 cm. Chicago, Art Institute

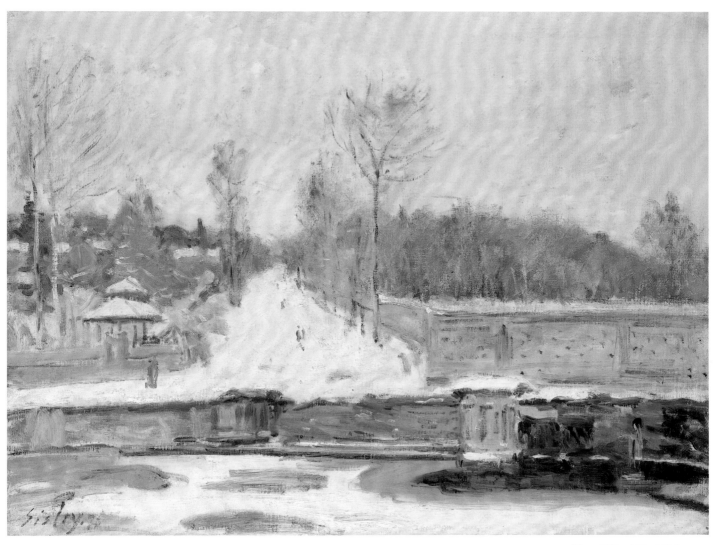

Plate 132 Alfred Sisley,
The Watering Place at
Marly-le-Roi

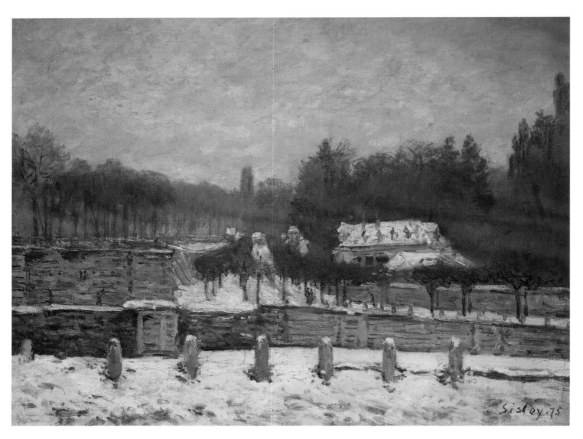

Sisley painted *The Watering Place at Marly-le-Roi* on a standard no. 15 landscape size canvas (see pages 45–6) bought from Latouche of 54 rue de Lafayette. The supplier's stamp was recorded on the back of the canvas before it was wax-lined in 1958. The ground was presumably commercially applied and consists of a single layer containing lead white and chalk, lightly tinted with small quantities of a warm dark brown (Plate 134). Its colour is now a pale pinkish beige, but originally it may have been a little lighter: it is very likely that some darkening has resulted from lining.

The ground colour is visible in all parts of the picture and remains completely uncovered in much of the sky, where it forms the principal tone. Almost every touch in the painting is affected by this underlying colour. Subtle simultaneous contrasts certainly exist in the composition, but Sisley's original intentions may be a little less obvious now if the ground has changed. In any case, he certainly used the ground as the dominant colour, to suggest the leaden atmosphere of a winter afternoon, briefly illuminated by a sudden flare of orange sunlight (Plate 135).

The thinness of the paint (for example in the trees) is typical of Sisley's work during this period. In the initial layers the brushwork is dry and scrubbed and even the more fluid brushstrokes on top are dragged with fairly stiff paint. In some areas, Sisley has needed to thin the paint to help it flow and some pale blue paint has run down with excess diluent (Plate 136).

Plate 134 Muted greenish-blue foreground, left, containing white tinted with cobalt blue and viridian. Traces of warm dark brown pigment are discernible in the ground layer beneath. Cross-section, 550×

Plate 135 Alfred Sisley, *The Watering Place at Maly-le-Roi*, macro detail of orange paint in sky

Plate 136 Alfred Sisley, *The Watering Place at Marly-le-Roi*, detail of paint run, bottom right

The palette is very restricted, consisting of just five colours plus black and white. The use of colour is restrained and simple. There are colour mixtures, but these are usually straightforward and do not have the unexpected complexity found in Monet's work. For example, the slightly mauve-tinted blues everywhere on the picture consist essentially of cobalt blue, white and a red lake (Plate 137); the intense violet touch immediately above the water spout contains the same pigments with proportionately more red lake. No pure violet pigment was found. Where the blues have a more greenish tint, the same mixture has been simply modified by the addition of a little viridian green (Plate 138). The purest blues contain mainly cobalt blue. The orange-brown of the wall to the left and of the sky at the end of the avenue relies on combinations of reddish-brown earth pigment and chrome yellow (lead chromate) with traces of white and black.

Sisley worked up the composition in a general progression from darker to lighter tones. The main areas and lines were sketched very rapidly in dark paint, followed by the broad opaque blue of the woodland, the greenish blue of the wall, the sky, and then the snow and foreground details. He then quickly went back over many passages, working over the wet paint, adding lighter touches to the woods and to the trunks and branches of individual trees.

The picture has every appearance of a rapid work, painted at a single sitting. Indeed, one can imagine Sisley, fingers numb with cold, trying to capture the scene with all possible speed. He probably carried the painting home afterwards behind a board or another canvas: the tell-tale marks of the canvas pins that he would have used to keep his wet paintings apart are present in each corner. In fact, he did not quite complete his painting on the spot; after the paint had dried, he discreetly added a few higher-toned touches, particularly in the lower right foreground. The violet touch above the water spout is one; others contain virtually pure chrome yellow (Plate 139) or viridian (Plate 140). Some touches of pure black may also have been added at this late stage.

With its subtle evocation of atmospheric effects through soft light colours and thin sketchy brushwork, *The Watering Place at Marly-le-Roi* is typical of Sisley's work of the 1870s. The delicacy of his touch belies the daring of his approach: his picture is certainly less finished in the conventional sense than many other works in this catalogue. However, Sisley seems to have regarded it as a completed work. He added his signature and the date and included it among his exhibits in the 1876 Impressionist group show.

Plate 137 Mauvish blue of wall, right, painted in a combination of cobalt blue, red lake pigment and white. Top surface of an unmounted fragment, 200×

Plate 138 Mauvish blue of trees, right, with viridian added to the mixture of cobalt blue, red lake and white. Top surface of an unmounted fragment, 200×

Plate 139 Alfred Sisley, *The Watering Place at Marly-le-Roi*, macro detail of final touches of yellow paint, lower right

Plate 140 Cold green streak of pure viridian laid over warm mixed underlayers, from reflection in water, right. Cross-section, 550×

Pierre-Auguste Renoir

8. At the Theatre (La Première Sortie)

Signed upper left: Renoir.
65 × 51 cm (25⅝ × 20 in.)

This painting (Plate 142) has been known under various titles since its first recorded sale at the end of the last century. In 1899, when sold as part of the collection of Count Armand Doria, the picture was entitled *Le Café-Concert*; in the catalogue of Renoir's work produced by Vollard in 1918 it was called *Au Théâtre*, but in the early 1920s it acquired the popular title *La Première Sortie* (*The First Outing*). This sentimental title emphasises an anecdotal quality in Renoir's picture which focuses on a rather hesitant but excited girl with a chaperon who is just visible behind her. Vollard's title, however, is undoubtedly the most accurate. The setting appears to be a theatre box with a view across to other spectators at the left and although the costumes are not grand and ostentatious, the atmosphere seems more formal than at a *café-concert*.

The world of public entertainment offered a rich vein of subject matter for the Impressionists, especially Degas, Renoir and, later, Mary Cassatt. Tiers of balconies and theatre boxes provided painters with a variety of unusual viewpoints from which to observe the colourful spectacle and the equally colourful audience. Above all, the theatre was a distinctly 'modern' theme and Renoir in particular was attracted by the opportunity to portray elegant spectators parading the latest fashions. He first tackled this subject around 1874, most notably in *La Loge* (Plate 141), the well-known picture now in the Courtauld Institute Galleries. In contrast to the National Gallery painting, the young woman in *La Loge* stares directly out of the canvas and is consciously on display. In the shadows behind, her companion lifts his opera glasses, presumably to observe his fellow spectators.

The date of *At the Theatre* is not known but the costume of the girl indicates that it must have been painted in 1876–7. As it now stands, the composition is more open than *La Loge* and includes a dramatic visual leap from the foreground figures to the distant audience. However, recent technical photography has revealed that Renoir initially had

a quite different composition in mind which still exists beneath the present one. The girl and her female companion appeared much as they do now but, instead of the view out over the audience that we now see, there were originally two figures sitting in front of them. Infra-red photographs and X-rays (Figs. 74 and 75) show the unmistakable outlines of two heads to the left of the girl. Nearest to her is a man who appears to be half turning away to speak to a woman beyond. The images are

Plate 142 Pierre-Auguste Renoir, *At the Theatre*

Plate 141 Pierre-Auguste Renoir, *The Theatre Box (La Loge)*, 1874. 80 × 63·5 cm. London, Courtauld Institute Galleries

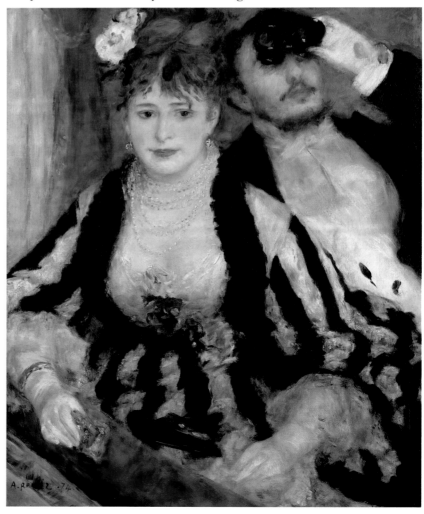

152

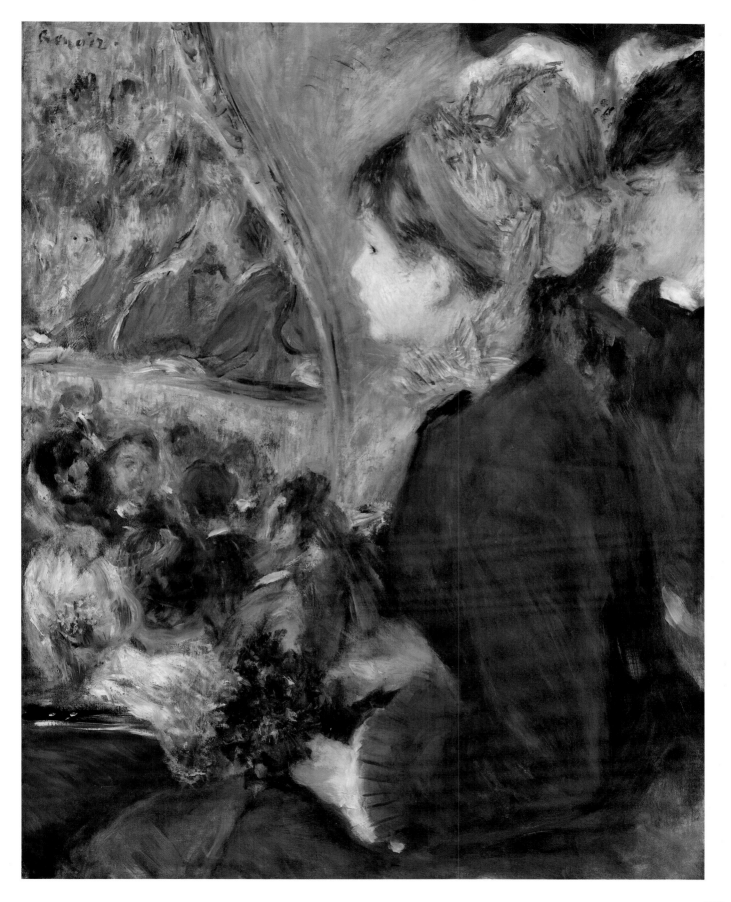

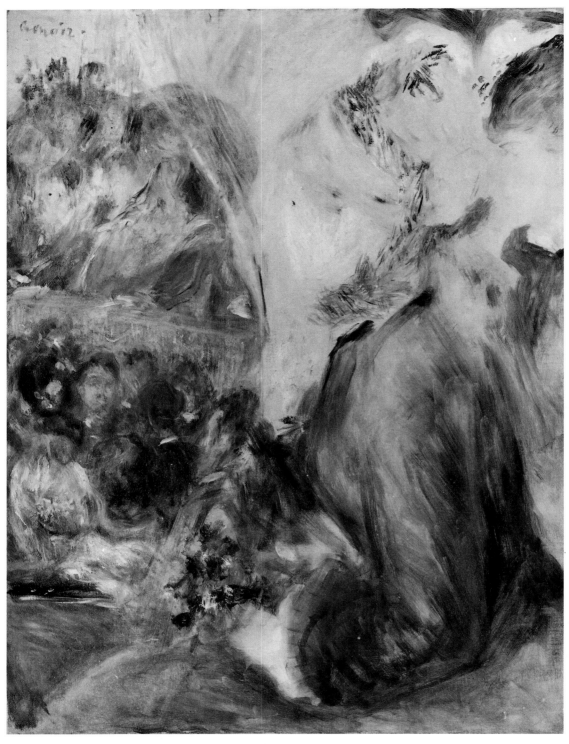

Fig. 74 Pierre-Auguste Renoir, *At the Theatre*, infra-red photograph

tantalisingly shadowy, but complete enough for there to be no doubt that these figures were once part of the original composition.

Once we know they are there, certain features on the picture surface are explained. The curved outline showing through the arched partition is the back of the man's head; the covered-up impasto to the left of the girl's face (Plate 143) is the man's collar; the dark paint underlying the heads of the lower audience is his suit. It is tempting also to read a distinct profile for the woman at the left side in the infra-red photograph – forehead, nose, mouth and chin – but some of this may be due to paint on top. Renoir did re-use some of the paint of these two original figures for his final painting. For example, the rather oddly shaped man with the blue jacket

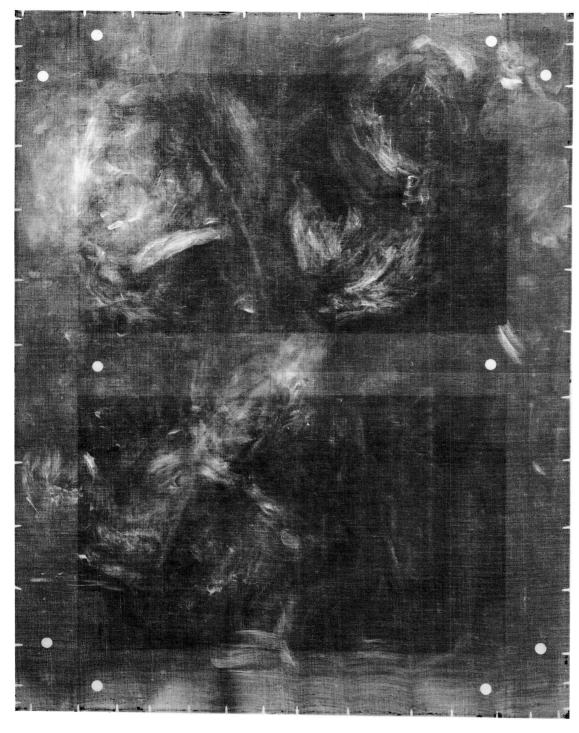

Fig. 75 Pierre-Auguste
Renoir, *At the Theatre*,
X-ray

now seen immediately to the left of the girl's head (Plate 144) actually consists of part of the original man's jacket and part of his hair: Renoir retained these fragments by painting his upper layers around them.

The presence of these two figures at the first stage of painting throws the whole question of Renoir's original intention wide open. Were the two extra figures sitting in front of the girl and her companion in a separate row, or beyond them in the same curved row? Was a distant view across the theatre intended, or simply a close-up study of four figures? Was Renoir attempting another closed intimate view *into* a theatre box, as in *La Loge*? Whatever the answers to these questions, Renoir clearly became dissatisfied with the composition and radically changed it into the present familiar image.

The painting is preserved in almost perfect condition. The original canvas is unlined and bears the stamp of the supplier, Alexis Ottoz (Fig. 76). It is commercially primed with a white ground of chalk and lead white.

As a result of the extensive reworking of the image and the densely packed brushstrokes elsewhere, very little of the white ground is visible. Renoir's brushwork is complex and varied: it comprises broad areas of opaque colour, punctuated by sudden patches of vivid wet-in-wet handling (Plate 145), fine feathered detailing on top and a surprisingly widespread use of transparent glazes and 'semi-glazes'.

One particular glaze has interesting parallels with *La Loge*. In the upper centre of *At the Theatre* a greenish-yellow colour is used which appears to illuminate the partitition behind the girl. A similar yellowish glaze has been observed in *La Loge*, where it has been suggested that it might represent the colour of the light within the theatre. In the National Gallery painting Renoir is perhaps aiming at a similar effect. A strong light seems to be shining on the girl's face, producing the pronounced yellow shadow behind her ear; the shadow below her chin is full of green reflections, partly from the partition behind. Her dress, too, although presumably a blue one, shimmers with the greenish tones of artificial light.

The greenish-yellow paint behind the girl's head is translucent; it functions as a glaze more through its fluidity and thinness than from the incorporation of transparent pigments such as yellow lakes. The colour is made from a thinly brushed layer of 'lemon yellow' (barium chromate), rendered greenish by the addition of a little cobalt blue. A few strokes that are richer in cobalt blue suggest the texture of the partition, the curve of which is outlined with narrow streaks of a deep red lake. 'Lemon yellow' is much less opaque than the equivalent lead chromate yellow (chrome yellow), and the blue pigment is also somewhat translucent, giving a glaze-like effect to the paint when it is used over a reflective white ground. The same mixture is thinly pulled over underlayers containing cobalt blue and ivory black to yield the very dark flat greenish patches of the clothes of the crowd in the theatre audience (Plate 146).

A true glazing pigment in the form of a red lake, mixed with a little cobalt blue, is used directly over the ground to give the thinly painted mauve streaks in the hair of the girl's companion to the right (Plate 147). At the front of the theatre box, the deep mulberry-coloured plush is virtually pure red lake glazed over a solid violet-tinged underlayer of cobalt blue, red lake and white, the surface worked

Plate 143 Pierre-Auguste Renoir, *At the Theatre*, detail of covered impasto to the left of the girl's face

Plate 144 Pierre-Auguste Renoir, *At the Theatre*, detail

Plate 145 Pierre-Auguste Renoir, *At the Theatre*, macro detail of flowers in the girl's bouquet

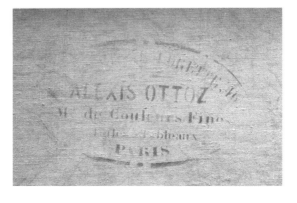

Fig. 76 Pierre-Auguste Renoir, *At the Theatre*, stamp on back of canvas

while wet with a few strokes of brighter, more opaque vermilion.

The method of painting for the girl's dress, which picks up both muted blue-green and dark purplish-blue reflections of light, also employs rather translucent surface paints to model the form and elaborate its colour, in a way that corresponds technically to more traditional methods of painting. Although fairly thinly and flatly composed, the dress is made up of an undercolour in varying tones mixed from cobalt blue, red lake, white and black, with thinner 'semi-glazes' on top, where the opaque lead white has been omitted and only pigments of some transparency are intermixed (Plate 148).

The more thickly painted passages generally make use of purer pigment. The faces of the two young women are densely painted with lead white lightly tinted with vermilion. The brushstrokes are narrow and diagonally closely hatched to construct a fairly thick solid surface. The richest impasto is reserved for the white, blue and green strokes of the hat-band and the girl's collar, which are made up of separate interlocking touches of virtually pure lead white, cobalt blue or emerald green (Plate 149). A patch of undiluted vermilion passes over the dress of the girl's companion, which is painted as a deep shadow of pure ivory black (Plate 150). Thick blobs of paint, clearly used directly from the tube, make up the vivid tones of the girl's bouquet in emerald green, cobalt blue, red lake and chrome yellow.

At the Theatre combines elements of traditional practice with more modern painting methods. Renoir's palette for this picture is not typically Impressionist; the use of black pigment in some quantity is unusual, while the use of glazes and semi-glazes is a technique that seems contrary to the direct, opaque handling that is normally associated with Impressionism (see, for example, Cat. no. 11). However, this complexity of brushwork and colour is by no means unusual in Renoir's work of the later 1870s. His apparent willingness to modify his paintings in considered stages illustrates an element of deliberation that appears equally contrary to the spontaneity of Impressionism. It seems

that he was prepared to adapt his style and choice of palette according to his subject matter; clearly he found the technique of painting by *tache* ill-suited to figure and portrait painting.

Plate 146 Blackish green of clothes of distant audience, left, comprising a thin layer of 'lemon yellow' and cobalt blue drawn over an underlayer of cobalt blue and ivory black. Cross-section, 550×

Plate 147 Red lake glaze, with a little cobalt blue, used directly over the reflective white ground for the mauvish streaks in the woman's hair, right. Top surface of an unmounted fragment, 100×

Plate 148 Dark purplish blue of the girl's dress in two layers. A mauve underpaint of white with cobalt blue and red lake is glazed in a mixture of cobalt blue, ivory black and red lake. Cross-section, 350×

Plate 149 *Far left* Pure emerald-green impasto of the girl's collar. Cross-section, 550×

Plate 150 *Left* Vermilion patch of the companion's dress, right, over a layer containing virtually pure ivory black. Cross-section, 550×

157

Camille Pissarro

9. The Côte des Boeufs at L'Hermitage

Signed lower right: C. Pissarro. 1877
115 × 87.5 cm (45¼ × 34½ in.)

This picture (Plate 152) was first exhibited under its present title at the dealer Durand-Ruel's in 1892. Pissarro's original label for that exhibition is still attached to the back of the stretcher (Fig. 77). It seems likely, however, that the painting had already been shown to the public at the third Impressionist exhibition in 1877 and it may have been the 'large landscape by Pissarro' which hung as one of the centrepieces of the show, close to Renoir's *Bal du Moulin de la Galette*.

The painting depicts a group of farm buildings on the Côte des Boeufs, a hillside close to Pissarro's home in L'Hermitage near Pontoise. The artist had first moved to Pontoise in 1866 and with only brief interruptions it was to remain his base until 1883. Pontoise itself was a busy market town only thirty kilometres from Paris but it offered easy access to quiet rural areas. Pissarro found motifs for numerous paintings in the varied landscape around the hamlet of L'Hermitage with its traditional farm buildings set among rolling hills.

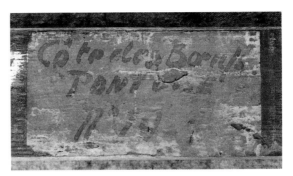

Fig. 77 Camille Pissarro, *The Côte des Boeufs at L'Hermitage*, label on the stretcher

Pissarro's work of around 1877 is characterised by an enormous variety of technique. In a group of paintings executed along the banks of the Oise, for example, he continued to develop the fluid Impressionist style that he had adopted around 1870, capturing the light and movement of the river with broken touches of paint. These informal and spontaneous studies seem far removed from *The Côte des Boeufs*, which is a complex and ambitious work, about twice the average size of his paintings

Plate 151 Camille Pissarro, *L'Hermitage at Pontoise*, 1867. 91 × 150 cm. Cologne, Wallraf-Richartz-Museum

Plate 152 Camille Pissarro, *The Côte des Boeufs at L'Hermitage*

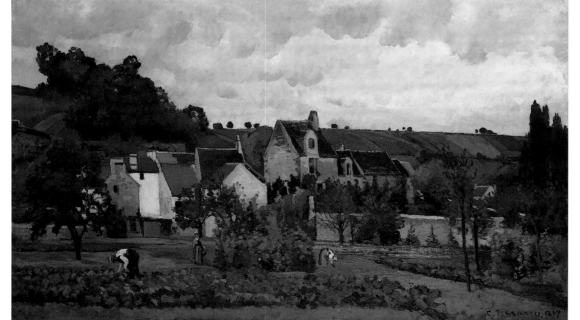

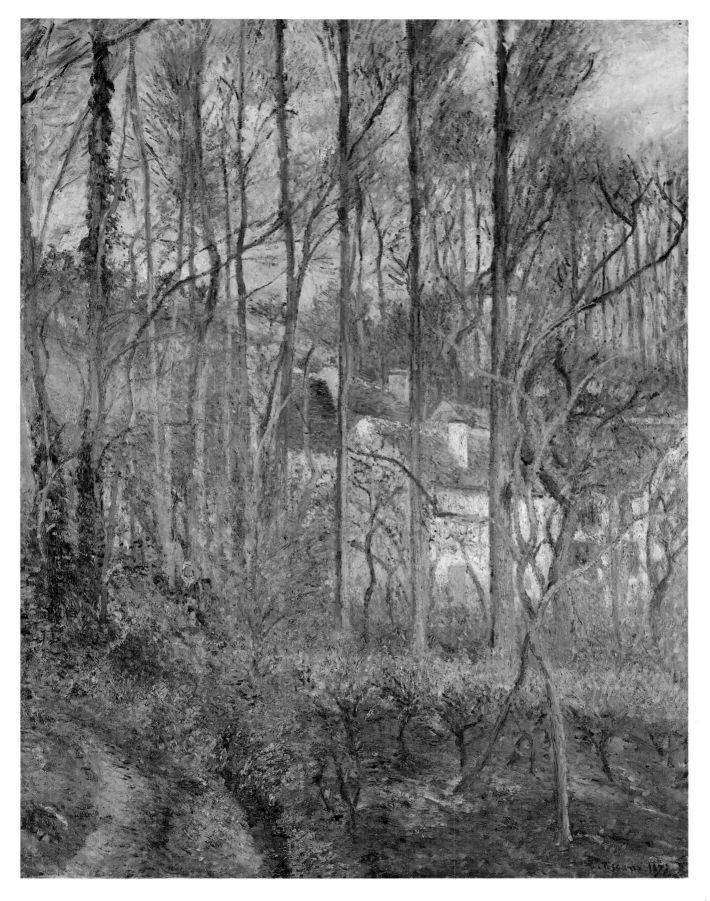

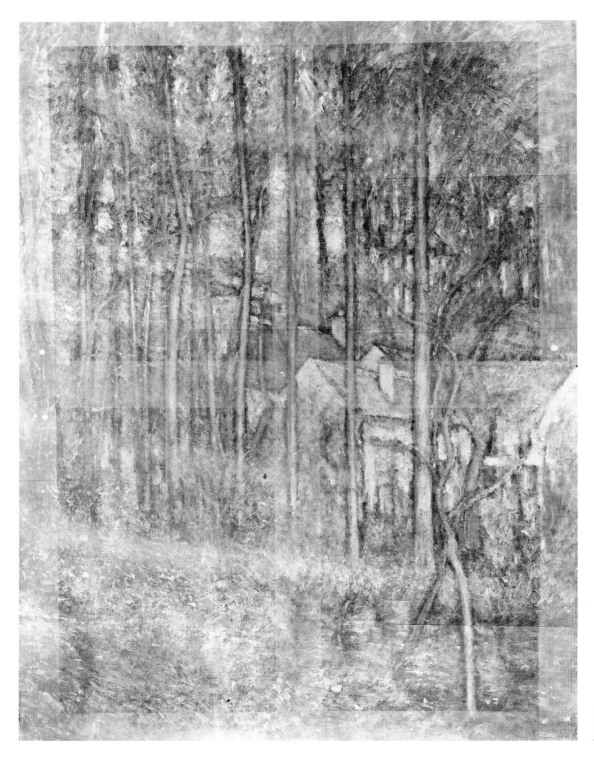

Fig. 78 Camille Pissarro,
*The Côte des Boeufs at
L'Hermitage.* X-ray

of this period. Its dimensions are almost precisely those of *The Côte du Jallais, Pontoise* (New York, Metropolitan Museum of Art) of a decade earlier. Indeed, *The Côte des Boeufs* has the monumental quality of some of his earliest paintings of Pontoise; the composition echoes the careful design of paintings like *L'Hermitage at Pontoise* (Cologne, Wallraf-Richartz-Museum; Plate 151) of 1867, where the interlocking shapes of the buildings are set off by the curving bands of the background fields. In the present picture the buildings and fields are enmeshed by the screen of trees which binds foreground and background into an intricate two-dimensional pattern.

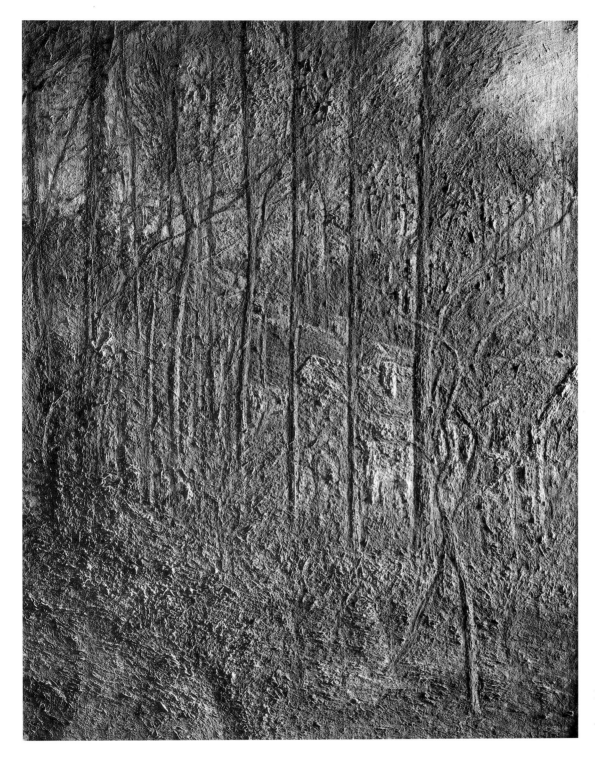

Fig. 79 Camille Pissarro,
*The Côte des Boeufs at
L'Hermitage*, photograph in
raking light

The surface of *The Côte des Boeufs* has often been described as 'woven': in some areas it is worked and reworked into an interlocking mesh which is a very long way from the spontaneous touch of the *plein-air* painter. Evidently, Pissarro laboured for a long time in the construction of the painting, some of it perhaps in the studio: Sickert reported that Pissarro had referred to the pictures as 'the work of a Benedictine [monk]'. It is worth pointing out, however, that the painting still bears the marks of canvas pins, perhaps indicating that Pissarro carried the picture to and from the site while the paint was still wet.

So complex is the surface that it is almost

impossible to 'read' the order of working from the overlap of the brushstrokes. But the complexity is mostly on the surface, and a simpler underlying structure based on the verticals of the trees and the outlines of the buildings can be seen in the X-ray (Fig. 78). The main forms have black silhouettes showing the build-up of the painting in distinct areas that do not quite overlap. A similar construction may be seen in *The Avenue, Sydenham* (Cat. no. 5) of 1871.

The tree trunks form the basic framework of the composition and were the first features to be painted. At the top of the picture they can be seen to lie directly on the ground with the sky painted around and in between, overlapping them slightly in places. Pissarro piled colour upon colour to build up the tree trunks until they were almost three-dimensional: the series of raised vertical parallels appears very striking in raking light (Fig. 79).

The main blocks of the buildings were then placed between the trees, as solid slabs of colour, massively thick in some areas such as the white chimney and white walls. In places, the lowest layer of the red roofs appears to pass just under the adjacent tree trunks, so these must also have been developed at quite an early stage. Next, the sky and landscape were filled in around the tree trunks and buildings, the branches of the trees were painted fluidly across them, and then the complex weaving of the surface texture began. The sky paint is some of the thinnest on the picture, but even here two layers are evident in a cross-section (Plate 153). Pissarro worked slowly across the surface of this large canvas, brushing, dabbing, piling the paint into the spiky, broken surface that we now see. So fragmented is the paint that it is very difficult for the eye to penetrate and identify details, especially in the foreground and at the left side: the two figures on the path almost merge into the colours around them (Plate 154). A heavily textured surface is often a feature of Pissarro's rural landscapes of the mid-1870s: clearly he felt that a certain coarseness of technique was appropriate for rustic subject matter. Here, the paint layers over much of the surface are among the most thickly worked of any in Pissarro's career. The canvas (a standard no. 50 portrait size; see pages 45–6) is of fine weave and may have been unable to support the great weight of paint that Pissarro used. Perhaps for this reason the painting has been lined; the lining is clearly an early one and conceivably 'original', that is, put on by or for Pissarro himself.

The canvas was prepared with a creamy-white ground, showing in many places between the paint strokes. Analysis has shown the ground layer to be composed of fairly pure lead white containing small

Plate 153 Cross-section from the sky, upper edge, showing two layers of paint. The upper layer contains French ultramarine; the lower, viridian and red lake in addition. Magnification, 500×

Plate 154 Camille Pissarro, *The Côte des Boeufs at L'Hermitage*, raking-light detail

Plate 155 Camille Pissarro, *The Côte des Boeufs at L'Hermitage*, detail of trees and sky

quantities of calcium carbonate and barium sulphate, the creamy quality probably arising from slight yellowing of the binding medium. The light ground is still visible among the trees and sky at the top left of the picture (Plate 155), and appears here to be used deliberately to give luminosity and to suggest sunlit airy distances beyond the branches. As with many Impressionist paintings, the warm cream ground showing through a loosely painted cool blue is more successful in suggesting a bright dappled sky than the use of solid layers of opaque paint.

The Côte des Boeufs is surprisingly intricate in its use of colour. It has a relatively low-key tonal understructure overlaid with intense highlights (Plates 156 and 157). Through all the stages of construction, Pissarro seems to have maintained an even balance of colour across the surface. Only at the last stage did he heighten the contrast by loading his brush with a saturated deep blue of pure French ultramarine and adding dark accents all down the left side of the picture and to some prominent branches (Plate 158); he also signed the painting in this colour. At this late stage, he further strengthened some bright greens and yellows in the foreground and background and added some random strokes of fierce red vermilion (Plate 159), notably at the base of the tree to the left of the figures and on a vertical branch above the upper red roof. The roofs themselves he finished in striped tones over a complex underworking of browns, greens and blues.

Despite the complexity in construction, the palette for *The Côte des Boeufs* is not particularly extensive, although some of the mixtures of pigment turn out to be so. In common with certain other Impressionist works, particularly Monet's paintings from the 1870s, even the sombre tonalities are composed of elaborate combinations of strongly coloured pigments, their intensity subdued by intermixture. This technique is particularly evident in the paint of the understructure of *The Côte des Boeufs*, where the duller yellows, greens, reds and browns contain a multiplicity of pigment types, even though these colours could have been duplicated with a simpler selection of earth pigments. Clearly it was important for Pissarro to use the brighter pigments, with their associations of optical purity, even if his final effect was muted through mixing. It is also interesting that Pissarro seems to have restricted his range of basic colour; by limiting his palette he was perhaps aiming to achieve an underlying sense of colour harmony and unity.

The use of the intense, deep blue of French ultramarine as a general dark colour in place of black is common in the paint mixtures, while the

Plate 156 Camille Pissarro, *The Côte des Boeufs at L'Hermitage*, detail of foreground

Plate 157 The build-up of the foreground paint, with mixed layers of green beneath, and a highlight of pure emerald green at the surface. Cross-section, 145×

Plate 158 Impasto touch of pure French ultramarine for branch of tree, left edge. Cross-section, 400×

Plate 159 Scarlet streak in the foreground path in pure vermilion paint. Cross-section, 550×

warmer constituents are vermilion, a red lake pigment and an orange-coloured earth. The greens are emerald green and viridian, used both singly and in combination, and the yellow pigment exclusively chrome (lead chromate). Clear examples of some of the pigment combinations used for the underpainting can be seen in Plates 157, 160 and 161. The final accents of pure pigment were the powerful colours of vermilion, emerald green, chrome yellow and French ultramarine. Pissarro used a comparable palette for *The Avenue, Sydenham* (Cat. no. 5), although the differences in paint handling and the greater proportion of white pigment incorporated into the upper paint layers produce a totally different overall effect in colour and texture in the earlier picture.

The painting that is often linked with *The Côte des Boeufs* because of its very similar subject, *The Red Roofs, Corner of a Village, Winter* (Plate 162), is quite unlike it in technique. However, *Red Roofs* is a most unusual picture in that it is painted over an earlier portrait, and the need to obliterate the underlying picture has dominated the painting methods. The canvas is very thickly covered, with no underlying luminosity, and the grey ground below the portrait is only visible at the very edge. Unlike *The Côte des*

Plate 160 Dull mixed green undercolour for tree trunk, centre, containing principally white mixed with French ultramarine, red lake, orange ochre and emerald green. Cross-section, 460×

Plate 161 Sage-green paint of the foreground, showing the multilayered construction of colour and highly mixed pigment. Red lake, vermilion and French ultramarine, with other pigments, are distributed throughout the layer structure. Cross-section, 370×

Boeufs, the horizontals of the composition are laid in first – the great curving background landscape, the

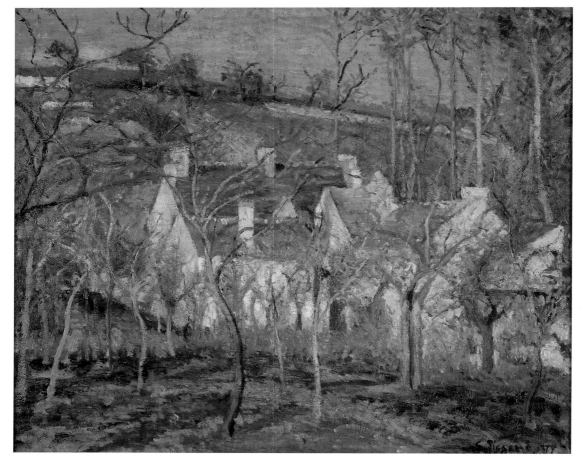

Plate 162 Camille Pissarro, *The Red Roofs, Corner of a Village, Winter*, 1877. 54·5 × 65·5 cm. Paris, Musée d'Orsay

164

buildings and the foreground. Then the vertical trees are painted on top, and finally the thickest details between the trees. The dense saturated tonality of the whole picture has been forced on Pissarro by the need to cover the earlier picture. The rich, powerfully coloured sky and landscape, much higher in hue and value than *The Côte des Boeufs*, are quite unrelieved by the lightness and sparkle of a paler ground beneath.

Of all the artists represented in this catalogue, Pissarro seems to have been least comfortable with the direct rendering and informal compositions that characterised Impressionism in the early 1870s. As the decade progressed he began to reassess the qualities of order and unity that were the hallmarks of his early style. In a letter to Caillebotte in 1878, Pissarro justified the rigour of his approach: 'Create good paintings [*tableaux*], don't exhibit sketches [*esquisses*], be severe with our paintings, that's worth more don't you think? That the public rebukes the most beautiful sketches is a pretext.'

The Côte des Boeufs exemplifies Pissarro's attempts to combine the spontaneous observation and recording of *plein-air* effects with the more considered approach of his earlier works. The final painting retains an appearance of immediacy but the artist has worked long and hard to achieve this. Technical analysis offers an insight into Pissarro's laborious working and reworking of the picture surface. This gradual build-up of paint is perhaps the key element in his method. An initial broadly painted layer in muted colours acts as a base for the more intricate weave of textural brushmarks and for the development of more intense colour contrasts. Through this gradual process of refining the initial sketch, Pissarro could work towards a more cohesive surface and a harmonious tonality.

In *The Côte des Boeufs* Pissarro is quite consciously presenting us with a carefully synthesised object, not an artless impression. This emphasis on order and structure may be partly explained by a desire to check the haphazard qualities inherent in his early Impressionism, but it may also reflect an external influence. There is a painting by Cézanne which appears to represent the same motif as the National Gallery picture from slightly further along the same hillside path (Fig. 80). The Cézanne has a similar compositional format but is even more severe and simplified in its design and is dominated by the almost geometric criss-cross patterns of the tree trunks and rooftops. Cézanne and Pissarro had first worked together in 1872–4 when the Provençal artist had much to learn from Pissarro's disciplined approach to landscape painting out of doors. By 1877, when Cézanne revisited Pontoise, the artistic relationship must have become more

equal. Pissarro, in turn, seems to have responded to Cézanne's modified and structured version of Impressionism and this is perhaps reflected in the elaborate composition and laboured execution of *The Côte des Boeufs*.

Pissarro eventually despaired of the highly textured surfaces of his paintings of the late 1870s and early 1880s. He later described his works as 'rough and rasping' and complained that they were only visible when lit from the front. His search to impose unity on diversity encouraged him to adopt an even more synthetic approach to brushwork and colour, a path which led him to experiment with Neo-Impressionist techniques in the later 1880s.

Fig. 80 Paul Cézanne, *The Côte des Boeufs at L'Hermitage*, 1877. 65 × 54 cm. Private Collection

165

Claude Monet

10. The Gare Saint-Lazare

Signed lower right: Claude Monet
54.3 × 73.6 cm (21⅜ × 29 in.)

The Gare Saint-Lazare (Plate 164) is one of twelve views of this station painted by Monet during an intense period of activity early in 1877. Although still based at Argenteuil, the painter rented a small apartment and a studio close to the station in January of that year. By March, three of the paintings of Saint-Lazare had been purchased by his patron Ernest Hoschedé, and in the third Impressionist exhibition which opened in April, Monet was to show a total of seven pictures of this subject. This unusual group of works attracted considerable attention. Unfortunately, it is not possible to tell either from the catalogue or from the reviews whether the present picture was included in this show.

The modern urban subject matter of the station paintings might appear to present a complete contrast with the landscapes and river scenes of Monet's work at Argenteuil (see Cat. no. 6). Yet the railway frequently appears in his work of the early 1870s, sometimes as a distant topographical feature but occasionally as a subject in its own right. As the point of departure for the Normandy coast, as well as for most of the major Impressionist sites including Bougival and Argenteuil, Saint-Lazare would have been a familiar landmark for the artist. It had already attracted the attention of Manet, whose *Railway Bridge* had been exhibited at the Salon of 1874, while Caillebotte's *Pont de l'Europe* was shown in the 1877 Impressionist show.

Several of Monet's paintings depict exterior views of the tracks and sidings, but the National Gallery picture is one of four painted within the station itself. As in the painting now in Chicago (Plate 163), the artist set up his easel at the terminus of one of the main lines looking along the *quais* and tracks towards the Pont de l'Europe in the middle distance. In the foreground of the London picture, two locomotives are making steam, surrounded by crowds of passengers who are presumably waiting to board. On the left of the painting a third train disappears under the bridge in a cloud of smoke and vapour. The Saint-Lazare paintings are primarily concerned with light and atmosphere, in spite of the mechanical subject. The severe lines of the station architecture provided Monet with a strong compositional framework but this is countered by the haphazard patterns of billowing steam.

The Gare Saint-Lazare is painted on a standard no. 20 landscape size pre-primed canvas supplied by Deforgue Carpentier, whose oval stamp is on the back of the canvas (Fig. 81). There is also the stamp of the stretcher-maker Hostellet, of 4 rue Laval, on the centre bar of the stretcher (Fig. 82). Structurally, the picture is almost unchanged from the moment it was painted: unlined, probably never removed from its original stretcher, only the tacks around the edge have been renewed. On the front of the picture, holes are still visible at each corner where Monet placed his canvas pins for carrying the wet painting behind another canvas at the end of the day.

Of the four paintings showing the station interior, the National Gallery version is the most freely and sketchily painted. Although it appears to

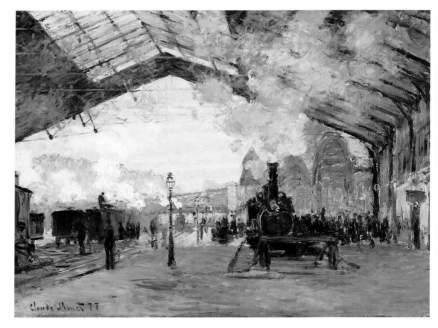

Plate 163 Claude Monet, *The Gare Saint-Lazare*, 1877. 59·6 × 80·2 cm. Chicago, Art Institute

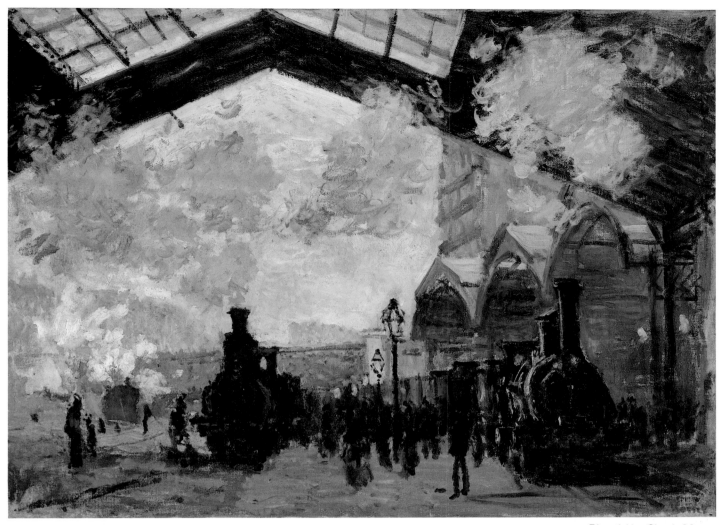

Plate 164 Claude Monet,
The Gare Saint-Lazare

be the work of a single sitting, at least three separate stages can be identified. It seems that Monet first established the main framework of the composition in dark scrubbed washes and lines. The bare outlines of the roof, the distant canopies and bridge, and possibly an indication of the positions of the trains, were all briefly mapped out at this preliminary stage.

In the second, principal stage of working, Monet carried out the bulk of the painting: working freely with fluid paint and flickering, whirling brushwork, he rapidly set down all the main forms. The density of the brushstrokes is enormously varied: thick, layered and opaque in some parts, but open and transparent in many others (Fig. 83 and Plate 165). The white ground shows through almost everywhere, both within forms and around outlines.

An especially prominent area of priming was initially left unpainted in the dark roof at the upper right: this formed a reserve for the billows of grey-blue smoke and steam to be painted in on top, but the ground is still highly visible through the sparse brushwork. Monet's planning and control of colour are very interesting here. Most of the grey-blue vapour is actually fairly consistent in tone, but its appearance varies in different areas of the picture. Where it lies directly on the ground at the upper right, it seems warm and pale: this is due to the combined effect of the underlying lighter tone and the contrast with the surrounding darks. Where the steam overlies the sky in the centre and at the left of the picture, it admittedly has a little more blue in parts, but the general effect is considerably darker, by contrast with the light surroundings. Finally, where it overlaps the roof at the upper left – where no reserve has been left for it – the underlying darks give it an extremely cool blue tonality.

Two effects are at work here: the effect of dark and light underlayers (now known as the 'turbid medium' effect), in combination with simultaneous contrast of brightness in surrounding areas. Working at such speed, some of this may have been unplanned. Monet could not have known precisely how much smoke and steam he was going to include and, indeed, only allowed the one significant reserve for it. However, the general combinations and contrasts of tone were clearly exactly what he wanted, and the optical principles perfectly understood even if perhaps only empirically developed.

After the major part of the painting had been completed, Monet returned to it slightly later to add a few final touches. Some of the greenish detailing of the foreground, the blue railway tracks at the left, some turquoise struts of the roof and the vermilion

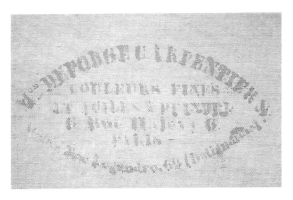

Fig. 81 Claude Monet, *The Gare Saint-Lazare*, stamp on back of canvas

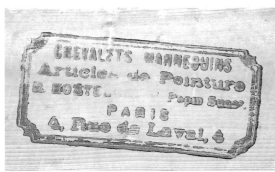

Fig. 82 Claude Monet, *The Gare Saint-Lazare*, stamp on stretcher

touches on the figures were all put in on top of partly dry paint. The signature, now rubbed and indistinct, was also added at this stage at the bottom right corner.

The picture presents an interesting aspect of Impressionist colour construction, and reveals Monet's particular technique at this time of mixing together bright colours to form even the strongest dark tones. Surprisingly, the nearly black parts of the locomotives and station canopy are in fact painted with combinations of vivid pigments. Black

Fig. 83 Claude Monet, *The Gare Saint-Lazare*. Photograph in raking light, detail

pigment is not entirely absent, but occurs only as a minor contribution to these complex colour mixtures. Apart from lead white, which forms the basis of all the lighter tints, and a little ivory black, Monet takes advantage of eight other pigments: three distinct blues, two greens, two reds of differing colour and transparency, and a bright yellow, which is restricted to smallish areas.

The three blue pigments are all nineteenth-century inventions, and consist of cobalt blue (cobalt aluminate), the greener-coloured cerulean pigment (cobalt stannate) and French ultramarine. The pure greens are the two most significant green pigments found in Impressionist painting: emerald green (copper acetoarsenite) and viridian. Vermilion is used as the bright opaque red, while a deep cherry-coloured lake pigment plays a fundamental part in paint mixtures, particularly for the darker parts of the composition. The yellow pigment is chrome yellow (lead chromate).

Both cerulean blue and the red lake pigment are slightly unusual choices. Cerulean blue is generally less commonly found in Impressionist painting than is cobalt blue or French ultramarine, although it has been identified in paintings by Manet and occurs also with cobalt blue and French ultramarine in Berthe Morisot's *Summer's Day* (Cat. no. 12). The attraction for Monet must have been to make use of the distinctive hue of cerulean to extend the blue-green range of the palette and to make the mixed tones more continuously variable. Preliminary analysis of the red lake pigment suggests that it is probably based on a synthetic dyestuff, and on a co-mixed substrate of aluminium and tin oxides, rather than a more conventional madder lake on a single substrate, usually alumina. Its presence here hints at a diverse choice of red lakes as artists' pigments available in the 1870s. The colour of this variety is particularly bright and strong.

For *The Gare Saint-Laṛare*, Monet seems to have evolved a kind of universal dark hue made up of all the pigments on his palette, fully intermixed, omitting only white and yellow. The resulting colour cast of the deeper tones, whether they are tinged with purple or with a bluish green, is determined by the dominant pigment or pigment combination in the mixture. Essentially, in the most purple-toned darks it is the red lake pigment that influences the colour of the paint to the greatest degree, while cobalt blue and cerulean blue together impart their colours most markedly in the blues and greenish blues. In the deep purple shadow of the station canopy, for example, the paint contains red lake in some quantity, combined with lesser amounts of the three blues, cobalt, cerulean and ultramarine, in conjunction with

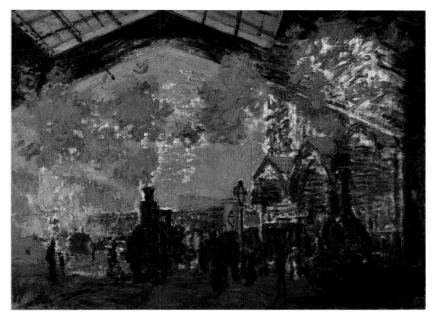

viridian and emerald green. Traces of vermilion and ivory black are also detectable in this area (Plate 166). On the other hand, where the canopy passes into dark greenish-blue shadow, the main pigments are cobalt blue with cerulean blue, but the paint contains in addition minor amounts of ultramarine, viridian and emerald green with traces of red lake, vermilion, white and black (Plate 167). In the painting of the locomotives the two dark shades are used alongside one another. This complex system of colour construction is used systematically throughout the composition, where the proportions of the blues, greens and reds are continuously varied to produce a large colour range in the translucent darks.

White is gradually incorporated as lighter and more opaque paints are required. For example, the mid-tone blue swirls of smoke and steam comprise mainly cobalt and cerulean blues mixed with lead white, but still with the addition of a little viridian and emerald green and, as before, traces of ultramarine and red lake. Where the steam is mauvish, the lead white is lightly tinted with cobalt blue, vermilion and red lake (Plate 168). At the extreme end of the range of light diluted colour, some of the steam and smoke issuing from the locomotives and also the patch of sky are painted in nearly pure lead white.

The duller opaque colours of reddish and mauvish brown, seen in the recesses of the station building, might easily have been based simply on earth pigments, but these also follow the system used to make the more translucent darker paints. For example, the opaque red-brown of the canopy relies on a main component of vermilion combined with lesser quantities of cobalt and cerulean blues,

emerald green and viridian, with a little red lake and chrome yellow. No earth colours are employed.

Certain of Monet's range of pigments used here in the complex mixtures of paint are adopted for reasons other than their colour quality alone. Viridian and particularly French ultramarine, which are both relatively transparent and also possess high tinting strengths, are used to impart darkness and depth of colour to mixtures that would potentially have become muddy as a consequence of their complexity. However, this is prevented by the inclusion of a large proportion of translucent pigment. A related use for French ultramarine as a substitute for black pigment has already been noted in Monet's *Beach at Trouville* (Cat. no. 3), and it is a technique employed also in Pissarro's *The Avenue, Sydenham* (Cat. no. 5). The red lake pigment has a similar function in *The Gare Saint-Lazare*, where it is used to darken and intensify the warmer shadow values without imparting opacity. Vermilion is used with the opposite intent: to add density as well as colour to the duller, more opaque passages. Chrome yellow correspondingly acts as a dense, opaque colour for the greenish-khaki patches of the station foreground.

Pure pigment is used sparingly in the picture, except for the lead white in the clouds of steam and in the outside sky. A streak of undiluted red lake marks the inner edge of the sloping roof to the right, and small touches of pure bright red vermilion pick out some of the passengers in the station. A little cobalt blue at full strength is used for small highlights on the locomotives, and minute swirls of bright chrome yellow can just be made out in the paint worked wet-in-wet for the lanterns at the base of each tall smokestack.

Monet's surprising technique of mixing together a large variety of strongly coloured pigments to yield paints of relatively subdued tone appears to be a consistent feature of the 1870s. *The Petit Bras of the Seine at Argenteuil* (Cat. no. 6) also makes similar use of complex mixtures of colourful pigment particularly for the relatively muted dull yellows, greens and browns of the foreground river bank, although in the painting as a whole this technique is less comprehensively explored and less coherent than in *The Gare Saint-Lazare*. Even in Monet's earlier *Bathers at La Grenouillère* (Cat. no. 2) there is a tendency to formulate the duller-coloured paints from mixtures of high-key pigment, although it is not applied there systematically. In *The Gare Saint-Lazare*, Monet was attempting a conscious unity of colour by specific technical means in a subject full of strong contrasts.

The Saint-Lazare paintings are often described as Monet's first series, anticipating his later persis-

Plate 166 Deep purple shadow of station canopy, comprising mainly red lake mixed with cobalt blue, cerulean blue, French ultramarine, viridian, emerald green and a trace of vermilion. Top surface of an unmounted fragment, 200×

Plate 167 Deep greenish-blue shadow of station canopy, comprising cobalt blue and cerulean blue mixed with lesser quantities of French ultramarine, viridian, emerald green, red lake, vermilion and white. Top surface of an unmounted fragment, 200×

tent exploration of a single motif under many varying conditions. However, the station pictures differ in technique, scale and ambition. For example, the London, Chicago (Plate 163) and Paris (Plate 169) pictures are painted on standard landscape canvases of size nos. 20, 25 and 40 respectively (see pages 45–6). The texture of the Chicago canvas is similar to that of the present picture, but the Paris painting is on much coarser canvas. No information is available on the suppliers of these two canvases, but the Chicago picture has a similar commercially applied white ground to the National Gallery version, whereas the ground of the Paris picture is a warm greyish-mushroom colour.

The Chicago picture is much closer in design and technique to the London version, having the same off-centre placing of the station roof and a similar colour scheme, although the overall tone is lighter and greener. The smoke and steam are again painted over a reserve in the roof at the upper right,

Plate 168 Pale mauve of steam mixed from white, lightly tinted with cobalt blue, vermilion and red lake. Top surface of an unmounted fragment, 160×

but much less ground shows through; also the lighter tones of the roof and the more varied colours of the vapour cause less contrast than in the London picture. The general order of working in the two pictures seems to be similar – a rapid sketch of the outlines, a fluid main painting stage and later added touches – but the Chicago picture has a much more composed, finished look and presumably took more time to paint.

The Paris picture must have taken considerably longer than either of the other two and is quite different in technique. The darker warmer ground is hardly visible anywhere and the paint used is very dry and stiff, worked and reworked into a thick, granular, porous structure with dried paint layers beneath. The direct fluid working of the London and Chicago pictures has given way to a conscious building and texturing of the paint surface that looks forward to the dense and highly worked style of some of the later series paintings. Tonally, the Paris picture is also raised to a higher key: the solid understructure of blues, mauves and dull turquoise was overlaid in the final stage of working by bright slabs of yellow, orange, red and grey which convey vividly the hot sunlight streaming through the glass roof of the station and illuminating the distant buildings around the Pont de l'Europe.

A variety in both technique and composition is perhaps the most striking feature of the Saint-Lazare paintings. As the critic Georges Rivière noted when describing the paintings at the 1877 Impressionist group show: 'these paintings are amazingly varied, despite the monotony and aridity of the subject. In them more than anywhere else can be seen that skill in arrangement, that organisation of the canvas, that is one of the main qualities of Monet's work.' As we have seen, this skill in composition was matched by a sophistication in technique. The shifting effects of indoor and outdoor light and the contrasting qualities of dark metal and translucent vapour offered a challenging subject which taxed Monet's technical facility to the full.

Plate 169 Claude Monet, *The Gare Saint-Lazare*, 1877. 75·5 × 104 cm. Paris, Musée d'Orsay

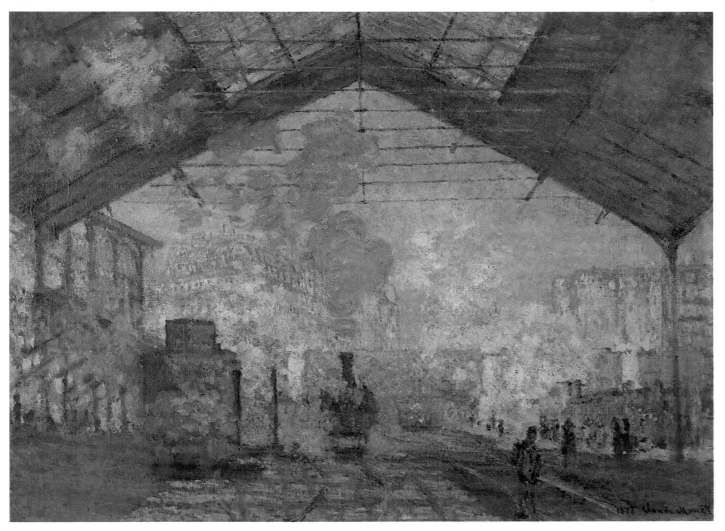

Pierre-Auguste Renoir

11. Boating on the Seine

Signed bottom left: Renoir.
71 × 92 cm (28 × 36¼ in.)

The exact setting for this picture (Plate 172) has yet to be identified. By tradition it is known as *The Seine at Asnières*, but this seems unlikely to be the area shown here. Asnières, on the outskirts of Paris, was well known as a centre for boating earlier in the nineteenth century, but by the 1870s it had been absorbed into the industrial sprawl of the capital, and other areas had become the preferred resorts for rowing, sailing and swimming. Although Asnières continued to attract the attention of artists, it is not a site that is normally linked with Renoir. Further down the river, the village of Chatou was particularly associated with rowing and Renoir worked there frequently in the late 1870s. *Boating on the Seine* is likely to be one of a group of boating subjects which he painted in this area in about 1879–80 (Plate 171).

At Chatou, the Seine is divided by a series of long narrow islands, and in the nineteenth century these were dotted with cafés which attracted a lively mix of urban pleasure-seekers. The character of the riverside scenery in *Boating on the Seine*, with its tree-lined banks and villa, suggests that it may have been painted near Chatou, although the rectilinear form of the bridge differs from the arched structure shown in other pictures identifiable with this area.

Renoir had painted women in boats in several canvases earlier in the 1870s, but there were also precedents for this imagery in the work of his friends Caillebotte and Monet. The composition is particularly reminiscent of Monet's pictures of the boat basin at Argenteuil, as is the detail of the train passing over the iron bridge, an unobtrusive reminder of the proximity of Paris (Plate 170). Yet unlike Monet, Renoir seems less concerned to document a specific site than to present a generalised and evocative image of suburban leisure. Similarly, Renoir's women are elegant amateurs drifting slowly in the haze of a hot summer's day, whereas Caillebotte (an enthusiastic rower and sailor) presents rowing as a vigorous sport.

Despite its appearance of absolute spontaneity, *Boating on the Seine* evolved in appreciable

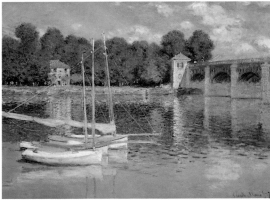

Plate 170 Claude Monet, *The Bridge at Argenteuil*, 1874. 60·5 × 80 cm. Paris, Musée d'Orsay

stages. Dried brushwork below the present surface shows some minor adjustments of outline to the prow of the skiff, the foreground rushes, the oar and the right-hand woman, who may originally have been reclining; these alterations are visible in the X-ray (Fig. 84), which also gives a somewhat abstract image of the scintillating brushwork across the entire composition. The brilliant mosaic of water

Plate 171 Pierre-Auguste Renoir, *Oarsmen at Chatou*. 81 × 100 cm. Washington, National Gallery of Art

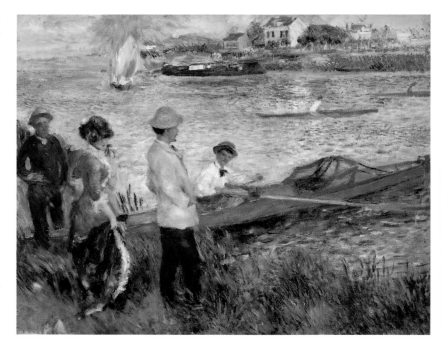

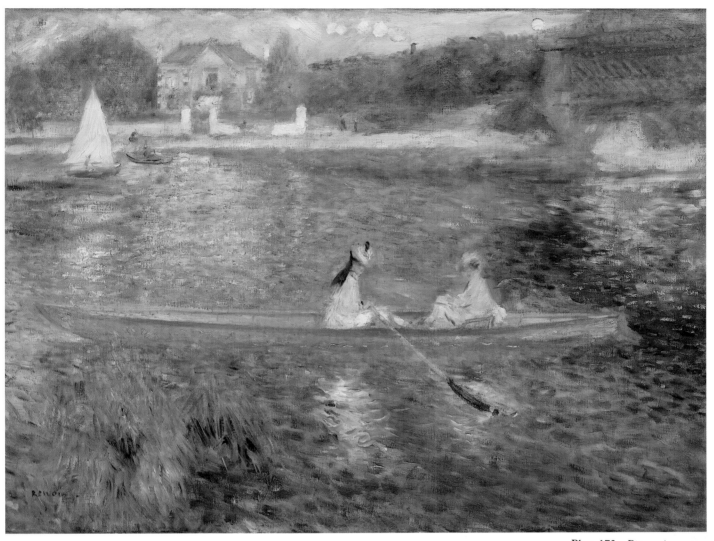

Plate 172 Pierre-Auguste
Renoir, *Boating on the Seine*

173

Fig. 84 Pierre-Auguste Renoir, *Boating on the Seine*, X-ray

and reflections is constructed with a variety of textures and consistencies of paint. The basic tones were put on rather dry, hardly wetting the weave of the canvas which constantly shows through. The high-toned blue touches and reflections of the two figures, applied next, are quite fluid, blended together in a flurry of wet-in-wet painting (Plate 173). By contrast, the reflection of the distant villa is thick, pasty and lean, dragged into a rather formless texture over the dried underpaint of the water (Plate 176). Some of the final white highlights – in the boat for example – are just flicked on the surface and allowed to fall as they please (Plate 174). These accidental paint textures added dimensions of freedom and instantaneity that were an essential part of Impressionist technique.

Renoir seems to have prepared his own canvas for this painting. The size is non-standard, being slightly smaller than a no. 30 landscape (see pages 45–6), and the priming is distinctly amateurish. Unlike most commercially primed canvases, the ground is simply lead white in oil, but it is applied so thinly and unevenly that the canvas itself is quite bare in many places (Plate 175). Even where the layer of ground is continuous, it is so thin that the darker colour of the canvas shows through. This, combined with some natural darkening of the oil binder, results in a ground that is a dull greyish colour rather than the white it was intended to be.

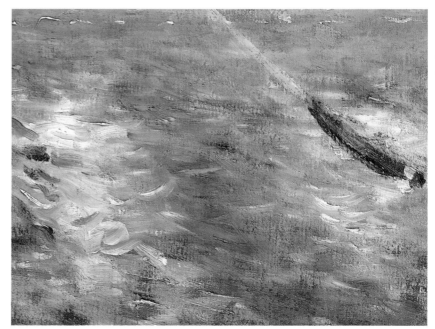

The overall tonality of the picture, then, is based on this rather low-key priming interspersed with even lower-key patches of bare canvas weave. These are indeed visible towards the more thinly painted edges of the picture, where the overall brightness seems to fade a little.

The brilliance of the painting is all on the surface, achieved by the direct use of opaque,

Plate 173 Pierre-Auguste Renoir, *Boating on the Seine*, detail

almost unmixed colours. Renoir's palette for the picture is composed of just seven intense pigments: cobalt blue, viridian, chrome yellow, 'lemon yellow', chrome orange, vermilion and red lake. Lead white, of course, is included as the pure white paint, and for colour tints throughout the painting. There is no black pigment used, and no earth colours appear. Not only is the pigment range severely restricted, the application of colour involves very limited intermixing in the main part of the scene. Much of the paint is applied directly from the tube, the technique relying on the juxtaposition of unblended bright colours, rather than on the physical mixing of paints.

The broad expanse of the river is in pure cobalt blue (Plate 177), with white added where the tone is made lighter. The translucent lake pigment provides a purplish undercolour to contrast with the deep blue of the water's surface, particularly towards the right. Elsewhere, the underpaints are a pale yellowish green (Plate 177). For the skiff, Renoir makes use of the powerful hues supplied by chromate pigments: the yellows and brownish yellows of the hull are depicted in combinations of chrome yellow (lead chromate) and 'lemon yellow' (here, strontium chromate), and outlined in flat, thick strokes of pure opaque chrome orange (basic lead chromate), used also for the broken reflections of the boat in the water.

Chromium pigments also make up the greens and yellow-greens of the river-bank landscape and the foreground foliage. The bank of rushes, for example, is painted in thick, partially merging strokes of pure viridian (transparent chromium oxide), worked over chrome yellow and white (Plate 178), while the flatter tones in the distance make use of the same pigments, rather more blended, with cobalt blue or viridian brushed into the shadows, and chrome orange for the hottest-coloured patches. Thickly applied pure lead white forms the garden wall of the villa and the sail of the dinghy, and a tint of lead white with vermilion is used to make the clear, light pink of the dress of the rower's companion reading in the skiff.

The complementary colour contrasts in the picture are striking. By setting the bright orange of the skiff against the extensive blue of the river, Renoir is applying the key principle of the colour theory that appears to have most interested Impressionist painters. This was the law of simultaneous contrast proposed by Chevreul in 1839 (see page 79). On Chevreul's colour circle, orange and blue are placed opposite one another, and according to the theory, when they are seen as adjacent colours the 'height of tone' (intensity) and 'colour property' (hue) of each are mutually enhanced.

Whether by intuition or design, the juxtaposition of blue and orange in *Boating on the Seine* is almost a text-book illustration of these theories. The choice of pink for the woman passenger's dress exploits another of Chevreul's principles of colour contrast: that by placing the tint of a colour, in this case red, next to one adjacent to it on the colour circle, here orange, a heightened contrast between the two will also be produced. By exploiting effects of simultaneous contrast and by using pure unmixed pigment, Renoir conveys the intensity of bright outdoor light with unparalleled success. Of all the pictures discussed in this catalogue, *Boating on the Seine* provides the clearest case of the direct Impressionist method expressed in its purest and most uncompromising form.

Plate 174 Pierre-Auguste Renoir, *Boating on the Seine*, macro detail of white highlight on boat

Plate 175 Pierre-Auguste Renoir, *Boating on the Seine*, macro detail showing uneven priming and bare canvas

Plate 176 Pierre-Auguste Renoir, *Boating on the Seine*, detail

Plate 177 Intense blue impasto of the water, painted in pure cobalt blue over a light yellowish-green underlayer. Cross-section, 550×

Plate 178 Deep green of the foreground rushes in pure viridian worked into an underlayer of chrome yellow. Reverse surface of an unmounted fragment, 100×

Berthe Morisot

12. Summer's Day

Signed lower right: Berthe Morisot
45.7 × 75.3 cm (18 × 29¾ in.)

This is probably the picture exhibited at the fifth Impressionist exhibition in 1880 with the title *The Lake in the Bois de boulogne* (Plate 180). The same models appear in identical costume in another of Morisot's exhibits of 1880, *In the Bois de Boulogne* (Plate 179), and both works were probably painted during the previous summer.

Morisot's contribution to the 1880 exhibition attracted some favourable comment. Her works were praised for their lightness of touch and skilful rendering of outdoor effects. 'I have been utterly seduced and charmed by Morisot's talent', wrote one reviewer, 'I have seen nothing more delicate in painting. Her works, *L'été* [and] *Le lac du bois de Boulogne*, . . . have been painted with extraordinarily subtle tones.'

The Bois de Boulogne was familiar territory for Morisot, who had been brought up in the nearby suburb of Passy, and she went there frequently on painting trips. In the 1850s the Bois had been transformed from a formal park into an area of 'natural' woodland, interspersed with ponds and lakes. With the added attractions of a racetrack, a zoo and a botanical garden, the Bois soon became an extremely popular venue with fashionable Parisians. In Morisot's paintings, however, the Bois

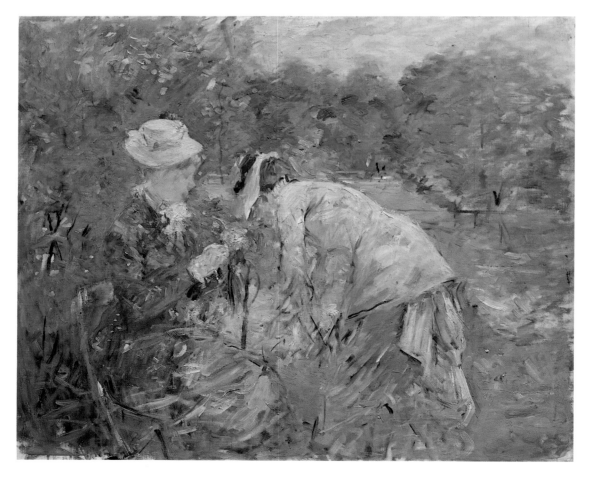

Plate 179 Berthe Morisot, *In the Bois de Boulogne*. 61 × 73·5 cm. Stockholm, Nationalmuseum

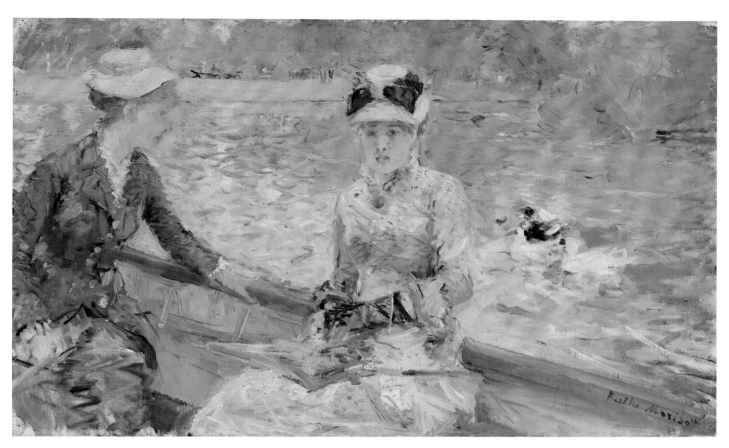

Plate 180 Berthe Morisot,
Summer's Day

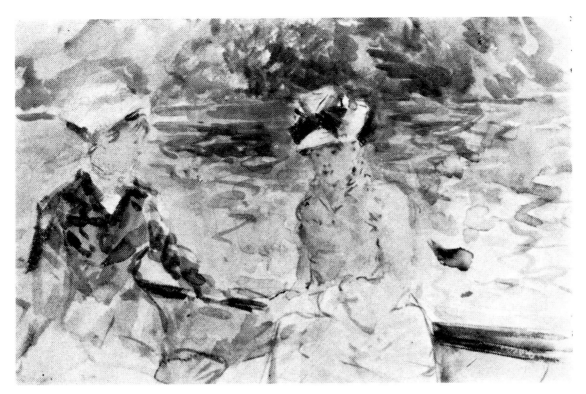

is never represented as a crowded suburban playground. Usually she concentrates on one or two figures shown against a generalised background of water and foliage, sometimes boating on the lake or resting by the shore. The setting for *Summer's Day* has been identified as the northern end of the Lac Inférieur, but the background is only summarily indicated. On the far bank there are some figures and a speeding carriage, while the tip of land in the upper right corner may be an island.

Painting figures out of doors was one of Morisot's constant preoccupations and – perhaps following the example of Daubigny – she is known to have painted from boats. Her letters often refer to the difficulties involved in working in *plein air*. Jacques-Emile Blanche recalled that Morisot, working in the Bois de Boulogne, became so frustrated with a study of some swans that she had been following from a boat that she cast her work into the lake. We can only speculate whether *Summer's Day* was painted with models actually posing on a boat. There is a watercolour study for the picture (Fig. 85) and, given that this medium is more portable and less time-consuming, it would seem likely to have been executed in front of the subject. For some of the final painting, however, the painter may well have posed the models in the privacy of her garden at home.

Morisot has used a commercially primed canvas from Moirinat of faubourg Saint-Honoré, whose stamp is on the back (Fig. 86). The canvas

Fig. 86 Berthe Morisot, *Summer's Day*, stamp on back of canvas

Plate 181 Berthe Morisot, *Summer's Day*, detail of canvas pin marks, bottom left corner

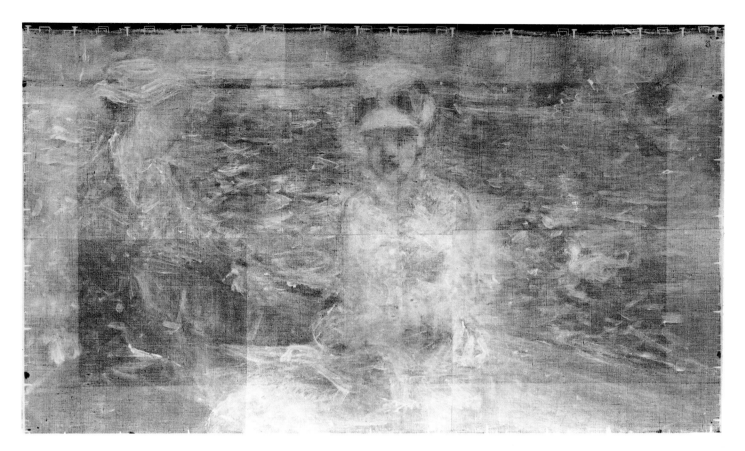

size is non-standard; the dimensions do not correspond to any of the usual listed formats. The priming is a very pale cream colour composed of lead white, lightly tinted with traces of a translucent yellow pigment (see, for example, Plate 184). This ground extends around the stretcher at the sides and bottom, but the upper turnover is unprimed, which means that this particular piece of canvas was cut from the very edge of the huge primed length by the supplier: it does not imply that Morisot primed or even stretched the canvas herself.

Summer's Day has not been lined and the canvas and priming are in almost perfect condition. The light cream ground is visible around the edges of the painting and at the corners. Morisot has used double-pointed canvas pins – apparently mounted in corks – to transport the wet picture during painting and the marks show clearly in each corner. Curiously, she may have painted some of the picture with the corks in place, because the paint appears to go around their circular shape – even outlining it in the lower left corner (Plate 181). In the upper and lower right corners, some brown ochre paint has been dabbed on (presumably by the artist) to conceal the cork marks, at the last stage of painting.

In the central areas of the picture, the ground is used only slightly for the final tone. It shows

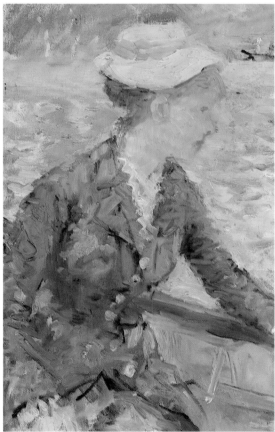

Plate 182 Berthe Morisot,
Summer's Day, detail

179

between some of the brushstrokes of the water, and gives a dimmed luminosity below some of the duller greens. Colour is used mostly opaquely and thickly, built up in several layers. As with many Impressionist paintings, it is possible to identify at least three principal stages – the initial, rapid lay-in defining the main forms; the main wet-in-wet painting; and the finishing touches. Here, the main painting stage was itself done over some period of time, since there are dried *pentimenti* under some of the fluid upper layers, and, in a number of cases, cross-sections show a clear demarcation between the surface and underpaint layers (see, for example, Plates 185 and 186).

Traces of the preliminary lay-in in dull dark scrubbed colours can be seen in the skirt and coat of the left-hand figure (see Plate 183) and in the paint of the boat between the two figures (see Plate 185). At the top of the painting, the trees were indicated with thin washes of dull green.

The main painting stage followed, but with some intervals. Examination of the picture surface and of the X-ray (Fig. 87) shows that the pale river bank was at first higher: Morisot painted it out and moved it down, presumably because the horizontal line confused the upper outlines of the two women's hats. By the time this adjustment was made, the paint of the first position was already dry. Other alterations over dried paint are apparent. The blue parasol was originally a little lower, and the edge of the boat as it curves down to the right was higher. There also seems to have been a long flat boat by the river bank to the right, which was subsequently painted out. The outlines of the two women were defined and sharpened by painting around them over the already dried paint of the water.

The most striking feature of the principal painting stage is Morisot's unique and unmistakable brushwork, much commented upon by her contemporaries. Its repeated zig-zags give a shimmering, restless quality to the image as if the entire scene were refracted through countless prisms (Plate 182). The effect of this is to unify everything into one continuous sweep of texture and colour: figures, background and water merge into a luminous blond tonality which ripples across the whole surface of the picture. Individual forms are almost submerged in the decorative patterning of the paint.

The final touches are dashed in on the surface very rapidly. The black outlines of the gloves and the strong red-brown touches on the parasol are dabbed on with uncalculated freedom. One particularly intriguing final detail is the series of olive-green zig-zags above and below the hands of the woman on the right, which might seem to define

Plate 183 Grey-blue of left-hand figure's coat. The lay-in contains cerulean blue with a little French ultramarine and black. Cobalt blue with some French ultramarine makes up the surface paint. Cross-section, 550×

Plate 184 Vivid green of foliage, right, containing emerald green, viridian, cadmium yellow and white. A small amount of yellow pigment can be seen to tint the ground layer. Cross-section, 200×

some vague shadow but which are surely intended to add to the patterning of the surface in a slightly blank area. Carried out with very diluted paint, they seem to be almost the last brushstrokes on the picture.

Morisot's choice of pigments for this picture is distinctive, and departs from some of the restrictive constraints of the type of palette which might have been set out according to Impressionist colour concepts. It is unusual to find cerulean blue (cobalt stannate), for example, which occurs, with other blue pigments, in the complex colour design of the skirt and coat of the woman to the left. It is also quite early to find cadmium pigment being used as the main bright opaque yellow, although its presence is not immediately obvious, since it is largely submerged in colour mixtures for the background foliage greens. Morisot seems to have had neither a reluctance to work with earth colours, which are used without any modification in the painting of the boat, nor any hesitation in using pure black paint, which she uses for its lay-in. The plumage of the ducks and the black gloves of the central figure are also in ivory black. Her technique seems more directed by the range of colour that she wished to achieve, rather than by an overall integrated tonality.

There is an interesting similarity between Berthe Morisot's palette and that of Edouard Manet, who is known also to have been painting with both cerulean blue and cadmium yellow in the late 1870s,

for example in *The Waitress* (London, National Gallery) of 1878.

In *Summer's Day*, the left-hand figure's dark blue coat is underpainted with cerulean blue, combined with white and black pigment and a little French ultramarine. The tonality of the underlayer is both greenish and greyish, and this can be seen exposed in places where no thicker paint has been applied on top. Over this lay-in, the pigments are cobalt blue with a little added French ultramarine (Plate 183) and further patches containing cerulean. The final jagged strokes dashed over the surface are in pure synthetic ultramarine. Black is used to darken the tone, while the three different blue pigments produce the flickering quality, reinforced by the disjointed brushwork.

The lighter and yellower greens of the background paints for the foliage, the water's surface and the far river bank contain mixtures of two green pigments – emerald green and lesser amounts of viridian – combined with lead white and cadmium yellow (Plate 184). Some of these palette mixtures contain chrome yellow as well, while the colder, stronger green paints are enriched with viridian, for example in the bluish-green foliage overhanging the edge of the island at the right. Certain of the green paints contain also a little added ultramarine.

Analysis has shown that the duller-coloured paints of brown, greyish brown and dull orange used for the inside of the boat are based on several kinds of natural ochre. These are principally yellow, orange and brown varieties, which are used on their own and combined in mixtures, as well as modified with white and black pigment (Plate 185). The strongest orange-yellows are virtually pure ochre: an unusually straightforward method in an Impressionist painting. Unusual too is the use of unmixed ivory black in the lay-in (Plate 185), although this does occur in Renoir's *At the Theatre* (Cat. no. 8) of about the same date. Surprisingly, the brownish red of the lining of the parasol, which suggests the colour of a strong red earth pigment, is in fact vermilion subdued by working in a brownish lake and some black (Plate 186).

The signature is double-toned – dark brown and orange – as if Morisot picked up an accidental colour mixture from the palette. From the first 'o' of 'Morisot' onwards, she seemed to find a purer dark tone with which to finish.

As we have seen, *Summer's Day* is painted on a conventional commercially primed canvas, which was Morisot's normal painting support. Soon after this – in the early 1880s – she experimented with unprimed canvases, applying oil paint to the raw fabric. On occasions, she used or re-used the backs of primed canvases. In general, these experimental

Plate 185 Thin dark brown interior of the boat, with earth pigments, black and white in the surface layer, and pure ivory black for the lay-in. Cross-section, 200×

Plate 186 Red-brown of the parasol in vermilion and red lake with a little black pigment, over mauvish underpaint. Cross-section, 550×

canvases have changed tone drastically as a result of lining and varnishing, becoming dark orange in the areas where the canvas is unpainted.

Morisot was consistently daring in her experiments in technique. Her brushwork in particular is often startling in its freedom and vigour and *Summer's Day* is a typical example of her bold visual shorthand. The animated, fragmented surface makes no concession to traditional notions of an acceptable degree of finish. Morisot's pursuit of spontaneity and directness often provoked harsh criticism: surveying her works, including *Summer's Day*, at the 1880 Impressionist exhibition, one reviewer asked, 'Why with her talent, does she not take the trouble to finish?' To many viewers, her work seemed to be nothing more than sketches or studies: for Paul Mantz writing in *Le Temps* they were merely 'projects, promises of paintings that will never be done . . .'.

Claude Monet

13. Lavacourt under Snow

Signed: Claude Monet 1881
59.5 × 81 cm (23½ × 31¾ in.)

Although traditionally known as *Vétheuil: Sunshine and Snow* there is no doubt that this picture (Plate 188) is a view of Lavacourt, a hamlet on the opposite side of the Seine from Vétheuil, where Monet lived between 1878 and 1881.

This was an unsettled time for Monet. His move to Vétheuil, some sixty kilometres from Paris, marked the beginning of a period of isolation and independence from his fellow Impressionists. As he wrote to Théodore Duret in 1879: 'I have become a country-dweller again and . . . I only come to Paris very rarely to sell my canvases.' A sense of disillusionment with the group activities of the 1870s was compounded by the faltering market for his work, and Monet was to suffer severe financial hardship before his situation improved in the early 1880s. His circumstances were further complicated by the protracted illness of his wife and the strange *ménage* at Vétheuil where Monet and his family shared a house with the family of his former patron, the bankrupt financier Ernest Hoschedé. The death of Madame Monet in 1879 and the establishment of a more or less permanent relationship with Hoschedé's wife, Alice, heralded a new phase in the artist's career.

Lavacourt under Snow is signed and dated 1881,

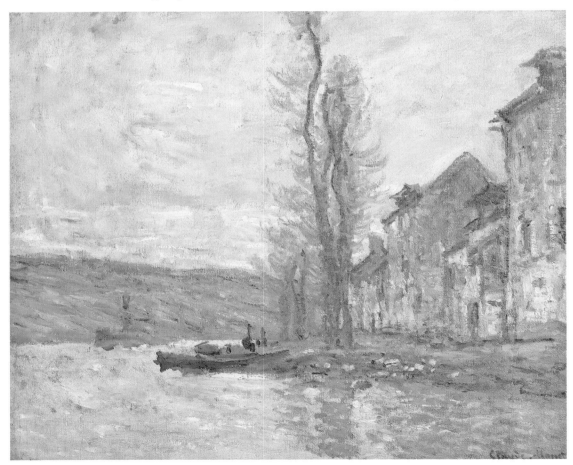

Plate 187 Claude Monet, *The Seine at Lavacourt*, *c.* 1879. 54 × 65 cm. Oregon, Portland Art Museum

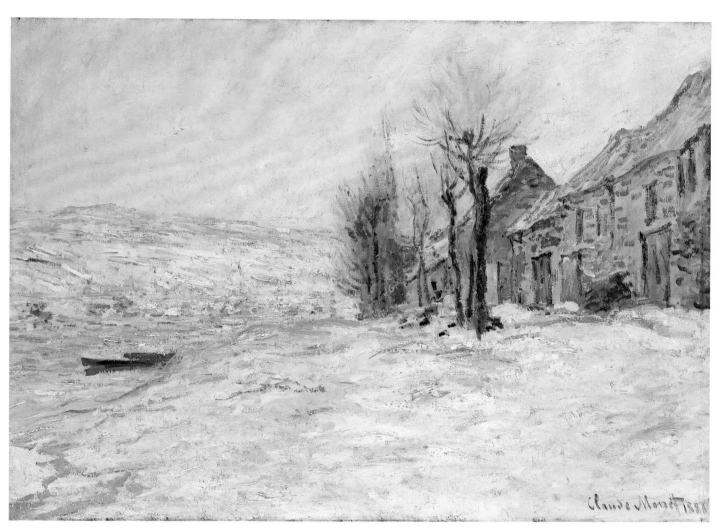

Plate 188 Claude Monet,
Lavacourt under Snow

but in the catalogue of Monet's works compiled by Daniel Wildenstein the picture is said to have been painted in the winter of 1878–9. The artist frequently added his signature long after the completion of a picture, sometimes when it was sold or if it left his studio for an exhibition, and his dating was often inaccurate. Wildenstein offers no reason for the re-dating of this particular painting, although it does appear to be close in style to other works painted during Monet's first months at Vétheuil.

The National Gallery painting is one of a group of similar views, taken from the river bank looking upstream, with the tumbledown cottages of Lavacourt on the right (Plate 187). In contrast to the explicit modernity that was often apparent in his work in Paris and its suburbs during the 1870s, the picture presents an unchallenging and traditional rural scene – an image of nature untouched by industrial development. In several other respects *Lavacourt under Snow* anticipates Monet's preoccupations during the 1880s. The composition is simple and sparse, allowing the artist to concentrate on the play of light across the blanket of snow in the foreground. The snow effect demonstrates his

developing interest in extremes of weather – the severe winter of 1879–80 and the dramatic thaw were to inspire some of his most memorable works.

The canvas is of the standard no. 25 landscape size (see pages 45–6), but was clearly not bought ready-prepared from a supplier. The turnover edges are unprimed at all four sides – a sure indication that priming was carried out with the canvas already on its stretcher, and therefore not cut from a pre-primed length. Monet was perhaps re-using a standard-size stretcher from which he had discarded a commercially prepared canvas, but certainly here the stretching and priming appear to have been carried out by him.

The layer structure of *Lavacourt* is complex and puzzling. The thick ground applied to the fine-weave canvas is in fact a double one. The lower, buff-coloured layer comprises lead white and barium sulphate (as an extender) tinted with yellow-brown ochre. The upper, yellowish-grey layer, granular in appearance, comprises lead white and lithopone with a little yellow-brown earth. Lithopone, a manufactured mixture of barium sulphate and zinc sulphide, was patented in Eng-

Fig. 88 Claude Monet, *Lavacourt under Snow*, X-ray

land in 1874: this is, therefore, quite an early use for it. In cross-sections, the two grounds tend to delaminate from each other, perhaps confirming the less-than-expert application by a painter, rather than by a professional primer.

Above the double ground but below the present painting in almost all parts of the picture is an extensive layer of green paint (Plate 189), fragments of which are visible at the edges of the canvas (Plate 191). The colour varies from place to place – from a very deep cold green of almost pure viridian to lighter yellow-greens containing cadmium yellow and/or lead white. A possible explanation for the existence of this layer is that Monet was laying-in a completely different composition – presumably a landscape where green was the dominant colour. There are some dried brush-strokes beneath the surface paint which may belong to this stage, but it is impossible to discern any coherent structure for the lower layer; the X-ray is unhelpful in this respect, since the green pigments used are not very dense to X-rays, and we see only the forceful brushwork of the surface (Fig. 88).

If the original composition was a landscape, it was not pursued beyond this initial lay-in. Monet painted directly over it with the broad greyish underpaints of the present composition. In a few areas – most obviously near the signature – he used a palette knife to apply this colour stage, but all the vigorous final painting is done with brushes heavily loaded with thick fluid paint. A raking-light photograph (Fig. 89) conjures up a vivid glimpse of the painter at work, applying flurries of impasto across the sky, distant hillside and snow-covered fore-

Plate 189 Emerald-green highlight on water's surface, left edge. Two layers of ground are visible beneath: the lower, buff-coloured, and the upper a coarse yellowish grey. A split at the interface of the two primings is evident. A deep green paint layer, which forms part of Monet's earlier composition, lies directly on the upper ground. Cross-section, 200×

Fig. 89 Claude Monet, *Lavacourt under Snow*, photograph in raking light

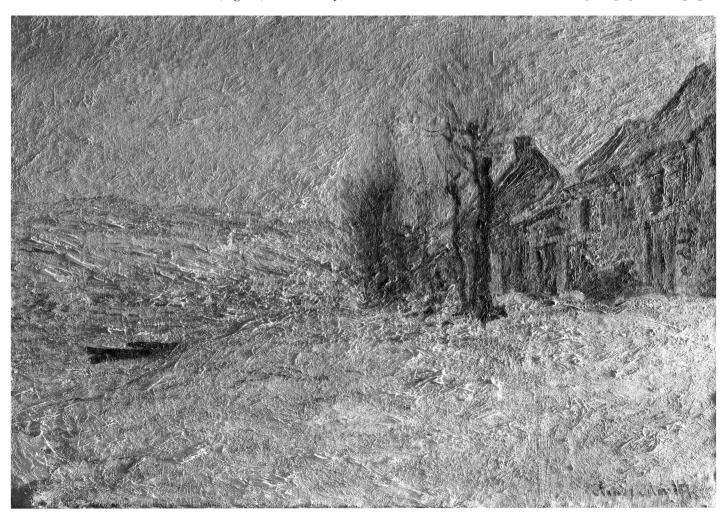

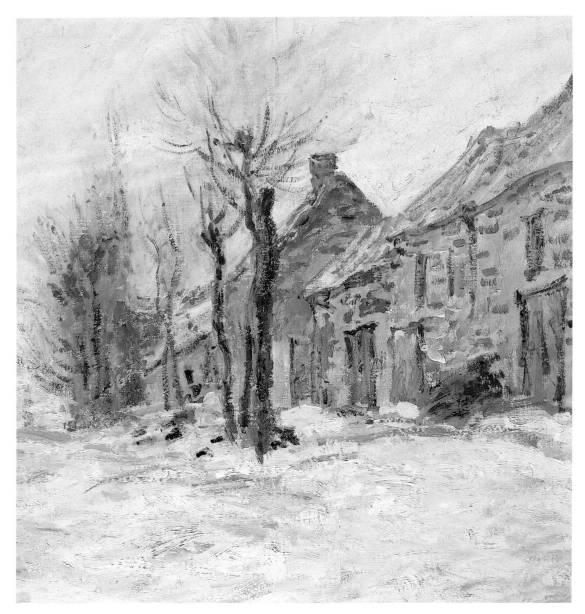

ground. The only areas relatively free of thick paint are the trees in the centre. These were clearly planned from the beginning and consist simply of underpaint with a few thin lines and washes at the surface.

Unlike many of Monet's earlier paintings, the greater part of the composition makes use of pure pigment for the thickly worked surface, to create the striking colour effects and tonal contrasts which dominate its design. In the expanse of the snow-field, the river, the distant hillside and the sky, Monet used mainly single pigments and their tints. These are worked over underlayers devised as softer tones, made from white and small amounts of more mixed pigment, but nowhere is the construction of colour so complex as in the earlier paintings, for example *The Petit Bras of the Seine at Argenteuil*

(Cat. no. 6) and *The Gare Saint-Lazare* (Cat. no. 10). The underpaints seem generally designed to provide discreet simultaneous contrasts with the high-key impasto laid on top, or to echo the bright

surface colours in a related tint. This tonal under-structure is most evident in the painting of the group of cottages with their line of trees (Plate 190), in which duller-coloured mixed paints are left more exposed, heightened only here and there with a few narrow vertical streaks of purer pigment.

By this time, Monet had refined his palette to a fairly small selection of pigments. Here they have been identified as: cobalt blue, synthetic ultramarine, viridian, emerald green, vermilion, red lake, cadmium yellow and lead white. Apart from the yellow and white pigments, it is noticeable that each colour is represented by a pair, chosen for their differing properties in hue, translucency and saturation (depth or intensity of colour). For example, the functions of opaque bright red vermilion and the deep crimson-toned lake are quite different in the picture, the first forming clear, light pink tints in the surface impasto, while the second is used for intensity of colour in the dark, coloured shadows of the tree trunks and in the duller undercolours (see Plate 194). The two blue pigments are also used in distinct ways; so too are the greens. No earth colours are used, and, for this picture, Monet avoids black pigment altogether.

The strongest blues of the snowfield are entirely of cobalt blue lightened with white in the mid-tones and paler tints. The underlayers incorporate some ultramarine, lending them a slightly greyish tinge, and in places, traces of red lake are also added, giving a very pale mauve effect (Plate 192). The light-coloured paints of the distant hillside are mixed simply from a single pigment and white: vermilion for the rose colours, emerald green for the clear light yellow-greens, and cadmium yellow in the pale lemon colours. In contrast, the surface streaks of the most saturated strong dark colours used for the group of buildings and for the trees are pure pigment, undiluted with white. Particularly evident are the intense hues of cobalt blue, red lake and viridian (Plate 193).

A decade earlier, in *Bathers at La Grenouillère* (Cat. no. 2), Monet was constructing his more sombre-toned paints from the most elaborate palette mixtures. He was also using chromate pigments, earth colours and black. Here, the technique is simplified. The flatter tones of the cottage walls are now restricted to mixtures of two or three colourful pigments only, combined with white. There are dull opaque mauves made from cobalt blue or ultramarine with red lake (Plate 194), and similar browner tones containing added viridian. The olive and khaki paints are mixed from cobalt blue, viridian and cadmium yellow, while the red-brown branches of the trees are in vermilion and cobalt blue with white (Plate 195).

Plate 192 Mid-blue of the snowfield in a tint of cobalt blue, over a thick pale mauve underpaint, comprising lead white with a little French ultramarine and red lake. Cross-section, 200×

Plate 193 Pure viridian touch on the wall of the cottages, over a mixed mauvish-brown background layer. Cross-section, 550×

Plate 194 Brownish-red (vermilion) patch of cottage wall, over mixed dull mauves of cobalt blue, red lake and white. Cross-section, 550×

Plate 195 Dull reddish-brown branch of tree, painted in vermilion mixed with cobalt blue and white. Top surface of an unmounted fragment, 200×

Painted at the end of a decade of experimentation, *Lavacourt under Snow* illustrates the growing assurance of Monet's technique. Analysis of the painting shows that he was able to refine and simplify his initial Impressionist style, as he strove to capture ever more transitory effects.

Pierre-Auguste Renoir

14. The Umbrellas (Les Parapluies)

Signed bottom right: Renoir.
180 × 115 cm (71 × 45 in.)

The pattern of Renoir's career changed dramatically in the 1880s. Towards the end of the previous decade his work had begun to gain some recognition, albeit with a small circle of patrons and collectors, and he now experienced a degree of financial security. For the first time he was able to travel widely and his art developed and broadened in response to a great variety of external stimuli.

While Renoir enjoyed his first taste of success, this was also a period marked by an increasing anxiety about the nature and ambition of his art. Like Monet, Renoir had become disillusioned with the group activities of the Impressionists and seems to have been acutely aware of the repeated criticisms, even from sympathetic writers, which pointed to a lack of resolution in their paintings. He was particularly concerned about his technique and began to question the validity of his stylistic researches of the 1870s. The process of building up a paint surface with rapid touches of colour which had suited his work as a *plein-air* landscapist (see Cat. no. 11) was difficult to adapt to the portrait and figure paintings which played an increasingly important role in his work in the late 1870s and early 1880s.

Renoir now had to face one of the central problems of the Impressionist style: how to combine bright luminous surfaces with the sense of structure and clarity of form which he admired in many forms of traditional art. As he later confided to Vollard, 'I had come to the end of Impressionism, and I was reaching the conclusion that I didn't know how either to paint or draw. In a word, I was at a dead end.'

Renoir became more willing to accept the 'instruction of the museums' and began to express an admiration for Ingres and the qualities of his drawing. When he travelled to Italy in 1881 he was inspired by the frescoes of Raphael at the Villa Farnesina and by the ancient Roman wall-paintings that he saw in Naples. Classical art was admired for its 'purity and grandeur', qualities which he thought were lacking in his own painting. On his return

journey, a prolonged stay with Cézanne in Provence seems to have reinforced a desire to introduce an increased sense of order and harmony into his work.

The Umbrellas (Plate 197) was painted during this restless period of the 1880s and few paintings offer a better illustration of the conflicting directions in his art. It is immediately apparent that the picture exhibits two distinct styles. The group of figures on the right is painted in a soft feathery style reminiscent of his work of the later 1870s, while the umbrellas and the couple at the left are painted in a harder manner with more distinct outlines and subdued steely colours (Plates 196 and 198). The exact date of the painting is not known but it is generally accepted that it was worked on over a period of several years. Suggestions for the dating

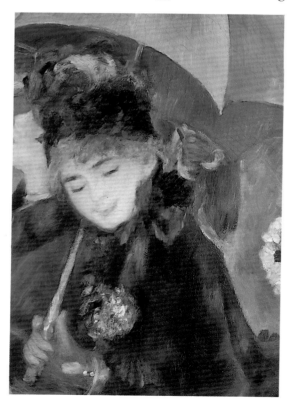

Plate 196 Pierre-Auguste Renoir, *The Umbrellas*, detail

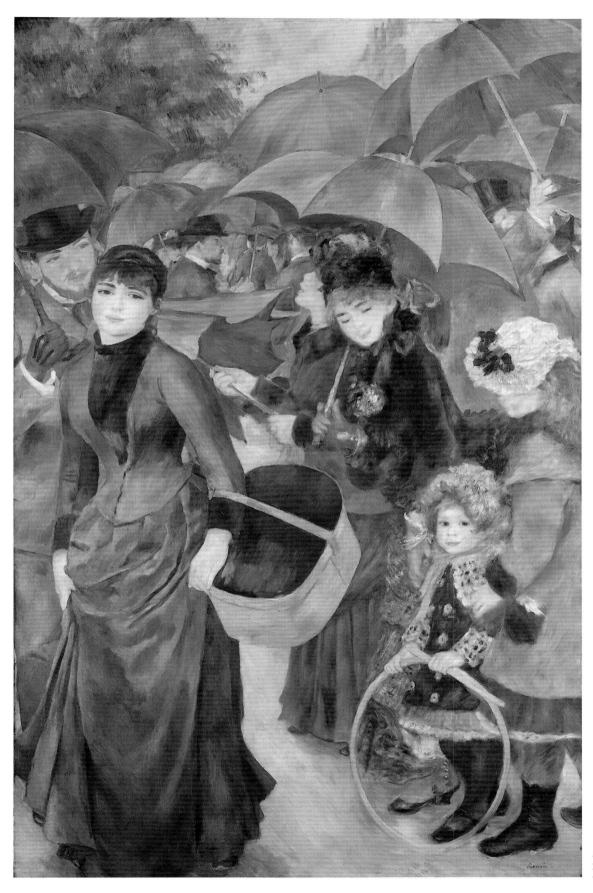

Plate 197 Pierre-Auguste
Renoir, *The Umbrellas*

189

and genesis of the *Umbrellas* were first put forward by Martin Davies and developed further by John House in the catalogue for the Renoir exhibition in 1985–6. Using the evidence provided by an early X-ray photograph, as well as examining the painting's style and the fashions worn by the women, it was suggested that *The Umbrellas* was painted in two distinct stages with a probable interval of about four years. House compared the treatment of the figures on the right, painted in fluid, atmospheric touches, to several works datable around 1880–1, including *On the Terrace* (Art Institute of Chicago; Plate 200). The taut, disciplined style of the left-hand figures was compared with works of around 1885, including the *Portrait of Aline Charigot* (Philadelphia Museum of Art; Plate 201).

An analysis of the differing fashions illustrated in *The Umbrellas* confirms this dating, since the women in Renoir's paintings are usually dressed in the latest styles. The dresses and hats worn by the figures at the right conform to a fashion that appeared in 1881 and which became popular in 1882. This vogue was superseded the following year by a more severe style of dress with simple, straight lines. The woman with a band-box is dressed in this later style which was the height of fashion in 1885–6 but which had fallen out of favour by 1887.

Although the broad development of the painting in two separate stages several years apart has been understood for some time, the extent of the composition at the end of the first stage, and hence the appearance of the picture during the intervening years, has been a matter for speculation. Using technical photography, pigment analysis and detailed examination of the layer structure of the picture, it is now possible to confirm and extend the past interpretations of the evolution of the composition.

The X-ray (Fig. 90) has thrown some light on the problem. For example, there is little sign of any substantial change to the group at the right, only a certain amount of minor adjustment of surface colour at a late stage. However, on the left-hand side there is evidence of more radical alterations, particularly to the costume of the woman with the band-box. She was certainly present at the first stage and, moreover, was painted in the earlier feathery technique – apparently wearing clothes close in style to those of the group on the right, with a skirt arranged in tiers of horizontal frills. She appears at this stage to have had white lace cuffs and collar. She was also wearing a hat, of which the outlines are visible in the X-ray and on the picture surface: that this is a coloured hat and not simply a more elaborate hairstyle is confirmed by a cross-

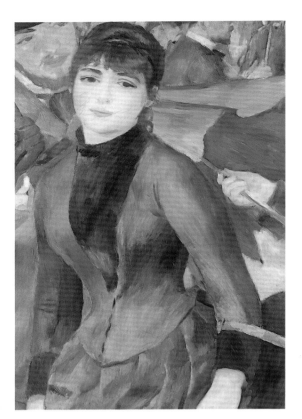

Plate 198 Pierre-Auguste Renoir, *The Umbrellas*, detail

Plate 199 Thin chestnut-brown colour of left-hand woman's hair (Stage 2), concealing thick impasto of her earlier hat (Stage 1), painted in red lake, cobalt blue, yellow and white pigment. Cross-section, 150×

section from the area which shows vivid swirls of red lake pigment, incorporating streaks of cobalt blue, white and yellow (Plate 199), comparable to the painting of the bouquet in *At the Theatre* (Cat. no. 8). The woman may also have been wearing a belt or waistband, and she seems to have had a rather different expression on her face.

Beyond these details, which show a slightly different image below the present one, the X-ray does not go further in establishing what was present at the end of Stage 1 and what was subsequently painted during the much delayed Stage 2. However, recent technical examination of the painting has clarified matters considerably, and it is now possible to assign the many levels of paint observed in cross-sections to Stage 1 or Stage 2.

Renoir appears to have changed his palette significantly between the two stages. Examination

of the cross-sections shows that in the earlier phase he used exclusively cobalt blue, his habitual choice during the 1870s and early 1880s, but in finishing and revising the composition he used only French ultramarine. Since a great many layers within the painting's complex structure contain blue pigment, the identity and location of each type is the key that unlocks the problem. In short, any paint layer identified as containing cobalt blue belongs to Stage 1, whereas the presence of French ultramarine indicates the later reworking (see Plates 202 and 203).

Apart from assisting the interpretation of the way in which the composition was evolved, the very widespread use of the ultramarine in the second stage of the painting also exerts an important colour effect in the picture. The high tinting strength of artificial ultramarine leads to a characteristic overall slate-grey tonality everywhere the pigment is used, quite unlike that of the sections of painting which contain cobalt blue, as in the Stage 1 figure group to the right. Much of the second stage is rendered as coloured greys, where the ultramarine is mixed with a range of other pigments, while the first stage suggests use of colour of a more obviously Impressionist type. Only the yellow and green foliage to the upper left, which is part of the revised composition and contains no ultramarine pigment, shows the brighter, clearer use of colour of Renoir's earlier method.

There is a second change in palette between Stages 1 and 2 that confirms the evolution of the painting in two quite separate phases. In the 1870s, Renoir generally used chromate yellows, as in, for example, *At the Theatre* and *Boating on the Seine* (Cat. nos. 8 and 11). By the 1880s, he had abandoned chrome yellows in favour of lead-antimonate pigments (Naples yellow). In this case analysis shows the transition quite clearly, with the use of zinc yellow (zinc potassium chromate) in Stage 1 and a lead-antimony yellow for Stage 2. The underlayers for the foreground (see Plate 207 below), for example, contain zinc yellow, as these belong to the initial composition, while the foliage in the upper left makes use of Naples yellow in combination with emerald green.

Certain other features of the structure of the painting should also be mentioned. If the edges of the picture – where the canvas turns over the side of the stretcher – are examined, it can be seen that only the right-hand side has its original primed but unpainted turnover. On the other three edges the turnover has priming plus some paint. This indicates that the canvas was cut down at these three edges, although perhaps not by very much, and then remounted on a smaller stretcher. In its present

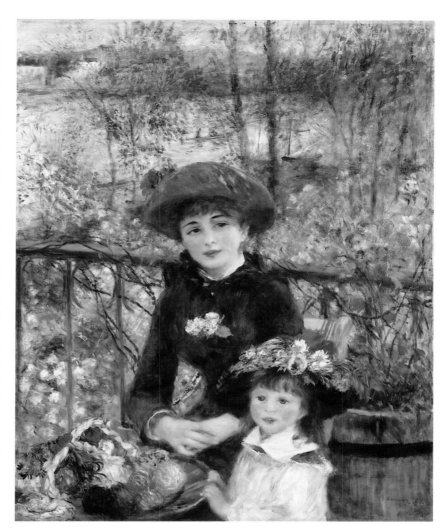

Plate 200 Pierre-Auguste Renoir, *On the Terrace*, 1881. 100·5 × 81 cm. Chicago, Art Institute

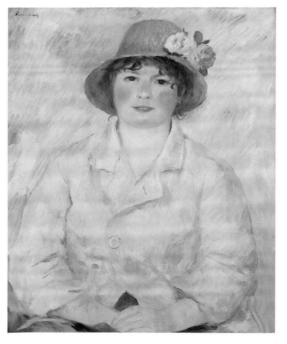

Plate 201 Pierre-Auguste Renoir, *Portrait of Aline Charigot*, c. 1885. 65 × 54 cm. Philadelphia Museum of Art

Fig. 90 Pierre-Auguste Renoir, *The Umbrellas*, X-ray

size it does not correspond to any of the listed formats: it may have been cut down from a no. 120 figure size canvas (see pages 45–6), or originally made up to a particular non-standard specification for Renoir.

This cutting-down must have occurred between the two stages of work and therefore the paint on the edges belongs to the first phase (see Plate 207). It is possible that, in the intervening years, the painting was stored off its stretcher, perhaps even rolled, which might account for the marked cracking of the ground and paint layers. When Renoir resumed work on the painting, the old stretcher may have been lost or he may have decided to reduce the dimensions.

Examination of the lower part of the left turnover edge (Plate 205) shows a swathe of purple-blue drapery that disappears under the pinkish foreground paint on the front surface of the painting and does not join up with the woman's present dress. This, quite clearly, is the dress of the woman at Stage 1 and, as expected, it contains cobalt blue as its principal component. Originally, both the style of her clothes and their colour were quite different. The paint layer structure beneath the present surface is extremely complicated, but it is possible to interpret something of Renoir's initial construction of colour for the dress. The woman's bodice was first painted in varying tones of a powerful greenish blue. Significantly, the same pigments were employed as for the figure group to the right, principally cobalt blue combined with zinc yellow. The painting of the bodice then continued with several layers of pinks, mauves and blues based on cobalt blue, red lake and white. This was the state in which it was left at the end of Stage 1. The revision at Stage 2 lies directly on top, in at least three more layers of the greyer-coloured paint containing ultramarine (Plate 204).

The long frilled skirt of the dress is rather less re-cast in its Stage 1 colour design. It was first painted as varying combinations of purple, pink and blue, once again constructed from cobalt blue, red lake and white in a complex series of layers. As before, the upper layers belonging to the revision are rich in ultramarine (Plate 206). It is clear that the overall tonality of the composition at the end of Stage 1 was a great deal more vivid and more saturated in colour than the finished picture we now see.

On the bottom turnover edge, there are also traces of the same purple-blue dress that pass under the upper paint layers on the picture surface. Further along to the right, however, the pink and blue paint of the foreground continues quite unchanged from the bottom edge to the front of the

picture, thus confirming that the area surrounding the right-hand figure group was not altered substantially during Stage 2.

Returning to the left-hand turnover edge, it is clear that the man immediately behind the woman with the band-box was also present at the first stage of painting. However, the fragments of paint on the edge corresponding to flesh colours, jacket and hat do not convey a very clear image of his appearance at Stage 1. Neither is the X-ray particularly helpful here – except perhaps to indicate that the man may originally have been wearing a cap rather than a hat.

The other major feature that appears to belong to Stage 1 is underpaint below the figures and foreground, the colour of which varies between pale yellow, orange and pink (Plates 207 and 208). A cross-section (Plate 209) from the pinkish-brown coat (Stage 2) of the man immediately behind the older girl of the right-hand group (Stage 1) shows

Plate 202　Detail of the lower paint layers of the sample shown in Plate 204, which are part of the Stage 1 composition, and contain solely cobalt as the blue pigment. Cross-section detail, 550×

Plate 203　Detail of the upper paint layers of the sample shown in Plate 204, which belong to the Stage 2 reworking of the composition and contain solely French ultramarine as the blue pigment. Cross-section detail, 550×

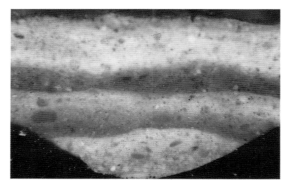

Plate 204　Bluish streak of left-hand woman's bodice, showing its surface modification (Stage 2), and original colour design (Stage 1) beneath. The principal pigments in the lower layers are cobalt blue, zinc yellow and red lake, while the second stage involves the use of French ultramarine. Cross-section, 150×

these coloured underlayers as part of a background left incomplete at the end of the first stage of painting.

To summarise, the areas present at the end of Stage 1 were the group of four figures at the right, the man and woman at the left, dressed somewhat differently, and the basic foreground paint. There may have been some figures, umbrellas and foliage indicated for the background, but these were not seriously developed until Stage 2. The evidence for this is twofold: first, the umbrellas are painted directly on to the white ground and, secondly, they contain only synthetic ultramarine in all the layers above the ground; no cobalt blue from Stage 1 is present (Plate 210).

It is very interesting to note in the cross-sections that there is no evidence of dirt, varnish or any other clear discontinuity between the layers of Stage 1 and Stage 2. If a painting is re-started after an interval of several years, one would certainly expect to see some indication of this in the layer structure. Here, the successive stages are not only in close contact but even rather unusually blended together at their interfaces in some parts. The most likely explanation is that Renoir washed down the painting with some cleaning agent or solvent to remove accumulated dirt before he began his second campaign of painting. In some areas the paint may have been slightly softened by this action and subsequently fused with the new layer above.

Recent examination has revealed one more technical complexity in the evolution of the painting. Some samples of paint showed water sensitivity in the layers between Stage 1 and Stage 2, and the medium analysis indicated the presence of paint with a gum binder. It seems possible that, when beginning again on his half-finished work, Renoir adjusted some of the colours with a highly unconventional layer of gouache.

In terms of layer structure and painting materials, *The Umbrellas* is one of the most complex works ever examined at the National Gallery. This complexity is in itself revealing about Renoir's difficulties in the 1880s as he struggled to resolve his conflicting interests. Technical examination of this work confirms that his exploration of differing styles is matched by experimentation with his materials. It seems that Renoir was engaged in a complete overhaul of the mechanics of his painting.

Renoir later told Vollard that some of his paintings of the 1880s were not 'very solid'. His interest in the clear light colours of fresco painting (a legacy of his trip to Italy), and his concern about the possible darkening of his own colours in the future, had encouraged him to experiment with the binding medium of his pigments; for example, he

Plate 205 Pierre-Auguste Renoir, *The Umbrellas*, left turnover edge, showing first-stage paint of woman's dress

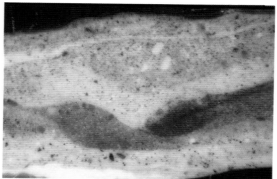

Plate 206 Dark mauvish-grey shadow of left-hand woman's skirt, showing all layers down to the white ground. The lower (Stage 1) paint is stronger in colour than the upper (Stage 2) layers. The Stage 2 composition begins with the yellowish-grey application of paint seen near the centre of the layer structure. Cross-section, 160×

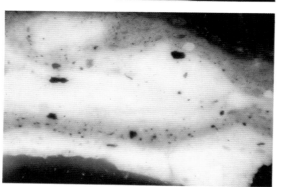

Plate 207 Dark mauvish-blue paint on lower turnover edge, near left-hand woman's skirt. The paint belongs to Stage 1 only. A layer containing zinc chromate yellow was brushed on to the ground as the first paint layer. Cross-section, 200×

had tried to remove the oil from his colours before painting, often with disastrous results. He was also attempting to learn more about traditional methods; in the early 1880s he read the treatise on painting techniques by Cennino Cennini, *Il Libro*

dell'Arte (*The Craftsman's Handbook*), and this may have encouraged his research into fresco and tempera painting. The discovery in *The Umbrellas* of traces of an aqueous medium may relate to this technical experimentation. He was obviously unaware that this water-based medium would have been incompatible with his oil paints, although in fairness it should be added that Renoir readily confessed his ignorance of such matters and constantly decried the general loss of knowledge about traditional methods.

Renoir's contact with Cézanne may have acted as a further stimulus during this period. This is evident, at least in terms of style, in certain passages in *The Umbrellas*, most notably in the foliage at the upper left (Plate 211) where the diagonal patterns of hatched brushwork are reminiscent of Cézanne's 'constructive stroke' (see page 196). The example of Cézanne may also have prompted Renoir to pay closer attention to his materials. It is interesting to note that although the ultramarine pigment detected in the reworking of *The Umbrellas* was an uncharacteristic choice for Renoir, it was Cézanne's favoured blue pigment.

We now know a great deal about the physical make-up of this unusual painting. However, one important question must remain a matter for speculation. Why did Renoir leave the painting in its present state, having reworked some areas extensively and other areas hardly at all? The disjunction between the different parts of the picture would certainly have been jarring to a spectator in the 1880s when the clash in the fashions depicted here would have been obvious. Of course, Renoir may have been entirely satisfied with some parts of his first work on the canvas and may have wished to retain some of the qualities of life and movement that characterised this stage. He may even have been intrigued by the visual discrepancies between the chiselled forms of the left-hand group and the soft, delicate brushwork of the earlier phase of work. It is equally possible that he gradually realised that his new severe style was inappropriate to such a modern (and Impressionist) subject.

However, perhaps the most likely answer is that Renoir's interest in the painting simply faded as his attention began to focus on other subjects. This was to be his last large-scale picture of a contemporary urban subject and, as he moved towards more traditional and timeless themes, *The Umbrellas* may have been left to one side without further reworking. Ultimately, whatever the answer to this question, *The Umbrellas* remains a striking record of the uncertainties underlying Renoir's art in the aftermath of Impressionism.

Plate 208 Darkest blue shadow of older girl's skirt, right-hand group. The paint here was not modified after the conclusion of Stage 1. Only cobalt blue, white and red lake pigment are present in the upper layers. The lowest layer on the white ground contains zinc chromate yellow. Cross-section, 200×

Plate 209 Brownish-pink coat of man with raised umbrella, immediately behind right-hand figure group. The upper layers contain French ultramarine and belong to the revised composition. Over the white ground are two layers, light orange and pale pink, which were present at the end of Stage 1. Cross-section, 180×

Plate 210 Mid-greyish blue of most distant umbrella, upper centre. The paint of the umbrella, in several layers, lies directly on the white ground, and contains only French ultramarine as the blue. This area must have been left unpainted at the end of Stage 1. Cross-section, 200×

Plate 211 Pierre-Auguste Renoir, *The Umbrellas*, detail of foliage

Paul Cézanne

15. Hillside in Provence

63.5 × 79.4 cm (25 × 31¼ in.)

Cézanne's art is traditionally set apart from the work of the Impressionists. His well-known statement that he wished to 'make of Impressionism something solid and durable like the art of the museums' is often used to reinforce the image of Cézanne moving beyond the mere recording of fugitive effects towards a more considered, structured and analytical painting. Yet Cézanne's approach developed in direct contact with the Impressionists and throughout his career he shared many of their concerns. His art remained rooted in his personal response to nature. He told a journalist in 1870: 'I paint as I see, as I feel – and I have very strong sensations.' At the end of his career he was still struggling to 'realise his sensations'. A slavish imitation of nature had little appeal for Cézanne; rather he sought an elusive balance between perceptual experience and individual temperament, between seeing and feeling, an aim that would have found sympathy with Monet and Pissarro.

Cézanne exhibited with the Impressionists for the last time in 1877. However, he maintained his close contacts with Pissarro (and also with Renoir) until the early 1880s. Under Pissarro's influence he had adopted the small touches and lighter colours of Impressionism in his work of the early 1870s, but later in the decade his handling became increasingly ordered and systematic. Often his brushmarks are arranged into groups of parallel hatchings, a device often described as the 'constructive stroke' in recent literature on the artist. He planned his compositions carefully, seeking to express the underlying rhythms and structures of his chosen motifs.

In his early career, Cézanne divided his time between Paris and his native Aix-en-Provence, but his visits to the north became less frequent in the 1880s and he gradually cut himself off from the friends and associates of his youth. Only a handful of paintings from this period may be dated with any confidence. *Hillside in Provence* (Plate 213) was almost certainly painted in the second half of the 1880s but probably not later than 1886/7. It is close in style to a group of pictures depicting the village of Gardanne (some ten kilometres from Aix) where Cézanne is known to have worked in 1885 and 1886. This picture has been variously identified as a view of Les Lauves (a hill near Aix) and as a landscape in the neighbourhood of Gardanne. Neither identification is convincing and we can be certain only that this is a Provençal scene.

The simple composition is typical of Cézanne's work in the 1880s. The foreground is closed by the row of massive rocks. Beyond, the landscape is open and panoramic with the line of the hill sweeping across the top of the picture. This apparent simplicity and assurance belies the calculated structure of the composition and its careful, logical execution. There is evidence from cross-sections that in preparation for painting Cézanne sketched parts of the design in cursory outline, in places first drawing lightly with graphite pencil on the cream-coloured ground (see Plate 214). Elsewhere the limits to be painted were suggested in tentative lines drawn with a fine brush using thin dark grey or greyish-blue paint containing French ultramarine. One of these early painted lines is clearly visible at the point where the highest distant hilltop meets the horizon (Plate 212). Close examination of the surface of the picture reveals that the linear scheme was not always followed in the paint applied on top, most noticeably in the complex network of shadows between the rocks.

Much of the colour is brushed in thin diluted washes of oil paint, giving an effect rather like watercolour, with the light-coloured ground

Plate 212 Paul Cézanne, *Hillside in Provence*, detail of first painted outline

196

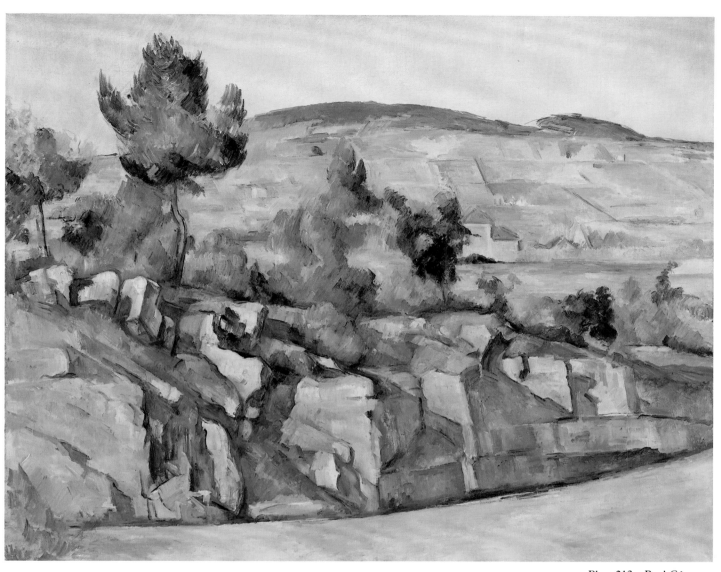

Plate 213 Paul Cézanne,
Hillside in Provence

imparting its luminosity to the overlying paint. In places the ground is left entirely unpainted, for example in the rocks towards the left edge of the composition; elsewhere the ground is left partially exposed, particularly in the sky and foreground. The sky seems to have been laid in at a late stage, since it overlaps slightly the crown of the tallest tree.

A variety of styles of brushwork is used to elaborate the different zones of the composition: for the hillside in the middle distance, the paint is hatched in rather geometrical patches with a broad, flat-tipped brush, while the foliage of the trees is constructed from thicker curving strokes of paint to suggest their volume. The shadow structure of the rocky outcrop is worked in more linear ridges of quite thickly applied paint (Plate 214).

Many of the features present in *Hillside in Provence* are more readily apparent in the well-known painting of *Gardanne* (New York, Metropolitan Museum of Art; Plate 216). In the New York picture, much larger areas of the cream-white ground have been left unpainted, and the first light pencil drawing – all but invisible in the London painting – can be seen in many places. Here too, the outlines were painted in grey or greyish blue and the colours filled in with washes of diluted oil paint. None of the paint on *Gardanne* quite attains the thickness and opacity of the foreground rocks in *Hillside in Provence*, but the handling of the hatched greens, red-browns and grey-blues is strikingly similar to parts of the background here.

Cézanne's palette for the National Gallery picture is a fairly restricted one, making use equally of nineteenth-century introductions and of traditional pigments. The sky to the left is tinted with French ultramarine, while the turquoise patch to the right also incorporates emerald green (Plate 215). Emerald green with small quantities of viridian make up the vivid greens of the hillside, which register as dark areas on an infra-red photograph of the painting (Fig. 91). Yellow and yellow-brown natural earth pigments provide the orange and brown tones of the rocks, the trees and the foreground path. Vermilion occurs in many of the paint mixtures, adding warmth to the browns and a rose-mauve tinge to some of the greys. A thin yellow lake glaze, over white tinted with viridian (Plate 217), gives a greenish translucency to parts of the foreground, and suggests the considered adjustment of colour by Cézanne at a late stage of the painting.

Hillside in Provence shows the extension of aspects of Impressionist ideas of colour in Cézanne's painting practice of the mid-1880s, although they are explored in a restrained form. The deep

Plate 214 Intense bluish-black shadow between the rocks, painted in French ultramarine with a little white and black. The warm light brown background colour beneath contains white, vermilion and some emerald green. A trace of graphite from the initial pencil sketch is present over the cream-coloured ground at the right of the sample. Cross-section, 200×

Plate 215 Turquoise sky, right, comprising white tinted with French ultramarine and emerald green, directly on cream-coloured ground. Cross-section, 550×

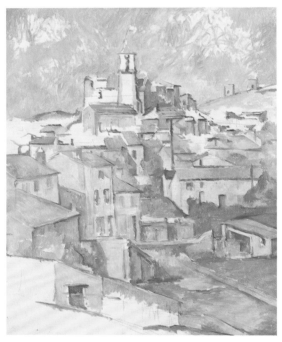

Plate 216 Paul Cézanne, *Gardanne*. 80 × 64·1 cm. New York, Metropolitan Museum of Art

shadows between the rocks are lent their dark grey-blue tonality by the use of considerable quantities of French ultramarine, with only the sparing addition of ivory black to the paint. Between the orange-brown of the rocks and their blackish-blue shadows, Cézanne makes use of the simultaneous contrast of complementary colours set out in Chevreul's theory. Blue is set against orange, but here in muted tones (Plate 218). In the same way, the fields of the middle distance make use of the

juxtaposition of mauvish reds and brownish reds with strong greens. These pairs of subtly matched near-complementaries react sufficiently with each other to give a decided tonal vibration to the landscape. Cézanne has also exploited traditional methods of alternating warm and cool tones. The use of cool half-tones, seen here at the edges of the rocky shadows, is a standard chiaroscuro technique for suggesting solidity and depth; Cézanne has readily adapted the old convention for his own use.

Hillside in Provence may be seen as a refinement rather than as a rejection of Impressionist principles. Cézanne did not deny the validity of working directly from nature, but the present picture illustrates his planned and deliberate approach with an emphasis, for example, on preliminary drawing. The brushwork is methodical, setting up subtle decorative rhythms across the surface yet animating the picture with a sense of shimmering atmosphere. The painting retains colour of fairly high key and exploits many of the colour contrasts that are seen in Impressionist painting, although Cézanne was apparently content to use traditional pigments (including earth colours and black) alongside the established newer materials. By using subtle nuances and combinations of colour to suggest form and atmosphere, Cézanne found he could 'represent' rather than 'imitate' the effects of

Plate 217 Thin translucent greenish yellow of foreground path, comprising a yellow lake glaze over an underpaint of viridian and white. Cross-section, 550×

Plate 218 Paul Cézanne, *Hillside in Provence*, detail

sunlight, creating, in his own words, 'a harmony parallel with nature'.

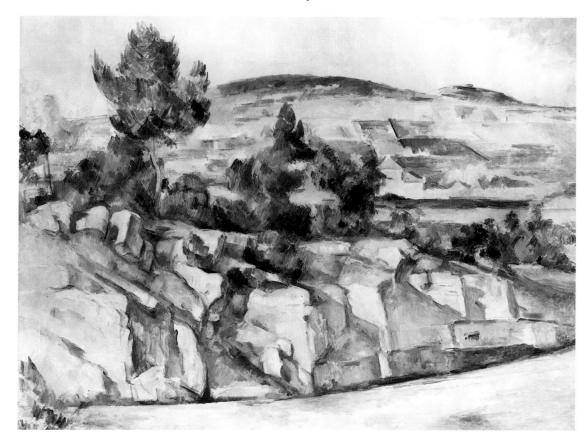

Fig. 91 Paul Cézanne, *Hillside in Provence*, infra-red photograph

The Artists' Palettes

The tables below give the range of pigments detected in each of the paintings examined for the catalogue by sampling, and in general are likely to be complete. In one case, Pissarro's *Fox Hill, Upper Norwood* (Cat. no. 4), only a restricted number of samples could be taken, and consequently the full palette for the picture cannot be described.

The pigment occurrences noted here are based on one or more positive methods of identification, initially using optical microscopy of paint samples, with confirmatory analyses being made by instrumental means: particularly energy-dispersive X-ray microanalysis in the scanning electron microscope (SEM-EDX), laser microprobe analysis (emission spectrography; LMA), and X-ray diffraction analysis (XRD). These techniques are described briefly in the Glossary.

The dyestuffs present in lake pigment samples have not in general been identified, although the principal element or elements of their substrates are noted in brackets in many cases.

Standard pigment names in modern English use are applied here. For the most commonly encountered pigments these are: lead white (basic lead carbonate; *hydrocerussite*), zinc white (zinc oxide), Prussian blue (ferric ferrocyanide), cobalt blue (cobalt aluminate), French ultramarine (synthetic *lazurite*), emerald green (copper acetoarsenite), viridian (hydrated chromium (III) oxide), Naples yellow (lead antimony oxide; *bindheimite*); chrome yellow (lead chromate; *crocoite*); chrome orange (basic lead chromate); vermilion (mercuric sulphide; *cinnabar*); ivory black (calcium phosphate with elemental carbon). The mineralogical equivalents, where appropriate, are noted in italics. Less common materials are footnoted for each palette, while the range of pigments used by Impressionist painters is described more fully on pages 51–72.

All the paintings are oil on canvas.

Cat. no. 1
Manet, *Music in the Tuileries Gardens*, 1862

Lead white
Prussian blue[1]
Cobalt blue
Scheele's green (copper arsenite)
Emerald green
Viridian
Naples yellow (lead antimonate yellow)
'Naples yellow' shade (manufactured mixture)[2]
Merimée's yellow[3]
Yellow lake (Al)
Yellow ochre
Orange ochre
Chrome orange (basic lead chromate)
Vermilion
Ivory black

1. *Present only in an underlayer for the sky.*
2. *Composed of zinc white, lead chromate and some yellow ochre.* **3.** *Manufactured colour based on zinc white with lead oxy-chloride (also called patent yellow, Turner's yellow and mineral yellow).*

Cat. no. 2
Monet, *Bathers at La Grenouillère*, 1869

Lead white
Prussian blue
Cobalt blue
Emerald green
Viridian
'Chrome green' (manufactured mixture)[1]
Chrome yellow
'Lemon yellow' (barium chromate)
Yellow ochre
Organic yellow (not identified)
Vermilion
Red ochre
Red lake
Cobalt violet (?)[2]
Ivory black

1. *Prussian blue combined with chrome yellow, extended with barium sulphate and china clay.*
2. *Possibly a mauve shade of cobalt blue.*

Cat. no. 3
Monet, *The Beach at Trouville*, 1870

Lead white
Cobalt blue
French ultramarine
Viridian
Yellow ochre
Vermilion
Red-brown ochre
Ivory black

Cat. no. 4
Pissarro, *Fox Hill, Upper Norwood*,[1] 1870

Lead white
French ultramarine
Viridian
Chrome yellow
Vermilion
Orange-red ochre
Ivory black

1. *Incomplete survey of colours.*

Cat. no. 5
Pissarro, *The Avenue, Sydenham*,[1] 1871

Lead white
French ultramarine
Emerald green
Viridian
Chrome yellow
Vermilion
Orange-red ochre
Ivory black

1. *Analytical results indicate the use of zinc-white-based colours.*

Cat. no. 6
Monet, *The Petit Bras of the Seine at Argenteuil*, 1872

Lead white
French ultramarine
Opaque chromium oxide green (anhydrous chromic oxide)
Viridian
Chrome yellow
Yellow ochre
Vermilion
Red ochre
Ivory black

Cat. no. 7
Sisley, *The Watering Place at Marly-le-Roi*, 1875

Lead white
Cobalt blue
Viridian
Chrome yellow
Red-brown ochre
Red lake (Al)
Ivory black

Cat. no. 8
Renoir, *At the Theatre*, 1876–7

Lead white
Cobalt blue
Emerald green
Chrome yellow
'Lemon yellow' (barium chromate)
Vermilion
Red lake (Al)
Ivory black

Cat. no. 9
Pissarro, *The Côte des Boeufs at L'Hermitage*, 1877

Lead white/zinc white[1]
French ultramarine
Emerald green
Viridian
Chrome yellow
Orange ochre
Vermilion
Red lake (Al/Ca)[2]

1. *Manufactured mixture.*
2. *The lake substrate may contain tin in addition (see also Cat. no. 10, below).*

Cat. no. 10
Monet, *The Gare Saint-Lazare*, 1877

Lead white
Cobalt blue
Cerulean blue (cobalt stannate)
French ultramarine
Emerald green
Viridian
Chrome yellow
Vermilion
Red lake (Al/Sn)[1]
(Ivory black)[2]

1. *Probably contains a synthetic red dyestuff.*
2. *Trace quantities only.*

Cat. no. 11
Renoir, *Boating on the Seine*, c.1879

Lead white
Cobalt blue
Viridian
Chrome yellow
'Lemon yellow' (strontium chromate)
Chrome orange (basic lead chromate)
Vermilion
Red lake (Al)[1]

1. *Probably contains a synthetic red dyestuff.*

Cat. no. 12
Morisot, *Summer's Day*, 1879

Lead white
Cobalt blue
Cerulean blue (cobalt stannate)
French ultramarine
Emerald green
Viridian
Cadmium yellow (cadmium sulphide)
Chrome yellow
Yellow ochre
Orange ochre
Vermilion
Red lake (Al)
Brown ochre
Ivory black

Cat. no. 13
Monet, *Lavacourt under Snow*, 1879

Lead white
Cobalt blue
French ultramarine
Emerald green
Viridian
Cadmium yellow (cadmium sulphide)
Vermilion
Red lake (Ca)

Cat. no. 14
Renoir, *The Umbrellas*

Stage 1: *c.* 1881 (see text)

Lead white
Cobalt blue
Emerald green
Zinc yellow (zinc potassium chromate)
Vermilion
Red lake (Al)
Red ochre
Ivory black

Stage 2: *c.*1886 (see text)

Lead white
French ultramarine
Prussian blue[1]
Emerald green
Naples yellow (lead antimonate yellow)
Yellow ochre
Orange ochre
Red ochre
Red lake (Al)
Ivory black

1. *Late adjustments to the final colour composition of the picture by Renoir.*

Cat. no. 15
Cézanne, *Hillside in Provence*, c.1886

Lead white
French ultramarine
Emerald green
Viridian
Yellow ochre
Yellow-brown ochre
Yellow lake (Ca/Al)
Vermilion

Biographies of the Artists

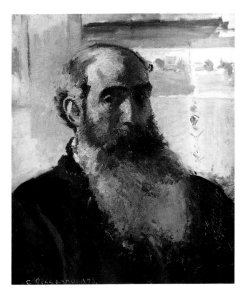

Fig. 92 Camille Pissarro, *Self Portrait*, 1873. 56 × 46·7 cm. Paris, Musée d'Orsay

Camille Pissarro 1830–1903

Pissarro was born on the island of St Thomas in the West Indies, and was of Jewish origin. His father, a shopkeeper, disapproved strongly of Pissarro's early inclinations towards drawing. In 1842 he was sent to France to complete his secondary education and was encouraged to paint by his headmaster. On returning to St Thomas in 1847 to join the family business, Pissarro made friends with Fritz Melbye, a Danish marine and landscape artist, who taught him the importance of sketching out of doors. Melbye and Pissarro travelled to Venezuela together in 1852 and spent two years there.

Having finally decided to give up a business career, Pissarro arrived in Paris in 1855. He visited the Exposition Universelle, where he was particularly impressed by the works of Corot and Delacroix. The following year he visited Corot, who gave him advice on painting. He also attended sessions on life drawing at the Académie Suisse, where he met Monet, Cézanne and Guillaumin. During the 1860s he painted landscapes in and around Pontoise and Louveciennes and had some success at the Salon, although he found it difficult to support his family. After the Franco-Prussian War and a period of residence in London, Pissarro returned to Louveciennes and then moved to Pontoise in 1872, where he was to live until 1882. His landscapes of the surrounding countryside often contain figures at work, in marked contrast to Monet's and Renoir's scenes of bourgeois leisure. In the mid-1870s, partly perhaps as a result of working closely with Cézanne, Pissarro experimented with a variety of techniques, moving towards more densely worked surfaces.

Pissarro participated in all the Impressionist group exhibitions. Despite the internal disputes, he was committed to the idea of the co-operative, which accorded with his socialist beliefs. Pissarro's generous and tolerant nature made him a helpful mentor for artists of the Post-Impressionist generation – notably Gauguin, van Gogh, Seurat and Signac.

In the first half of the 1880s Pissarro shifted his focus from landscapes to peasant figures. He also began to seek greater unity in his paint surfaces by applying small brushstrokes, often in parallel sequence. In 1885 he became interested in the pointillist techniques of Seurat and exhibited paintings in this style in the eighth group exhibition. However, he eventually became disillusioned with the technique, since he felt that it precluded spontaneity of response to the motif and became monotonous in effect. In his later years he renewed his interest in urban subject matter, painting landscape vistas of the ports of Dieppe and Le Havre and cityscapes of Paris and Rouen. Throughout this period he suffered repeatedly from eye infections but continued to paint with unremitting energy.

Edouard Manet 1832–1883

Manet was born in Paris and was encouraged to learn to draw by an uncle. His developing interest in art met with opposition from his father, chief-of-staff at the Ministry of Justice, but he was finally allowed to enter the studio of Thomas Couture in 1850. Manet stayed with Couture intermittently for six years and supplemented his teacher's instruction with copying in museums.

Although Manet was closely associated with the Impressionists, he did not join their independent group exhibitions and remained committed to showing his work at the Salon. Of independent means, Manet was a member of fashionable society. Influenced by his friend Baudelaire, he attempted to find a way of depicting modern life which was informed by the great works of the past. His first Salon attempt, *The Absinthe Drinker* (Copenhagen, Ny Carlsberg Glyptotek), was rejected in 1859. Success came two years later with *The Spanish Singer* (New York, Metropolitan Museum of Art), and critics began to note not only his interest in Spanish subject matter but also in the paintings of Velázquez and Goya.

In 1863 he achieved much critical attention, particularly for his technique, when his *Déjeuner sur l'herbe* (Paris, Musée d'Orsay) was exhibited at the Salon des Refusés. The same year he painted *Olympia* (Paris, Musée d'Orsay), which was exhibited at the Salon of 1865. This painting, which offered a direct challenge to contemporary conventions for representing the female nude, provoked a number of angry comments.

Following this débâcle, Manet visited Spain where concentrated exposure to the works of Velázquez and Goya made a

Fig. 93 Henri Fantin-Latour, *Edouard Manet*, 1867. 117·5 × 90 cm. Chicago, Art Institute

further profound impression. He returned to Paris and painted numerous single figure pieces against neutral backgrounds inspired by Velázquez. Although two of these works were rejected at the Salon of 1866, they were admired by Emile Zola who took up Manet's cause. The following year he exhibited in his own pavilion during the Exposition Universelle. In 1868 Manet met Berthe Morisot in the Louvre and a few months later she modelled for *The Balcony* (Paris, Musée d'Orsay). The two painters were to exercise a reciprocal influence on each other's work, and Morisot was eventually to become Manet's sister-in-law.

During the 1870s Manet became interested in open-air figure scenes and worked with Monet and Renoir at Argenteuil in 1874, exhibiting *Argenteuil* (Tournai, Musée des Beaux-Arts) at the Salon of 1875. His palette had noticeably brightened in response to the shift in his subject matter and he remained committed to the figure as the chief focus of his work. In 1876, after the Salon jury had refused two of his pictures, he opened his studio to the public to exhibit these and other works. In April 1880 he held a one-man show of his work at La Vie Moderne, and the following year received a second-class medal from the Salon and was made a Chevalier of the Légion d'Honneur. His last major Salon piece, *Bar at the Folies-Bergère* (London, Courtauld Institute Galleries), was exhibited at the Salon of 1882. Manet spent the summer of 1882 at Rueil where he rented a summer house and, despite being very ill, painted a number of landscapes and still lifes.

Alfred Sisley 1839–1899

Sisley was born in Paris of British parentage. His father was a business man dealing in the export of silk flowers to South America. Sisley was sent to London in 1857 to study business and during the course of his stay visited many galleries, where he admired the works of Turner and Constable.

After persuading his parents to allow him to study painting, Sisley entered the studio of Charles Gleyre in Paris in 1862.

Fig. 94 Pierre-Auguste Renoir, *Alfred Sisley*, c. 1875–6. 66·4 × 54·2 cm. Chicago, Art Institute

There he met Monet and Bazille and formed a close friendship with Renoir. The two friends often painted in the Forest of Fontainebleau with fellow-artist Jules Le Coeur. Sisley's early landscapes are influenced by Corot, Daubigny and Courbet and are often dominated by dark tonalities. Around 1870, contemporaneously with Monet and Renoir, Sisley developed a lighter palette and broken brushwork (*View of the Canal Saint Martin*, Paris, Musée d'Orsay).

The Franco-Prussian War had a disastrous effect on the business and health of Sisley's father, who died in 1871 leaving Sisley and his family in reduced circumstances. From then on Sisley struggled against poverty. He and his family moved from Paris, first settling in Louveciennes, where he painted many works of the surrounding area (*The Road to Sèvres*, Paris, Musée d'Orsay). In 1874, under the patronage of the baritone Jean-Baptiste Faure, Sisley visited England and painted a series of views of the Thames and of regattas at Hampton Court. From 1874 until 1877 he lived at Marly-le-Roi and exhibited many subjects from this area at the Impressionist exhibitions of 1874, 1876, 1877 and 1882. In 1876 he made a series of paintings of floods at nearby Port-Marly, one of which featured in the second Impressionist exhibition (Paris, Musée d'Orsay).

In the 1880s Sisley moved to the Fontainebleau area, eventually settling at Moret-sur-Loing, where he continued his landscape work. Since 1870 Sisley had been interested in painting groups of works of the same motif. Around 1885 he painted at least ten paintings of the Canal du Loing and from 1893 to 1894 he made a series of paintings of Moret Church, which show an awareness of Monet's Rouen Cathedral series of 1892–4. Like Monet, Sisley studied the church in varying weather and light conditions (*The Church at Moret, after the Rain*, Detroit Institute of Arts).

In 1897 Sisley visited the south of England and Wales at the invitation of his patron François Depeaux, a Rouen industrialist. Sisley made numerous paintings of Penarth and Langland Bay, Swansea.

Because of certain affinities in handling and subject matter, Sisley's paintings are often compared with Monet's, perhaps to Sisley's detriment, since his works are usually more subdued in effect. But if during his lifetime his work was largely unappreciated by the art world, it was nevertheless greatly respected by his friends. Reviewing Sisley's career, Pissarro concluded that Sisley was 'a great and beautiful painter'.

Paul Cézanne 1839–1906

Cézanne, the son of a wealthy banker, trained initially as a lawyer at the university of Aix-en-Provence and took drawing lessons at the local academy. His artistic leanings were encouraged by his friend Emile Zola but fiercely opposed by his father. In 1861 Cézanne abandoned his law studies and followed Zola to Paris, where he visited museums and met Pissarro at the Académie Suisse. Discouraged by his first experience of Paris, Cézanne returned to Aix and took a job in his father's office. However, by 1862 he was back in Paris. He was to alternate between Aix and Paris throughout his life.

Cézanne's early paintings were influenced by Delacroix, Daumier, Courbet and Manet, and by Old Masters seen in the Louvre. He had a predilection for violent and erotic subject matter which he

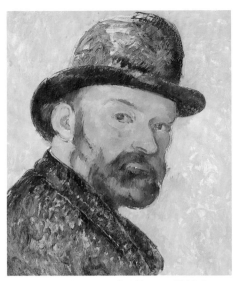

Fig. 95 Paul Cézanne, *Self Portrait*, 1883–7. 44·5 × 35·5 cm. Copenhagen, Ny Carlsberg Glyptotek

rendered in a forceful agitated manner with strong contrasts of light and dark. He was also, perhaps inspired by Courbet, an enthusiast for palette-knife painting, a method notably present in his portraits of his Uncle Dominique (version in the Fitzwilliam Museum, Cambridge). In the mid-1860s Cézanne became more interested in outdoor painting. He pursued this interest in a series of paintings made at L'Estaque on the Marseille coast during his flight from the Franco-Prussian War. After the war, Cézanne accepted Pissarro's invitation to join him in painting out of doors at Pontoise and later at Auvers.

The years that Cézanne spent with Pissarro from 1872 to 1874 were crucial for his development. In several of his landscapes he adopted Impressionist techniques, using lighter colour and broken brushwork while maintaining a strong concern for the structure and solidity of forms as in *The House of the Hanged Man* (Paris, Musée d'Orsay). Pissarro encouraged Cézanne to participate in the Impressionist group shows of 1874 and 1877, where his work provoked some of the most hostile critical reviews. Cézanne, however, was more anxious to be accepted by the Salon – an achievement he did not realise until 1882, after trying for nearly twenty years. Cézanne's sense of disillu-

sionment with the Paris art world was exacerbated in 1886 by the publication of Emile Zola's *L'Oeuvre*, the story of a failed artist clearly modelled on Cézanne.

In the late 1870s and early 1880s Cézanne attempted to impose more control on the spontaneity of his paintings by increasingly ordered brushwork, as in the *Château of Médan* (Glasgow, Burrell Collection) where individual strokes are arranged in parallel patterns. His palette was also subjected to the same rigour after he had come to the realisation that 'sunlight cannot be reproduced ... it must be represented by something else – by colour'. Cézanne's search to render the harmonic complexities he observed in nature as colour relationships in his work proved to be a lifelong obsession. He worked slowly and methodically and painted many still-life arrangements, which he could study for long periods.

Cézanne's late work is dominated by landscapes of the Mont Sainte-Victoire and surrounding countryside in Aix. In 1901 he constructed a special studio on the hillside of Les Lauves in order to paint the Mont Sainte-Victoire. His continuing interest in imaginary figure scenes now found an outlet in large bathing compositions, one of which is in the National Gallery.

Cézanne's success in the art world came late. He was given a one-man show by Vollard in 1895 and after 1900 exhibited in several group shows, inspiring the admiration of many young artists who went to seek him out in Aix. A year after his death, a large exhibition of his work was held at the Salon d'Automne.

Claude Monet 1840–1926

Monet grew up in Le Havre, the son of a grocer. He began his artistic career by producing skilful caricatures of local celebrities. In about 1856 he met Boudin, who introduced him to outdoor painting. In 1859 he arrived in Paris, and mixed with a number of painters, including Troyon, Courbet and Pissarro. After a short period of military service in North Africa, he returned to Paris in 1862 and entered the studio of Gleyre, where he met Renoir, Sisley and Bazille. At the Salon of 1865 he

exhibited two seascapes, including *The Pointe de la Hève at Low Tide* (Fort Worth, Kimbell Art Museum), a large work executed in clear luminous colours and indebted to the landscape work of Jongkind. His most ambitious project of the 1860s was a huge *Déjeuner sur l'herbe* conceived in response to Manet's famous picture, and now surviving only in fragments. This was followed by another monumental open-air figure painting, *Women in the Garden* (1866–7; Paris, Musée d'Orsay), which was rejected at the Salon. Subsequently, Monet returned to landscape painting.

In 1869 he worked alongside Renoir at La Grenouillère. *Bathers at La Grenouillère* (Cat. no. 2) prefigured his more informal compositional style of the following decade. At the first 'Impressionist' exhibition the sketch-like *Impression, Sunrise* (1872; Paris, Musée Marmottan) helped to earn the group its title.

After the outbreak of the Franco-Prussian war in 1870 Monet fled to London, where Daubigny introduced him to the dealer Durand-Ruel, later to feature prominently in Impressionist circles. Monet also made contact with Pissarro. On his return to France in the winter of 1871, he settled at Argenteuil, which remained his base until 1878. In numerous views of

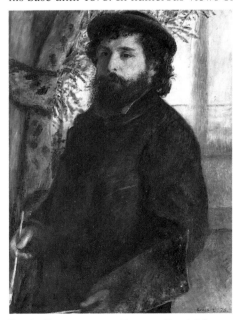

Fig. 96 Pierre-Auguste Renoir, *Claude Monet*, 1875. 85·6 × 60·6 cm. Paris, Musée d'Orsay

the Seine, and the activities along its banks, Monet developed his technique for rendering atmospheric outdoor light using broken, rhythmic brushwork. His series of views of the Gare Saint-Lazare of 1877, which includes Cat. no. 10, reflects his interest in the industrialisation of Paris and its environs.

However, around 1880, following the death of his first wife, and in the face of financial difficulties and increased critical hostility, his work and lifestyle took a different direction. He travelled widely, working in Normandy, Brittany and on the Mediterranean coast, often seeking out the extremes of nature, painting gales at Etretat and ice floes on the Seine. In the early 1890s he embarked on two series of paintings, one depicting haystacks, and the other the façade of Rouen Cathedral, captured in different light conditions and at different times of day.

In 1883 he had moved to Giverny, about eighty kilometres north-west of Paris, and it was there during the 1890s that he began building the famous garden which was to form the subject matter of his later work. In 1900 he exhibited paintings depicting the water garden with its Japanese footbridge, such as *The Water-Lily Pond* (London, National Gallery), and after the pond was enlarged in 1901 the surface of the water with its floating water-lilies became his principal motif. In his last years Monet painted a great mural cycle of water-lilies, which was installed in two special rooms constructed to his design in the Orangerie in Paris in 1927, a year after his death.

Berthe Morisot 1841–1895

Berthe Morisot was born in Bourges, the daughter of a high-ranking civil servant. She was one of three sisters who were all encouraged to cultivate drawing as a social accomplishment. On moving to a suburb of Paris in 1855 the girls first took drawing lessons with Geoffrey Alphonse Chocarne, an academic painter, and then with Joseph-Benoît Guichard, a regular exhibitor at the Salon and a follower of Ingres and Delacroix. Guichard encouraged Berthe Morisot to copy the Old Masters in

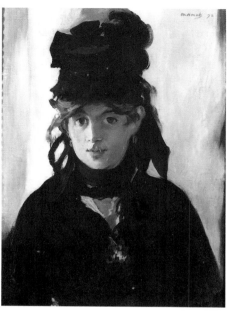

Fig. 97 Edouard Manet, *Berthe Morisot*, 1872. 55 × 38 cm. Private Collection

the Louvre and introduced her to Corot, who was to have a profound influence on her early work. Corot became a regular visitor to the Morisot household and although he never formally taught Morisot, she worked with him at Ville d'Avray during the summer of 1861.

In 1863 Morisot's burgeoning interest in painting out of doors was further nurtured by instruction from Achille François Oudinot, who was recommended to her by Corot. Oudinot lived and worked in the Auvers region and was a friend of Daubigny. Morisot's first Salon entries in 1864 were landscapes from this region and she was listed as a pupil of Guichard and Oudinot. Morisot's parents were supportive of her commitment to painting and a studio was built in the garden of their home. Morisot came into contact with Parisian artistic circles when she went to copy in the Louvre and became friendly with Fantin-Latour, Braquemond, Manet and Degas, and had further contact with them at soirées hosted by her mother. During the late 1860s Morisot aligned herself with the concerns of the Impressionist group by painting modern life subject matter informed by her experience of outdoor painting. Using her sisters and their young children as models, Morisot

devoted herself largely to domestic genre. She herself modelled for Manet and married his brother Eugène in 1874.

During the 1870s Morisot developed a highly distinctive light brushwork in her oils, pastels and watercolours, which many critics interpreted as a hallmark of her femininity. She exhibited at the Salon for the last time in 1873 and thereafter participated in all but one of the Impressionist exhibitions. At the sixth Impressionist exhibition of 1881 her style had become so abbreviated that one critic, Charles Ephrussi, wrote of her pastels: 'One step further and it will be impossible to distinguish or understand anything at all.'

Around 1885 Morisot began holding regular dinners which were attended by her friend the poet Stéphane Mallarmé and by her Impressionist friends. Among her artist friends Morisot was perhaps closest to Renoir. Both shared a great regard for eighteenth-century French painting (Morisot made a large copy of a Boucher at this period) and both tackled similar subject matter. Morisot visited Renoir's studio in 1886 and was shown a series of his preparatory drawings. Inspired by Renoir's example, Morisot began to make preparatory studies for some of her own figure works, the most elaborate project being a painting entitled *The Cherry Pickers* (1891–4). At this period she also began to make studies of the nude in a variety of media, including pastel, charcoal and drypoint.

An exhibition of Morisot's work was held at the Boussod and Valadon gallery in 1892 comprising some forty oils, along with pastels, drawings and watercolours. In 1894 she went to Brussels to see a large group exhibition organised by Libre Esthétique, in which she exhibited four paintings. These works were praised by Gauguin in his review of the exhibition.

Morisot died of pneumonia aged fifty-four. After attending her funeral Pissarro wrote to his son Lucien: 'You can hardly conceive how surprised we all were and how moved, too, by the disappearance of this distinguished woman, who had such a splendid feminine talent and who brought honour to our impressionist group which

is vanishing – like all things. Poor Madame Morisot, the public hardly knows her!'

Pierre-Auguste Renoir
1841–1919

Renoir was born in Limoges, the son of a tailor. He started his career as an apprentice porcelain painter in Paris and joined the studio of Charles Gleyre in 1861, where he met Monet, Sisley and Bazille. In 1862 he enrolled at the Ecole des Beaux-Arts.

Renoir painted in the Forest of Fontainebleau frequently during the 1860s, and it was here that he met Diaz, who was to influence his early landscapes. During the same period Renoir was also painting life-size figure paintings, inspired by Courbet. In 1867 he combined his landscape and figure interests in an outdoor painting of his mistress *Lise* (Essen, Museum Folkwang) which was accepted at the Salon.

In 1869 Renoir worked alongside Monet at La Grenouillère. He adopted the small sketchy brushstrokes and vibrant high-keyed colours of his friend, but his interest was principally captured by the bustle of the figures. Renoir painted outdoors alongside Monet on many subsequent occasions. In 1873 Renoir moved to the rue Saint-Georges in Montmartre, an area he was to inhabit until the early 1880s. In the mid-1870s he began to paint scenes of modern life, such as *La Loge* (London, Courtauld Institute Galleries) and *Ball at the Moulin de la Galette* (Paris, Musée d'Orsay), which he exhibited in subsequent Impressionist exhibitions. After lending his support to the first three of these exhibitions he shifted his allegiance again to the Salon and had notable success with *Madame Charpentier and her Children* (New York, Metropolitan Museum of Art) at the Salon of 1879.

Renoir's increasing financial stability due to the patronage of Durand-Ruel and various others enabled him to travel in 1881 to North Africa and Italy. Later, however, in conversation with the dealer Vollard, he described this period as one of artistic crisis, in which he had 'gone to the end of Impressionism'. A renewed concern for drawing led him to the study of Ingres,

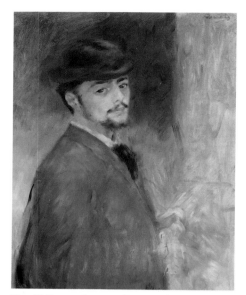

Fig. 98 Pierre-Auguste Renoir, *Self Portrait at Thirty-five*, 1876. 73·2 × 57·1 cm. Cambridge, Mass., Fogg Art Museum

Raphael's frescoes in Rome and Pompeian wall paintings in Naples. The crisp outlines and hatching strokes of this new style can be seen in *The Umbrellas* (Cat. no. 14) in conjunction with the soft feathery brushwork of his previous work. The culmination of this more severe manner was *The Bathers* of 1887 (Philadelphia Museum of Art).

In the 1890s Renoir reverted to a softer style and his scenes of young women and children were very popular. In 1892 *Young Girls at the Piano* (Paris, Musée d'Orsay) was bought for the Luxembourg Museum. In 1907 after years of visiting the South of France, Renoir bought a small estate near Cagnes where he continued to paint despite suffering from arthritis. In response to the light of the Mediterranean his late works are warm, glowing evocations of idealised peasant life and timeless classical nudes (*The Bathers*, Paris, Musée d'Orsay). These late nudes reflect Renoir's lifelong admiration for Rubens, Veronese, and especially Titian, who, Renoir joked, was 'forever stealing my tricks'. A sense of *joie de vivre* characterises Renoir's art but, as he himself said: '. . . it is difficult for painting to be accepted as really great painting while remaining joyous. . . . They don't take people seriously who smile.'

Chronology

1850 Manet enters the Paris studio of Thomas Couture (1815–79).

1852 Manet travels to Holland and makes copies in the Rijksmuseum. Pissarro meets the Danish marine and landscape painter Fritz Melbye (1826–96) in St Thomas, Virgin Islands. They travel to Venezuela together, where they go on painting expeditions.

1853 Manet travels to Italy.

1854 Renoir goes to Paris and is apprenticed with a firm of porcelain painters, where he remains for four years. During this period he studies drawing with the sculptor Callouette.

1855 Exposition Universelle in Paris. Gustave Courbet (1819–77) organises his own Pavillon du Réalisme to exhibit his work. Pissarro arrives in Paris and is greatly impressed by the work of Camille Corot (1796–1875) and Eugène Delacroix (1798–1863) at the Exposition Universelle. He works as an assistant with Fritz Melbye's brother Anton (1818–75), who is also a painter. Manet meets Delacroix and requests permission to copy his *Barque of Dante* in the Luxembourg Museum. Monet works as a caricaturist in Le Havre.

1856 Pissarro associates with a circle of Danish artists and visits Corot, who gives him advice on painting. Monet meets Eugène Boudin (1824–98) in Le Havre and is introduced to open-air painting by him.

1857 Cézanne enrols at the Free Municipal School for Drawing in Aix-en-Provence. Berthe Morisot takes lessons with the painter Joseph-Benoît Guichard (1806–80). Following Corot's advice, Pissarro paints from nature at Montmorency and at La Roche-Guyon in the Val d'Oise with the Danish painter David Jacobsen (1831–71).

1858 Morisot is registered as a copyist in the Louvre. Renoir works as a painter of fans, heraldic devices and blinds. Pissarro paints at La Roche-Guyon.

1859 Pissarro submits a landscape of Montmorency to the Salon and it is accepted. He paints at La Roche-Guyon with Jacobsen and a Puerto-Rican artist, Francisco Oller y Castero (1833–1917). Manet's *Absinthe Drinker* (Copenhagen, Ny Carlsberg Glyptotek) is rejected by the Salon. Monet comes to Paris and meets Boudin's friend, the animal painter Constant Troyon (1810–65), and artists in the Realist circle. Monet and Pissarro meet at the Académie Suisse.

1860 Renoir registers as a copyist in the Louvre.

1861 Cézanne abandons his law studies to go to Paris, where he meets Pissarro and Armand Guillaumin (1841–1927) at the Académie Suisse. He returns to Aix in September and takes a job in his father's bank. Pissarro registers as a copyist in the Louvre. Morisot works with Corot at Ville d'Avray. At the Salon, Manet exhibits the *Spanish Singer* (New York, Metropolitan Museum of Art), which receives an honourable mention. Renoir enters the studio of the Swiss painter Charles Gleyre (1806–74). Pissarro meets Ludovic Piette (1826–77), a pupil of Couture, who becomes a close friend. Monet does military service in Algeria.

1862 Renoir is admitted to the Ecole des Beaux-Arts. Manet paints *Music in the Tuileries Gardens* (Cat. no. 1). Monet meets the Dutch painter Johan Barthold Jongkind (1819–91) on the Normandy coast. Monet, Sisley and Frédéric Bazille (1841–70) enter Gleyre's studio. In the Louvre Manet meets Edgar Degas (1834–1917) who is making an engraving after Velázquez's *Infanta Margarita*. Renoir works in the Forest of Fontainebleau and meets Diaz (1807–76). Cézanne returns to Paris to resume painting.

1863 Manet's first one-man show (fourteen exhibits, including *Music in the Tuileries Gardens*) at Martinet's gallery. Uproar caused by the Salon jury's rejection of around 4,000 works. After an intervention by the Emperor Napoleon III, the government stages a separate exhibition of rejected works (the Salon des Refusés), in which Manet, Pissarro, Cézanne, Sisley, Whistler, Guillaumin, Fantin-Latour and Jongkind all participate. Manet exhibits three etchings and three paintings at this exhibition, including *Le Bain*, now known as *Le Déjeuner sur l'herbe* (Paris, Musée d'Orsay). Morisot, at the recommendation of Corot, goes to study with Achilles François Oudinot (1820–91), a close friend of Charles François Daubigny (1817–78). Monet and Bazille work in the Forest of Fontainebleau. Cézanne requests a permit to copy in the Louvre.

1864 Gleyre closes his studio owing to deteriorating health and financial difficulties. Monet works in the Forest of Fontainebleau and with Bazille at Honfleur. Renoir has one painting accepted at the Salon which he destroys after the exhibition. Morisot has two paintings of the Auvers region accepted at the Salon; Cézanne is rejected; Manet and Pissarro each have two works accepted. Pissarro goes to stay with Piette at Montfoucault, Mayenne.

1865 Cézanne and Oller share lodgings in Paris. At the Salon, Manet exhibits two pictures, including the controversial *Olympia* (Paris, Musée d'Orsay). Morisot exhibits a still life and a figure painting. Monet makes his debut with two seascapes. Pissarro exhibits two landscapes, including *The Banks of the Marne at Chennevières* (Edinburgh, National Gallery of Scotland). Renoir also has two paintings accepted – one a portrait of Sisley's father (Paris, Musée d'Orsay). Cézanne is again rejected. In the summer Monet begins work on a project for a huge *Déjeuner sur l'herbe* at Chailly, Fontainebleau, and uses Bazille as one of his models. Renoir, Sisley and the painter Jules Le Coeur (1832–82) work together. Renoir stays with Le Coeur at Marlotte, Fontainebleau. Pissarro sees Cézanne and Oller frequently. Monet is closely associated with Courbet. Manet visits Spain.

1866 Renoir exhibits three paintings at the Société des Amis des Beaux-Arts in

Pau. Manet and Renoir are rejected at the Salon; Monet has two paintings accepted, although he fails to complete his *Déjeuner sur l'herbe*. Pissarro's *The Banks of the Marne in Winter* (Chicago, Art Institute) is highly praised by Emile Zola (1840–1902) at the Salon. Despite the intervention of Daubigny, Cézanne is again rejected at the Salon and writes a letter of protest to the Director of Fine Arts. At this time he is preoccupied with palette-knife painting and becomes interested in working out of doors. Morisot and Sisley are successful with two paintings each at the Salon. During the summer Monet works outdoors at Ville d'Avray on *Women in the Garden* (Paris, Musée d'Orsay). Renoir, Sisley and Le Coeur are frequently at Marlotte. Pissarro paints at Pontoise and works with Antoine Guillemet (1843–1918). Regular meetings of artists (Manet, Bazille etc.) at the Café Guerbois, Batignolles.

1867 Renoir and Monet lodge in Bazille's apartment in Paris. Monet completes *Women in the Garden* at Honfleur, but it is rejected by the Salon. Exposition Universelle in Paris. Manet and Courbet hold one-man shows in pavilions. An important Ingres exhibition is held at the Ecole des Beaux-Arts. Monet, Bazille, Renoir, Pissarro, Sisley and Cézanne are all rejected at the Salon. Morisot and Manet do not submit anything. Bazille draws up a petition to demand another Salon des Refusés; it is signed by Renoir, Sisley and Pissarro. Plans for an independent group exhibition are under discussion, but cannot be realised due to lack of funds. Cézanne meets Adolphe Monticelli (1824–86), a fellow Provençal painter, at the Café Guerbois.

1868 Cézanne copies in the Louvre. Renoir moves with Bazille to an apartment near the Café Guerbois, where Manet and his friends meet regularly. Fantin-Latour (1836–1904) – a friend of Manet and Degas – introduces Morisot to Manet in the Louvre. A few months later Morisot poses for Manet's *The Balcony*

(Paris, Musée d'Orsay). Renoir's *Lise* (Essen, Museum Folkwang) attracts attention at the Salon. Monet, Sisley and Morisot exhibit one painting each at the Salon. Pissarro has two landscapes accepted. Cézanne is once again rejected and returns to Aix, where he paints with his friend Antoine Marion (1846–1900). At the International Maritime Exhibition in Le Havre, Boudin, Courbet, Manet and Monet all receive silver medals. Pissarro paints blinds and shop signs with Guillaumin to earn money.

1869 Manet's paintings and lithographs of *The Execution of the Emperor Maximilian* are censored. He exhibits *The Balcony* at the Salon. Pissarro, Renoir and Bazille are accepted with one work each. Morisot abstains, but visits the Salon, where she singles out Bazille's *View of the Village* (Montpellier, Musée Fabre) for praise. Monet, Sisley and Cézanne are rejected – Daubigny resigns his place on the jury in protest. A petition calling for a Salon des Refusés is again drawn up. Monet and Renoir work at La Grenouillère and Monet paints *Bathers at La Grenouillère* (Cat. no. 2). Degas works on a portrait of one of Morisot's sisters and on a series of pastel landscapes with Manet at Boulogne. In a letter to his parents Bazille mentions the idea of holding yearly independent group shows in a large rented studio. This group would also invite the participation of Courbet, Corot, Diaz, Daubigny and others.

1870 Two works by Monet are rejected at the Salon. Works by Renoir, Sisley, Morisot, Bazille and Manet are accepted; Fantin-Latour exhibits *Studio in the Batignolles* (Paris, Musée d'Orsay), which shows Manet surrounded by his friends, including Monet, Renoir and Bazille. Monet honeymoons in Trouville and paints *The Beach at Trouville* (Cat. no. 3). The Franco-Prussian War breaks out in July. Monet travels to London. Renoir and Bazille are conscripted. Cézanne manages to avoid conscription and stays in the South working at Aix and L'Estaque. Manet and the Morisot family remain in Paris. Sisley also remains in

France. At the beginning of September Emperor Napoleon III is captured by the Prussians at the battle of Sedan and the Third Republic is proclaimed – Manet and Degas join the newly formed National Guard. At the end of September Pissarro and his family flee from Louveciennes, eventually escaping to London. Bazille is killed in action in November at Beaune-la-Rolande. In London Daubigny introduces Pissarro and Monet to the dealer Paul Durand-Ruel (1831–1922). Pissarro paints *Fox Hill, Upper Norwood* (Cat. no. 4).

1871 Pissarro paints *The Avenue, Sydenham* (Cat. no. 5). At the conclusion of the Franco-Prussian war, political authority is divided between the Republican government at Versailles and the socialist Commune in Paris. Manet visits Bordeaux in February and is unable to return to Paris. The Morisots retire to Saint Germain-en-Laye. Renoir is demobilised in March and obtains a pass which enables him to move between Paris and Louveciennes (where Sisley is a neighbour) during the Commune (18 March–28 May). Monet and Pissarro in London both have work rejected at the Royal Academy but exhibit at the International Exhibition in South Kensington. Pissarro returns to Louveciennes; Monet goes to Holland and from there to Argenteuil. Renoir and Sisley work at Bougival. Morisot visits Cherbourg.

1872 Manet sells twenty-four paintings to Durand-Ruel and exhibits *The Combat of the Kearsage and the Alabama* (Philadelphia, John G. Johnson Collection) at the Salon. A petition is drawn up by Charles Blanc asking for a Salon des Refusés; it is signed by Manet, Fantin-Latour, Jongkind, Pissarro and Cézanne. Pissarro, Guillaumin and Cézanne work closely together at Pontoise. Renoir and Monet work together at Argenteuil. Morisot stays at Saint Jean-de-Luz in the South and visits Spain. In November Durand-Ruel mounts an exhibition in London (the fifth exhibition of the Society of French

Artists) at which Manet, Pissarro, Sisley, Monet, Degas and Renoir are all represented.

1873 Manet achieves success at the Salon with *Le bon bock* (Philadelphia Museum of Art). Renoir exhibits at the Salon des Refusés. Renoir stays with Monet at Argenteuil during the summer. Pissarro and Cézanne work together at Auvers and with Guillaumin make etchings at Dr Gachet's house there. Morisot paints at Maurecourt, Ile-de-France. In December the Société Anonyme Coopérative d'Artistes-Peintres, Sculpteurs, etc. is officially constituted – among the founder members are Monet, Pissarro, Renoir, Degas, Sisley, Morisot, Guillaumin and about ten others. Manet, however, refuses to join, remaining loyal to the Salon system.

1874 An auction in January at the Hôtel Drouot featuring Impressionist work fetches good prices. Two weeks before the opening of the Salon on 15 April the first independent show of the newly formed Société des Artistes is held at the former studio of the photographer Nadar (1820–1910) at 35 boulevard des Capucines. Paintings, pastels, watercolours, prints and sculpture of about thirty artists are shown. Among the paintings are Cézanne's *Modern Olympia* (Paris, Musée d'Orsay) and *The House of the Hanged Man* (Paris, Musée d'Orsay), Morisot's *The Cradle* (Paris, Musée d'Orsay), Renoir's *La Loge* (London, Courtauld Institute Galleries), and Monet's *Impression, Sunrise* (Paris, Musée Marmottan). The term 'impressionism' becomes current and the critic Louis Leroy publishes a satirical review under the title 'Exhibition of Impressionists' in *Charivari*. The Hôtel Drouot auction had encouraged over-confidence in the pricing of pictures and the show is not a financial success. It closes on 15 May. Morisot paints at Maurecourt. In the summer Manet joins Monet and Renoir at Argenteuil, where they paint together. Morisot paints in Fécamp. Pissarro alternates between Pontoise and Montfoucault in Brittany. Sisley goes to London and works around Hampton Court. In December the Société is dissolved owing to financial problems. Morisot marries Manet's brother Eugène (1833–92).

1875 In March Renoir organises an auction of his work and that of his friends Monet, Sisley and Morisot at the Hôtel Drouot; several works are sold but fetch low prices. Manet exhibits *Argenteuil* (Tournai, Musée des Beaux Arts) at the Salon. Morisot visits the Isle of Wight and London. After his return from England Sisley moves to Marly-le-Roi.

1876 The second group exhibition is held at Durand-Ruel's gallery at 11 rue Le Peletier in April, showing the work of nineteen artists. Among the exhibits are Monet's *Woman with a Parasol* (Washington, National Gallery of Art), Renoir's *Torso of a Woman in the Sunlight* (Paris, Musée d'Orsay) and Sisley's *Watering Place at Marly-le-Roi* (Cat. no. 7). A noteworthy new exhibitor is Gustave Caillebotte (1848–94). In the summer Renoir works in Montmartre and Sisley paints the floods at Port-Marly. Cézanne works with Guillaumin at Issy-les-Martineaux. In the autumn Pissarro at Montfoucault contemplates decorating ceramic tiles for a living, while Monet decorates the house of the financier Ernest Hoschedé at Montgeron. Paul Gauguin (1843–1903) exhibits a landscape at the Salon and begins buying Impressionist pictures. Manet is rejected from the Salon and opens his studio to the public. Renoir's *At the Theatre* (Cat. no. 8) possibly painted around this time.

1877 Early in the year Monet works at the Gare Saint-Lazare (see Cat. no. 10). In April the third group exhibition, organised principally by Caillebotte, is held in a large apartment at 6 rue Le Peletier across the street from Durand-Ruel's gallery. There were nineteen participating artists. Monet exhibits several of his Gare Saint-Lazare subjects. Pissarro shows various Pontoise works, including possibly *The Côte des Boeufs* (Cat. no. 9), and his friend Piette shows thirty-two works, including some Pontoise landscapes. Renoir attracts attention with *Ball at the Moulin de la Galette* (Paris, Musée d'Orsay). During the exhibition a four-part journal entitled *L'Impressionniste* is published under the editorship of Renoir's friend Georges Rivière. In May Renoir organises another auction at the Hôtel Drouot; works by Caillebotte, Pissarro and Sisley are included. Pissarro and Cézanne work together at Pontoise. Sisley moves to Sèvres.

1878 In January Monet leaves Argenteuil and moves to Paris. Exposition Universelle in Paris. Abortive plans are made for fourth Impressionist exhibition. Degas introduces a new condition, that no artist intending to exhibit with the group should also submit to the Salon. Pissarro expresses concern over possible defections as a result of this and also about exhibiting sketches. Renoir exhibits one painting at the Salon. Cézanne is rejected. Théodore Duret publishes *Les Peintres Impressionnistes*, a pamphlet which singles out Monet, Sisley, Pissarro, Renoir and Morisot as the true Impressionists. Cézanne spends the year in the South, painting at Marseilles (where he meets Monticelli), Aix and L'Estaque. In August Monet moves to Vétheuil.

1879 In April the fourth group exhibition opens at 28 avenue de l'Opéra with fifteen exhibitors. Sisley, Renoir and Cézanne refuse to participate, and instead submit to the Salon, where only Renoir is successful with four exhibits, including *Madame Charpentier and her Children* (New York, Metropolitan Museum of Art). Morisot also abstains. Degas advertises the show as 'un Groupe d'artistes Indépendants'. Monet is reluctant to show but is persuaded by Caillebotte. In June Renoir has a one-man show at La Vie Moderne – an exhibition space associated with the arts periodical of that name. Renoir's *Boating on the Seine* (Cat. no. 11) is probably painted around this

time. Gauguin goes to Pontoise to paint with Pissarro during the summer.

1880 Sisley moves near to Moret-sur-Loing. Manet exhibits his *Execution of the Emperor Maximilian* (Mannheim, Kunsthalle) in America and has a one-man show at La Vie Moderne. His *Portrait of Antonin Proust* (Ohio, Toledo Museum of Art) and *At Père Lathuille's* (Tournai, Musée des Beaux Arts) are exhibited at the Salon. Monet, Renoir, Sisley and Cézanne refuse to participate in the fifth group exhibition held in April at 10 rue des Pyramides. Despite the support of Pissarro and Morisot (she shows *Summer's Day*, Cat. no. 12), the disunity of the group (consisting largely now of friends of Degas) provokes widespread criticism. Gauguin exhibits eight works. Monet and Renoir have work accepted at the Salon but both protest at bad hanging. In June Monet has a one-man exhibition at La Vie Moderne; in September he works on the Normandy coast. Renoir starts work on *Luncheon of the Boating Party* (Washington, Phillips Collection).

1881 Important reforms are introduced at the Salon – the state hands over supervision to an artists' association. Every artist who had exhibited could now vote for the jury. Manet obtains a second-class medal for *Portrait of Henri Rochefort* (Hamburg, Kunsthalle). Renoir exhibits two works there. Cézanne, Guillaumin, Pissarro and Gauguin work together at Pontoise. Monet works in and around Vétheuil (he paints *Lavacourt under Snow*, Cat. no. 13, at this period) and on the Channel coast. Sisley has a one-man show at La Vie Moderne. Morisot and Pissarro join Degas and his followers in a sixth group exhibition at 35 boulevard des Capucines. Morisot paints in Bougival and Nice. Renoir begins work on *The Umbrellas* (Cat. no. 14). In the autumn he departs for Italy where he studies the work of Raphael and antique Pompeian wall paintings. Manet is made Chevalier of the Légion d'Honneur.

1882 In January Cézanne and Renoir

paint together at L'Estaque. The Impressionist contingent is reunited once more at the seventh group show organised by Durand-Ruel at 251 rue Saint-Honoré. Works by Monet, Renoir, Sisley, Pissarro and Morisot are exhibited. Renoir shows his *Luncheon of the Boating Party*. Degas – under pressure to relinquish his support of his protégés – withdraws from the exhibition. Manet shows *Bar at the Folies-Bergère* (London, Courtauld Institute Galleries) at the Salon and Renoir and Cézanne exhibit portraits. Morisot spends the summer at Bougival. Monet paints at Pourville near Dieppe. In December Pissarro moves from Pontoise to nearby Osny.

1883 Manet dies in April. Durand-Ruel organises a series of one-man exhibitions in a new gallery – Monet (March), Renoir (April), Pissarro (May), Sisley (June). He also sends paintings to Boston, Berlin and Rotterdam for exhibitions. Monet moves to Giverny. Cézanne works mostly in the South and meets Monet and Renoir there in December. Morisot organises a Manet retrospective with Gustave and Eugène Manet and Manet's wife Suzanne.

1884 Memorial exhibition of Manet's work held at the Ecole des Beaux-Arts. Sale of contents of his studio. In April Pissarro moves to Eragny-sur-Epte. Cézanne works mostly around Aix; he is rejected at the Salon. Morisot spends the summer at Bougival. Durand-Ruel faces bankruptcy. Monet works on the Mediterranean coast.

1885 Pissarro meets Paul Signac (1863–1935) in Guillaumin's studio and Georges Seurat (1859–91) at Durand-Ruel's; he is greatly interested by their theories. Cézanne and Renoir work together at La Roche-Guyon in June and July. Monet works in Giverny and participates in Georges Petit's fourth Exposition Internationale. Monet, Pissarro and Sisley decline invitation from Durand-Ruel to hold a group exhibition, preferring to remain independent.

1886 The eighth and last group exhibition is held at 1 rue Lafitte. Morisot and Eugène Manet take an active part in organising the show. Pissarro exhibits his first 'pointilliste' works and insists on the inclusion of Seurat and Signac, which causes a bitter quarrel with Eugène Manet. Seurat exhibits *Sunday Afternoon on the Island of La Grande-Jatte* (Chicago, Art Institute). Monet, Renoir and Sisley all refuse to participate. Monet and Renoir exhibit at Petit's fifth Exposition Internationale and with Les Vingt in Brussels. Durand-Ruel, in search of new markets, takes 300 paintings from his stock to New York; Monet and Pissarro both disapprove of this move. Monet and Renoir work in Brittany. Cézanne paints at Gardanne; his *Hillside in Provence* (Cat. no. 15) probably dates from this period.

Glossary

barium sulphate Dense, inert white material sometimes used as an extender for manufactured oil colours and in the priming layers for artists' canvases (also called *blanc fixe*).

birefracting Pigment particles which are birefracting appear as bright points against a dark background under the microscope in polarised light. This optical property is often used as an aid to identification for small particles.

bone black See ivory black.

brun rouge A form of red ochre. See earth pigments.

cadmium red Opaque scarlet pigment consisting of cadmium sulpho-selenide, invented in 1892, but not manufactured until *c.* 1910.

cadmium yellow Stable, dense, deep yellow pigment consisting of cadmium sulphide; invented in 1817 and available from the mid-1840s.

canvas pin Small, cylindrical, wooden or metal pin, approximately one cm in diameter and in thickness, with a steel point projecting from each of the two flat sides (like two drawing pins joined back-to-back). Such pins, fixed in the corners of canvases, are used to separate wet canvases of the same size while they are being transported.

cerulean blue Greenish-blue pigment composed of cobalt stannate, introduced in 1860 (also called *caeruleum, blue céleste*).

chiaroscuro The modelling of a painted form by means of dark and light tones.

'chrome green' A manufactured mixture of chrome yellow (q.v.) and Prussian blue (q.v.), often extended with other materials (also called cinnabar green and various proprietary names, e.g. Milori green).

chrome orange Orange basic lead chromate pigment, discovered in 1809.

chrome yellow Strictly, pure lead chromate pigment, but often modified with other materials; invented in 1809 and widely used during the nineteenth century (also called Paris yellow, jonquil chrome yellow).

chromium oxide green, opaque Dull green anhydrous chromic oxide, originally used as a ceramic glaze colorant and later as an artists' pigment.

cobalt blue Stable, pure blue pigment composed of cobalt aluminate; invented in 1802 and available as an artists' pigment soon after (also called Thénard's blue, Dresden blue).

cobalt green Dull bluish-green pigment composed of cobalt zincate; invented in 1780, but not widely available until the mid-nineteenth century (also called zinc green, Rinmann's green).

cobalt violet Pure mauve pigment consisting of cobalt phosphate or cobalt arsenate, sometimes a mixture of both compounds; invented in 1859.

cross-section By examining minute samples of paint in cross-section under the microscope, the layer structure of the painting, including the ground layers, can be determined for that sample point. Many pigments can be identified by their colour and optical properties in a cross-section, and analysis by LMA (q.v.) or EDX (q.v.) can be carried out on individual layers. Samples are mounted in a block of cold-setting resin, then ground and polished to reveal the edge of the sample for examination in

reflected (incident) light under the optical microscope. The usual magnification range is 60–800×.

delaminate The physical separation of layers within a multilayered structure. A paint film, for example, may delaminate from a ground (q.v.) or priming layer, or two paint layers may split apart.

dragged A dragged brushstroke – one in which paint is stroked lightly over a rough surface of canvas or underpaint so that the paint covers raised areas, but leaves lower parts untouched; a 'broken' effect is thus created, with tiny irregular areas of canvas or underpaint showing through the upper paint layer.

earth pigments Traditional naturally occurring iron oxide pigments varying in colour between red, yellow, orange and brown, usually only of moderate intensity. The class includes ochres, siennas and umbers. Artificial forms of ochre called Mars colours were made from the late eighteenth century.

ébauche The first preparatory work or lay-in (q.v.) of paint on the canvas of what is intended to be a fully completed painting, perhaps after some preliminary drawing of the forms. In traditional academic painting the *ébauche* was monochrome, giving tonal values; later in the century the *ébauche* might be polychromatic, giving the colouristic as well as the tonal base for the painting.

emerald green Brilliant green pigment with the composition copper acetoarsenite; invented in 1814 and manufactured on a large scale thereafter (also called Schweinfurt green, *vert Véronèse*).

energy-dispersive X-ray microanalysis: EDX A method of elemental analysis carried out in the scanning electron microscope (q.v.). Small areas of a sample which has been imaged in the SEM can be selected and analysed for their component elements. For example, a single paint layer in a cross-section, or a single pigment particle, may be selectively analysed. The electron beam which falls on the specimen in the SEM generates X-rays which are characteristic in their energies of the elements in the sample which produce them. The instrument measures the energies of these X-rays and assigns them on a visual display to the elements present. For the purposes of pigment identification, the results show whether the sample contains lead, copper, arsenic, cobalt, chromium and so on, but not what the actual component pigments are. These analytical data must then be interpreted in conjunction with the examination of paint samples by optical microscopy in order to specify the pigments involved. See also LMA.

esquisse A small-scale trial sketch for the composition of a painting, characterised by its freedom and boldness; colour and modelling are broadly indicated. It is more restrained and decisive than a *pochade* (q.v.).

étude Usually a study or preparatory work for a painting; studies from nature were used to compose a final painting, but could also be treated as a painting in their own right. In landscape painting, an *étude* could be a finished picture painted directly from nature.

French ultramarine Deep blue synthetic form of ultramarine; invented in 1826–7 and commercially available soon after.

frit Partially fused or semi-crystalline product

resulting from heating together mixtures of materials.

gas-liquid chromatography: GLC An analytical separation technique for complex mixtures of organic materials, for example paint media (see medium), based on the partition of components of a vaporised sample between a moving inert gas stream and a stationary liquid phase. The use of sensitive detectors enables the identification of minute amounts of materials.

glaze A transparent or translucent surface paint layer, usually of a high degree of saturation (q.v.).

ground The first layer or layers laid on to a canvas to prepare the support for painting. The canvases used by the Impressionists were often bought ready-grounded with lead white and chalk, the ground sometimes also lightly tinted with small quantities of coloured pigment.

hue The colour quality of a visual sensation, related to the dominant wavelength of the spectrum of light observed, and expressed by names such as 'red', 'blue', etc.

impasto Paint applied in thick or heavy layers or strokes; the thickness, roughness or raised quality of the paint or brushstroke, as opposed to a smooth, flat paint surface.

infra-red photography/photograph Infra-red is similar to visible light, but slightly too long in wavelength for the eye to see: however, it can be photographed. In conventional infra-red photography, an image is recorded using film sensitive to infra-red radiation in an ordinary camera. An infra-red photograph shows layers just below the visible surface of a painting, for example *pentimenti* (q.v.). Certain pigments register as dark in infra-red photographs, whereas others give a light image; this behaviour may be used to distinguish different materials at the surface of the picture.

infra-red reflectography/reflectogram A technique related to infra-red photography in which a television camera adapted to receive infra-red radiation is connected to a television monitor. The image is seen instantaneously, but recording of the image is slightly blurred since it is photographed from the screen. An infra-red reflectogram, like an infra-red photograph, shows layers below the visible surface of a painting. The two techniques are complementary: infra-red photography produces a sharper image, but infra-red reflectography can achieve greater penetration of the upper paint layers because the detector used is sensitive to a greater range of wavelengths than infra-red film.

ivory black Warm, deep, brownish-black traditional pigment made by charring waste ivory or animal bones. Contains residual calcium phosphate and carbon.

lake pigment A translucent pigment made by co-precipitating an organic dyestuff on to a base material. Both synthetic and natural dyestuffs are used. Examples of natural red lakes include madder lake and cochineal lake (carmine). Yellow lake pigments are also made.

laser microspectral analysis: LMA A method for elemental analysis of minute samples, yielding similar information to EDX analysis (q.v.). An area of a sample is selected for analysis under a specialised microscope, and a laser pulse fired at

this spot, causing part of the specimen to be vaporised. The specimen vapour passes between a pair of electrodes across which an electrical spark is induced. This heats the vapour to a high temperature very rapidly, causing it to emit light of wavelengths which are characteristic of the composition of the sample. The emitted light is analysed by a spectrograph and recorded on a photographic plate as a spectrum of lines related to the elements present in the sample. In the same way as in EDX analysis, the pigment composition of a paint layer can be determined by referring its elemental composition to examination of the sample by optical microscopy. LMA may be used on paint cross-sections (q.v.) for a layer-by-layer analysis, or on minute unmounted flakes.

lay-in The first stage of work on a painting intended for completion, giving the general effect of colour and tonal values (see also *ébauche*).

lead white Traditional dense white pigment composed of basic lead carbonate (also called *blanc d'argent*, *blanc de Krems*; erroneously called Cremnitz white).

'lemon yellow' Usually barium chromate, sometimes strontium or calcium chromate; invented in 1809 (occasionally called ultramarine yellow).

medium The binding agent or vehicle for the pigments in paint. In Impressionist painting drying oils such as linseed, walnut and poppyseed are the principal media.

Naples yellow Strictly, an artificial opaque lead-antimony yellow pigment commonly used from the early eighteenth century (sometimes called *jaune d'antimoine*). The term is also a colour description for manufactured paint mixtures not necessarily containing genuine Naples yellow.

ochre See earth pigments.

palette A flat piece of wood, usually shaped as a rectangle or oval, on which painters would lay out and mix their paints. Also the term applied to the specific range of pigments used by a painter for a particular composition.

peinture claire Painting expressing light by means of a predominantly pale luminous tonality.

pentimento (plural **pentimenti**) An alteration made by the artist to an area already painted; literally, repentance.

pigment identification/analysis Many pigment identifications in minute samples of paint may be accomplished by optical microscopy of mounted cross-sections (q.v.), thin cross-sections and pigment dispersions, by classical methods of optical mineralogy. Supplementary chemical identification is often required to confirm the results of optical examination, and in the present study included laser microspectral analysis (q.v.), energy-dispersive X-ray microanalysis (q.v.), X-ray diffraction analysis (q.v.) and chemical microscopy (wet chemical tests carried out under the microscope). Certain pigment samples and cross-sections were investigated further by imaging in the scanning electron microscope (q.v.). All the pigment and media examples for the painting materials quoted in the catalogue are the result of some positive method of identification or analysis, whether by optical

microscopy in some form, or by instrumental means. In many cases confirmation of the identity of a material was obtained by several different techniques.

plein air Literally, fresh air or open air; thus painting *en plein air* is painting in the open air or out of doors.

pochade A very free, bold, rapid sketch, bolder and more imprecise or undecided than an *esquisse* (q.v.).

priming A synonym for a ground (q.v.).

Prussian blue A synthetic dark blue pigment, ferric ferrocyanide; invented in Berlin *c.* 1704–10 (also called Berlin blue, Paris blue).

raking light A technique for revealing the surface conformation of a painting by casting light across it at a low angle.

reserve To omit paint from an area of a composition so that some planned feature may be painted on it later; an area treated in this way.

saturation The intensity of colour, or freedom from grey – i.e. the intensity of 'redness', 'blueness', for example – of a particular hue.

scanning electron microscopy: SEM A technique capable of revealing the fine details of objects at far higher magnifications than is possible with the optical (light) microscope. The scanning electron microscope uses a beam of electrons to scan the sample under examination, and the electrons scattered by the surface are collected and used to generate a video image. The SEM will show surface topography and three-dimensional structure at magnifications up to 100,000×, but the image can only be in monochrome. Equipment for microanalysis of very small areas of a specimen can be attached to the SEM. See EDX analysis.

Scheele's green Dull green copper arsenite pigment; invented in 1775, but not commonly used after the 1870s.

scumble To apply a thin layer of semi-opaque paint over a colour to modify it; a layer of paint used in this way.

semi-glaze A partially translucent paint that contains a transparent material combined with small quantities of opaque pigment (see also glaze).

simultaneous contrast: of colours: the effect whereby adjacent complementary colours heighten each other's saturation (q.v.) and appear as unlike one another as possible; of **tones:** an identical grey figure seen simultaneously against a black and a white ground will appear lighter on the black ground and darker on the white ground.

size A weak glue made from gelatin.

stippling The application of paint in short dabs or spots of colour.

stretcher The chassis or wooden framework on which the canvas is stretched. Triangular wooden keys or wedges may be inserted into slots in the inner corners of the chassis to tighten the canvas if necessary. A chassis with rigidly joined corners, which does not allow any such tightening of the canvas, is known as a strainer.

tabby The simplest plain weave of a fabric.

tableau A painting intended by the artist to be completely worked up and finished, usually for exhibition or sale.

tache A patch or touch (of colour).

turbid medium A translucent substance – e.g. smoke, clouds, tissue paper. Light areas seen through a turbid medium appear warm in colour, while dark areas appear cool; thus dark hills seen through a mist appear bluish in colour. Unless it is very thick, a paint film is translucent and behaves as a turbid medium; the same paint layer thus will appear relatively cooler in colour when painted over a dark underpaint, and relatively warmer painted over a light one.

underpainting Preliminary layer of paint in a composition.

vermilion A traditional opaque scarlet pigment composed of mercuric sulphide, usually a synthetic product in nineteenth-century artists' paints.

viridian A very stable transparent form of hydrated chromic oxide of an intense deep green; discovered in the 1830s, but not widely available until the 1860s (also called *vert émeraude*, Pannetier's green, Guignet's green).

wet-in-wet Laying down one colour next to or on to another before the first is dry, so that some intermixing occurs.

X-ray A form of radiation which passes through solid objects, but is obstructed to differing degrees by differing materials. The heavier the atoms of which a substance is made, the more opaque it is to X-rays. Lead pigments are particularly opaque, those containing lighter metals less so. Thus in an X-ray image (known as a *radiograph*) of a painting, areas of paint containing lead pigments will appear almost white, while areas containing lighter materials will appear an intermediate grey or dark. In interpreting X-ray photographs, it should be remembered that all layers are superimposed: thus the image of a wooden stretcher, canvas tacks or the impression of the canvas weave in the priming layer, may seem to overlie the image of the paint itself. X-ray images are particularly valuable in revealing changes in the composition of a picture beneath its surface.

X-ray diffraction analysis: XRD A technique for the identification of substances in crystalline form (many pigments are crystalline materials). A narrow beam of X-rays (q.v.) is projected through a very small specimen inside a specially designed form of camera. The regular arrangement of atoms in the crystal scatters the X-rays, producing a 'fingerprint' pattern, unique to that crystalline material, on a strip of film. Identification of this pattern allows unambiguous recognition of the material under study. XRD is particularly suitable for the identification of fairly pure samples of crystalline pigments, containing, for example, lead white, zinc white, chromate pigments, cobalt blue, emerald green and others.

zinc white Zinc oxide white pigment; discovered in the late eighteenth century, but not widely available until after the 1840s.

zinc yellow Zinc potassium chromate; invented in 1809 and in commercial production from the 1850s.

Bibliography

The arrangement of the bibliography follows that of the catalogue; under each heading general references precede specific references in the text, which are cited in the order in which they appear. Texts are referred to in full the first time they are cited, which, in many cases, is in the section headed 'Introduction'. The exceptions are French nineteenth-century painting manuals and works on paint technology: these are listed together and cited in full under 'Impressionism and the Modern Palette'.

Introduction

A selection of general and introductory works on Impressionism, followed by books on each of the painters represented in the exhibition.

Adéline, Jules, *Lexique des termes d'art*, Paris, 1884.

Callen, Anthea, *Techniques of the Impressionists*, London, 1982.

Clark, Timothy J., *The Painting of Modern Life: Paris in the Art of Manet and his Followers*, New York and London, 1985.

The Crisis of Impressionism, 1878–1882; [exhibition catalogue] by Joel Isaacson; University of Michigan Museum of Art; Ann Arbor, 1979.

Davies, Martin, *National Gallery Catalogues: French School – Early 19th century, Impressionists, Post-Impressionists, etc.*, 2nd edn, revised, London, 1970.

A Day in the Country: Impressionism and the French Landscape; [exhibition catalogue] by Richard R. Brettell and others; Los Angeles County Museum of Art, Art Institute of Chicago, Grand Palais, Paris, 1984–5; Los Angeles, 1984.

Les Ecrivains devant l'impressionnisme; edited by Denys Riout, Paris, 1989. (A collection of writings on the Impressionists and their works by contemporary critics.)

Frédéric Bazille and Early Impressionism; [exhibition catalogue] by J. Patrice Marandel and others; Art Institute of Chicago, 1978.

Herbert, Robert L., *Impressionism: Art, Leisure and Parisian Society*, New Haven and London, 1988.

Impressionist and Post-Impressionist Masterpieces: the Courtauld Collection; [exhibition catalogue] by John House and others, New Haven and London, 1987.

Impressionist Drawings from British Public and Private Collections; [exhibition catalogue] by Christopher Lloyd and Richard Thomson; Ashmolean Museum, Oxford; Manchester City Art Gallery; Burrell Collection, Glasgow; Oxford and London, 1986.

Lighting up the Landscape: French Impressionism and its Origins; [exhibition catalogue] by Michael Clarke; National Gallery of Scotland; Edinburgh, 1986.

The New Painting: Impressionism 1874–1886; [catalogue of] an exhibition organised by the Fine Arts Museum of San Francisco with the National Gallery of Art, Washington, directed and co-ordinated by Charles S. Moffett, San Francisco, 1986.

Pool, Phoebe, *Impressionism*, London, 1967 (1988 reprint).

Rewald, John, *The History of Impressionism*, 4th revised edn, London and New York, 1973.

Rewald, John, *Studies in Impressionism*; edited by Irene Gordon and Frances Weitzenhoffer, London, 1985.

Taylor, Joshua C., *Nineteenth-century Theories of Art*, Berkeley and Los Angeles, 1987 (1989 reprint).

Venturi, Lionello, *Les Archives de l'impressionnisme*, 2 vols, Paris, 1939.

Edouard Manet

Adler, Kathleen, *Manet*, Oxford, 1986.

Hamilton, George Heard, *Manet and his Critics*, New Haven and London, 1954.

Hanson, Anne Coffin, *Manet and the Modern Tradition*, New Haven and London, 1977.

The Hidden Face of Manet: An Investigation of the Artists's Working Processes; catalogue of an exhibition held at the Courtauld Institute Galleries, by Juliet Wilson Bareau; The Burlington Magazine, London, 1986.

Manet, 1832–1883; [exhibition catalogue], Grand Palais, Paris; Metropolitan Museum of Art, New York; Paris, 1983.

Manet at Work; [catalogue of] an exhibition at the National Gallery to mark the centenary of the death of Edouard Manet, 1832–83, by Michael Wilson; London, 1983.

Rouart, Denis, and Wildenstein, Daniel, *Edouard Manet: Catalogue raisonné*, 2 vols, Lausanne and Paris, 1975.

Claude Monet

Gordon, Robert, and Forge, Andrew, *Monet*, New York, 1983.

Hommage à Claude Monet (1840–1926); [exhibition catalogue] by Helene Adhémar and others; Grand Palais, Paris; Paris, 1980.

House, John, *Monet: Nature into Art*, New Haven and London, 1986.

Isaacson, Joel, *Observation and Reflection: Claude Monet*, Oxford, 1978.

Monet: A Retrospective; edited by Charles F. Stuckey, New York, 1985 (cited below as Stuckey, C.F., 1985).

Monet in the 90's: The Series Paintings; [exhibition catalogue] by Paul Hayes Tucker; Museum of Fine Arts, Boston; Art Institute of Chicago; Royal Academy, London, 1989–90; Boston, 1989.

Claude Monet: Painter of Light; [exhibition catalogue], Auckland City Art Gallery; Auckland, 1985.

Tucker, Paul Hayes, *Monet at Argenteuil*, New Haven and London, 1982.

Wildenstein, Daniel, *Claude Monet: Biographie et catalogue raisonné*, 4 vols, Lausanne and Paris; Vol. I, 1840–1881, 1974; Vol. II, 1882–1887, 1979; Vol. III, 1888–1898, 1979; Vol. IV, 1899–1926, 1985.

Camille Pissarro

Bailly-Herzberg, Janine, *Correspondance de Camille Pissarro*, 4 vols, Paris; Vol. 1, 1865–1885, 1980; Vol. 2, 1886–1890, 1986; Vol. 3, 1891–1894, 1988; Vol. 4, 1895–1898, 1989.

Brettell, Richard R., and Lloyd, Christopher, *A Catalogue of the Drawings by Camille Pissarro in the Ashmolean Museum, Oxford*, Oxford, 1980.

Lloyd, Christopher, *Camille Pissarro*, London, 1981.

Pissarro: Camille Pissarro, 1830–1903; [exhibition catalogue], Hayward Gallery, London; Grand Palais, Paris; Museum of Fine Arts, Boston, 1980–1; London, 1980 (French edn 1981).

Pissarro, Ludovic-Rodo, and Venturi, Lionello, *Camille Pissarro: son art – son oeuvre*, 2 vols, Paris, 1939.

Studies on Camille Pissarro; edited by Christopher Lloyd, London, 1986.

Thomson, Richard, *Camille Pissarro: Impressionism, Landscape and Rural Labour*, [exhibition catalogue], City Museum and Art Gallery, Birmingham; Burrell Collection, Glasgow; London, 1990.

Alfred Sisley

Alfred Sisley, [exhibition catalogue] by Christopher Lloyd; Tokyo; Fukuoka; Nora, 1985.

Daulte, François, *Alfred Sisley: Catalogue raisonné de l'oeuvre peint*, Lausanne, 1959.

Shone, Richard, *Sisley*, New York, 1979.

Pierre-Auguste Renoir

Callen, Anthea, *Renoir*, London, 1978.

Daulte, François, *Auguste Renoir: Catalogue raisonné de l'oeuvre peint*, Vol. 1, *Figures, 1860–1890*, Lausanne, 1971.

Renoir; [exhibition catalogue] by John House and others; Hayward Gallery, London; Grand Palais, Paris; Museum of Fine Arts, Boston, 1985–6; Paris, 1985.

White, Barbara Ehrlich, *Renoir: His Life, Art and Letters*, New York, 1985.

Berthe Morisot

Adler, Kathleen, and Garb, Tamar, *Berthe Morisot*, Oxford, 1987.

Bataille, Marie-Louise, and Wildenstein, Georges, *Berthe Morisot: Catalogue des peintures, pastels et aquarelles*, Paris, 1961.

Berthe Morisot: Impressionist; [exhibition catalogue] by Charles F. Stuckey and William P. Scott; National Gallery of Art, Washington; Kimbell Art Museum; Mount Holyoke College Art Museum, 1987–8; Washington, 1987.

The Correspondence of Berthe Morisot; compiled and edited by Denis Rouart, with a new introduction and notes by Kathleen Adler and Tamar Garb, London, 1986 (first published 1957).

Paul Cézanne

Conversations avec Cézanne; edited by P. M. Doran, Paris, 1978.

Paul Cézanne: Correspondance; edited by John Rewald, revised edn, Paris, 1978; English edn translated by Seymour Hacker, New York, 1984.

Rewald, John, *Cézanne: A Biography*, New York, 1986.

Shiff, Richard, *Cézanne and the End of Impressionism: A Study of the Theory, Technique and Critical Evaluation of Modern Art*, London and Chicago, 1984.

Venturi, Lionello, *Cézanne, son art, son oeuvre*, 2 vols, Paris, 1936.

Impressionist Techniques: Tradition and Innovation

For the quotations from Edmond Duranty see: Duranty, Louis-Emile-Edmond, *The New Painting: Concerning the Group of Artists Exhibiting at the Durand-Ruel Galleries*, 1876, in *The New Painting: Impressionism 1874–1886*, 1986, pp. 37–49. The quotations are from pp. 42 and 41 respectively.

On Impressionism in the context of academic art see especially:

Boime, Albert, *The Academy and French Painting in the Nineteenth Century*, London, 1971.

Boime, Albert, 'The Teaching Reforms of 1863 and the Origins of Modernism', *Art Quarterly*; new series, 1, 1977, pp. 1–39.

Callen, A., 1982, pp. 8ff.

Charles Gleyre ou les illusions perdues; [exhibition catalogue], Winterthur, Kunstmuseum; Marseilles, Musée Cantini; Munich, Städtische Galerie im Lenbachhaus; Kiel, Kunsthalle; Aargau, Aargauer Kunsthaus; Lausanne, Musée Cantonal des Beaux-Arts, 1974–5; Zürich, 1975. See especially the essay by A. Boime, 'The Instruction of Charles Gleyre and the Evolution of Painting in the Nineteenth Century', pp. 102–24.

Shiff, R., 1984.

See also:

House, John, 'Impressionism and History: the Rewald Legacy', *Art History*, 9, 1986, pp. 369–76 (a review of Shiff's book, cited above, and of J. Rewald's *Studies in Impressionism*, 1985).

White, Harrison Colyar, and White, Cynthia Alice, *Canvases and Careers, Institutional Change in the French Painting World*, New York, 1965.

On the history of the French Academy and the Ecole des Beaux-Arts:

Delaborde, H., *L'Académie des Beaux-Arts*, Paris, 1891.

Grunchec, Philippe, *Le Grand Prix de peinture: les concours des Prix de Rome de 1797 à 1863*, Paris, 1983.

Grunchec, Philippe, *The Grand Prix de Rome: Paintings from the Ecole des Beaux-Arts 1797–1863*; [exhibition catalogue], Washington, DC, 1984–5; Washington, 1984.

Lemaistre, A., *L'Ecole des Beaux-Arts dessinée et racontée par un élève*, Paris, 1889.

Pevsner, Nicholas, *Academies of Art, Past and Present*, Cambridge, 1940.

Vitet, Louis, *L'Académie royale de peinture et de sculpture*, Paris, 1861.

For Cézanne's attempt to enter the Ecole des Beaux-Arts, see his comments to Rivière and Schnerb, cited in *Conversations avec Cézanne*, 1978, p. 87.

For the Ingres quotation see: *Impressionist Drawings from British Public and Private Collections*, 1986, p. 9.

For the painting of an *ébauche* in academic painting practice see Bouvier, P.-L., 1832, pp. 207–31, 275ff., 616–18 and Plate VII, cited in full below in the list of manuals under 'Impressionism and the Modern Palette'. Note that, in Plate VII, to save space the author has shown two sets of colours and mixed tints on the one palette, one for painting flesh tones, the other for an *ébauche*.

See also other manuals on painting practice dating from the first half of the nineteenth century, listed below, such as those by Arsenne, Delaistre, Delécluze, and Paillot de Montabert: even Ducrot and Panier, writing in the 1850s, describe traditional academic painting practice. J.-P. Thénot, writing in 1842, includes a short list of the palettes of certain Academic painters (including that of Ingres), pp. 2–5.

For the sketch stage of the Prix de Rome:

Boime, A., 1971, pp. 149ff.

Grunchec, P., 1984–5, pp. 26ff.

For a contemporary discussion of the training of students in the 1870s see:

Lecoq de Boisbaudran, Horace, *Lettres à un jeune professeur: Sommaire d'une méthode pour l'enseignement du dessin et de la peinture*, Paris, 1876.

There is no single history of the Paris Salon. Perhaps the best account is contained in Emile Zola's novel *L'Oeuvre*, first published in 1886; see also:

Lethève, Jacques, *Daily Life of French Artists in the Nineteenth Century*, London, 1972.

Milner, John, *The Studios of Paris: The Capital of Art in the late Nineteenth Century*, New Haven and London, 1988.

The Impressionists and the Salon (1874–1886); [exhibition catalogue], Los Angeles County Museum of Art; Riverside, University of California Gallery; Riverside, 1974.

White, H. C., and White, C. A., 1965.

The catalogues of the Salon exhibitions from 1699 to 1881 have been published in facsimile by Garland Press, New York and London, 1977.

On the Impressionist Exhibitions, see: *The New Painting: Impressionism 1874–76*, 1986.

For Duret's advice to Pissarro, 15 February 1874, see Pissarro, L.-R., and Venturi, L., 1939, Vol. I, pp. 33–4.

For Manet and Couture, see especially:

Alazard, Jean, 'Manet et Couture', *Gazette des Beaux-Arts*, 6th Period, 35, 1949, pp. 213–18.

Boime, A., 1971, pp. 65–78.

Boime, Albert, *Thomas Couture and the Eclectic Vision*, New Haven and London, 1980, pp. 457–80.

Duret, Théodore, *Histoire d'Edouard Manet et de son oeuvre*, Paris, 1902.

Proust, Antonin, *Edouard Manet, souvenirs*, Paris, 1913.

For Couture's remark about his training of artists, see Boime, A., 1971, p. 78.

For the description of Couture as 'the man who taught painting in 12 lessons', see: Claretie, Jules, 'Salon de 1874 à Paris', *L'Indépendance belge*, 13 June 1974, cited in *Les Ecrivains devant l'impressionnisme*, 1989, p. 74.

Couture's own writings on art:

Couture, Thomas, *Entretiens d'atelier. Paysage*, Paris, 1869.

Couture, Thomas, *Méthode et entretiens d'atelier*, Paris, 1867.

See also:

Bertauts-Couture, G., *Thomas Couture, sa vie, son oeuvre, son caractère, ses idées, sa méthode, par lui-même et par son petit-fils*, Paris, 1932.

For a comparison of *Music in the Tuileries* with Couture's *Romans*, see: Sandblad, Nils Gösta, *Manet: Three Studies in Artistic Conception*, Lund, 1954, pp. 33–6.

For Monet's letter to Boudin, 19 May 1859, see Wildenstein, D., Vol. I, 1974, letter no. 1, p. 419.

On Charles Gleyre:

Boime, A., 1971, pp. 58–65.

Boime, A., in *Charles Gleyre, ou les illusions perdues*, 1975 (cited in full above).

Charles Gleyre 1806–1874; [exhibition catalogue], Grey Art Gallery and Study Center, New York University; the University of Maryland Art Gallery; New York, 1980.

Clément, Charles, *Gleyre: étude biographique et critique*, 2nd revised edn, Paris, 1886.

Poulain, Gaston, *Bazille et ses amis*, Paris, 1932.

For Gleyre's opinions on painting practice and the quotation on 'the demon colour' see Clément, C.,

1886, pp. 175–6. For Gleyre and ivory black see also Boime, A., 1971, p. 63.

For Renoir on Gleyre, see: Vollard, Ambroise, *En écoutant Cézanne, Degas, Renoir*, Paris, 1938, pp. 149–51, 153.

For Bazille on Gleyre, see Poulain, G., 1932, p. 35.

On the Impressionists at the Atelier Suisse, see Rewald, J., 1973, p. 49.

For Renoir on Diaz see Vollard, A., 1938, pp. 152–3.

Cézanne's desire to 'avoid the influence of the academies' is mentioned in a letter from Zola to Cézanne, 29 September 1862; see *Paul Cézanne, Correspondance*, 1978, p. 106; English translation, New York, 1984, p. 101.

Monet's sketch 'based entirely on nature' is referred to in a letter to Bazille, 14 October 1864, Wildenstein, D., 1974, letter no. 11, p. 421; the translation is from Rewald, J., 1973, p. 113.

Monet's comment on a 'bad sketch' is from a letter to Bazille, 25 September 1869, Wildenstein, D., 1974, letter no. 53, p. 427.

For Monet's use of the terms *esquisse*, *impression* see House, J., 1986, pp. 157–64.

For the quotation from Maurice Denis see Shiff, R., 1984, p. 87.

For the quotation from Edmond Duranty see *The New Painting: Impressionism 1874–1886*, 1986, p. 42.

Painting in the Open Air

For a general discussion of painting in the open air in the nineteenth century, see:

Conisbee, Philip, 'Pre-Romantic *plein-air* painting', *Art History*, 2, 1979, pp. 413–28.

House, J., 1986, pp. 135ff. (cited in full above under 'Introduction').

Jacobs, Michael, *The Good and Simple Life: Artists' Colonies in Europe and America*, Oxford, 1985.

Lighting up the Landscape..., 1986 (cited in full above under 'Introduction').

Painting from Nature: the Tradition of Open-Air Oil Sketching from the 17th to 19th centuries; [exhibition catalogue] Fitzwilliam Museum, Cambridge; Royal Academy of Arts, London, 1981; London, 1980.

For the advice of Pierre-Henri de Valenciennes, see: Valenciennes, Pierre-Henri de, *Elémens de perspective pratique à l'usage des artistes*, 2nd edn, Paris, 1820, pp. 338–9; see also Taylor, J. C., 1987, pp. 246–59, especially pp. 253–6.

On Valenciennes himself see:

Boime, A., 1971, pp. 133ff. (cited in full under 'Impressionist Techniques: Tradition and Innovation').

Lacambre, Geneviève, *Les paysages de Pierre-Henri de Valenciennes*, Musée du Louvre, les dossiers du Département des Peintures, no. 11, Paris, 1976.

Lighting up the Landscape..., 1986, pp. 13ff.

For the 'colony of colonies' quotation, see: Henriet, Frédéric, *Le paysagiste au champs*, 2nd enlarged edn, Paris, 1876, p. 13.

On the necessity of the parasol see Robert, K., 1878, p. 20 (cited in full below: see list of manuals under 'Impressionism and the Modern Palette').

For Renoir's difficulty in adjusting tones see Vollard, A., 1938, p. 213 (cited in full above under 'Impressionist Techniques...').

On the necessity of suitable clothing, see: Hareux,

Ernest, *La peinture à l'huile en plein air*, Paris, 1909, p. 9.

See also:

Allemand, Hector, *Causeries sur le paysage*, Lyon, 1877, pp. 12–15.

Hareux, E., 1888–9, part II, *Paysages, Marines*, pp. 5–6 (see list of manuals under 'Impressionism and the Modern Palette').

For Daubigny's difficulties in painting out of doors, see: Henriet, Frédéric, *Les campagnes d'un paysagiste*, Paris, 1891, p. 43.

For Daubigny's *botin*, see: Fidell-Beaufort, Madeleine, and Bailly-Herzberg, Janine, *Daubigny*, Paris, 1975, pp. 48ff.

For Monet's studio boat see House, J., 1986, pp. 137–40.

For Gautier's criticism of Daubigny, see: Gautier, Théophile, *Abécédaire du Salon de 1861*, Paris, 1861, p. 119, cited in Fidell-Beaufort, M., and Bailly-Herzberg, J., 1975, p. 53.

For Astruc's support of Daubigny, see: Astruc, Zacharie, *Les 14 stations du Salon, août 1859*, Paris, 1859, p. 303, cited in Fidell-Beaufort, M., and Bailly-Herzberg, J., 1975, pp. 49–50.

For Thoré's comment, see: Thoré, Théophile, *Salons de W. Bürger 1861 à 1868*, 2 vols, Paris, 1870, Vol. 2, *Salon de 1866*, p. 313.

For Zola's comment on Corot:

Zola, Emile, *Salons*, edited by F. W. J. Hemmings and R. J. Niess, Geneva, 1959; 'Salon of 1866', p. 78.

On Monet's *Déjeuner sur l'herbe*, see: Isaacson, Joel, *Monet: Le Déjeuner sur l'herbe*, London, 1972.

For Monet on the 'division of colours' see House, J., 1986, pp. 111, 114.

For Cézanne's letters to Pissarro of 24 June 1874 and 2 July 1876 see *Paul Cézanne: Correspondance*, 1978, pp. 147, 152 (English edn, pp. 147, 154) (both references cited in full above under 'Introduction').

See also:

Conversations avec Cézanne, 1978, p. 202 (also cited above).

For Pissarro's comments of 1873 see Bailly-Herzberg, J., Vol. 1, 1980, letter 21, from Pissarro to Duret, 2 May 1873, p. 80; see also letters 277, pp. 335–6, and 100, p. 157.

For Berthe Morisot's difficulties while working from a boat see *The Correspondence of Berthe Morisot*, 1986, p. 104.

For Piette's letter to Pissarro, 8 October 1872, see: *Mon cher Pissarro: lettres de Ludovic Piette à Camille Pissarro*; edited by Janine Bailly-Herzberg, Paris, 1985, p. 73.

For Monet's work outdoors, see especially House, J., 1986, pp. 135–146.

For Mirbeau's comments on Monet, see: Mirbeau, Octave, 'Claude Monet', preface to a catalogue *Claude Monet, Auguste Rodin*, Galerie Georges Petit, Paris, 1889, p. 26, cited in House, J., 1986, p. 140. See also the facsimile of the original catalogue in *Claude Monet – Auguste Rodin: Centenaire de l'exposition de 1889*; [exhibition catalogue] Musée Rodin, Paris, 1989–90; Paris, 1989, pp. 48–53; see p. 53.

For Monet's work in the studio, see House, J., 1986, pp. 147–56.

For Renoir's 'documents for making pictures' see Venturi, L., 1939, Vol. I, p. 125; letter from Renoir to Paul Durand-Ruel, 27 September 1883.

See also:

Renoir, [exhibition catalogue], 1985, p. 239 (cited in full above under 'Introduction').

For Renoir on Corot and working in the studio see Vollard, A., 1938, p. 214.

On Pissarro's balanced approach, see: Lecomte, Georges, *Camille Pissarro*, Paris, 1922, p. 69.

For the interview with Pissarro in 1892, from which the quotation is taken, see: Gsell, P., 'La Tradition artistique française; 1: L'Impressionnisme', *Revue bleue*, 26 March 1892, p. 404.

For Pissarro's work in the studio, see especially: House, John, 'Camille Pissarro's idea of unity', in *Studies on Camille Pissarro*; 1986, pp. 15–34 (cited above under 'Introduction').

See also Pissarro's letters to Lucien, 13 and 14 May 1891, in Bailly-Herzberg, J., Vol. 3, 1988, letter 661, p. 81, and letter 662, p. 84.

The Painter's Studio

For Monet's remark to Taboureux in 1880, see: Taboureux, Emile, 'Claude Monet', *La Vie moderne*, 12 June 1880, translated in Stuckey, C. F., 1985, pp. 89–93, quotation from p. 90 (cited in full under 'Introduction').

For the quotation from Guillemot, see: Guillemot, Maurice, 'Claude Monet', *La Revue illustrée*, 15 March 1898, translated in Stuckey, C. F., 1985, pp. 195ff., quotation from p. 197.

On Monet's studios see House, J., 1986, pp. 147–56.

On Bazille's studios:

Frédéric Bazille and Early Impressionism, 1978 (cited in full under 'Introduction').

For the quotation from Georgel on the artist's studio, see: Georgel, Pierre, 'L'Image de l'atelier depuis le romantisme', in *Technique de la peinture: l'atelier*; catalogue rédigé par Jeannine Baticle et Pierre Georgel, Musée du Louvre, les dossiers du Département des Peintures no. 12, Paris, 1976, pp. 35–57, quotation from p. 48; see also *Frédéric Bazille and Early Impressionism*, 1978, p. 107.

On dark coloured studio walls:

Correspondance de Henri Regnault, annotée et recueillie par Arthur Duparc, Paris, 1872, pp. 382–3.

Goupil-Fesquet, F.-A.-A., 1877, p. 16 (cited in full in the list of manuals under 'Impressionism and the Modern Palette' below).

For Monet's studios at Giverny, see, for example: Trévise, Duc de, 'Le Pèlerinage de Giverny, *La Revue de l'art ancien et moderne*, Jan.–Feb. 1927, translated in Stuckey, C. F., 1985, pp. 318–41.

On Renoir's studio and working practices:

André, Albert, and Elder, Marc, *Renoir's Atelier*, revised reprint of original French edn, with English translation, San Francisco, 1989 (first published as *L'Atelier de Renoir*, 2 vols, Paris, 1931).

Renoir, Jean, *Renoir, my father*, London, 1962, pp. 341–2.

On Berthe Morisot:

Fourreau, Armand, *Berthe Morisot*, Paris, 1925, p. 8; see also *Berthe Morisot: Impressionist*, 1987, pp. 187–216, quotation on p. 189 (cited in full under 'Introduction').

For studios and studio equipment, see the painters' manuals and trade catalogues listed below under 'Impressionism and the Modern Palette'; references in the text are from:

Bourgeois *aîné*, [trade catalogue], 1888.

Robert, K., 1891, pp. 55–72.

For studios in particular see, for example, Goupil-Fesquet, F.-A.-A., 1877, pp. 15–24.

Colourmen

Annuaire générale du commerce et de l'industrie . . ., Paris, 1841–56; continued as:

Annuaire et Almanach [Annuaire-Almanach] du commerce et de l'industrie, de la magistrature et de l'administration . . . (Didot–Bottin), Paris, 1857–1908.

Lefranc & Cie., [trade catalogues], 1855–90 (cited in full under 'Impressionism and the Modern Palette').

The History and Development of Artists' Colourmen

Callen, A., 1982, pp. 8–10, 14, 18–21.

For early history of colourmen:

Des teintes et des couleurs; catalogue établi et rédigé par Martine Jaoul [and others]; Musée national des arts et traditions populaires, dossiers no. 2, Paris, 1988, pp. 40–4.

See also:

Lespinasse, René de, *Histoire générale de Paris: les métiers et corporations . . .*, Paris, 1892 (earlier edition 1886), p. 496.

Encyclopédie, ou, Dictionnaire raisonné des sciences, des arts et des métiers . . . mis en ordre et publié par Denis Diderot et Jean Le Rond d'Alembert, 17 vols, 1751–67, Vol. 10, entry under 'Marchands'.

On the sale of ready-ground colours, see: *Traité de mignature pour apprendre aisement à peindre sans maître* [by Claude Boutet?], 2nd edn, Paris, 1674, p. 13; 5th edn, Brussels, 1692, p. 14; another edn, Paris, 1696, p. 14.

On the name *marchand de couleurs*:

Pernety, Antoine-Joseph, *Dictionnaire portatif de peinture, sculpture et gravure*, Paris, 1757, p. 535.

Watin, Jean-Félix, *L'Art du peintre, doreur, vernisseur*, 3rd edn, Paris, 1776, title-page and 'Approbation', p. 371 verso.

On shop signs see *Des teintes et des couleurs*, 1988, pp. 50–2.

On the merchandise:

Lefranc & Cie., catalogue for 1876.

Watin, J.-F., 1776, pp. 346–56.

On Colcomb-Bourgeois see Arsenne, L.-C., 1833, Vol. 2, pp. 247–8 (cited in full below under 'Impressionism and the Modern Palette').

On madder carmine see Lefort, J., 1855, p. 173 (cited in full in the list of books on paint technology below under 'Impressionism and the Modern Palette').

Colour Makers and Colour Merchants

Annuaire-Almanach du commerce, 1864, 1868, 1871–2, 1876.

Pierre, L. [c. 1900], pp. 80–3.

Note: Most works cited in abbreviated form hereafter are referred to in full below under 'Impressionism and the Modern Palette'.

On Hardy-Milori, see the *Annuaire-Almanach du commerce*, 1868, and also:

Des teintes et des couleurs, 1988, p. 58.

On Lefranc & Cie.:

Callen, Anthea, *Artists' materials and techniques in nineteenth-century France*, PhD thesis, Courtauld Institute of Art, University of London, 1980, pp.

41ff. (on various colourmen, including Lefranc; this thesis formed the basis of the book published in 1982, cited above).

Francoeur, M., 'Rapport fait par M. Francoeur au nom du Comité des arts mécaniques sur le fabrique de couleurs et peintures de MM. Lefranc frères, rue du Four-Saint-Germain, no. 23', *Bulletin de la Société d'Encouragement pour l'Industrie Nationale*, 38, 1839, pp. 152–5.

Lefranc, A., *Notice adressée à messieurs les membres du jury de la classe 10, [Exposition Universelle 1878]*, Paris, 1878.

Pierre, L., [c. 1900], pp. 41, 47.

The house in which the firm was founded was originally occupied by the painter J.-S. Chardin: see Wildenstein, Georges, *Chardin*, Paris, 1933, pp. 48–9.

On the quality and stability of artists' colours:

Halphen, G., 1895, pp. 11–17.

Lefort, J., 1855, pp. 8–20.

Mérimée, J.-F.-L., 1830, pp. xviii–xx.

On the falsification of pigments:

Lefort, J., 1855, p. 172 (madder lakes).

Lemoine, R., and du Manoir, Ch., 1893, pp. 119ff. (adulterants listed under each group of pigments).

Pierre, L., [c. 1900], pp. 10–11 (falsification with aniline dyes).

Vibert, J.-G., 1892, pp. 58, 75–6 (aniline dyes; the addition of wax).

For extenders see the references cited below under this heading in 'Impressionism and the Modern Palette'.

For Robert's comments see Robert, K., 1878, p. 14 (quotation), and 1891, p. 78.

For Renoir's concern with craftsmanship:

Cennini, Cennino, *Le livre de l'art, ou, Traité de la peinture, mis en lumière pour la première fois . . .* traduit par Victor Mottez; nouvelle édition . . . précédé d'une lettre d'Auguste Renoir, Paris, 1911.

Renoir, J., 1962, pp. 72–3 (cited above under 'The Painter's Studio').

See also the references cited below under Cat. no. 14.

On Delacroix and Haro:

Correspondance générale d'Eugène Delacroix, publiée par André Joubin, 5 vols, Paris, 1936–8; Vols I–IV: letters; V: supplement. See index for letters to Haro; references to materials are very scarce.

Journal de Eugène Delacroix, revised edn by André Joubin, 3 vols, Paris, 1950, I, *1822–1852*; II, *1853–1856*; III, *1857–1863*; English translation by Walter Pach, New York, 1937 (1980 reprint). There are many references to Haro relining works, advising Delacroix on the purchase of a new studio (that in the rue de Furstenberg), etc. (see index).

Lethève, J., 1972, pp. 79–80 (cited above under 'Impressionist Techniques . . .').

For Delacroix's opinion of modern materials see *Journal de Eugène Delacroix*, 1950, Vol. III, entry for 11 January 1857, pp. 11–12.

Preparation of the Paint for Sale

On the grinding of pigments in general:

Halphen, G., 1895, pp. 13–15.

Pierre, L., [c. 1900], pp. 5–6; see also under individual pigments for further comments.

Riffault-Deshêtres, J.-R.-D., 1884, Vol. 1, pp. 40–1; Vol. 2, pp. 293–304 and plates.

For washing and hand-grinding of pigments:

Bouvier, P.-L., 1832, pp. 104–40.

Ducrot, A., 1858, pp. 14–18 (Note that Ducrot's description seems to be based on that of Bouvier).

For machine-grinding, see, in addition to the general references above:

Bouvier, P.-L., 1832, pp. 111–12.

Encyclopédie technologique . . . 1881, Vol. I, article on 'Broyage'.

A great many patents were taken out for grinding machines, which can be found in the *Brevets d'Invention* (see below under 'Impressionism and the Modern Palette'); for Lemoine's machines, for example, see:

Brevets d'Invention, série 1, 1791–1844, Vol. XXIV, pp. 160–1, no. 2175, 3 August 1822: 'Pour une machine propre à abreyer les couleurs, au sieur Lemoine, à Paris'; and Vol. XLV, pp. 370–1, no. 5019, 20 October 1826: 'Aux sieurs Lemoine et Meurice, à Paris, pour une machine à broyer les couleurs'.

For Hermann's machine:

'Description d'une machine à broyer les couleurs exécutée par M. Hermann, ingénieur-mécanicien, rue de Charenton, 102', *Bulletin de la Société d'Encouragement pour l'Industrie Nationale*, 38, 1839, pp. 305–7 and plate 772.

For other machines designed by Hermann, see the *Brevets d'Invention* (e.g. série 2, 1844–60, Vol. IX, pp. 199–200, and Vol. XXVI, p. 354).

For the development of paint tubes:

Harley, Rosamond D., 'Oil colour containers: development work by artists and colourmen in the nineteenth century', *Annals of Science*, 27, 1971, pp. 1–12.

On the consistency of the paint, the choice of oil and the storage of paint in bladders:

Bouvier, P.-L., 1832, pp. 84, 91–100.

Ducrot, A., 1858, pp. 17–19.

On the absorption of excess oil see Ducrot, A., 1858, p. 18.

Renoir's blotting of excess oil is mentioned by Vollard, A., 1938, pp. 216–17.

For the hand-filling of glass syringes and metal tubes see Ducrot, A., 1858, pp. 19–20.

Ducrot is one of the authors who describe tubes as being made of lead, but some manufacturers of paint tubes specified in their advertisements in the *Annuaire-Almanach du commerce* (from the late 1860s onwards) that their tubes were made of tin. Perhaps in France both lead and tin were in use for a time.

For the cost of colours in tubes see the Lefranc catalogue for 1855, p. 15.

On the regrinding of tube oil colours see Goupil-Fesquet, F.-A.-A., 1877, pp. 84, 131–2.

For other criticisms of tube oil colours, see:

Recouvreur, A., 1890, p. 86.

Gogh, Vincent van, *The complete letters of Vincent van Gogh*, 3 vols, London, 1958; Vol. III, letter no. 642 (to Theo), 17 June 1890, p. 283; see also letter T37 (from Theo to Vincent), 13 June 1890, p. 572.

For grinding colours out of doors, see, for example:

Lasalle, R. de, 1856, p. 4.

Thénot, J.-P., 1842, pp. 5–6.

For Renoir's comment on paint in tubes see Renoir, J., 1962, p. 73 (cited in full above under 'The Painter's Studio').

The Impressionists' Colour Merchants

For all general comments on individual colour merchants, see the *Annuaire-Almanach du commerce*, 1858–88.

On travelling colour merchants, see: Burty, Philippe, 'L'Atelier de Madame O'Connell', *Gazette des Beaux-Arts*, année 2, tome 5, 1860, p. 349.

On Père Tanguy:

Bernard, Emile, 'Julien Tanguy', *Mercure de France*, 16 December 1908, pp. 600–16.

Rewald, J., 1973, pp. 301, 307–8 (note 23), 556–8. (Cited in full above under 'Introduction'.)

Rewald, John, *Post Impressionism: From Van Gogh to Gaugin*, 2nd edn, New York, 1962, pp. 44–9, 78 (note 53), 460.

For comments on his products by Pissarro and others, see:

Bailly-Herzberg, J., Vol. 1, 1980, p. 32; Vol. 2, 1986, letter 427, to Lucien, pp. 172–3.

Gogh, V. van, 1958, Vol. II, letter 503 (1888), to Theo, p. 597 (on cobalt blue); Vol. III, letter 584a (1890), p. 153, from Signac to van Gogh, retracting the complaint about Tanguy's cobalt blue; letter 642, 17 June 1890, p. 283, to Theo, mentioning insipid colours.

Paul Cézanne: Correspondance, 1978; Hacker translation, 1984, letter to Tanguy dated 4 March 1878, p. 161; letter from Tanguy, reminding him of a debt, 31 August 1885, p. 221 (cited above under 'Introduction').

For Pissarro's 'zinc-based' colours see Bailly-Herzberg, J., Vol. 2, 1986, letter 500, 22 August 1888, to Lucien, p. 245.

On van Gogh's coarse-ground colours, see especially Gogh, V. van, 1958, Vol. III, letter 527, pp. 19–20; letter 541a, p. 50; letter 544, p. 62; letter 584, p. 152 (all dated 1888–9 and addressed to Theo).

For Delacroix's letter to Mme Haro see *Correspondance générale d'Eugène Delacroix*, 1936, Vol. I, letter of 29 October 1827, p. 200.

On Edouard's oil colours:

Bouvier, Joseph, *A Handbook for Oil Painting*, London, 1885; pp. 49ff.: catalogue of Lechertier, Barbe & Co., p. 56.

Fischer, Ludwig Hans, *Die Technik der Oelmalerei*, Vienna, 1898, p. 39.

For the description of hand-grinding at Mulard's see Renoir, J., 1962, p. 344.

For the purchase of colours from Moisse, see: Tabarant, A., 'Couleurs', *Bulletin de la vie artistique*, 15 July 1923; reminiscences of Moisse, quoted by J. House, 1986, note 10, p. 239; J. Rewald, 1973, p. 580 and note 61, pp. 589–90.

For Monet's letter to Bazille, 11 January 1869, see Wildenstein, D., Vol. 1, 1974, letter 46, p. 426 (cited above under 'Introduction').

On Diaz, Renoir and the *Maison* Deforge, see: André, Albert, *Renoir*, Paris, [1919] (later edn 1928), pp. 21–2.

For Monet's letter to Durand-Ruel, 19 May 1881, see Wildenstein, D., Vol. I, 1974, letter 217, p. 443.

For Bouvier's recommendation of Ange Ottoz's shop see Bouvier, P.-L., 1832, p. 121.

For the portrait of Jérôme Ottoz, see: Lemoisne, Paul-André, *Degas et son oeuvre*, 4 vols, Paris, 1946–9 (Garland reprint, New York, 1984, with a supplementary vol. by Philippe Brame and Theodore Reff); Vol. II, No. 378, pp. 202–3.

Canvases and Primings for Impressionist Paintings

A general account is given in Callen, A., 1982, pp. 59–61 (cited above under 'Introduction').

On the stretching and priming of canvases, see, for example:

Bouvier, P.-L., 1832, pp. 518–42.

Goupil-Fesquet, F.-A.-A., 1858, pp. 4–5 (cited in full under 'Impressionism and the Modern Palette'; see note on manuals).

For the quotation from Thénot see Thénot, J.-P., 1842, p. 42.

For Jean Renoir's preparation of his father's canvases see Renoir, J., 1962, p. 182 (cited above under 'The Painter's Studio').

For stretchers, sizes and formats of ready-stretched canvases, weights and weaves of canvas, primings and canvases by the roll:

Bourgeois aîné, [trade catalogue], 1888, pp. 86–8.

Lefranc & Cie., [trade catalogues], 1855–90.

(Cited in full below under 'Impressionism and the Modern Palette'.)

On standard canvas sizes:

Paillot de Montabert, J.-N., 1829, Vol. 9, pp. 144–7.

Pernety, A.-J., 1757, pp. 534–5 (cited in full above under 'The History and Development of Artists' Colourmen').

On the use of hemp canvases, see, for example, Thénot, J.-P., 1842, p. 43.

For Renoir's use of canvas by the roll see Renoir, J., 1962, pp. 344–5.

For Monet's painting of fish, mentioned in a letter to Bazille, 14 October 1864, see Wildenstein, D., Vol. I, 1974, letter 11, p. 421.

For Pissarro's canvases see Bailly-Herzberg, J., Vol. 1, 1980; letter 65, 1878, to Murer, p. 122; letter 181, 19 October 1883, to Lucien, p. 242.

On the thicknesses of canvas primings and resultant texture of the ground see Bouvier, J., 1885, pp. 7–8 (cited above under 'The Impressionists' Colour Merchants').

For Pissarro's poor quality canvas see Bailly-Herzberg, J., Vol. 2, 1986; letter 427, 25 May 1887, to Lucien, pp. 172–3.

For the colours of primings, see the trade catalogues cited above and also:

Grand dictionnaire universel . . . [compiled by] Pierre Larousse (Dictionnaire du XIX siècle), 15 vols, Paris, 1864–76, 2 supplementary vols 1878, 1890; Vol. 15, p. 258, article on 'Toiles à peindre'.

Pasteur, L., 'Obscurcissement de la peinture à l'huile'; unpublished notes from a lesson on physics and chemistry applied to the arts, given at the École des Beaux-Arts, 10 April 1865, Bulletin du Laboratoire du Musée du Louvre (supplement to the Revue des arts), June 1956, pp. 3–4.

For the canvas for Pissarro's Fox Hill (Cat. no. 4), see: Charles Roberson & Co., Professional price list of materials for drawing and painting, London [undated; probably 1850s], p. 20.

On the admixture of barium sulphate to lead white see Lefort, J., 1855, p. 59.

For the preparation and priming of canvas, see the article in the Grand dictionnaire universel, cited above.

For E. Hostellet see the Annuaire-Almanach du commerce, 1877, p. 1200.

Impressionism and the Modern Palette

This section is preceded by a list of French nineteenth-century books on paint technology and artists' manuals, concentrating on oil painting. The list makes no claim to be complete: in particular, works from the early part of the century, books of 'secrets' (mostly very early in origin) and reprints of eighteenth-century works have in general been omitted.

A number of the manuals listed below were aimed principally at the amateur painter and were on sale at colour merchants. Those marked * have contents that are, in part, closely similar, to the extent that entire sections are identical in all of them. Several (e.g. Goupil, 1877) give the impression of having been assembled from reprinted sections of other works, with perhaps some original material. Parts may be much earlier than their apparent date; this is particularly the case with the descriptions of canvases and primings, which differ little from those dating from the 1840s and earlier (e.g. Thénot). As a result, these works cannot necessarily be viewed as reliable indicators of practice in the 1860s and 70s, regardless of the date of publication. In general most of the manuals are conventional in their instructions, recommending either academic-type palettes or a range of suitable mixtures of pigments for colours (particularly greens, e.g. Robert, 1878); none could be said to describe much that resembles Impressionist practice in this respect at least.

Paint technology:

The following periodicals have been found invaluable for different aspects of paint technology and for individual pigments:

Annales de chimie, Paris, 96 vols, 1789–1815 [1st Series]; continued as Annales de chimie et de physique, 2nd series, 1816–40; 3rd, 1841–63; 4th, 1864–73; 5th, 1874–83; 6th, 1884–93; 7th, 1894–1902; 8th, 1904–13 (then another change of title; publication continues).

Brevets d'Invention, Paris: loi de 1791, série 1, 1791–1844; loi de 1844, série 2, 1844–70; new series thereafter.

Bulletin de la Société d'Encouragement pour l'Industrie Nationale, Paris, 1802–1926.

These and other periodicals are indexed in:

Garçon, Jules, Répertoire générale; ou, Dictionnaire méthodique de bibliographie des industries tinctoriales et des industries annexés, depuis les origines jusqu'à la fin de l'année 1896. Technologie et chimie, 3 vols, Paris, 1900–1. Useful, although incomplete.

Other works:

Encyclopédie technologique: Dictionnaire des arts et manufactures et de l'agriculture. Description des procédés de l'industrie française et étrangère, 5th edn, 4 vols, Paris, 1881 (1st edn, 1847); Vol. I, article on 'Couleurs materielles'.

Guignet, Charles-Ernest, Les Couleurs, Paris, 1889. A book on colour in general; very little on paint technology.

Halphen, Georges, Couleurs et vernis, Paris, 1895.

Lefort, Jules, Chimie des couleurs pour la peinture à l'eau et à l'huile, Paris, 1855.

Lemoine, Raoul, and du Manoir, Ch., Les matières premières employées en imprimerie, arts & peinture. Etude, préparation et emploi des huiles, essences, vernis et couleurs, Rouen, 1893 (later edn Paris, 1898).

Pierre, Ludovic, Renseignements sur les couleurs, vernis, huiles, essences, siccatifs et fixatifs employés dans la peinture artistique. Paris [undated; c. 1900].

Riffault-Deshêtres, Jean-René-Denis, Nouveau manuel complet du fabricant de couleurs et de vernis, par MM. Riffault, Vergnaud et Toussaint. Nouvelle edition . . . par F. Malepeyre et E. Winckler, 2 vols, Paris, Encyclopédie Roret (Manuels Roret), 1862; later edn, devoted almost exclusively to pigments, omitting varnishes, but including a short section on grinding machines, 2 vols, 1884. First published 1827, but considerably updated.

Artists' manuals, general books on painting and trade catalogues:

Arsenne, Louis-Charles, Manuel du peintre et du sculpteur, ouvrage dans lequel on traite de la philosophie de l'art et des moyens pratiques, 2 vols, Paris, Encyclopédie Roret (Manuels Roret), 1833 (later edn, 1858); see especially Vol. 2, 'Des procédés matériels', pp. 195ff.

Bourgeois aîné, Catalogue générale illustré. Fabrique de couleurs fines et materiel pour l'aquarelle, la gouache, le dessin, le modelage, la peinture à l'huile et la peinture sur porcelaine, Paris, January 1888.

Bouvier, P.-L., Manuel des jeunes artistes et amateurs en peinture, 2nd edn, Paris, 1832 (first published 1827).

Cavé, Marie-Elisabeth-Blavet, La Couleur: Ouvrage approuvé par M. Eugène Delacroix pour apprendre la peinture à l'huile et à l'aquarelle, 3rd edn, Paris [1863]. (English translation New York, 1869.) Originally published as the 2nd part of Le Dessin sans maître: Méthode pour apprendre à dessin de mémoire, Paris, 1850.

Cuyer, Edouard, Le dessin et la peinture, Paris, 1893.

* Delaire, Edouard, Traité pratique et méthodique de la peinture à l'huile, en quatre leçons, avec ou sans maître . . ., Paris, 1878. His method is based on the addition of siccatives, of undefined composition and different strengths, to the paint.

Delaistre, Louis, Cours méthodique du dessin et de la peinture, 2 vols text, 1 vol. plates, Paris, 1842.

Delécluze, Etienne-Jean, Précis d'un traité de peinture, contenant les principes du dessin, du modelé et du coloris, et leur application à la composition . . ., Paris, 1828 (reprinted 1842).

Ducrot, A., La peinture à l'huile et au pastel apprises sans maître: nouvelle méthode élémentaire et pratique accompagnée d'études ébauchées et terminées . . ., Paris, 1858.

Duroziez, A.-M., Considérations sur la peinture à l'huile, Paris, 1849. An earlier version appeared as part of Manuel du peintre à la cire, Paris, 1844. The author was well known for the preparation of oils and other materials for painting; his siccatives were particularly recommended and he appears to have been the inventor of the widely used siccatif de Harlem.

* Goupil-Fesquet, Frédéric-Auguste-Antoine, Manuel complet et simplifié de la peinture à l'huile, suivi du traité de la restauration des tableaux, Paris, 1858. Almost identical to de Lasalle (see below): same publisher and series.

* Goupil-Fesquet, Frédéric-Auguste-Antoine, Manuel général de la peinture à l'huile, précédé de considérations sur les anciennes et modernes . . ., Paris, 1877.

* Goupil-Fesquet, Frédéric-Auguste-Antoine, Traité méthodique et raisonné de la peinture à l'huile, 4th edn, Paris [1867].

Hareux, Ernest, Manuel pratique de la peinture à l'huile: [4 parts] I. Natures mortes . . .; II. Paysages, marines; III. Figures, animaux; IV. L'Art de faire un tableau, Paris, 1888–9. Also translated into English: 3rd English edn, parts I–III only, London, 1894.

* Lasalle, R. de, *Manuel complet et simplifié de la peinture à l'huile, suivi du traité de la restauration des tableaux*, Paris, 1856. Compare with Goupil-Fesquet, 1858, above.

Lefranc & Cie., *Fabrique de couleurs et vernis, toiles à peindre, carmin, laques, jaunes de chrome de Spooner, couleurs en tablettes et en pastilles, pastels et généralement tout ce qui concerne la peinture et les arts . . .* [catalogue], Paris, 1855. Other trade catalogues consulted included those for 1858 (1867 prices), 1863, 1876, 1877, 1883 and 1890.

Mérimée, J.-F.-L., *De la peinture à l'huile . . .*, Paris, 1830 (facsimile reprint, Puteaux, 1981).

Paillot de Montabert, J.-N., *Traité complet de la peinture*, 9 vols text, 1 vol. plates, Paris, 1829. See Vol. 9 for the methods and materials of painting.

Panier, Joseph, *Peinture et fabrication des couleurs: ou, Traité des diverses peintures à l'usage des personnes des deux sexes qui veulent cultiver les arts*, Paris, Encyclopédie Roret (Manuels Roret), 1856. A colour maker; for a description of his factory see the report by Dumas in *Bulletin de la Société d'Encouragement pour l'Industrie Nationale*, 40, 1841, pp. 407–9.

Recouvreur, Adrien, *Grammaire du peintre: Discussion et réglementation du procédé en peinture*, Paris, 1890.

Robert, Karl [i.e. Georges Meusnier], *Traité pratique de la peinture à l'huile*, Paris, 1878; 5th enlarged edn (subtitled *Paysage*) Paris, 1891.

Thénot, Jean-Pierre, *Essai de peinture à l'huile: ou, Manuel indispensable à toute personne qui s'occupe de ce mode de peinture*, Paris, 1842.

Vibert, Jehan-Georges, *La Science de la peinture*, 4th edn, Paris, 1891. This book derived from a course of lectures given by the author at the Ecole des Beaux-Arts: 1891 seems to be the date of the earliest edn. English translation from the 8th edn, London, 1892.

See also:

Blockx, Jacques, *Compendium à l'usage des artistes peintres et des amateurs de tableaux*, 3rd edn, Anvers, 1904 (first published 1881).

References in the text:

For Vauquelin's work on chromium, see:

Vauquelin, Louis-Nicolas, 'Mémoire sur la meilleure méthode pour décomposer le chromate de fer, obtenir l'oxide de chrome, préparer l'acide chromique, et sur quelques combinaisons de ce dernier', *Annales de chimie*, 1st Series, LXX, 1809, pp. 70–94.

On the scientific aspects of pigments:

Mérimée, J.-F.-L., 1830.

Field, George, *Chromatography: or, A Treatise on Colours and Pigments and of their Powers in Painting, Ec.*, London, 1835.

Lefort, J., 1855.

Vibert, J. G., 1891, English translation 1892; the quotation is from p. vi of the English edn. For the list of stable colours and Appendix of 'good' and 'bad' colours, see French edn, 1891, pp. 97–8 and pp. 280ff.; English edn, 1892 p. 64 and pp. 162–72. The endorsement of the colours produced by Lefranc & Cie. is at the back of the book in both French and English edns (p. 196 of the English edn.)

On traditional lake pigments and dyestuffs:

Guignet, Ch.-E., 1889, pp. 137–53 (reds); 159–63 (yellows).

Kirby, Jo, 'A Spectrometric Method for the Identification of Lake Pigment Dyestuffs', *National Gallery Technical Bulletin*, 1, 1977, pp. 35–45.

Kirby, Jo, 'The Preparation of Early Lake Pigments: A Survey', *Dyes on Historical and Archaeological Textiles*, 6, 1987, pp. 12–18.

For William Henry Perkin and mauveine:

Perkin, William Henry, 'Cantor Lectures. "On the Aniline or Coal Tar Colours"', *Journal of the Society of Arts*, 17, (1, 8 and 15 January), 1869.

Sir William Henry Perkin, CIBA Review, no. 115, June 1956, pp. 2–49.

On the preparation of artificial alizarin:

Graebe, Carl, and Lieberman, Carl, 'Uber Alizarin und Anthracen', *Berichte der Deutschen Chemischen Gesellschaft*, I, 1868, pp. 49–51.

Thomson, R. H., *Naturally occurring quinones*, 2nd edn, London, 1971, pp. 374–5.

For the effect of this discovery on the madder-growing industry, see: Dumas, M., and others, 'Fabrication artificielle des couleurs de la garance', *Bulletin de la Société d'Encouragement pour l'Industrie Nationale*, 74, 1875, p. 652.

On the impermanence of geranium lake:

Gogh, V. van, 1958, Vol. II, letters 475–6 (1888), to Theo, pp. 542–5.

Cadorin, Paolo, Veillon, Monique, and Mühlethaler, Bruno, 'Décoloration dans la couche picturale de certains tableaux de Vincent van Gogh et de Paul Gauguin', *ICOM Committee for Conservation, 8th Triennial Meeting, Sydney, Australia, 6–11 September, 1987: Preprints*; edited by Kirsten Grimstad, 3 vols, Marina del Rey, 1987, Vol. I, pp. 267–73.

For a discussion of paint tubes and paint texture, see the references above under 'Colourmen: Preparation of the Paint for Sale'.

On extenders and their role:

Halphen, G., 1895, pp. 15–16.

Lefort, J., 1855; see discussions of individual pigments for extenders, where added, e.g. p. 115, for the addition of calcium sulphate and alumina to lead chromate in watercolour paint to give body.

Lemoine, R., and du Manoir, Ch., 1893, pp. 119ff. (white pigments in general).

Riffault-Deshêtres, J.-R.-D., 1862 edn, Vol. 1, pp. 16ff. (chapter on white pigments in general), or same chapter in 1884 edn.

For comments by painters on the quality of their materials, see, for example, the references cited above under 'Colourmen: Colour Makers and Colour Merchants' for the opinions of Renoir and Delacroix; see also:

André, A., [1919], p. 22 (cited in full above under 'Colourmen: The Impressionists' Colour merchants'), for Renoir's comments on yellow pigments.

Trévise, Duc de, 1927, in Stuckey, C. F., 1985, p. 333 (cited in full above under 'The Painter's Studio'), for Monet's comments on a 'dreadful chrome'.

Vollard, A., 1938, p. 209 (cited in full above under 'Impressionist Techniques . . .'), for Renoir's dislike of Prussian blue and his comments on black.

On siccatives:

Most of the painting manuals listed above discuss the correct use of siccatives; see especially Duroziez, A.-M., 1849. For a painting method based on the use of proprietary siccatives, see E. Delaire, 1878. For a description of siccatives and oils treated to improve their drying properties see especially L. Pierre, [c. 1900], pp. 89–90, 99–103.

See also the *Brevets d'Invention*, for example: *Brevets d'Invention*, série 2, XXIV, 1844–, no. 7521, 11 November 1852, pp. 319–23, 'Au sieur Zienkowicz, à Paris: Pour des perfectionnnements apportés dans la composition et la fabrication des siccatifs employés dans la peinture'.

New Blues in the Nineteenth Century

For Prussian blue and its invention, see: Harley, Rosamond D., *Artists' Pigments c. 1600–1835: A Study in English Documentary Sources*, 2nd edn, London, 1982, pp. 70–7.

Cobalt blue:

For Thénard's research on a blue pigment containing cobalt, see: Thénard, Louis-Jacques, 'Sur les couleurs, suivies d'un procédé pour préparer une couleur bleue aussi belle que l'outremer', *Journal des Mines*, 15, 1803–4, pp. 128–36.

For methods of manufacture, see, e.g.:

Halphen, G., 1895, pp. 150–60.

Riffault-Deshêtres, J.-R.-D., 1862 edn, Vol. 1, pp. 192–6; 1884 edn, Vol. 1, pp. 309–13.

Cerulean blue:

For the date of introduction by G. Rowney & Co., see: Gettens, Rutherford J., and Stout, George L., *Painting Materials: A Short Encyclopaedia*, New York, 1942 (reprinted New York: Dover; London: Constable, 1966), p. 103.

For methods of manufacture:

Halphen, G., 1895, p. 161.

Riffault-Deshêtres, J.-R.-D., 1862 edn, Vol. 1, p. 265; 1884 edn, Vol. 1, p. 428.

For Manet's use of the pigment, see: Roy, Ashok, 'Manet's "Waitress": paint structure and analysis', in: Bomford, David, and Roy, Ashok, 'Manet's "The Waitress": An Investigation into its Origin and Development', *National Gallery Technical Bulletin*, 7, 1983, pp. 3–19; see pp. 15 and 17, notes 4 and 6.

Synthetic and natural ultramarine:

For the analysis of lapis lazuli, see: Désormes, J.-B., and Clément, F., 'Mémoire sur l'outremer', *Annales de Chimie*, 1st series, LVII, 1806, pp. 317–26.

For Vauquelin's work on a blue material from a demolished furnace, see: Vauquelin, Louis-Nicolas, 'Note sur une couleur bleue artificielle analogue à l'outremer', *Annales de Chimie*, 1st series, LXXXIX, 1814, pp. 88–91.

For the background history on the development of a process for the manufacture of synthetic ultramarine and methods of manufacture:

Mérimée, J.-F.-L., 1830, pp. 182–6.

Riffault-Deshêtres, J.-R.-D., 1862 edn, Vol. 1, pp. 206–62; 1884 edn, pp. 327–409.

For the price of natural ultramarine, see: Lefranc et Cie., [trade catalogue], 1858 (prices for 1867 handwritten), p. 7 (70 F for 30 g). The pigment continued to be available sporadically, but always at a high price.

For an outline of the composition of ultramarine, see: Plesters, Joyce, 'Ultramarine Blue, Natural and Artificial', *Studies in Conservation*, 11, 1966, pp. 62–91.

Arsenical Greens

For Scheele's green:

Harley, R. D., 1982, pp. 83–4.

Mérimée, J.-F.-L., 1830, pp. 194–7.

Riffault-Deshêtres, J.-R.-D., 1862 edn, Vol. 2, pp. 10–11; 1884 edn, Vol. 2, pp. 216–17.

Scheele, Carl William, *Collected Papers*, translated by L. Dobbin, London, 1931, pp. 53, 195–6.

Emerald green (Schweinfurt green, *vert Véronèse*):

For early methods of preparation:

Liebig, Justus von, 'Sur une couleur verte', *Annales de chimie*, 2nd series, XXIII, 1823, pp. 412–13.

Mérimée, J.-F.-L., 1830, pp. 197–200.

For other methods:

Halphen, G., 1895, pp. 191–4.

Riffault-Deshêtres J.-R.-D., 1862 edn, Vol. 2, pp. 12–13; 1884 edn, Vol. 2, pp. 218–20.

For comments on the pigment and its use:

Cuyer, E., 1893; in a discussion of pigments, pp. 270–9, the pigment is described as 'crude' in colour.

Vibert, J.-G., English translation, 1892, p. 170.

The poisonous nature of the pigment was such common knowledge that wallpapers were advertised as having been produced with 'non-arsenical greens', and the use of the pigment in cheap paint-boxes, used by children for example, was banned by the Comité Consultatif d'Hygiène in 1884; see, e.g., *Grand dictionnaire universel*, supplementary Vol. 17, 1890, p. 929.

Pigments Based on Chromium

Chromium oxide (opaque):

For Vauquelin's work on chromium chemistry and chromium oxide in particular see Vauquelin, L.-N., 1809 (cited in full above), pp. 70–80, 92–4; the quotation is from p. 93.

For its preparation:

Lefort, J., 1855, pp. 297–9.

Mérimée, J.-F.-L., 1830, pp. 188–91.

Riffault-Deshêtres, J.-R.-D., 1862 edn, Vol. 2, pp. 25–6; 1884 edn, Vol. 2, pp. 237–9.

Viridian (hydrated chromium oxide, *vert émeraude*):

For early references to the pigment:

Arsenne, L.-C., 1833, Vol. 2, p. 248.

Lefort, J., 1855, p. 300: the pigment is described as Pannetier's green, costing 140 F/kg, but no method of preparation is given.

For history and methods of preparation:

The early history of the pigment is confused; different accounts give different dates for its introduction. For a reasonable general account see Riffault-Deshêtres, J.-R.-D., 1862 edn, Vol. 2, pp. 27–31; 1884 edn, Vol. 2, pp. 240–7.

For Guignet's green in particular, see the account above and Guignet, Ch.-E., 1889, p. 188. (See also Guignet, Charles-Ernest, *Fabrications des couleurs*, Paris, 1888, pp. 149–53, which the present authors have been unable to trace.)

Chrome yellows and oranges:

Kühn, Hermann, and Curran, Mary, 'Chrome Yellow and Other Chromate Pigments', in: *Artists' Pigments: A Handbook of their History and Characteristics*, Vol. 1; edited by Robert L. Feller, Cambridge and Washington, 1986, pp. 187–217. (This book is referred to below as *Artists' Pigments . . .*, Vol. 1, 1986.)

For Vauquelin's work and lead chromate in particular see Vauquelin, L.-N., 1809, pp. 80–2, 88–92; lead chromate is described on pp. 90–1.

For conditions of precipitation and manufacture of chromate pigments:

Lefort, J., 1855, pp. 10–11, 107–9 (zinc chromate), 109–17 (lead chromate).

Riffault-Deshêtres, J.-R.-D., 1862 edn, Vol. 1, pp. 290–311; 1884 edn, Vol. 2, pp. 16–44.

On chrome yellows in van Gogh's *A Cornfield, with Cypresses*, see: Roy, Ashok, 'The materials of van Gogh's "A Cornfield, with Cypresses"', in: Leighton, John [and others], 'Vincent van Gogh's "A Cornfield, with Cypresses"', *National Gallery Technical Bulletin*, 11, 1987, pp. 50–8, especially pp. 51, 54–6.

On the permanence of chrome yellow, see, for example:

Ducrot, A., 1858, p. 8.

Goupil-Fesquet, F.-A.-A., 1877, pp. 45–6.

Lefort, J., 1855, pp. 11–17 (tables of stability of different pigments).

Vibert, J.-G., English translation 1892, p. 166.

Monet's 'dreadful chrome' is referred to above: see Stuckey, C. F., 1985, p. 333 (cited in full above under 'The Painter's Studio').

For early work on zinc and barium chromates, see, for example, the patent awarded to Leclaire and Barruel: *Brevets d'Invention*, série 2, IX, 1844–, no. 2568, 16 February 1847, pp. 230–5, 'Aux sieurs Leclaire et Barruel, à Paris: Pour des procédés de composition et de fabrication de quelques couleurs propres à la peinture'.

For chrome greens see Riffault-Deshêtres, J.-R.-D., 1862 edn, Vol. 2, p. 17; 1884 edn, Vol. 2, p. 225; see also the sections for chrome yellows and Prussian blue.

Cadmium Colours

Fiedler, Inge, and Bayard, Michael A., 'Cadmium Yellows, Oranges and Reds', in: *Artists' Pigments . . .* Vol. 1, 1986, pp. 65–108. A brief historical account is given on pp. 66–9.

Mid-nineteenth-century French sources generally describe the pigment as good but expensive, and give little account of its preparation; see, for example:

Lefort, J., 1855, p. 90.

Riffault-Deshêtres, J.-R.-D., 1862 edn, Vol. 1, p. 315; 1884 edn, Vol. 2, p. 50.

A better account is given in later works, e.g.: Halphen, G., 1895, pp. 127–31.

For Vibert's recommendation of cadmium yellow see Vibert, J.-G., English edn, 1892, pp. 167–8.

For Monet's use of the pigment in his later paintings see Fiedler, I., and Bayard, M. A., 1986, p. 104.

Pure Mauve Pigments

For cobalt arsenate, etc.:

Halphen, G., 1895, p. 164.

Lefort, J., 1855, p. 159.

Riffault-Deshêtres, J.-R.-D., 1862 edn, Vol. 1, p. 362; 1884 edn, Vol. 2, p. 117.

For manganese violet:

Halphen, G., 1895, pp. 219–20.

Lemoine, R., and du Manoir, Ch., 1893, pp. 335ff.

Riffault-Deshêtres, J.-R.-D., 1884 edn, Vol. 2, p. 151.

Zinc White versus Lead White

Zinc white:

Fleury, Paul, *The Preparation and Uses of White Zinc Paints*, London, 1912 (French edn, 1911).

Kühn, Hermann, 'Zinc White', in *Artists' Pigments . . .*, Vol. 1, 1986, pp. 169–86.

The manufacture of the pigment is described by, for example, Halphen, G., 1895, pp. 57–64 (illustrated).

For early history see also Harley, R. D., 1982, pp. 176–80.

For the merits of zinc white see also: Société Anonyme des Mines et Fonderies de Zinc de la Vielle-Montagne, *Blanc de zinc, remplaçant la ceruse*, Paris, 1855.

For Leclaire's work on zinc white:

Brevets d'Invention, série 2, VI, 1844–, no. 1348, 31 December 1845, p. 9, 'Au sieur Leclaire, à Paris: Pour le blanc de zinc'; no. 1349, pp. 9–10, 'Pour un siccatif applicable au blanc de zinc'.

Chevallier, M., 'Rapport fait par M. Chevallier, au nom du comité des arts chimiques, sur la substitution du blanc de zinc et des couleurs à base de zinc au blanc de plomb et aux couleurs à base de plomb et de cuivre, par M. Leclaire, entrepreneur de peintures, rue Saint-Georges, 11', *Bulletin de la Société d'Encouragement pour l'Industrie Nationale*, 48, 1849, pp. 15–38.

For the legislation of 1909 see Fleury, P., 1912, pp. 186–8.

For the cost of the pigment see Lefranc et Cie., [trade catalogue], 1876, p. 2.

For van Gogh's use of zinc white:

Gogh, V. van, 1958; see, e.g., Vol. II, letter 475 (1888), to Theo, pp. 542–3 (cited in full above under 'Colourmen: Preparation of the Paint for Sale').

Roy, A., 1987, pp. 51–3 (cited above under 'Chrome yellows').

For Pissarro's use of colours containing zinc, see reference above under 'The Impressionists' Colour merchants'.

Lead white:

For the different names and qualities on sale see the Lefranc catalogues for 1855, pp. 15, 17; 1863(?), pp. 18, 21; 1876, pp. 2, 4; 1883, pp. 11–12; 1858 (1867 prices, wholesale catalogue), p. 2.

On *schulpwit* and *lootwit*, see *Art in the Making: Rembrandt*; [exhibition catalogue] by David Bomford, Christopher Brown and Ashok Roy; National Gallery, 1988–9; London, 1988, pp. 21–2.

For the history and manufacture of the pigment, see, for example, Mérimée, J.-F.-L., 1830, pp. 222–36; Krems white is discussed on pp. 227ff.

For the processes of manufacture see also:

Halphen, G., 1895, pp. 29–56 (illustrated).

Riffault-Deshêtres, J.-R.-D., 1862 edn, Vol. 1, pp. 18–107; 1884 edn, Vol. 1, pp. 53–182 (very detailed).

For extenders and adulterants in lead white, see, for example:

Lefort, J., 1855, p. 56 (Lefort also gives a good account of the history and manufacture of the pigment).

Lemoine, R., and du Manoir, Ch., 1893, pp. 156–63.

For the French equivalent of Krems white, see: 'Rapport sur le prix pour la fabrication de blanc de plomb' [décerné à MM. Brechoz et Leseur], *Bulletin de la Société d'Encouragement pour l'Industrie Nationale*, 8, 1809, pp. 275–9, 295.

Vermilion

For cadmium red: the German patent (no. 63558) of 1892 is cited by Gettens, R. J., and Stout, G. L.,

1942 (1966 reprint), p. 101 (cited in full above under 'Cerulean blue').

For additives to vermilion:

Vibert, J.-G., 1891, p. 121; English edn, pp. 76–7.

White, R., 'The medium [of van Gogh's "A Cornfield, with Cypresses"]', in: Leighton, J. (and others), 1987, p. 59 (cited in full above under 'Chrome yellows').

For the history and processes of manufacture:

Lefort, J., 1855, pp. 148–58.

Riffault-Deshêtres, J.-R.-D., 1862 edn, Vol. 1, pp. 341–7; 1884 edn, Vol. 2, pp. 88–98 (full accounts, describing the after-treatments given to modify the colour).

For the varieties of vermilion for sale:

Bourgeois aîné [trade catalogue], 1888, pp. 82, 84–5.
Lefranc et Cie. [trade catalogues]; e.g., that for 1876, pp. 2–4.

Naples Yellow

Wainwright, Ian N. M., Taylor, John M., and Harley, Rosamond D., 'Lead Antimonate Yellow', in: Artists' Pigments . . ., 1986, pp. 219–54.

For Lefranc's production of Naples yellow see Lefranc, A., 1878 (referred to above under 'Colourmen: Colour makers and Colour merchants').

For Naples yellow and jaune d'antimoine see the Lefranc et Cie. catalogues, 1855–90; all list both 'jaune d'antimoine' and 'jaune de Naples'; interestingly, the wholesale catalogue of 1858 with 1867 prices lists two qualities of Naples yellow, both about one-tenth the price of 'jaune d'antimoine'.

For 'Naples yellow' as a mixture of yellows see Pierre, L., [c. 1900], pp. 10, 41.

Renoir's opinion of Naples yellow and other yellows is referred to above: see André, A. [1919], p. 22 (cited in full under 'Colourmen: The Impressionists' Colour merchants'); see also the widely quoted list of pigments, noted down by Renoir and thought to date from the Impressionist period, reproduced in, e.g., Renoir, J., 1962, plate facing p. 209 and p. 342 (cited in full above under 'The Painter's Studio').

Lake Pigments

For notes on pigment selections made by Monet, Renoir and Pissarro, mentioning lake pigments, see:

For Monet, see (i) his letter to Bazille of 11 January 1869, in: Wildenstein, D., Vol. I, 1975, letter 46, p. 426 (cited in full under 'Introduction') ('laque fine').

(ii) Rashdall, E. M., 'Claude Monet', The Artist, IX, 2 July 1888, pp. 195–7, especially p. 196; reprinted in Impressionists in England: The Critical Reception; edited by Kate Flint, London, 1984, pp. 307–8 ('laque de garance' – madder).

For Renoir, see above under 'Naples yellow' ('laque de garance').

For Pissarro, see Bailly-Herzberg, J., Vol. 2, 1986, letter to Lucien, 25 February 1887, p. 134 (interestingly, considering his palette for the Côte des Boeufs, the lake pigment he requests is a 'laque brune').

For late palettes see also:

Conversations avec Cézanne, 1978, p. 72; Emile Bernard recorded Cézanne's late palette in 1904. For a lake pigment see Paul Cézanne: correspondance, 1978; Hacker translation, 1984; letters to colour

merchants, in 1905 and 1906. The 'lake' is not identified (and 'laque' is mistranslated as 'lacquer').

Gimpel, René, Journal d'un collectionneur, marchand de tableaux, Paris, 1963, p. 89; based on Gimpel's recollections of Monet's palette in 1918. (Note: this late list does not mention a lake pigment.)

Tabarant, A., 1923, late palettes of Monet and Renoir, quoted in J. House, 1986, p. 239, note 10, and J. Rewald, 1973, pp. 589–90, note 61; the former lists the pigments said to have been used by Monet and the sources giving these details; the latter also describes the late palette of Pissarro, taken from the private notes of Louis Le Bail, which included a dark madder lake. Renoir is described as using super-fine carmine and a madder lake. The Tabarant article is cited in full above under 'The Impressionists' Colour Merchants'.

Wildenstein, D., Vol. IV, 1985; letter from Monet to Georges Durand-Ruel, 3 July 1905, letter 1780, p. 369 ('garance foncée' – madder lake deep). This is the letter in which Monet wrote that his palette consisted of 'blanc d'argent, jaune de cadmium, vermillon, garance foncée, bleu de cobalt et vert émeraude' only.

For the preparation of lakes:

Halphen, G., 1895, pp. 17–29 (general discussion); 178–96 (reds).

Lefort, J., 1855, pp. 117–25 (yellows); 164–90 (reds).

Riffault-Deshêtres, J.-R.-D., 1862 edn, Vol. 1, pp. 285–90 (yellows); pp. 364–86, 388–95 (reds); 1884 edn, Vol. 2, pp. 10–16 (yellows); 120–1 (general discussion); 122–51, 154–62 (reds).

For the varieties of lakes sold by Lefranc et Cie. see their trade catalogues, 1855–90.

For laques de Smyrne and laques de Robert, see: Péligot, M., 'Rapport fair par M. Péligot, au nom du comité des arts chimiques, sur les laques de garance de madame Gobert, rue d'Enfer', Bulletin de la Société d'Encouragement pour l'Industrie Nationale, 39, 1840, pp. 404–6.

Earth Pigments and Black

For Renoir's comment on ochres, see the note at the bottom of his list of pigments referred to above under Naples yellow (Renoir, J., 1962, p. 342).

For iron oxide pigments and black pigments in general, see, for example, Riffault-Deshêtres, J.-R.-D., 1862 edn, Vol. 1, pp. 279–83 (yellow ochres), 334–7 (red ochres), 399ff. (browns and blacks); 1884 edn, Vol. 2, pp. 2–6 (yellow ochres; 79–82 (red ochres), 168ff. (browns and blacks).

A Survey of Impressionist Paint Media

Drying oils in general:

The oils and their methods of use are discussed in many of the manuals and monographs on paint technology listed under 'Impressionism and the Modern Palette'; the books by R. Lemoine and Ch. du Manoir, 1893, and L. Pierre [c. 1900] are especially useful. See also:

Mills, John S., and White, Raymond, The Organic Chemistry of Museum Objects, London, 1987, pp. 26–40.

On the analysis of drying oils:

Mills, John S., 'The gas-chromatographic examination of paint media. Part I. Fatty acid composition and identification of dried oil films', Studies in Conservation, 11, 1966, pp. 92–106.

Mills, John S., and White, Raymond, 'Organic

Mass-Spectrometryof Art Materials: work in Progress', National Gallery Technical Bulletin, 6, 1982, pp. 3–18.

Mills, J. S., and White, R., 1987, pp. 141–6.

On the difficulty of distinguishing between walnut oil and a mixture of linseed and poppy oils, see also:

Delbourgo, Suzy, and Rioux, Jean-Paul, 'Contribution à l'étude de la matière picturale des impressionnistes', Annales du Laboratoire de Recherche des Musées de France, 1974, pp. 34–42, especially pp. 39–41.

Mills, John S., and White, Raymond, 'Analyses of Paint Media', National Gallery Technical Bulletin, 3, 1979, pp. 66–7, especially note 10, p. 66, on the analysis of samples from Manet's The Execution of Maximilian [Fragments]; 4, 1980, pp. 65–7, especially note 10, p. 66, on Monet's Bathers at La Grenouillère (see also note at the end of the bibliography to this section); 7, 1983, pp. 65–7, especially note 7, p. 67, on Manet's The Waitress.

On the expressing and purification of oils:

Encyclopédie technologique . . . 5th edn, 1881, Vol. II, article on 'Huiles' (cited in full above under 'Impressionism and the Modern Palette').

Julia de Fontenelle, Jean-Sebastian-Eugène, Manuel du fabricant et de l'épurateur d'huiles, 2nd edn, Paris, Encyclopédie Roret (Manuels Roret), 1836. (First published 1828, later enlarged edns 1866, 1880, 1902.)

Lemoine, R., and du Manoir, Ch., 1893, pp. 6–41.

Romain, Adolphe, Nouveau manuel complet du fabricant de vernis, Paris, Encyclopédie Roret (Manuels Roret), 1888 (mostly on varnishes; a little on oils).

For possible adulterants see Lemoine and du Manoir and also: Beauvisage, Georges, Les matières grasses: caractères, falsifications et essai des huiles, beurres, graisses, suifs et cires, Paris, 1891 (section on oils).

On the prices of oils see Lefranc et Cie. [trade catalogues], 1855–90, particularly 1876, p. 6; 1883, p. 21.

For modifications and additions to the paint medium during the nineteenth century, see the Brevets d'Invention. It should be said that, of the modifications to paint media patented, a great many were made in the attempt to improve the properties of drying oils by the use of different metal salts as driers; to counteract damp, affecting mural painting or interior decorating; or to reduce the amount of oil present and thus reduce darkening of the paint. Before the 1880s at least, there is little reference to materials being added to improve or alter paint consistency; it could well be that modifications of this sort were unpublished 'trade secrets'. Examples of the patents that were taken out include:

Brevets d'Invention, série 2, (1844–), XXXI, pp. 141–2, no. 9455, 19 December 1853: 'Au sieur Haro, à Paris. Pour un système de préparation des couleurs qui les rend fixes et ingerçables, en leur conservant tout l'éclat et la fraîcheur désirables'. Materials incorporated with the oil included neats-foot oil and wax; the aim was to prevent colours changing. This, or a similar process, may have been the 'procédé Haro' that Delacroix went to judge at Saint-Eustache, on 26 February 1850 (see Journal de Eugène Delacroix, 1950, Vol. I, p. 345); unfortunately he was too intrigued by an architectural matter to comment on the process.

Brevets d'Invention, série 2, (1844–), LVII, pp. 425–6, no. 16766, 13 October 1856: 'Au sieur Dorange, à

Joigny (Yonne). Pour des perfectionnements dans la préparation et la composition des couleurs, enduits, mastics.' On avoiding the use of turpentine and similar diluents, largely because of their smell.

For the presence of resin in the medium of one of Monet's Rouen Cathedral paintings see Delbourgo, S., and Rioux, J.-P., 1974, p. 40.

For prepolymerised or stand oils see Mills, J. S., and White, R., 1987, pp. 34–5.

On the presence of wax in the paint medium see Mills, J. S., and White, R., 1987, pp. 45–6, 146.

On gums and their analysis see Mills, J. S., and White, R., 1987, pp. 66–9.

Note to Table on page 74 of the results of analysis of samples from Monet's *Bathers at La Grenouillère* (Cat. no. 2):

These results were originally reported in the *National Gallery Technical Bulletin*, 4, 1980, p. 67, note 10, as containing walnut oil or poppy oil or a mixture. In the present study, to avoid ambiguity, particular care was taken to ensure that the paint layer and the ground were sampled separately; poppy oil was thus found to be the medium of the paint layer, while the ground was found to contain linseed oil.

Nineteenth-Century Colour Theory

The most useful general accounts, covering all the topics discussed, are:

Kemp, Martin, *The Science of Art: Optical Themes in Western Art from Brunelleschi to Seurat*, New Haven and London, 1990; Part III, chapter VI, pp. 280–4, and chapter VII, especially pp. 285–92, 294–8, 306–16.

Sherman, Paul D., *Colour Vision in the Nineteenth Century: the Young–Helmholtz–Maxwell Theory*, Bristol, 1981.

See also:

Homer, William Innes, *Seurat and the Science of Painting*, Cambridge, Mass., 1964 (1978 reprint), pp. 20–53 (for the work of M.-E. Chevreul and Charles Blanc, and also Ogden Rood, who is outside the scope of the present discussion).

McLaren, Keith, *The Colour Science of Dyes and Pigments*, Bristol, 1983, pp. 63–73, 94–6.

Padgham, Charles A., and Saunders, John E., *The Perception of Light and Colour*, London, 1975, pp. 61–5, 67–74, 78–82.

Taylor, J. C., 1987, pp. 448–79 (extracts from the works of M.-E. Chevreul and Charles Blanc; cited in full above under 'Introduction').

See also the references cited below under 'Impressionist Use of Colour: Primary and Complementary colours'.

For Newton's work:

'A Letter of Mr. Isaac Newton . . . containing his New Theory about Light and Colours', *Philosophical Transactions of the Royal Society*, VI (1671), no. 80, 1671–2, pp. 3075–87.

Newton, Isaac, *Opticks; or, A Treatise of the Reflexions, Refractions, Inflexions and Colours of Light*, London, 1704 (Dover reprint, New York, 1952).

For other seventeenth-century writers on the three primary colours, see Kemp, M., 1990, pp. 281–2, Sherman, P. D., 1981, pp. 60–1, and also:

Boyle, Robert, *Experiments and Considerations Touching Colours*, London, 1664, pp. 219–20.

Félibien, André, *Entretiens sur les vies et sur les ouvrages des plus excellens peintres anciens et modernes*, 3 vols, Paris, 1666–79, Vol. III, 1679, pp. 27–8.

Félibien, André, *Des principes de l'architecture, de la sculpture, de la peinture et des autres arts qui en dépendent* . . . 3rd edn, Paris, 1697; Book III, p. 311 (on mixing colours in enamels 'like the painters do').

For research on trichromatic theories and colour vision up to the mid-nineteenth century:

Lang, Heinwig, 'Trichromatic Theories Before Young', *Color Research and Application*, 8, 4, 1983, pp. 221–31.

McLaren, K., 1983, pp. 63–5.

Sherman, P. D., 1981, especially pp. 1–19 for Young and Wollaston (the following chapter, pp. 20ff., discusses Brewster's work, which is also of interest); pp. 60ff. for research on the primary colours.

Wollaston, William Hyde, 'A Method of examining refractive and dispersive powers by prismatic reflection', *Philosophical Transactions of the Royal Society*, XCII, 1802, pp. 265ff.

Young, Thomas, 'On the Theory of Light and Colours' [Bakerian Lecture, November 1801], *Philosophical Transactions of the Royal Society*, XCII, 1802, pp. 12ff.

Young, Thomas, 'An Account of some cases of the production of colours not hitherto described', *Philosophical Transactions of the Royal Society*, XCII, 1802, pp. 387ff.

On LeBlon and his work:

Birren, Faber, 'J. C. LeBlon, Discoverer and Developer of the Red-Yellow-Blue Principle of Color Printing and Color Mixture', *Color Research and Application*, 6, 2, 1981, pp. 85–92.

LeBlon, Jakob Christophe, *Coloritto; or, The Harmony of Colour in Painting*, London and Paris [1756]. In English and French; see especially pp. 6–9.

On Helmholtz and his work:

Helmholtz, Hermann von, 'On Sir David Brewster's new analysis of solar light', English translation, *Philosophical Magazine*, 4th series, IV, no. XXVII, 1852, pp. 401–16.

Helmholtz, Hermann von, 'On the theory of compound colours', English translation, *Philosophical Magazine*, 4th series, IV, no. XXVIII, 1852, pp. 519–34.

Holmholtz, Hermann von, *Physiological Optics*, English translation of 3rd German edn, Hamburg and Leipzig, 1911, New York, 1924 (first published 1866).

Sherman, P. D., 1981, pp. 43–56 (on colour vision); 81–92, 111–15 (on primary colours; see also the discussion on Grassmann, pp. 93ff.).

On Maxwell and his work see Sherman, P. D., 1981, pp. 153ff. and also: Maxwell, James Clerk, 'Experiments on colour as perceived by the eye, with remarks on colour blindness', in *The Scientific Papers of James Clerk Maxwell*, edited by W. D. Niven, 2 vols, Cambridge, 1890, Vol. 1, pp. 126–54. See also 'On the theory of colours', pp. 119–25. Both give accounts of the spinning top experiments.

The definition of additive and subractive primary colours is taken from McLaren, K., 1983, pp. 65–6.

On de Buffon's 'accidental colours':

Buffon, Comte de, 'Sur les couleurs accidentales', *Mémoires de l'Académie Royale des Sciences*, 1743, H, pp. 1–8, M, pp. 147–58, especially p. 157.

Chevreul, Michel-Eugène, *De la loi du contraste simultané des couleurs, et de l'assortiment des objets colorés*, 2 vols (text and plates), Paris, 1839; English translation by Charles Martel, *The Principles of Harmony and Contrast of Colours, and their Applications to the Arts*, London, 1854, 3rd edn, 1859 (1887 reprint). For de Buffon's work see (120–2) pp. 58–9, or pp. 37–8 in the 1887 reprint.

Encyclopédie; ou, Dictionnaire raisonné . . ., 1751–67, Vol. 4, article on 'Couleur' (cited in full under 'Colourmen').

On early colour classification schemes:

Kemp, M., 1990, pp. 286–92.

Parkhurst, Charles, and Feller, Robert L., 'Who Invented the Color Wheel?', *Color Research and Application*, 7, 3, 1982, pp. 217–30.

Sherman, P. D., 1981, pp. 60–80.

For Bourgeois's work:

Bourgeois, Charles-Guillaume-Alexandre, *Mémoire sur les lois que suivent leurs combinaisons entre elles . . . les couleurs*, Paris, 1812.

Bourgeois, Charles-Guillaume-Alexandre, *Manuel d'optique expérimental, à l'usage des artistes et des physiciens*, 2 vols (text and plates), Paris, 1821.

For Prieur's work on colour, see:

Prieur, C.-A., 'Considérations sur les couleurs, et sur plusieurs de leurs apparences singulières', *Annales de Chimie*, 1st series, LIV, [1805], pp. 5–27.

For the work of Grégoire, see:

Grégoire, Gaspard, *Théorie des couleurs, contenant explication de la table des couleurs . . .*, 2 vols (text and illustrations), Paris, [no date, c. 1820?]. For complementary colours see pp. 51–2.

Work on complementary colours in decoration, such as that of Grégoire and Chevreul, was greatly developed later in the century by A. Rosenstiehl and others, but is outside the scope of the present discussion.

For Chevreul and his work:

Chevreul, Michel-Eugène, 'Mémoire sur l'influence que deux couleurs peuvent avoir l'une sur l'autre quand on les voit simultanément', *Mémoires de l'Académie Royale des Sciences*, 11, 1828, pp. 99, 447–520 (and given as a public lecture, Paris, 1828).

Chevreul, M.-E., 1839 (cited above); the book was reprinted in 1889.

Guignet, Ch.-E., 1889, pp. 95–133 (cited in full under 'Impressionism and the Modern Palette'). (A good account: Guignet taught Chevreul's course at the Museum of Natural History, Paris, from 1884–9.)

Taylor, J. C., 1987, pp. 448–66.

For Chevreul's law of simultaneous contrast see Chevreul, M.-E., 1839, (8)–(16) pp. 7–14; English translation, 1887 reprint, pp. 7–11. For applications see (323)ff., pp. 189–276; English edn, 1887 reprint, pp. 123–38.

For Scherffer's work:

Chevreul, M.-E., 1839, (123) pp. 59–60, 133–40 pp. 68–76; English edn, 1887 reprint, pp. 38, 43–7.

Guignet, Ch.-E., 1889, pp. 96–7, 105.

For successive contrast and mixed contrast see Chevreul, M.-E., 1839, (79) p. 49, (81)ff. pp. 50–7; English edn, 1887 reprint, pp. 32–7.

For Chevreul's colour diagram, circles and scales:

Chevreul, M.-E., 1839, (156)ff. pp. 87–105 and plate 4; English edn, 1887 reprint, pp. 56–67 and plate 2.

Chevreul, Michel-Eugène, *Des couleurs et leurs applications aux arts industriels à l'aide des cercles chromatiques*, Paris, 1864.

For Digeon's method of printing these circles see: Salvetat, M., 'Rapport fait par M. Salvetat, au nom de la commission des beaux-arts appliqués à

l'industrie, sur les procédés de gravure et de l'impression présentés par M. Digeon, rue Galande 65', *Bulletin de la Société d'Encouragement pour l'Industrie Nationale*, 57, 1858, pp. 257–61.

For their use by colour makers see Riffault-Deshêtres, J.-R.-D., 1862, Vol. 1, p. 5; this leads on to a discussion of Chevreul's work and the contrast of colours, pp. 5–10 (cited in full under 'Impressionism and the Modern Palette').

For the discussion of colour in early nineteenth-century treatises;

Delaistre, L., 1842, Vol. 2, pp. 431–6 and Vol. 3, plate 10, figs. 1, 2, and 4.

Mérimée, J.-F.-L., 1830, pp. 269–98.

Paillot de Montabert, J.-N., 1829, Vol. VII, pp. 361ff., especially pp. 366–97. Bourgeois's work is discussed on pp. 368ff.

See also, for example:

Arsenne, L.-C., 1833, Vol. 2, pp. 140–60.

Delécluze, E.-J., 1828, chap. 3.

For Delacroix:

Blanc, Charles, *Les Artistes de mon temps*, Paris, 1876, pp. 23–88; for Blanc's analysis of Delacroix's colour and some general comments see pp. 62ff.

Delacroix, Eugène, *Oeuvres littéraires*, 2 vols, Paris, 1923; Vol. 1, pp. 71–4: Delacroix's notes on colour, made at Dieppe in 1854, first published by Piron (q.v.). The comment on the colours of shadows and reflections in the sea is on p. 71.

Johnson, Lee, *Delacroix*, London, 1963, especially pp. 7–8, 62–77, 103–4, 114–15; based on his unpublished PhD thesis, *Colour in Delacroix: Theory and Practice*, Cambridge, 1958.

Journal de Eugène Delacroix, 1950; for the statement on the colours of reflections and shadows, 'Tout reflet participe du vert, tout bord de l'ombre, du violet', see Vol. III, entry for 13 January 1857, p. 14. The comments that earth colours should be banned and that grey is the enemy of all painting occur in the same entry, p. 16. In the English translation, 1980, see pp. 535–7.

Piron, Achille, *Eugène Delacroix, sa vie et ses oeuvres*, Paris, 1865, pp. 416–18. The book was not distributed until 1868 and had a limited circulation among Delacroix's friends only. It was reprinted in 1923 in *Oeuvres littéraires* (see above).

Silvestre, Théophile, *Eugène Delacroix: Documents nouveaux*, Paris, 1864, pp. 16–17.

For Delacroix and the Impressionists see, for example:

Bailly-Herzberg, J., Vol. 2, 1986, letter 424, 16 May 1887, to Lucien, p. 169; Pissarro refers to the Saint-Sulpice decorations.

House, J., 1986, pp. 110–11 (cited in full above under 'Introduction').

For Mme Cavé, see Cavé, M.-E., 3rd edn, [1863] (cited in full above under 'Impressionism and the Modern Palette'); the quotation is taken from p. 71.

For Blanc's writings on colour:

Blanc, C., 1876, pp. 62ff.

Blanc, Charles, *Grammaire des arts du dessin: Architecture, sculpture, peinture*, Paris, 1867, pp. 594–610.

Homer, W. I., 1964, pp. 29–36.

Taylor, J., 1987, pp. 467–79.

For Couture's approach to colour:

Bertauts-Couture, G., 1932, pp. 108ff., 211–12, 229–32.

Boime, A., 1980, pp. 451–4.

Couture, T., 1867, pp. 2–34, 212ff.

Couture, T., 1869, p. 76.

All cited in full under 'Impressionist Techniques: Tradition and Innovation'.

For Goupil-Fesquet's discussion of colour see Goupil-Fesquet, F.-A.-A., 1877, pp. 127–30; the use of Chevreul's circles is suggested on p. 128.

For discussions of colour in other painting manuals and texts in the second half of the nineteenth century, see also, for example:

Bracquemond, Joseph-Félix, *Du dessin et de la couleur*, Paris, 1885. A general discussion of colour, defining terms and including a little colour theory (see, for example, pp. 141, 144–6, 241–5). The author was a painter and a friend of the Impressionists, exhibiting with them at the 1st Impressionist Exhibition in 1874; some of his comments can be seen to be reflected in their practice.

Cuyer, E., 1893, pp. 259–69.

Delaire, E., 1878, pp. 49–51.

Hareux, E., 1888–9, part I, p. 36; part IV, pp. 49–50, 55.

Vibert, J.-G., 1891, pp. 15–69; English edn, 1892, pp. 17–47.

(All are cited in full above under 'Impressionism and the Modern Palette').

Impressionist Use of Colour

For a general discussion see Homer, W. I., 1964, pp. 51–65 (cited in full under 'Nineteenth-century colour theory').

See also Bracquemond, J.-F., 1885, cited above.

The Myth and Reality of Impressionist Colour

For Monet's remark to Lilla Cabot Perry, see: Perry, Lilla Cabot, 'Reminiscences of Claude Monet, 1889–1909', *American Magazine of Art*, March 1927, pp. 119–25; reprinted in Stuckey, C. F., 1985, pp. 181–95: the quotation is on p. 183.

For Webster's analysis of Impressionist technique, see: Webster, J. Carson, 'The Technique of Impressionism: A Reappraisal', *College Art Journal*, IV, 1, 1944, pp. 3–22.

For the quotation from Edmond Duranty, see: Duranty, Louis-Emile-Edmond, *La Nouvelle peinture: A propos du groupe d'artistes qui expose dans les galeries Durand-Ruel*, Paris, 1876, reprinted in *Les Ecrivains devant l'impressionnisme*, 1989, pp. 108–34; the quotation is taken from pp. 121–2. For an English translation see *The New Painting: Impressionism 1874–1886*, 1986, pp. 37–47, especially pp. 42–3. (Both books cited in full under 'Introduction'.)

For the quotation from Jules Laforgue, see: Laforgue, Jules, *L'Impressionnisme* [review of an exhibition at the Gurlitt Gallery, Berlin, 1883], first published in *Mélanges posthumes. Oeuvres complètes*, Vol. 3, Paris, 1903, reprinted in *Les Ecrivains devant l'impressionnisme*, 1989, pp. 333–41; the quotation is from p. 336. For an English translation see 'Impressionism: The Eye and the Poet', *Art News*, LV, May 1956, pp. 43–5, reprinted in Nochlin, Linda, *Impressioinism and Post-Impressionism 1874–1904: Sources and Documents*, Englewood Cliffs, 1966, pp. 14–20, especially pp. 16–17.

Primary and Complementary Colours

For a general, non-technical treatment of the aspects of colour discussed in the text see:

Osborne, Roy, *Lights and Pigments: Colour Principles for Artists*, London, 1980.

Rossotti, Hazel, *Colour*, Harmondsworth, 1983.

See also the references cited under 'Nineteenth-Century Colour Theory' above.

For Goethe's summary description of retinal fatigue, see: Goethe, Johann Wolfgang von, *[Zur Farbenlehre] Theory of Colours*; translated from the German with notes by Charles Lock Eastlake, Cambridge, Mass., and London, 1970 (1978 reprint), p. 25. (This edn first published London, 1840, original edn published in Tübingen, 1810.)

For Delacroix's description of the boy climbing a fountain see *Journal de Eugène Delacroix*, 1950, entry for 7 September 1856, Vol. II, pp. 465–6.

For Goethe's description of a sunset see Goethe, J. W. von, 1970, pp. 34–5.

For Antonin Proust's recollection of Manet's description of the shadows of a cedar see Proust, A., 1913, p. 40 (cited in full under 'Impressionist Techniques . . .'), quoted in Herbert, R. L., 1988, p. 36 (cited in full under 'Introduction').

For a general discussion of the contemporary view of the Impressionists' colour see: Reuterswärd, Oscar, 'The "Violettomania" of the Impressionists', *Journal of Aesthetics and Art Criticism*, IX, 2, 1950, pp. 106–10. For the quotation from Théodore Duret see *Les Peintres impressionnistes*, Paris, 1878, reprinted in *Les Ecrivains devant l'impressionnisme*, 1989, pp. 209–24; the quotation is on p. 216 (translated in Stuckey, C. F., 1985, p. 66). The quotation from Albert Wolff first appeared in an article in *Le Figaro*, 3 April 1876, quoted in Rewald, J., 1973, pp. 368–9.

For Huysmans' views, see: Huysmans, Joris-Karl, 'L'Exposition des Indépendants en 1880', in *L'Art moderne*, Paris, 1883, pp. 85–123, reprinted in *Les Ecrivains devant l'impressionnisme*, 1989, pp. 252–76; see especially p. 255.

For Pissarro's letter to Lucien, 9 May 1883, see Bailly-Herzberg, J., Vol. 1, 1980, letter 145, pp. 203–4. See also letter 146, also dated 9 May 1883, from Pissarro to Huysmans.

Colour Contrasts

For Chevreul's laws of simultaneous, successive and mixed contrast see Chevreul, M.-E., 1839, or Martel's English translation, 1854 (often reprinted), all cited above under 'Nineteenth-century Colour Theory'.

For Monet's use of complementary contrasts see Rashdall, E. M., 1888, in *Impressionists in England . . .*, 1984, pp. 305–9; the quotation is from p. 307 (cited in full above under 'Lake Pigments').

Impressionist practice

For Bouvier's palette and traditional painting practice see Bouvier, P.-L., 1832, pp. 207–31, 275ff., 616–18 and Plate VII (cited in full above under 'Impressionism and the Modern Palette'; see also references under 'Impressionist Techniques: Tradition and Innovation').

For Delacroix's palette for Saint-Sulpice, see: Piot, René, *Les Palettes de Delacroix*, Paris, 1931, pp. 96–8. Notes on Delacroix's palettes were taken from his student and assistant Pierre Andrieu and first published in 1876 by Alfred Bruyas and Théophile Silvestre.

For colour in Impressionist paintings see particularly:

House, J., 1986, especially pp. 109–33.

Shiff, R., 1984, especially part 2, pp. 70–123, and part 3, pp. 199–219.

Shiff, Richard, *Impressionist Criticism, Impressionist Color and Cézanne*, PhD dissertation, Yale University, 1973, University Microfilms, Ann Arbor, 1976.

For Monet's use of a white canvas see Trévise, Duc de, 1927, in Stuckey, C. F., 1985, pp. 318–41; quotation from p. 333 (cited in full above under 'The Painter's Studio').

For Cézanne's statement on Pissarro's use of earth colours, see: Gasquet, Joachim, *Cézanne*, Paris, 1921, p. 90; apparently Pissarro's advice had been to paint only with the three primary colours and their immediate derivatives. The 1865 date may derive from the article by Georges Lecomte, 'Camille Pissarro', *Les Hommes d'aujourd'hui*, 8, no. 366, 1890. See Shiff, R., 1984, pp. 204–6 and notes 23 and 24, pp. 299–300.

For Pissarro's *The Artist's Palette with a Landscape* (Sterling and Francine Clark Art Institute, Williamstown) see Shiff, R., 1984, p. 207 and note 25, p. 300, for analysis of the pigments present.

The Paint Layers and Surface of Impressionist Paintings

A good general account is given in House, J., 1986; see especially chapters 4, 5, 9, 10 and 11, pp. 63ff.

For Monet's practice of working on several canvases at once see Perry, L. Cabot, 1927, in Stuckey, C. F., 1985, pp. 181–95, quotation from pp. 184 and 193 (cited in full under 'Introduction').

For Monet's painting of Etretat see Perry, L. Cabot, 1927, in Stuckey, C. F., 1985, p. 181.

On Manet's painting 'par larges taches', see: Zola, Emile, *Mon Salon*, Paris, 1866, in *Mes Haines: causeries littéraires et artistiques*, Paris, 1923, p. 293 (this work has been reprinted many times, most recently as *Mon Salon; Manet; Écrits sur l'art*, edited by A. Ehrard, Paris, 1970).

On the *tache* in Impressionist painting see *Conversations avec Cézanne*, 1978, the term is referred to by Emile Bernard, see note 20, pp. 192–3 (cited in full under 'Introduction').

For Théophile Gautier's criticism of Daubigny, see: Moreau-Nélaton, Etienne, *Daubigny raconté par lui-même*, Paris, 1925, p. 81 (see also House, J., 1986, p. 75 and note 6, p. 238).

For Bracquemond's discussion of the *tache* see Bracquemond, J.-F., 1885, pp. 42–3 (cited in full under 'Nineteenth-century Colour Theory').

Compare the broad handling of the paint by *taches* and the resultant surface texture with the smooth finish given to paintings in traditional practice by the use of the soft, broad *blaireau*, which was drawn lightly over the wet paint to merge or 'marry' the brushstrokes and the tones; see, for example, Bouvier, P.-L., 1832, pp. 467–73, 609 and plate V, and Panier, J., 1856, p. 19 (both cited in full under 'Impressionism and the Modern Palette').

For artists' brushes, see: Harley, Rosamond D., 'Artists' Brushes – Historical Evidence from the Sixteenth to the Nineteenth Century,' in *Conservation and Restoration of Pictorial Art*; edited by Norman Brommelle and Perry Smith, London, 1976 (proceedings of the Lisbon Congress of the International Institute for Conservation of Historic and Artistic Works, 1972), pp. 61–6, especially pp. 64–6.

For Monet's long-handled brushes see Perry, L. Cabot, 1927, in Stuckey, C. F., 1985, p. 184.

Pissarro was certainly particular about his brushes: see, for example, Bailly-Herzberg, J., Vol. 2, 1986, letters 454, 457 and 459, to Lucien, 24 September, 4 October and 8 October 1887, pp. 201–2 and 203–6. Pissarro had asked for a dozen no. 8 sable brushes, 'demi-longue'; when they arrived he found them to be shorter than those he had had before, which he described as 'very tiresome'.

On Monet's preoccupation with the texture of his paint surfaces see Perry, L. Cabot, 1927, in Stuckey, C. F., 1985, p. 184.

For Sisley's letter on the animation of the paint surface, see: Tavernier, A., 'Sisley', *L'Art français*, 18 March 1893, partly translated in *Artists on Art*; edited by R. Goldwater and M. Treves, New York and London, 1947, p. 194; reprinted in *The Impressionists at First Hand*; edited by Bernard Denvir, London, 1987, pp. 122–3.

For the views of contemporary critics on the Impressionists' brushwork, see: Reuterswärd, Oscar, 'The Accentuated Brushstroke of the Impressionists: The Debate Concerning Decomposition in Impressionism', *Journal of Aesthetics and Art Criticism*, X, 3, March 1952, pp. 273–8. For the Huysmans comment see Huysmans, Joris-Karl, 'L'Exposition des Indépendants en 1881', in *L'Art moderne*, Paris, 1883, reprinted in *Les Ecrivains devant l'impressionnisme*, 1989, pp. 277–97, quotation on p. 283 (cited in full under 'Introduction'). The review by Ernest Chesneau, which first appeared in *Paris-Journal*, 7 May 1874, p. 2, is reprinted in the same collection, pp. 61–70, quotation from p. 65; for translation see Stuckey, C. F., 1986, p. 59.

For the 'comma-like brushstroke' of Monet and Renoir see Rewald, J., 1973, p. 281.

For the quotation on Monet's range of brushstrokes see House, J., 1986, p. 76.

For Cézanne's 'constructive stroke', see: Reff, Theodore, 'Cézanne's Constructive Stroke', *Art Quarterly*, XXV, 1962, pp. 214–27.

For Fauré's complaint about a painting see House, J., 1986, p. 164 and notes 55 and 56, p. 242.

For Lilla Cabot Perry's description of Monet's first lay-in of a painting see Perry, L. Cabot, 1927, in Stuckey, C. F., 1986, p. 183.

For Pissarro's advice to Louis Le Bail see Rewald, J. 1973, pp. 456–8 and note 31, p. 479. The advice was received by Le Bail in 1896–7.

For Carolus-Duran's technique, see: Stevenson, R. A. M., *Velazquez*, London, 1900, pp. 107–8 (reprinted in *The Impressionists at First Hand*, 1987, pp. 89–90).

The Appearance, Condition and Framing of Impressionist Paintings

Bruce-Gardner, Robert, Hedley, Gerry, and Villers, Caroline, 'Impressions of Change', in *Impressionist & Post-Impressionist Masterpieces . . .*, 1987, pp. 21–34 (cited in full under 'Introduction').

For Degas's approval of the 'Italian' method of picture lining see Vollard, A., 1938, p. 124 (cited in full above under 'Impressionist Techniques: Tradition and Innovation').

For the lining of the fragments of Manet's *Execution of Maximilian* see Davies, M., 1970, pp. 97–8.

For the lining of Manet's *The Waitress* and its relationship with *Au Café* (Reinhardt Collection, Winterthur), see: Bomford, David, 'Examination of two café scenes by Manet', in Bomford, D., and

Roy, A., 1983, pp. 3–13 (cited above under 'Impressionism and the Modern Palette').

For the use of wax and wax-resin adhesives in picture lining, see: Bomford, David, and Staniforth, Sarah, 'Wax-Resin Lining and Colour Change: An Evaluation', *National Gallery Technical Bulletin*, 5, 1981, pp. 58–65.

For Durand-Ruel's need to varnish Impressionist paintings see Gimpel, R., 1963, p. 156 (cited in full under 'Impressionism and the Modern Palette: Lake Pigments').

For Pissarro's letter to Murer, 1878, mentioning the use of a colourless varnish on a painting see Bailly-Herzberg, J., Vol. 1, 1980, letter 54, pp. 110–11.

Pissarro exhibited paintings under glass at the 6th and 7th Impressionist exhibitions of 1881 and 1882. The matt, unvarnished surface was said to have 'a velvety tone with a charming effect' by the critic Gonzague-Privat in 'L'Exposition des artistes indépendants', *L'Evénement*, 5 April 1881, quoted in Cahn, I., 1989, note 51, p. 85 (cited in full below). See also Huysmans, J.-K., 'L'Exposition des Indépendants en 1881: [Les cadres]', in *Les Ecrivains devant l'impressionnisme*, 1989, p. 293 (this reference is given above under 'The Paint Layers and Surface of Impressionist Paintings').

On the framing of pictures during the nineteenth century, see: Cahn, Isabelle, *Cadres de peintures*, Paris, 1989 (referred to below as Cahn, I., 1989 (i).)

For the Impressionists' frames in particular:

Cahn, Isabelle, 'Les cadres impressionnistes', *La Revue de l'art*, 76, 1987, pp. 57–9. (This issue of the journal is devoted to frames in general.)

Cahn, Isabelle, 'Degas's Frames', *The Burlington Magazine*, CXXXI, 1989, pp. 289–92.

For the Caillebotte bequest:

Bazin, Germain, *Impressionist Paintings in the Louvre*, 3rd edn, London, 1961, pp. 44–9.

Rewald, J., 1973, pp. 383–90, 570–2.

For Pissarro's opinion of the exhibition of the paintings see Bailly-Herzberg, J., Vol. 4, 1989, letters 1373 and 1378, to Lucien, 18 February and 10 March 1897, pp. 328–9, 333–5.

For white frames see Cahn, I, 1989 (i), pp. 65–8.

For Pissarro's use of white frames and Paul Durand-Ruel's opposition see Bailly-Herzberg, J., Vol. 1, 1980, letter 120, to Lucien, 28 February 1883, pp. 177–8 (see also note 3); and letters 141 and 148, also to Lucien, 24 April and 13 May 1883, pp. 198–9 and 206–7. The quotation describing the hanging of Pissarro's one-man show in 1883 is from p. 206.

For Chevreul's work with coloured borders see Chevreul, M.-E., 1839, (564–72), pp. 354–61; English edn, 1887 reprint, pp. 231–5.

For the use of coloured frames by the Impressionists:

Cahn, I., 1989 (i), pp. 69–70 and notes 68–9, p. 86.

Huysmans, J.-K., 1883, in *Les Ecrivains devant l'impressionnisme*, 1989, pp. 292–4.

For Pissarro's letter to Esther, 12 December 1885, see Bailly-Herzberg, J., Vol. 1, 1980, letter 300, pp. 359–63; in a postscript he says he will send her the colour all prepared although he does 'not understand why you are using this orange – there is hardly any blue in the picture'.

For the frame of Caillebotte's painting of *Richard Gallo and his Dog Dick at Petit-Gennevilliers* see Cahn, I., 1989 (i), p. 70 and plate 7.

For the use of dark wood frames see Hareux, E., 1888–9, part IV, p. 61 (cited above under 'Impressionism and the Modern Palette').

For Renoir's liking of gold frames see Renoir, J., 1962, pp. 244, 345 (cited in full under 'The Painter's Studio').

For Monet's frames:

House, J., 1986, pp. 180–1, 215 (gold frames).

Wildenstein, D., Vol. III, 1979, letters 1104, 13 April 1891, and 1138, 9 March 1892, both to Paul Durand-Ruel, pp. 261, 264 (white frames).

Dealers, Galleries and the Exhibition of Pictures

House, John, 'Impressionism and its contexts', in *Impressionist & Post-Impressionist Masterpieces*, 1987, pp. 14–20 (cited in full above under 'Introduction').

Lethève, J., 1972, pp. 108ff. (cited in full under 'Impressionist Techniques: Tradition and Innovation').

Rewald, J., 1973 (cited in full under 'Introduction').

White, H. C., and White, C. A., 1965, particularly pp. 94–100, 106–8, 124–9, 140ff. (cited in full above under 'Impressionist Techniques . . .').

For an example of the dissatisfaction with the Salon and its exhibitions felt by painters, see: Reff, Theodore, 'Some Unpublished Letters of Degas', *Art Bulletin*, L, 1968, pp. 87–94; pp. 87–8 reprints an open letter from Degas to the members of the Salon jury, 1870, first published in *Paris-Journal*, 12 April, 1870; in this, Degas suggests that there should be only two rows of pictures, with a space of at least 20–30 cm between them, 'without which one harms its neighbours'.

For Louis Latouche:

Bailly-Herzberg, J., Vol. 1, 1980, p. 72.

Rewald, J., 1973, pp. 150–1 and note 20, pp. 193–4, pp. 214, 316, 324 and note 26, p. 339.

For Boudin's letter on the painting exhibited in Latouche's window see Wildenstein, D., Vol. I, 1974, letter 25, Boudin to F. Martin, 25 April 1869, p. 445 (cited in full under 'Introduction').

On Paul Durand-Ruel and the Durand-Ruel galleries, see:

Mémoires de Paul Durand Ruel, in Venturi, L., 1939, Vol. II, pp. 143–220 (cited in full under 'Introduction').

Whiteley, Linda, 'Accounting for Tastes', *Oxford Art Journal*, I, 2, 1978, pp. 25–8.

On Adolphe Goupil and the Goupil galleries, see: Rewald, John, 'Theo Van Gogh, Goupil and the Impressionists' [part I], *Gazette des Beaux-Arts*, 6th period, LXXXI, 1973, pp. 1–64.

For the degree of 'finish' of Impressionist paintings, particularly with respect to Monet, see House, J., 1986, pp. 165–6; the quotation from Zola is on p. 166; for Zola's criticisms see also 'Le Naturalisme au Salon' [etc.], *Le Voltaire*, June 1880, reprinted in *Les Ecrivains devant l'impressionnisme*, 1989, pp. 169–77. For the quotation see note 14, pp. 175–6.

For Durand-Ruel's arrangements with Bouguereau and Rousseau:

Lethève, J., p. 145.

Whiteley, L., 1978, p. 27.

For Père Martin:

Bailly-Herzberg, J., Vol. 1, 1980, note 4, p. 65.
Pissarro refers to Martin a number of times; see particularly letter 74, to Théodore Duret, November (?) 1878, pp. 129–30.

Rewald, J., 1973, pp. 214, 255, 334, 414.

For Durand-Ruel's comment on the ease of selling fashionable work see Venturi, L., 1939, Vol. II, p. 162.

For Durand-Ruel and Renoir, see, for example, Renoir, J., 1962, pp. 289–90 (cited in full under 'The Painter's Studio').

For Monet's relations with Durand-Ruel, and with dealers in general see House, J., 1986, pp. 10–11.

On the location of galleries see Venturi, L., 1939, Vol. II, pp. 173–4.

For Théophile Gautier's description of the rue Lafitte see Lethève, J., 1972, p. 144 (taken from *L'Artiste*, 3 January 1858).

For the Impressionist exhibitions and contemporary criticisms see *The New Painting: Impressionism 1874–1886*, 1986 (cited in full under 'Introduction').

For the Impressionists' one-man shows, see, for example:

Bailly-Herzberg, J., Vol. 1, 1980, letter 122, from Pissarro to Lucien, 3 March 1883, on Monet's show, pp. 179–80, and letter 148, 13 May 1883, on his own show, pp. 206–7.

Rewald, J., 1973, pp. 481–2.

Venturi, L., 1939, Vol. II, p. 213.

For the red-brown colour of wall coverings, particularly at the 1874 Impressionist exhibition, see, for example:

Burty, Philippe, 'News of the Day', *La République française*, 16 April 1874, in Stuckey, C. F., 1985, p. 57.

House, J., 1987, p. 15.

The New Painting: Impressionism 1874–1886, 1986, p. 106.

For a summary of the changes to Article 5 of the rules of the Salon, governing the framing of paintings, see Cahn, I., 1989, p. 27.

For Pissarro's wall colours at the 5th Impressionist Exhibition, 1880, and his comments on Whistler's exhibition see Bailly-Herzberg, J., Vol. 1, 1980, letter 120, to Lucien, 28 February, 1883, pp. 177–8.

On the hanging of pictures for Salon exhibitions:

Lethève, J., 1972, pp. 108ff., especially pp. 116–18 and plates 11–13.

Rewald, J., 1973, pp. 77–80, 213–16, 310 (many scattered references throughout).

See also the works listed under this heading above under 'Impressionist Techniques: Tradition and Innovation'.

For the letter from François Bonvin to Louis Martinet, see: Moreau-Nélaton, Etienne, *Bonvin raconté par lui-même*, Paris, 1927, p. 58.

For Louis Martinet, the role of the Salon, and the role of exhibitions in promoting the reputations of artists, see: Huston, Lorne, 'Le Salon et les expositions d'art: Réflexions à partir de l'expérience de Louis Martinet (1861–1865)', *Gazette des Beaux-Arts*, 6th period, CXVI, July–August 1990, pp. 45–50.

On the height for hanging pictures see Goupil-Fesquet, F.-A.-A., 1877, p. 145.

For Pissarro's comments on Monet's one-man exhibition see Bailly-Herzberg, J., Vol. 1, 1980, letter 122, to Lucien, 3 March 1883, pp. 179–80. The installation at Pissarro's own exhibition, described in letter 148, pp. 206–7, has been referred to above under 'The Appearance, Condition and Framing of Impressionist Pictures'.

For Burty's comment on Monet's *Seine at Lavacourt* at the 1880 Salon, see: Burty, Philippe, 'The Salon of 1880', *La République française*, 19 July 1880, in Stuckey, C. F., 1985, p. 93.

On the viewing distance for Impressionist paintings:

Burty, Philippe, 'The Landscapes of Claude Monet', *La République française*, 27 March 1883, in Stuckey, C. F., 1985 pp. 98–101, quotation from p. 100.

Castagnary, Jules, 'Exposition du boulevard des Capucines – Les Impressionnistes', *Le Siècle*, 29 April, 1874, in *Les Ecrivains devant l'impressionnisme*, 1989, pp. 52–8; the quotation is taken from pp. 55–6; translated in Stuckey, C. F., 1985, pp. 58–9.

House, J., 1986, p. 83 and note 17, p. 238.

On the lighting at the 1st Impressionist Exhibition:

Burty, Philippe, 'Exposition de la Société anonyme des artistes', *La République française*, 25 April 1874, pp. 2–3, reprinted in *Les Ecrivains devant l'impressionnisme*, 1989, pp. 42–6; see especially pp. 42–3.

Burty, P., 1874, in Stuckey, C. F., 1985, p. 57.

For the quotation on the lighting at the Salon, see: Merson, Olivier, *Exposition de 1861: La peinture en France*, Paris, 1861, pp. 38–41, quotation from p. 39.

For Hareux's advice see Hareux, E., 1888–9, part IV, pp. 77–9. With reference to the strong lighting conditions, Hareux makes the point that smaller easel paintings, which could be seen in their entirety, would not be as badly affected (that is, if they could be seen close to).

For Goupil-Fesquet's advice see Goupil-Fesquet, F.-A.-A., 1877, pp. 145–6.

For Monet's letter to Durand-Ruel, 5 March 1883 see Wildenstein, D., Vol. II, 1979, letter 336, p. 227.

For the shadow cast by frames see Cahn, I., 1989 (i), pp. 63–4.

The Catalogue

Note: References cited in abbreviated form are given in full in the section of the bibliography headed 'Introduction', unless otherwise indicated.

Cat. no. 1. Edouard Manet
Music in the Tuileries Gardens

Davies, M., 1970, pp. 91–4.

Manet, 1832–1883, 1983, pp. 122–7.

Manet at Work, 1983, pp. 16–21.

Rouart, D., and Wildenstein, D., 1975, Vol. 1, No. 51, p. 62.

Sandblad, N. G., 1954, pp. 17–68 (cited above under 'Impressionist Techniques: Tradition and Innovation').

For Monet's visit to Manet's one-man show in 1863, see: Duret, Théodore, *Histoire d'Edouard Manet et de son oeuvre*, Paris, 1902, p. 61.

Bazille's letter to his parents is cited in Poulain, G., 1932, p. 36 (cited above under 'Impressionist Techniques . . .').

For the identification of the portraits in the picture, see especially:

Meier-Graefe, Julius, *Edouard Manet*, Munich, 1912, p. 107.

Moreau-Nélaton, Etienne, *Manet: raconté par lui-même*, 2 vols, Paris, 1926, Vol. I, p. 35.

Tabarant, Adolphe, *Manet et ses oeuvres*, 4th edn, Paris, 1947, pp. 38–9.

Sandblad, N. G., 1954, pp. 21–2.

Manet 1832–1883, 1983, pp. 122–4; for a summary of possible sources for the imagery of the picture see pp. 124–6.

On Manet and Baudelaire see Sandblad, N. G., 1954, pp. 56–8.

For the sketch of Ambroise Adam, see: Bareau, Juliet Wilson, 'The Portrait of Ambroise Adam by Edouard Manet', *The Burlington Magazine*, CXXVI, 1984, pp. 750–8.

For Manet's studies in the open air for the painting see Proust, A., 1913, p. 39 (cited above under 'Impressionist Techniques . . .').

For the ink and wash sketch relating to the painting ('Coin de jardin aux Tuileries'), see *Manet 1832–1883*, 1983, p. 127.

For the oil study of nursemaids and children (in the Museum of Art, Rhode Island School of Design) see Bareau, J. Wilson, 1984, p. 757.

The other surviving sketches are listed in Rouart, D., and Wildenstein, D., 1975, Vol. 2, Nos. 309–15, pp. 120–3.

For the dating of the picture see Davies, M., 1970, p. 91.

For a comparison of Manet's painting methods with traditional practice see Hanson, A. Coffin, 1977, pp. 155–76.

For criticism of the painting, see: Mantz, Paul, 'Exposition du Boulevard des Italiens', *Gazette des Beaux-Arts*, 1863, p. 383; and Babou, Hippolyte, 'Les dissidents de l'exposition. M. Edouard Manet,' *Revue Libérale*, Vol. 2, 1867, p. 289.

For Emile Zola's anecdote see Zola, E., *Ed. Manet. Etude biographique et critique*, Paris, 1867, pp. 31–2.

Cat. no. 2. Claude Monet
Bathers at La Grenouillère

Champa, Kermit, *Studies in Early Impressionism*, New Haven and London, 1973, pp. 56–67.

A Day in the Country: Impressionism and the French Landscape, 1984, No. 14, p. 88.

House, J., 1986, pp. 114–15, 136, 147, 161, 205.

Isaacson, J., 1978, pp. 17–18.

Wildenstein, D., Vol. I, 1974, No. 135, p. 178.

Wilson, Michael, Wyld, Martin, and Roy, Ashok, 'Monet's "Bathers at La Grenouillère"', *National Gallery Technical Bulletin*, 5, 1981, pp. 14–25.

On La Grenouillère, the following reference is especially useful: Pickvance, Ronald, 'La Grenouillère', in *Aspects of Monet: A Symposium on the Artist's Life and Times*; edited by John Rewald and Frances Weitzenhoffer, New York, 1984, pp. 36–51.

See also:

Catinat, Maurice, *Les Bords de la Seine avec Renoir et Maupassant; l'Ecole de Chatou*, Chatou, 1952.

A Day in the Country . . ., 1984, pp. 82–4.

Herbert, R. L., 1988, pp. 210–19.

Renoir [exhibition catalogue], 1985, pp. 191–2.

For Monet's letter to Bazille, 25 September 1869, see Wildenstein, D., 1974, letter 53, p. 427.

For the lost painting of La Grenouillère see Gordon, R., and Forge, A., 1983, pp. 44–5.

The lost painting of La Grenouillère is often identified as one of the two paintings by Monet rejected by the Salon of 1870, the other being *Le Déjeuner* of 1868. However, Dr John House has drawn our attention to a review by Zacharie Astruc in which the rejected landscape is called a marine and is therefore unlikely to be a view of La Grenouillère. The review is in *L'Echo des Beaux-Arts*, 8 May 1870, p. 2.

On the relationship between the various paintings of La Grenouillère by Monet see House, J., 1986, p. 161 and note 38, p. 242. House estimates the dimensions of the lost painting as 60 × 100 cm.

For the cleaning of the painting see Wyld, Martin, 'Removal of varnish and overpaint', in Wilson, M., Wyld, M., and Roy, A., 1981, pp. 19–21.

Cat. no. 3. Claude Monet
The Beach at Trouville

Davies, M., 1970, No. 3951, p. 105.

House, J., 1986, pp. 64–5, 140.

Isaacson, J., 1978, pp. 18, 201.

Seitz, William Chapin, *Monet*, London, 1960, p. 86.

Wildenstein, D., Vol. I, 1974, No. 158, p. 188.

For Boudin's letter to Monet, 14 July 1897, see: Jean-Aubry, G., *Eugène Boudin d'après des documents inédits*, Paris, 1922, p. 106.

For Monet's work at Trouville:

Herbert, R. L., 1988, pp. 293–9.

Wildenstein, D., Vol. I, 1974, Nos. 154–162, pp. 188–91.

For the identification of the figures in the picture:

Davies, M., 1970, p. 105.

Isaacson, J., 1978, p. 201.

Wildenstein, D., Vol. I, 1974, pp. 188–90.

On *L'Hôtel des Roches Noires, Trouville* (Wildenstein No. 155):

A Day in the Country . . ., 1984, p. 280.

Herbert, R. L., 1988, pp. 296–9.

Cat. no. 4. Camille Pissarro
Fox Hill, Upper Norwood

Davies, M., 1970, pp. 114–15.

Pissarro, L.-R., and Venturi, L., 1939, Vol. 1, No. 105, p. 93.

For Pissarro in London:

House, John, 'London in the Art of Monet and Pissarro', in *The Image of London: Views by Travellers and Emigrés, 1550–1920*, [exhibition catalogue] by Malcolm Warner and others; Barbican Art Gallery; London, 1987, pp. 73–98.

House, John, 'New Material on Monet and Pissarro in London in 1870–71', *The Burlington Magazine*, CXX, 1978, pp. 636–42.

Reed, Nicholas, *Camille Pissarro at the Crystal Palace*, London, 1987.

Reid, Martin, 'Camille Pissarro: Three Paintings of London of 1871. What do they represent?', *The Burlington Magazine*, CXIX, 1977, pp. 251–61.

Reid, Martin, 'The Pissarro family in the Norwood area of London 1870–1: where did they live?', in *Studies on Camille Pissarro*, 1986, pp. 55–64.

Shikes, Ralph E., and Harper, Paula, *Pissarro, his life and work*, New York and London, 1980, pp. 89–102.

The Impressionists in London; [exhibition catalogue]; Hayward Gallery; London, 1973.

Pissarro's recollections of London are quoted from a letter of 1902 to W. Dewhurst, cited in: Dewhurst, W., 'Impressionist Painting: Its Genesis and Development', *The Studio*, XXIX, 15 July 1903, p. 31.

On works by Pissarro exhibited in London see House, J., 1978, pp. 636–42.

Cat. no. 5. Camille Pissarro
The Avenue, Sydenham

Pissarro, L.-R., and Venturi, L., 1939, Vol. 1, No. 110, p. 94.

The bibliography for Cat. no. 4 should be consulted for this painting also.

The possible impact of Hobbema's *The Avenue, Middleharnis* on Pissarro is proposed by Christopher Lloyd in 'Camille Pissarro and Hans Holbein the Younger', *The Burlington Magazine*, CXVII, 1975, pp. 722–6; see p. 725.

The Annual Report of the National Gallery for 1871 records that the Peel collection was purchased in March and 'open to public exhibition by the 8th. of May following'.

With respect to the purchase of the painting by Paul Durand-Ruel, *The Avenue, Sydenham* was purchased from Paul Durand-Ruel by the Galerie Durand-Ruel on 25 August 1871. However, the painting remained in the private collection of the Durand-Ruel family until the 1920s.

Cat. no. 6. Claude Monet *The Petit Bras of the Seine at Argenteuil*

Lighting up the Landscape . . ., 1986, No. 94, p. 76.

Wildenstein, D., Vol. I, 1974, No. 196, p. 202.

For Monet's work in the Argenteuil area:

Herbert, R. L., 1988, pp. 229–46.

Tucker, P. Hayes, 1982; the paintings of the Petit Bras are discussed on pp. 92–7.

For a comparison of Cat. no. 6 with Daubigny's *Evening on the Oise* see Tucker, P., 1982, p. 20.

On the provenance of the picture: the first recorded owner is Paul Durand-Ruel, *c.* 1881 (Wildenstein, D., Vol. I, 1974, p. 202).

Cat. no. 7. Alfred Sisley
The Watering Place at Marly-le-Roi

Alfred Sisley [exhibition catalogue], 1985.

Daulte, F., 1959, No. 152.

Davies, M., 1970 pp. 133–4.

Musée Promenade de Marly-le-Roi – Louveciennes, *De Renoir à Vuillard: Marly-le-Roi, Louveciennes, leurs environs*, 1984, p. 112.

On the Château de Marly:

A Day in the Country . . ., 1984, pp. 84–5.

Herbert, R. L., 1988, pp. 202–3.

For Sisley's views of the *abreuvoir* see Musée Promenade de Marly-le-Roi – Louveciennes, 1984, pp. 104–15.

On the *abreuvoir* as a washing place see *A Day in the Country . . .*, 1984, p. 98.

On the inclusion of the painting in the 1876 Impressionist group exhibition see *The New Painting: Impressionism 1874–1886*, 1986, No. 37, p. 186.

Cat. no. 8. Pierre-Auguste Renoir
At the Theatre (La Première Sortie)

Daulte, F., 1971, No. 182.

Davies, M., 1970, pp. 120–1.

On the various titles for the picture:

Album-Souvenir of the Armand Doria sale, 1899, No. 203.

Vollard, Ambroise, *Tableaux, Pastels et Dessins de Pierre-Auguste Renoir*, 2 vols, Paris, 1918, Vol. 1, No. 332, p. 83.

For a discussion of Renoir's paintings of the theatre see Herbert, R. L., 1988, pp. 93–103.

On *La Loge* see *Renoir* [exhibition catalogue], 1985, No. 26, p. 203.

On the dating of *At the Theatre*:

Cooper, Douglas, *The Courtauld Collection*, London, 1954, No. 52, pp. 109–10.

Davies, M., 1970, p. 121.

Cat. no. 9. Camille Pissarro
The Côte des Boeufs at L'Hermitage
Brettell, Richard R., *Pissarro and Pontoise: the Painter in a Landscape*, [PhD thesis], New Haven, 1977, pp. 243–5, 249–50, 308–9.

Davies, M., 1970, pp. 113–14.

Pissarro: Camille Pissarro 1830–1903, 1980, No. 46, pp. 110–11.

Pissarro, L.-R., and Venturi, L., 1939, No. 380, p. 134.

Shikes, R. E., and Harper, P., 1980, pp. 130, 153.

Thomson, R., 1990, No. 24, pp. 38–40.

For Pissarro's list of pictures for his 1892 exhibition see Venturi, L., 1939, Vol. II, p. 34.

In the catalogue of the exhibition the picture is entitled 'La Côte des boeufs, à l'Hermitage'.

For this picture and the 1877 Impressionist exhibition see *The New Painting . . .*, 1986, p. 195.

For Pissarro's work in the region around L'Hermitage:

Brettell, R., 1977.

A Day in the Country . . ., 1984, pp. 175–206.

On *L'Hermitage at Pontoise* (Wallraf-Richartz Museum, Cologne):

Pissarro: Camille Pissarro 1830–1903, 1980, p. 76.

For Pissarro's remark to Sickert, see: Sickert, Walter, 'French Painters at Knoedler's Gallery', *The Burlington Magazine*, XLIII, no. CCXLIV, July, 1923, pp. 39–40: 'But the charm of a picture like this lies chiefly in its immense and indefatigable laboriousness, . . . "Un travail de Benedictin", as I have heard himself call it.'

On *The Red Roofs* (Musée d'Orsay, Paris):

A Day in the Country . . ., 1984, No. 67, pp. 184, 190.

Pissarro: Camille Pissarro 1830–1903, 1980, No. 47, p. 112.

For Pissarro's letter to Caillebotte (1878) see Bailly-Herzberg, J., Vol. 1, 1980, letter 53, pp. 109–10.

For Pissarro's own description of the surfaces of his paintings as 'rough and rasping' see Bailly-Herzberg, J., Vol. 1, 1980, letter to Lucien, 4 May 1883, p. 202.

Cat. no. 10. Claude Monet
The Gare Saint-Lazare
Cooper, D., 1954, No. 42, pp. 104–5 (cited in full under Cat. no. 8).

Wildenstein, D., Vol. I, 1974, No. 441, p. 306.

On Monet at the Gare Saint-Lazare:

Herbert, R. L., 1988, pp. 24–8.

Hommage à Claude Monet, 1980, pp. 159–63.

Rewald, J., 1973, pp. 379–80.

Wildenstein, D., Vol. I, 1974, pp. 83–4.

For reactions to the pictures at the 1877 exhibition see *The New Painting . . .*, 1986, pp. 222–4, 227.

On the Saint-Lazare paintings as a series, see:

Seiberling, Grace, *Monet's Series*, PhD dissertation, Yale University, 1976, Garland, New York, and London, 1981, pp. 47–9.

For pencil sketches relating to the Saint-Lazare paintings:

House, J., 1986, p. 229.

Isaacson, J., 1978, p. 209.

On the technique and various other aspects of the Saint-Lazare paintings see House, J., 1986, especially pp. 80, 83, 184.

For Rivière's comments in his description of the 1877 Impressionist exhibition see *The New Painting . . .*, 1986, p. 223.

Cat. no. 11. Pierre-Auguste Renoir
Boating on the Seine
Cooper, D., 1954, No. 54, p. 110.

Gaunt, William, *Renoir*, 3rd enlarged edn, with notes by Kathleen Adler, Oxford, 1982, No. 33.

Renoir [exhibition catalogue], 1985, No. 47, p. 216.

Roy, Ashok, 'The Palettes of Three Impressionist Paintings', *National Gallery Technical Bulletin*, 9, 1985, pp. 12–20.

Van Gogh à Paris; [exhibition catalogue], Musée d'Orsay, Paris; Paris, 1988, No. 102, p. 270.

The painting is first recorded in the sale of Victor Choquet's collection, July, 1899, No. 93 (*La Seine à Asnières*). In an exhibition at the dealer Bernheim-Jeune in 1913 it was entitled *La Yole*.

For Renoir's work at Chatou:

Catinat, M., 1952 (cited in full under Cat. no. 2).

A Day in the Country . . ., 1984, pp. 137ff.

Herbert, R. L., 1988, pp. 246–54.

The arches of the railway bridge appear in several works by Renoir, including *Pont du chemin de fer à Chatou*, 1881 (Musee d'Orsay, Paris).

Cat. no. 12. Berthe Morisot
Summer's Day
Adler, K., and Garb, T., 1987, pp. 123–4.

Bataille, M.-L., and Wildenstein, G., 1961, No. 79, p. 28.

Berthe Morisot: Impressionist, 1987, No. 36, p. 82.

Davies, M., 1970, pp. 110–11.

For the fifth Impressionist exhibition see *The New Painting*, 1986, pp. 293ff. The quotation on Morisot's work is on p. 326.

For Morisot in the Bois de Boulogne:

Adler K., and Garb, T., 1987, pp. 105ff.

Herbert, R. L., 1988, pp. 151–2.

For Jacques-Emile Blanche's reminiscence see *Berthe Morisot: Impressionist*, 1987, p. 57.

For the watercolour study of *Summer's Day* see Bataille, M.-L., and Wildenstein, G., 1961, No. 641, fig. 621.

For the quotations on Morisot's work see *The New Painting*, 1986, p. 299.

Cat. no. 13. Claude Monet
Lavacourt under Snow
Bodkin, Thomas, *Hugh Lane and his Pictures*, Dublin, 1932, Plate XLIV.

Davies, M., 1970, p. 104.

House, J., 1986, p. 121.

Wildenstein, D., Vol. I, 1974, No. 511, p. 336.

For Monet at Vétheuil see *Hommage à Claude Monet*, 1980, pp. 184–229.

For Monet's letter to Duret (8 February 1879) see Wildenstein, D., Vol. I, 1974, letter no. 154, p. 436.

For other views of Lavacourt see Wildenstein, D., Vol. I, 1974, Nos. 512–517. Wildenstein also reproduces a view of Lavacourt by Daubigny and a photograph of the village *c*. 1900 on p. 103.

Cat. no. 14. Pierre-Auguste Renoir
The Umbrellas (Les Parapluies)
Daulte, F., 1971, No. 298.

Davies, M., 1970, pp. 119–20.

Gaunt, W., and Adler, K., 1982, No. 39 (cited in full under Cat. no. 11).

Renoir [exhibition catalogue], 1985, No. 58, p. 228; for Renoir's work in the 1880s see pp. 220ff.

For Renoir's remark to Vollard, on his having reached the end of Impressionism, see Vollard, A., 1938, p. 213 (cited above under 'Impressionist Techniques: Tradition and Innovation').

For Renoir in Italy, see: White, Barbara Ehrlich, 'Renoir's Trip to Italy', *Art Bulletin*, LI, 4, 1969, pp. 333–51. Renoir's admiration for Raphael and the ancient wall-paintings in Naples are discussed on p. 341.

Notes on the costumes, by Stella M. Pearce, are in the National Gallery archives. These notes are based mainly on fashions depicted in *La Mode Illustrée* and *L'Art de la Mode*.

For Renoir's comment to Vollard on the solidity of technique of his paintings of the 1880s see Vollard, A., 1938, p. 216.

For Renoir's interest in Cennino Cennini, see: Lilley, Edward, 'Renoir's Preface to Cennino Cennini', *Gazette des Beaux-Arts*, 6th période, tome CXV, March 1990, pp. 122–8.

The Vollard reference cited above should also be consulted. Renoir's preface takes the form of a letter addressed to the editor of the 1911 revision of the French edition of Cennini's treatise; the reference is given in full in the bibliography for 'Colourmen'.

For Renoir's 'fresco-like' techniques see White, B. E., 1969, p. 344.

Pissarro also experimented with different supports and media (e.g. gouache and tempera) during this period and seems to have been looking for a particular type of matt, chalky surface which would help him to render the pale, luminous qualities of outdoor light. His *Wool Carder*, 1880 (Tate Gallery, London), for example, is painted on cement.

On Renoir and Cézanne:

Demus, O., 'The Literature of Art. *Auguste Renoir, Les Parapluies*', *The Burlington Magazine*, LXXXVII, 1945, pp. 258–9.

Renoir [exhibition catalogue], 1985, pp. 220, 233; for a discussion of the problems of the picture and the final appearance of *The Umbrellas*, see p. 228.

Cat. no. 15. Paul Cézanne
Hillside in Provence
Cooper, D., 1954, p. 86 (cited in full under Cat. no. 8).

Davies, M., 1970, pp. 18–19.

For Cézanne's desire to make Impressionism 'something solid and durable' see *Conversations avec Cézanne*, 1978, p. 170: Cézanne to Maurice Denis.

Cézanne's comment to the journalist Stock is in Rewald, J., 1973, p. 246.

Bernard in 1904 reported Cézanne as saying: 'Peindre d'après nature ce n'est pas copier l'objectif, c'est réaliser ces sensations' (see *Conversations avec Cézanne*, 1978, p. 36).

The best account of Cézanne's work in the context of Impressionism is given by Richard Shiff, 1984 (see 'Introduction').

On Cézanne's distinctive brushwork see Reff, T., 1962, pp. 214–27 (cited above under 'The Paint Layers and Surface of Impressionist Paintings').

On the dating of *Hillside in Provence* see Davies, M., 1970, pp. 18–19.

The arguments about the identification of the site are summarised here also.

The quotation on Cézanne's representing, rather than imitating, nature is from a conversation Cézanne had with Maurice Denis, cited in *Conversations avec Cézanne*, 1978, p. 173.

Accounts of Recent Scientific Examinations of Paintings by the Artists discussed in the Catalogue:

Bomford, David, and Roy, Ashok, 'Manet's "The Waitress": An Investigation into its Origin and Development', *National Gallery Technical Bulletin*, 7, 1983, pp. 3–19.

Bruce Gardner, R., Hedley, G., and Villers, C., 1987 (cited above under 'The Appearance, Condition and Framing of Impressionist Paintings').

Butler, Marigene H., 'An Investigation of the materials and technique used by Paul Cézanne', in *Preprints of Papers presented at the Twelfth Annual Meeting of the American Institute for Conservation of Historic and Artistic Works*, Los Angeles, California, 15–20 May 1984, Washington, DC, 1984, pp. 20–33.

Butler, Marigene H., 'An Investigation of Pigments and Technique in the Cézanne painting "Chestnut Trees"', *Bulletin of the American Institute for Conservation of Historic and Artistic Works*, 13, 2, 1973, pp. 77–85.

Butler, Marigene H., 'Technical Note' in *Paintings by Renoir* [exhibition catalogue], Art Institute of Chicago, 3 February–1 April, Chicago, 1973, pp. 209–14.

[Clapp, Anne F.], 'Cézanne and Emerald green', *Bulletin of the American Group of the International Institute for Conservation of Historic and Artistic Works*, 6, 2, 1966, p. 14. A report of the occurrence of the pigment in a painting of 1900.

Corradini, Juan, *Edouard Manet "La Ninfa sorprendida" del Museo Nacional de Bellas Artes de Buenos Aires*, Buenos Aires, 1983. Examination by X-ray radiography and infra-red photography.

Gifford, E. Melanie, 'Manet's "At the Café": Development and Structure', *Journal of the Walters Art Gallery*, 42/43, 1984–5, pp. 98–104.

The Hidden Face of Manet . . ., 1986 (cited above under 'Introduction').

Hours, Madeleine, and others, 'Manière et matière des Impressionnistes', *Annales du Laboratoire de Recherche des Musées de France*, 1974.

Jones, Elizabeth F., 'Monet Observed: Materials; Technique', in *Monet Unveiled: A New Look at Boston's Paintings* [exhibition catalogue], Museum of Fine Arts, Boston, 1977, pp. 6–10.

Papillon, M.-C., Lefèvre, R., Lahanier, Ch., Duval, A., and Rioux, J.-P., 'Réalisation et étude par microscope électronique analytique en transmission de coupes ultra-fines d'échantillons de peintres', in *ICOM Committee for Conservation, 8th. Triennial Meeting, Sydney, Australia, 6–11 September, 1987, preprints*; edited by Karen Grimstad, Marina del Rey, 1987, Vol. 1, pp. 79–86. On the pigments in Manet's *The Waitress* (Paris, Musée d'Orsay).

Roy, Ashok, 'The Palettes of Three Impressionist Paintings', *National Gallery Technical Bulletin*, 9, 1985, pp. 12–20.

Shiff, R., 1984, pp. 199ff., and notes 23–25, 27–30, pp. 299–301 for reports of pigment identification in certain of Cézanne's and Pissarro's paintings, including the *Artist's Palette with a Landscape* discussed under 'Impressionist Use of Colour: Impressionist Practice'.

Stuckey, Charles F., 'Manet revised: Whodunit?', *Art in America*, 71, 10, 1983, pp. 158–77, 239, 241. Some evidence from X-ray radiographs.

Wilson, Michael, Wyld, Martin, and Roy, Ashok, 'Monet's "Bathers at La Grenouillère"', *National Gallery Technical Bulletin*, 5, 1981, pp. 14–25.

Photographic credits